Kant, Art, and Art History

Moments of Discipline

Kant, Art, and Art History: Moments of Discipline is the first systematic study of Immanuel Kant's reception in and influence on the visual arts and art history. Working against Kant's transcendental approach to aesthetic judgment, Cheetham examines five "moments" of his influence, including the use of his political writings by German-speaking artists and critics in Rome around 1800; the canonized patterns of Kant's reception in late nineteenth- and early twentieth-century art history, particularly in the work of Wölfflin and Panofsky; and Kantian language in the criticism of cubism. Cheetham also reassesses Clement Greenberg's famous reliance on Kant. The final chapter focuses on Kant's "image" in both contemporary and posthumous portraits and examines his status as the personification of philosophy within a disciplinary hierarchy. In Cheetham's reading, Kant emerges as a figure who has constantly defined and crosses the borders among art, its history, and philosophy.

Mark A. Cheetham is a Professor in the Department of Fine Art at the University of Toronto, where he teaches the history, theory, and criticism of the visual arts. A recipient of a John Simon Guggenheim Memorial Fellowship, he is the author of several books, including *The Rhetoric of Purity: Essentialist Theory and the Advent of Abstract Painting, Remembering Postmodernism: Trends in Recent Canadian Art,* and *Alex Colville: The Observer Observed.* He is also coeditor of *The Subjects of Art History: Historical Objects in Contemporary Perspective* and *Theory between the Disciplines: Authority / Vision / Politics.*

Kant, Art, and Art History

Moments of Discipline

MARK A. CHEETHAM

University of Toronto

 CAMBRIDGE
UNIVERSITY PRESS

PUBLISHED BY THE PRESS SYNDICATE OF THE UNIVERSITY OF CAMBRIDGE
The Pitt Building, Trumpington Street, Cambridge, United Kingdom

CAMBRIDGE UNIVERSITY PRESS
The Edinburgh Building, Cambridge CB2 2RU, UK
40 West 20th Street, New York, NY 10011-4211, USA
10 Stamford Road, Oakleigh, VIC 3166, Australia
Ruiz de Alarcón 13, 28014 Madrid, Spain
Dock House, The Waterfront, Cape Town 8001, South Africa

http://www.cambridge.org

First published 2001

Printed in the United States of America

Typeface Concorde 9.75/13 pt. *System* MagnaType [AG]

A catalog record for this book is available from the British Library.

Library of Congress Cataloging in Publication Data
Cheetham, Mark A. (Mark Arthur), 1954 –
Kant, Art, and Art History: moments of discipline / Mark A. Cheetham.
p. cm.
Includes bibliographical references and index.
ISBN 0-521-80018-8
1. Kant, Immanuel, 1724 – 1804 – Contributions in aesthetics. 2. Aesthetics, Modern.
3. Art – Philosophy. I. Title.
B2799.A4 C48 2001
111'.85'092 – dc21 00-063029

ISBN 0 521 80018 8 hardback

For

Elizabeth, Nicholas, and Anthea

Contents

Acknowledgments

The complexity and duration of my work on Immanuel Kant and the visual arts places me in the happy position of acknowledging the support of a great number of institutions and individuals. In 1994, I was awarded two research fellowships, one from the Social Sciences and Humanities Research Council of Canada, which furnished travel funds, and the other from the John Simon Guggenheim Memorial Foundation, which provided time and the invaluable sense that my research should and could proceed as I envisioned it. More recently, the University of Western Ontario, J. B. Smallman Fund – through the kindness of Kathleen Okruhlik, Dean, Faculty of Arts – afforded welcome help with the acquisition of images for this book.

I would also like to thank most sincerely those who invited me to present my ideas orally and the many who responded so helpfully to them on those occasions: the Centre for the Study of Theory and Criticism at the University of Western Ontario; the organizers of the "Beauty in the Nineteenth Century" conference, University of Toronto, 1997; the Canadian Society of Aesthetics (St. John's, 1997); the Universities Art Association of Canada, Toronto (1999); the College Art Association of America, New York (2000); Trent University; and especially McMaster University, which kindly invited me to give a series of lectures as Hooker Distinguished Visiting Professor in 1998. I am also grateful to the editors of SUNY Press, *Aporia*, *C Magazine*, and *World & Image* for permission to incorporate here versions of my arguments already published, and to the artists and collections noted in my captions for the right to reproduce their works.

I wish to express my sincere appreciation to those students who have

worked for me as researchers: Jen Cottrill, Sarah Demelo, Barbara Edwards, Julie Krygsman, Florence Leong, Kathryn Price, Christine Sprengler, and Diana van Do. Thanks too to the staff at the interlibrary loan department, D. B. Weldon Library, the University of Western Ontario; to Barry Cook and to Brenda MacEachern at Western; and to Catherine Gordon and Jonathan Vickers at the Witt Library, Courtauld Institute. Many colleagues and friends have responded to dimensions of this work with great magnanimity and insight, for which I remain indebted: heartfelt thanks to Daniel Alder, Jenny Anger, Mark Antliff, Sheila Ayearst, A. A. Bronson, Erin Campbell, Christian Eckart, Wyn Geleynse, Michael Ann Holly, Linda Hutcheon, Salim Kemal, Karen Lang, Anne-Marie Link, Peter McCormick, Keith Moxey, Cameron Munter, Andy Patton, Tilottama Rajan, Joel Robinson, Tobin Siebers, Joanne Tod, William Vaughan, Andrew Wernick, and Ryan Whyte. Special thanks to Beatrice Rehl at Cambridge University Press for her ongoing support of this project.

David Carrier has listened and responded to my ideas about Kant with constant intellectual and personal generosity. His many honest questions and encouraging remarks have sustained me. Mitchell Frank not only provided expert translations of nineteenth-century German texts but was also extraordinarily ready with ideas that challenged and expanded my own. As always – though I marvel anew at its depths – my most profound gratitude goes to Elizabeth Harvey and our children, to whom I dedicate this book.

I

Introduction

Bo(a)rders

Hegel and Kant were the last who, to put it bluntly, were able to write major aesthetics without understanding anything about art.

Theodor W. Adorno

What counts in judging beauty is not what nature is, nor even what purpose it [has] for us, but how we receive it.

Immanuel Kant

Proper names are indeed, if not passages, then at least points of contact between heterogeneous regimes.

J.-F. Lyotard[1]

This book examines the far-reaching and varied reception of Immanuel Kant's thought in art history and the practicing visual arts from the late eighteenth century to the present. Although many art historians, critics, and artists are aware that Kant's name and formalist critical practice were summoned by Clement Greenberg in his apologies for the European avant-garde and for post–World War II abstract painting, or that Kant's ideas were used by the central founders of academic art history – especially Wölfflin and Panofsky – as a way to demarcate and ground the discipline, Kant has not been perceived as pervasively influential in art history and the visual arts. Yet, for better or worse, his ideas (or those attributed to him) are immanent to these fields. To note an example so obvious that it tends to slip from our consciousness, his *Critique of Pure Reason* (1781) is the source for the famous analytic/synthetic distinction used traditionally in discussions of cubism to distinguish both the working methods and

the chronological development of this art movement. Panofsky's distinctly Kantian search for a stable Archimedean vantage point outside the flux of empirical reality from which to judge individual works of art is another central instance of Kant's profound influence. It is worth emphasizing that the need for grounding in or from philosophy is itself a Kantian legacy, one that has done much to shape and place the discipline of art history, both in its infancy and today. Kant's authority has also been used recently to buttress what we might call an ethics of art-historical behavior: in the final paragraph of his essay on Hegel, Ernst Gombrich invokes Kant's "stern and frightening doctrine that nobody and nothing can relieve us of the burden of moral responsibility for our judgement" as an antidote to the "theophany" that Hegel purportedly saw in history (1984, 69). L. D. Ettlinger similarly looked to Kant to support his defense of individual, humanist priorities in art history. In a lecture delivered in 1961 titled "Art History Today," Ettlinger mentioned Kant in his final remarks, relying on him as the ultimate exponent of a renewed humanism that focused on "those central problems which concern man and his works" (1961, 21). It is as a humanist that Kant is of greatest importance to the later Panofsky.

Willi Goetschel has provocatively suggested that "the two hundred years that have elapsed since the publication of the [first] *Critique* seem to mark just the beginning of Kant interpretation" (1994, 115). Even in the face of a Kant bibliography of sublime and rapidly expanding proportions, Goetschel is right. Kant's thought is topical and pertinent across the humanities today in an unprecedented way. It is increasingly clear, as Tobin Siebers has put it, that we cannot discover "a single defense of art on ideological grounds that does not owe a substantial debt to Kant" (1998, 34). I also agree with Koenraad Geldof that he is "an author whose authority doubtless has never been so great as it is today." We should heed Geldof's caveat that in addition to being sensitive to the implications of invoking Kant, we must also guard against misusing "the authority of counterauthority" gained by resisting Kant (Geldof 1997, 23, 28). While I will be critical of how Kant's ideas have been used, my primary goal is to establish the extensive historical and theoretical presence of his thought in the historiography of art history and art criticism as well as in the work of artists from his time to our own.[2] But *how* is he important? I exhibit Kant – the man and his ideas, his name and its authority, and the discipline of philosophy that he frequently came to personify – as an active, contouring force in the visual arts and their histories. This force I call Kant's "discipline," a term

with broad implications, whose shifting meanings I will exploit rather than attempt to define narrowly. I describe the manifestations of his reception with the term "plasmatics." In ways that I will examine in detail, it is precisely because of his apparent "outsider" status in these contexts – and that of philosophy generally – that he has been so influential. Kant himself established a juridical hierarchy between historical and theoretical pursuits that applies to his treatment by art historians. Because he is an outsider, and because philosophy is often held to be different from and antithetical to art, it has been possible for the discipline of art history to suppress the importance of his name. I seek to illuminate the effects of Kant's thought on the minute level of individual interaction between a theorist and art critics during the inception of cubism or American color-field painting, for example, and I also deal with Kant's influence on the broader plane of disciplinary interaction. My primary concern is with the practical implications of high theory as it has been employed by the art historians, artists, and critics who have received Kant's philosophy.

As the book's subtitle suggests, I proceed by paying close attention to the spatial and temporal aspects of Kant's legacy. The selective "moments" of reception that I examine – Rome during the Napoleonic invasions, the Paris of the cubists, Clement Greenberg's New York, and others – are, however, not allied with the transcendental judgments and the categories of space and time set out by Kant in his *Critiques* but are, rather, the historically inflected intersections and intensities of "placed" reception. For example, whereas Kant's moment of "quality" in the *Critique of Judgment* (1790) is defined as "aesthetical" and depends upon disinterestedness, my first moment (Chapter 2) focuses on the broadly political use made of a wide range of his writings in the German-speaking artists' colony in Rome circa 1800. Kant as a German icon and his manipulation for various nationalistic ends is a theme I establish here and follow throughout the book. In Chapter 3, I examine Kant's immense authority in twentieth-century art and art history. I look at Panofsky's Kantianism, the strategic use of the philosopher's name in early defenses of cubism, and finally at Clement Greenberg's deployment of Kant's arguments for the autonomy of the aesthetic as a way of discriminating high art from "kitsch." In Chapters 4 and 5, I consciously allow the layering of multiple instances of Kant's influence to become more complex and less ordered by chronology. My goal is to enact as well as to analyze Kant's legacy in current art and art history. In Chapter 4, I study the return to the Kantian sublime in recent French

3

theory and link this preoccupation to "examples" of the sublime in contemporary art practice. The final chapter interprets the history of Kant portraiture from the late eighteenth century to the present as both representative and constitutive of his remarkable authority in art and its history. As I have mentioned, Chapter 2 details how an early form of German cultural nationalism precipitated around Kant's texts as they were received in the German *Künstlerrepublic* in Rome in the late eighteenth century. The identification of Germanness with philosophy and of philosophy with Kant found in this context remains topical in our own time, as Anselm Kiefer demonstrates in two of his three *Wege der Weltweisheit* images (1976–80), which include miniature portraits of Kant in the company of others who have shaped German national and cultural identity. By investigating Kant portraiture, then, I gain access to one of current art history's most theoretically and historically engaging domains and I delineate a Foucauldian "genealogy" of Kant himself that reflects how he figures culturally and how his image has been used to model disciplinary relationships.

The moments of reception that I will examine feature literal references to Kant's texts and ideas on the part of the artists and historians in question: they are more explicitly Kantian than much of the diffused neo-Kantianism that is to be found everywhere in European thought for much of the nineteenth and early twentieth centuries.[3] Looking for Kant, one can all too easily find and thus reify his doctrines. It is easy to claim too much in his name. For this reason I have focused on only a few instances of his influence. There are others – in architectural theory and contemporary art especially – and I happily anticipate that readers of this study will point them out. My principal claims about Kant's interactions with art and art history emerge from and can be amply corroborated through the selective probings into the very extensive legacy that I present. I hope to display patterns of influence, not an exhaustive survey. At times my investigation may seem to specialists in art history or philosophy to be too broad; to others, I may seem to provide too much detail about relatively little-known instances of Kant's influence. My defense for this approach is that I use Kant very much as he has been used outside philosophy over the past two hundred years. If my technique seems to some to be inappropriately informal, it is again for the reason that much of Kant's influence is precisely "casual" in ways that I will describe. I will show that Kant's leverage in art history and the visual arts extends well beyond the themes of the *Critique of Judgment,* the book in which he seems to have the most to

say about art and the aesthetic, and the source to which critics today tuned to Kant's peculiar interest in the arts therefore turn almost exclusively. In general, Kant's political writings have been at least as influential in the contexts examined here as have his *Critiques*. I will argue that his legacy has been "political" as much as "formal," even when his name is dropped by Clement Greenberg. The shape of Kant's reception depends in large measure upon what I will describe as "concurrency," the specific temporal and "placed" contexts in which his ideas are received. I have shaped my study very much in accord with this principle. While Kant in the third *Critique* famously demands universality for his second moment of "quantity," for example, I insist on the particularities of reception. In his moment of "relation," "purposiveness" depends on the autonomy and freedom of the Kantian subject, which I redescribe according to the interdependencies and vagrancies of genealogy. While he requires "necessity" to satisfy the moment of "modality," I emphasize the contingencies of how his ideas were known and used. In arranging my chapters chronologically, I hope to demonstrate that Kant's influence has been constant (if not consistent) from the 1770s until the 1990s, that his impact is in some ways cumulative, and that it has appeared across (and may well define the formation of) boundaries between theoretical, historical, art-critical, philosophical, and strictly artistic practices. Finally, it seems to me that Kant's reception in art history and the visual arts is paradigmatic of a relationship among disciplines that leads to a redefinition and reshaping of their priorities and methodologies. More often than not, a discipline's central concerns are defined not so much by self-conscious, programmatic statements of principle but by the activities of *bordering* fields. There is no pure Kant and no secure border between the many areas that he has influenced. In its attempts to understand Kant's relations with art and art history, then, this book is systematically un-Kantian and frequently anti-Kantian. I acknowledge but also resist his terminology and the often seductive securities of his architectonic, his penchant for systems built from the purifying rituals of critique.[4] At the same time, in reading Kant's reception in detail, I find that many aspects of his theories remain potent for art and art history today. But the book is "about" Kant and art history and the visual arts only in a spatial sense. Responding to an oral version of parts of Chapter 5 in the fall of 1998, a colleague from a philosophy department was kind enough to remark that my paper was not really about Kant; she meant that I did not deal with philosophical issues in the Kant canon, which was true. But in exploring his propinquity to the visual

arts and art history over two hundred years, I will argue for a greater and more complex interaction than the old disciplinary protocols allow. As I hope to show in my final chapter especially, Kant's image has not and should not be left behind in the visual arts and art history. Reciprocally, his migrations to and from these disciplines help us to understand and assess his philosophy.

The manipulations of Kant's name and ideas are paradigmatic of disciplinary interactions among art, its history, and philosophy, each of which adopts his "critical" method and arguments about disciplinary freedom and autonomy to keep itself pure and yet is systematically dependent on its neighbors. Fundamental to my work is the notion that each field recurrently uses another as a Derridean *supplement,* a *parergon* in a perpetual process of self-definition. The result is a spatial interaction that constantly places and realigns these disciplines in terms of one another, frequently and paradigmatically with Kant as the fulcrum point. As Timothy Lenoir suggests, "disciplines are political institutions that demarcate areas of academic territory, allocate privileges and responsibilities of expertise, and structure claims on resources" (1993, 82). It is in these terms that I emphasize how Kant has often been taken as the synecdochic personification of philosophy in his interactions with art history and the visual arts. I characterize these relations as analogous to those performed by a domestic boarder – a temporary and sometimes both involuntary and unwelcome lodger or visitor – whose presence "in" art and art history helps to define the shifting borders among these areas. Kant's legislative bo(a)rder work in the third *Critique* and *The Conflict of the Faculties* (1798) epitomizes the spatial and temporal complexity of these disciplinary interrelationships.

Arthur Danto writes portentously of the "essential division between philosophy and art" and the ultimate "disenfranchisement" of art at the hands of philosophy (1986, xv). By contrast, my examination of Kant's reception suggests that the borders among disciplines cannot adequately be imagined as straight lines or impenetrable boundaries with uncomplicated insides and outsides that can be associated with simple, hegemonic hierarchies. Philosophy, art, and art history are not as separate as Kant, Danto, and many others have wished them to be. How, then, can philosophy stand over art to disenfranchise it? A conventional geometrical model of disciplinarity where Kant is seen as either inside or outside a field needs to be rethought in terms of a more organic and less hierarchical scheme of what I will describe in detail below as "plasmatics," both in order to understand as fully as possible his re-

markable effects in the visual arts and art history and to adumbrate a more widely applicable model of disciplinary description and change. Without plotting an a priori map of the territories I will examine or succumbing to the fantasy that I can, through critique, offer a self-transparent description of my motives and theoretical position, I want now to describe more fully the shape of the project.

Why (Not) Kant?

On the face of it – and the contours of Kant's face and skull will become central to my argument in Chapter 5 – Kant is an unlikely thinker to influence the visual arts or the discipline of art history. The epigraph from Adorno at the beginning of this chapter invokes what has become a common refrain: Kant knew little about the arts, so how was he qualified to judge them? Adorno attempts to understand why Kant (and Hegel) have been instrumental in spite of this apparent handicap. But like many commentators before and after him, he assumes that Kant, as a philosopher, is somehow outside the orbit of the artist. Construed somewhat reductively, Adorno's complaint about Kant is a version of the simplistic opposition of thinker and maker, idea and matter. Variations on this theme may be heard today, especially with regard to Greenberg's famous invocation of Kant's name. Even very sophisticated commentators surmise that Greenberg did not (or could not) understand Kant and thus misused him.[5] Beneath this assertion often lies the prejudice that art and art criticism have no business with philosophy. As I show in greater detail in Chapter 2, Friedrich Schlegel was perhaps the first to censor Kant's aesthetics because of its a priori method, for which Schlegel self-consciously substituted the (return to) empirical descriptions of style, a method that depended on knowledge of individual artists and works. Nietzsche applied this prohibition to disciplines. "Kant, like all philosophers," he argued, "instead of envisaging the aesthetic problem from the point of view of the artist (creator), considered art and the beautiful purely from that of the 'spectator'" (1989, §6). Many contemporary historians and theorists adopt a weaker or stronger version of this position when they discuss Kant's relationship to the visual arts and, by extension, the disciplinary interactions among philosophy, the visual arts, and art history. For David Rodowick, "the object of Kant's [third] *Critique* is not art per se. Art or the making of art has no place in Kant's philosophy" (1994, 100). Terry Eagleton is equally outspoken: "With the birth of the aesthetic . . . the sphere of art itself

7

begins to suffer something of the abstraction and formalization characteristic of modern theory in general" (1990, 2). As I have noted, Danto – whose sympathies for Nietzsche are evident – envisions the "disenfranchisement" of art by philosophy, a belief that is based on his assumption of an "essential" separation between these spheres. While we might have sympathy for Nietzsche's and Danto's attitude and grow justifiably impatient with Kant's abstractions about the arts, the reception of Kant's ideas nonetheless shows that those who would bar philosophy from art or vice versa are in effect behaving as good Kantians by drawing disciplinary boundaries in too rigid a fashion. Put more positively, perhaps in spite of himself, Kant helps us to understand that one need not be an artist to comment effectively on art, or a philosopher to theorize.[6]

Nietzsche's assessment that Kant's aesthetics acknowledges only the position of the spectator is correct but need not be taken as a weakness. If Kant's subjectivist, "Copernican" turn in his critical philosophy, his experimental supposition "that objects must conform to our knowledge" (1967, Bxvii), establishes the mind's capacities as constitutive of the only reality we can know – while positing the necessity of a noumenal thing-in-itself – it follows that his will always be an aesthetics of reception, of how the mind shapes its world. As he put it in the second epigraph to this chapter, how we receive nature (or art) occasions and determines the judgment of beauty.[7] There are resources in this theory for our examination of Kant's own reception in art and art history, especially when we recall that for him judgment is fundamentally social and public in nature. Kant made it clear that he was writing "about" art in the third *Critique* for transcendental and architectonic purposes only. "Since this inquiry into our power of taste . . . has a transcendental aim, rather than the aim to [help] form and cultivate taste," he claimed in his preface, "I would like to think that it will be judged leniently as regards its deficiency for the latter purpose" (1987, 170). Because Kant was constantly inveighing against the epistemological uncertainty of any empirical or indeed historical procedure – whether in aesthetics, ethics, metaphysics, politics, or natural history – his reference to the "deficiency" of the *Critique of Judgment* must be read as heavily ironic. For him, the transcendental method was anything but deficient. As method and system, it needs the empirical – in this case, art – as a foil or supplement. Kant needs art in the third *Critique* just as reason and its discipline – philosophy – need other fields to judge and govern. Art is not cognitive; it always remains "other," even though it exists for us only

in judgment.[8] The transcendental mission of Kantian reason is therefore fuelled, not distracted, by what Ted Cohen and Paul Guyer revealingly call "mere digressions on some specific issues raised by judgments about works of art" (1982, 4). Just as Kant's epistemology is one of reception, so too we can productively focus on how his ideas about art were in turn received. John Zammito claims with ample justification that "Kant was primarily and professionally enmeshed in the *Aufklärung*'s epistemological project. He was not interested in fine art, in its system, in creativity or artistic taste" (1992, 21). Even if we accept this very restrictive view, however – one that takes Kant literally – artists, critics, and historians were and remain free to use Kant's ideas and to trade on his considerable authority. And as a corrective to Zammito's claims, we should recall that aesthetics is marginal within Anglo-American philosophy and, though this is changing, that the arts remain peripheral within aesthetics (Devereaux 1997).

The notorious conceptual and stylistic difficulty of Kant's texts – recognized in his time as much as in our own – might also seem to exclude them from a significant role in less theoretically inclined fields. What Nietzsche memorably calls Kant's "garrulousness due to a superabundant supply of conceptual formulations" (1974, §97) accurately enough describes the three *Critiques* and his other full-length works. The early and frequent appearance of popular restatements of Kant's theories would seem to corroborate the intuition that his main works would be of little interest outside a circle of professional philosophers. Yet Friedrich Grillo wrote a lengthy text titled "Ueber Kunst nach Herrn Kant," published in 1796 specifically "Für denkende Künstler, die Critik der Urteilskraft nicht lesen" (721)![9] His publication points to the acknowledged difficulties of Kant's text, but also to the existence of a wider audience that sought to understand Kant. As a recent critic puts it, "perhaps only Goethe was a more unavoidable presence to his contemporaries than was the Kantian philosophy" (Simpson 1984, 3). In addition, Kant's own writing was not always too difficult for nonspecialists, and the disciplinary specialization we take as a given was in any case only beginning to form when he wrote. His essays were frequently praised for their engaging style as well as their trenchancy. Reading the chapter titles from *Dreams of a spirit-seer elucidated by dreams of metaphysics* (1766) – "Preamble, which promises very little for the execution of the project," "First Chapter: A Tangled Metaphysical Knot, Which Can Be Either Untied or Cut As One Pleases" (1992c, 305, 307) – one could be forgiven for thinking more of Derrida than of the Kant of the

Critiques. As Goetschel argues in detail, both in his precritical and critical phases, Kant very much groomed himself as an "author" in order to survive economically and to speak publicly to a large educated class (Goetschel 1994). At the same time, his reputation for difficulty, which characterized the discipline he increasingly came to personify, had measurable cachet in his time, as "theory" does in the visual arts and art history now. Yet, then as now, artists, critics, and art historians did not necessarily wish to provide the systematic and often technical readings of Kant often demanded by self-identified philosophers. Their interested uses of Kant are not, therefore, inferior.

Patterns of reception tell us as much about Kant's thought, and about the evolving relationships between the disciplines in question here, as do attempts to explicate a supposedly timeless, "correct" version of his ideas; but these unauthorized, "undisciplined" narratives take paths divergent from the "reconstructive" (Yovel 1980, 5) or "augmented analysis" (Henrich 1992, 41) of Kant's texts commonly prescribed in philosophical circles. While these and other philosophical readings are essential to our understanding of Kant's historical and theoretical import, we should also remember that most readers of Kant (and of other philosophers) receiving his ideas in places beyond the orbit of professional philosophy will select from his work what they need for their own purposes. To censure and correct this practice, Paul Crowther adopts the (Kantian) position of the superior philosopher, rectifying terminological misunderstandings so that he may conclude, for example, that the analytic/synthetic contrast employed by the critic Daniel-Henry Kahnweiler and others involved in the early definition of cubism "is entirely at odds with the underlying expressive dynamic" of this art movement (1987, 197). He cites Kahnweiler's statement that "Picasso never, never spoke of Kant" as evidence of the inappropriateness of philosophical distinctions in an art context – Nietzsche's complaint again. To balance these restrictive measures, we might recall that Kahnweiler and other artists and critics instrumental in the evolution of cubism *did* speak of Kant. The matter of whether they used Kant's terms correctly or whether his terminology was apt to cubist art is (or should be) distinct from the question of why philosophy, and Kant's especially, should be sought as the ground for their speculations. What the symbolist critic Albert Aurier wrote of Paul Gauguin's free and creative relationship with Platonic and Neoplatonic texts is generally true of Kant's reception: Gauguin's is the "plastic interpretation of Platonism done by a savage genius."[10] I will argue more fully in Chapter 3 that "savage,"

situated reception is, in the contexts I develop, more productive than the dream of pure philosophy.

Moments and Places of Discipline

In my discussion of the reasons why Kant's thought would seem un-promising as an influence outside the borders of philosophy, I have asserted the near equation of Kant's name with that discipline since the late eighteenth century. Kant/philosophy know little of the visual arts. Kant/philosophy are too difficult and technical to have important effects outside their own field. I will add detail to this picture in the "moments" that follow this introductory chapter. At this point, it is necessary to consider in some detail two questions that follow from the merging of philosopher and discipline. First, what is Kant's doctrine of the relationship between philosophy and other fields? Second, is his reception in art and art history more the result of general, disciplinary hierarchies or of a unique place for "Kant" among philosophers? Kant's philosophy is marked by a constant preoccupation with limits, bound-aries, and prescriptions of proper disciplinary behavior. The urgent mo-tivation of his critique of metaphysics to limit, in both a positive and a negative sense, what we can know characterizes his thinking generally. As Ernst Cassirer writes, Kant "regarded philosophical reason itself as nothing else than an original and radical faculty for the determination of limits" (1951, 276). Geoffrey Bennington has recently echoed this claim: "Kant's philosophy in general is . . . all about drawing frontiers and establishing the legality of territories" (1994, 261). Kant's constant usc of terms such as "territory" and "domain" expresses spatially the essentially legislative, juridical nature of his thought. Ultimately, this border work is accomplished in his writings by the faculty of reason, defined in *The Conflict of the Faculties* (1798) as "the power to judge autonomously . . . freely (according to principles of thought in general)" (1992b, 43). Reason is "pure" because it proceeds transcendentally from a priori self-investigation, critique. This procedure and its results entail both the territorial and patriarchal[11] imperatives of Kant's work: "a complete review of all the powers of reason," he claims in the first *Critique*, "and the conviction thereby obtained of the certainty of its claims to a certain territory . . . induces it to rest satisfied with a limited but undisputed patrimony" (A768/B796). Reason neither consults nor (directly) impinges upon the empirical. It is definitively "disinterested," which in Kant's mind guarantees its universal and necessary efficacy. In

the first *Critique* as well as in the late *Conflict of the Faculties*, Kant speaks of reason in terms of the freedom of the liberal, judging subject,[12] of jurisdictions surveyed and governed. Kant refers to reason's dominance and priority within philosophy itself, to the relationship of philosophy to other disciplines and faculties, and finally to the interaction of the state, ruler, and philosopher. Adequate governance on any of these strictly parallel and analogous planes, Kant argues, needs a "lower" and truly independent judge, "one that, having no commands to give, is free to evaluate everything" (1992b, 27).

Reason and philosophy are "lower" in the hierarchy of the university faculties – the stated context of Kant's analysis – because they are not directly useful, practical powers, compared with the concerns of those he memorably deems the "businessmen or technicians of learning," the lawyers, doctors, and theologians who comprise the higher faculties in his scheme (1992b, 25). But precisely because philosophy is outside (or beyond) these domains and answerable to no authority but itself, it may, for Kant, "lay claim to any thinking, in order to test its truth" (1992b, 45). Reason – and its institutionalized discipline, philosophy[13] – have the right, and indeed the duty, to "control" the other faculties and to do so in public (1992b, 45). This doctrine is initially difficult to square with Kant's insistence that reason operates through pure freedom. In the *Critique of Pure Reason,* he claims that "reason depends on . . . freedom for its very existence. For reason has no dictatorial authority; its verdict is always simply the agreement of free citizens. . . ." (A739/B767). Thus Kant will often speak of the "peace" promised by reason in intellectual and state matters. Freedom is for him possible only by knowing and working within limits, the limits determined by reason's self-examination. "The whole concept of an external right," he argues, moving transcendentally from a priori principles to practical effects, "is derived entirely from the concept of *freedom*. . . . *Right* is the restriction of each individual's freedom so that it harmonizes with the freedom of everyone," as he puts it in "Theory and Practice" ([1793] Kant 1991c, 73). In Kant's mind, then, other disciplines attain "freedom" only as subordinate parts, "subjects" of philosophy's reasoned system, which has the right of disciplinary surveillance, inspection, and coercion in the name of the tribunal of reason. "The agreement of free citizens" in the context of faculties and disciplines in a university, then, is the freedom to agree that philosophy and reason are correct and within their rights with regard to the limits and methodologies they prescribe. Kant associated this freedom with that enjoyed by the (male, middle- and higher-class)

subjects in Prussia under Frederick II ("the Great": king from 1740 to 1786), about whom he famously wrote, in "An Answer to the Question: 'What Is Enlightenment?'" of 1784: "Only one ruler in the world says: *Argue* as much as you like and about whatever you like, *but obey!*" (Kant 1991a, 55).

The judgment of beauty examined in the third *Critique* partakes in a similar manner of both freedom and coercion. For Kant, the predicates beautiful and sublime apply, not to objects, but to the pleasure (or, in the case of the sublime, pain, followed by pleasure) taken in the form of judgment by the perceiving subject. This pleasure comes only from the free harmony of the subject's mental faculties, a harmony that seems as if it were designed to accord with the observer's abilities.[14] But because this harmony is in Kant's sense pure, it warrants universal approbation and even allows for coercion. In the judgment of the beautiful, Kant asserts, the subject "*demands* that [others] agree. He reproaches them if they judge differently, and denies that they have taste, which he nevertheless demands of them, as something they ought to have" (213, 56). Kant explains in his *Anthropology* (1798) that "taste is a faculty of *social* appraisal of external objects" (1963, 64), though strictly speaking we only behave as if we are judging the world of external objects and not our own responses. "Sociability with other men presupposes freedom," he goes on to say, and the internal feeling of freedom is pleasure. All these components are then linked with reason: "the faculty of representing the universal is *reason*. The judgment of taste is, therefore, an esthetic judgment, as well as a judgment of reason, but conceived as a unity of both" (1963, 65).

In the aesthetic as in the political sphere, reason maintains its integrity for Kant by being "regulative" rather than "constitutive" of experience. Through self-critique, the theory goes, reason can present ideas or principles that can regulate but not directly inform what Kant calls the "practical" aspects of human activity. Reason constructs only the form of aesthetic judgment, for example, by presenting the regulative principle of purposiveness without purpose. A close analogue to this principle in the *Critique of Judgment* is the teleology of nature, without the enabling regulation of which scientific progress would not be possible, because nature could not be assumed to operate according to consistent and predictable laws. As I will argue more fully in Chapter 3, Kant's insistence on the primacy of form – his undeniable "formalism" – is not an attempt to *prejudge* the content of an aesthetic judgment, to dictate taste a priori. Content is always and crucially present, but only in indi-

vidual cases and regulated by form. Philosophy itself is for Kant ideally regulative, as he makes clear in the (little read) first chapter of the final section of the first *Critique,* which is called the "Discipline of Pure Reason" (Neiman 1994). Here we find the root of his thoughts about the conflict of the faculties in 1798: reason's "proper duty is to prescribe a discipline for all other endeavours" (A710/B738). To this end, "a quite special negative legislation seems to be required, erecting a system of precautions and self-examination under the title of a *discipline*" (A711/B739). How might the practice and study of art be so disciplined? In a comment closely allied with the academic teaching of art in the neo-classical period, Kant argues that "taste, like the power of judgment in general, consists in disciplining (or training) genius" (1987, §50, 320/188). When reading Kant's warnings about disciplinary purity, we should recall Clement Greenberg's notorious doctrine of medium specificity and aesthetic progress through self-criticism and Michael Fried's critique of the supposed "theatricality" in minimalism. "As soon as we allow two different callings to combine and run together," Kant insisted, "we can form no clear notion of the characteristic that distinguishes each by itself" (1992b, 37). Purity is lost, and reason can no longer achieve its mandate to establish clear boundaries and jurisdictions. Kant's immediate target in this passage is the encroachment of the theology faculty on the business of philosophy, but the point is easily generalized. Indeed, he supremely manifests what Barbara Stafford has deemed the Enlightenment's characteristically "fearful disdain of mixtures" (1991, 211).

The irony is that Kant's doctrine of philosophy's right to assess and command other disciplines is constantly enacted and also inevitably contradicted in the history of his ideas' reception. Philosophy may guarantee the autonomy of art and the aesthetic for Kant, but to do so it must "mix." If we think of artists who used Kant's theories to justify their work, for example, we are faced with just such a mixture, a word–image interaction. Is Barnett Newman's invocation of the Kantian (and Burkean) sublime in his 1948 defense of abstraction "philosophy"; is it still "Kant"? For a Kantian model of purity that must insist on the separateness of art and philosophy, artist and philosopher, vexing issues arise, ones that can be seen to have helped to define modernism itself. As Stephen Melville and Bill Readings have suggested, "'modernism' names the break with [the *Ut pictura poesis*] tradition, the sundering of the rhetorical unity of the visual and textual in favour of the acknowledgment of a radical difference between the two modes" (1995, 9).[15] To

use Kant to justify a medium's necessary self-criticism and purification (as Greenberg does), or to underwrite a return to the discourse of the sublime (as Newman does), is to reveal the tension in the Kantian doctrine of border autonomy and disciplinary purity.

Although Kant thought that even pure reason had a history, his position on philosophy's regal role vis-à-vis the other disciplines sprang from historical contingencies more than he would have admitted. In his time, the authority of reason was widely challenged by several relativist or historicist theories, especially those of Johann Georg Hamann (1730–88) and Johann Gottfried Herder (1744–1803). "To the German mind at the end of the eighteenth century," Frederick C. Beiser writes, "reason seemed to be heading towards the abyss" (1987, 46–47). Kant attempted to reverse its decline by putting it on an irrefragable footing. He also had political motivations for the articulation of a philosophy of right based upon the directives of reason instead of constantly shifting empirical exigencies. In the 1790s, Prussia was in conflict with France over Napoleon's territorial exploits across Europe. Only in 1795, with the Treaties of Basel, were these disputes suspended. Kant wrote *Perpetual Peace* (1795) as a protest over the inability of these parties and mankind generally to find lasting peace, a situation that could follow only from negotiations based on reason. As I argue in the next chapter, Kant's book was crucially important to German-speaking artists and critics in Rome at this time. *The Conflict of the Faculties* was composed and published in the wake of Kant's personal and bitter experience with state censorship. Frederick the Great's nephew Frederick William came to power in 1787. His minister of justice, Wöllner, was very much opposed to the perceived secular advances of the *Aufklärung*, especially in matters of religion, and took repressive measures against Kant's publications in this field. Because Kant's 1793 *Religion within the Limits of Reason Alone* intruded, according to some theologians, on their territory, he was banned from writing on religion and all professors in Königsberg were forbidden to teach his philosophy of religion. Kant's initial attempts to have the work published in spite of a hostile censor trace the path of what became his theory of disciplinary interaction. The first section of the book actually cleared censorship without difficulty and appeared in the April 1792 issue of the *Berliner Monatsschrift*. To publish the balance of the manuscript, Kant then solicited the opinion of the theological faculty at the university in Königsberg "as to whether the book invaded the territory of biblical theology or whether it came under the jurisdiction of the philosophical facult" (Gregor, in Kant

1992b, xiv), as he believed, and which – given his theory of disciplinary relationships discussed above – would allow the book's approval by the censor because it behaved itself within the limits of philosophy "alone." He also submitted the manuscript to the philosophy faculty at the University of Jena at this time for the same purpose. Their imprimatur was granted and signified that the book was a work of philosophy. *Religion within the Limits of Reason Alone* was published in 1793, after which Kant was forbidden to write further on religious themes.

In composing and seeing into print this text, Kant enacted one of his most cherished principles, the freedom of reason and philosophy to speak publicly, an imperative he derived from Cicero (Nussbaum 1997, 27–30). He did not want philosophy to become hegemonic or philosophers to become rulers. Though not without irony and a touch of bitterness, Kant believed that the pure philosopher should be at most the neutral adviser to society, even if this role went against common sense. In "Theory and Practice" he writes that "the private individual, . . . the statesman, and the man of the world or cosmopolitan . . . are united in attacking the academic, who works for them all, for their own good, on matters of theory . . ." (1991c, 63; italics removed). Despite these aspersions, he explicitly sought a position of resistance[16] for philosophy as an "opposition party [on] the left side" of the government. "In this way," he speculated,

it could well happen that the last would some day be first (the lower faculty would be the higher) – not, indeed, in authority, but in counselling the authority (the government). For the government may find the freedom of the philosophy faculty, and the increased insight gained from this freedom, a better means for achieving its ends than its own absolute power. (1992b, 59)

Here Kant places philosophy both on the left ideologically and at the ear of those in power politically. In *Perpetual Peace*, he also suggests that philosophy's role as counsel to power should be "secret." His reception in art and its history has not always been in the direction of resistance, but, as we shall see, Kant has been placed in ways that are indeed consistently secret, outside, and thus highly influential.

Kant's name is virtually unmentioned in the historiography of art history: it is "dropped" in the sense of omitted. Kant is noted in art criticism and by artists but rarely discussed in any depth: his name is "dropped" mostly for the authority it carries.[17] When his ideas are discussed in the context of the visual arts and their history, it is usually in terms of the philosophical or aesthetic "background" in which they

figure. The notions of disciplinary autonomy and separateness that Kant did so much to establish are fundamental to the occlusion of his name in these fields. In the detailed compendium of writings about art, for example, Julius von Schlosser's *Die Kunstlitteratur,* we will not find Kant's name in the "Register" nor in the seemingly exhaustive list of German "Kunstlehre des 18 Jarhunderts" (Schlosser 1924, 585–87). We do not find Kant's name in Evert van der Grinten's *Enquiries into the History of Art-Historical Writing* (1952), nor in Heinrich Dilly's 1979 *Kunstgeschichte als Institution,* in which Hegel is certainly noted. In "The Literature of Art," E. H. Gombrich omits any reference to Kant or any other philosophical writer (1992). One reason for this pattern is articulated in perhaps the most widely consulted recent text on the historiography of art history, W. Eugene Kleinbauer's *Modern Perspectives in Western Art History* (1971): "The aesthetician tries to learn the nature of art," he points out, "to evolve a (nonhistorical) theory of art, to define such terms as 'beauty,' 'aesthetic value,' 'truth,' and 'significance.' The modern art historian avoids all such metaphysical speculation. In much of the Western world, and especially in the United States, art history today is nonphilosophical" (3). While accurate enough for its time about the intentions and empirical motivations of most art historians, Kleinbauer's commentary is itself "metaphysical" in a Kantian way. Kleinbauer rigorously separates those fields having to do with art: aesthetics, art criticism, and art history are for him different and autonomous and must keep to their own proper territories. The remarkable success of Kantian disciplinary theory subtends Kleinbauer's confidence as well as that of a more recent commentator, James Elkins, when he claims in reaction against the so-called new art history that "within practice" in the discipline "all is well" without the importation of "theory," new or old (1988, 378). The pattern of territorial separation in philosophy is remarkably aligned with that in art history. With some notable exceptions – especially the work of Sarah Gibbons, Salim Kemal, and Rudolf Makkreel – those writing about Kant's aesthetics from "within" philosophy tend to ignore his interest in the arts in favor of his theoretical and structural arguments. Even two contemporary scholars who *have* added immeasurably to our knowledge of Kantian themes vis-à-vis the visual arts and art history – Michael Podro and David Summers – have done so from the subfield of art historiography, which Elkins (gloatingly and inaccurately) notes, has a "peripheral place" in the field (1988, 359).

The reception and influence of Kant's thought in art history and the

visual arts conform remarkably to what Derrida has described as the "logic of the *parergon*" (1987, 73). A parergon for both Derrida and Kant is something outside the work proper, a supplement that nonetheless stands in close relation to what is deemed essential. In a trenchant reading of Kant's procedures in the third *Critique*, Derrida demonstrates how Kant's relationship to art and to the aesthetic as a branch of philosophy is structured according to the movement of the pure and impure, essential and inessential, inside and outside. Performing his principle that he does not and strictly cannot know "what is essential and what is accessory in a work" (1987, 63), Derrida emphasizes what appears to be a doubly unimportant aspect of Kant's text, a place where he discusses art examples and their even less significant parerga. At the end of section 14 of the *Critique of Judgment*, Kant writes:

Even what we call *ornaments* (*parerga*), i.e., what does not belong to the whole presentation of the object as an intrinsic constituent, but [is] only an extrinsic addition, does indeed increase our taste's liking, yet it too does so only by its form, as in the case of picture frames, or drapery on statues, or colonnades around magnificent buildings. (§14, 226)

With these confident examples, Kant claims to show what is properly definitive of a work of art and yet also to appreciate the merely supplemental value of that which lies adjacent but outside. Derrida cleverly and profoundly demonstrates that this process of limitation is neither neat nor innocent, that while "the whole analytic of aesthetic judgment forever assumes that one can distinguish rigorously between the intrinsic and the extrinsic" (1987, 63), this process is driven by an indissoluble though frequently reversible link between ergon and parergon. The delimitation of a work can only be successful through the positing and positioning of an outer limit, an "other," a not-work. Whereas Kant sees this relation as a straightforward distinction between picture and frame, for example, Derrida argues that framing in general always occurs in a liminal space, one neither truly intrinsic or extrinsic. Timothy Lenoir has argued that a similar relationship is operative in disciplinary formation and interaction: "statements require the positioning of adjacent fields for their meaning," he claims (1993, 74). Paul Duro expresses the point I will stress: "The paradox of Kantian parergonality is that the self-identity of art is what produces the division between inside and outside in the first place" (1996, 5). It is this insight – an enactment of the logic of the parergon – that I wish to extend to the context of disciplinary inter-relations discussed above, a connection sanctioned in Derrida's writ-

ings. In "Tympan," his introduction to the essays collected in *Margins of Philosophy,* Derrida claims that

Philosophy has always insisted upon this: thinking its other. Its other; that which limits it, and from which it derives its essence, its definition, its production. To think its other: does this amount solely to *relever (aufheben)* that from which it derives, to head the procession of its method only by passing the limit? Or indeed does the limit, obliquely, by surprise, always reserve one more blow for philosophical knowledge? (1982, x–xi)

The "others" in the framework I am developing here are of course art and its history. In the third *Critique,* Kant cannot work without these parerga; art history and the practicing visual arts have not – since the late eighteenth century – worked without Kant.

The logic of the parergon operates in Kant's thought in his most minute examples, given in passing, as well as in the bold architectonic of the three *Critiques* that he describes in the opening sections of the *Critique of Judgment.* This logic delineates the all-important form of his philosophy in general. His examples of art objects and experiences of the beautiful and sublime must be kept incidental, almost secret, given their merely empirical status in his thought. Yet the faculty of judgment in the third *Critique* must also seek, immodestly and perhaps impossibly, to become a bridge between the realms of science and morality, because it trades necessarily with both the sensible and the intellectual. Judgment provides what is for Kant a necessary limit to both reason and materiality, each in terms of the other. The sublime – a seemingly disruptive, limitless category to which I will return in Chapter 4 – actually reinforces reason's dominion in Kant's philosophy. Just as the philosophy faculty ultimately stands above all others in judgment in *The Conflict of the Faculties,* so too aesthetics must in the third *Critique* command art in order to have it serve as a limit for philosophy in the direction of the sensible. Because of this perspective, Kant, as we have seen, adopts the critic's position but never that of the artistic producer. As Zammito emphasizes, Kant always judges the artist "from outside, from the standpoint of – science" (1992, 142). Science in his final *Critique* is indeed Kant's essential other, aesthetic's parergon, as the inclusion of the "Critique of Teleological Judgment" as the second part of the book amply demonstrates. Equally important as an outside that figures the inside of art is Kant's development of Rousseau's moral imperative in his regulative analogy between the beautiful and the good.[18]

For Kant, philosophy must be both separate from other disciplines and intimate with their subject matter in order "to control them and, in this way, be useful to them" (1992b, 45). This spatial and indeed political relationship obtains between faculties, as I have shown, but also within the faculty of philosophy itself, which for Kant must consist of "two departments: a department of *historical knowledge* . . . and a department of *pure rational knowledge*" (1992b, 45). Although Kant does not mention art history in the historical group, we know that Johann Dominicus Fiorillo (1748–1821), probably the first university-based art historian, who taught at Göttingen from 1781 until his death, was a member of the philosophy faculty.[19] Given Kant's manifest distrust of all historical pursuits and his characteristically approbative use of the term "pure," the hierarchy within this faculty is clear. We can speculate, however, that in the third *Critique* as in his idealized university structure, art and art history must be present to allow philosophy its critical role of judging "all parts of human knowledge" (1992b, 45). These "others" are necessary formally, though their content is by definition parergonal. Can the same be said of philosophy from the perspective of art history and the visual arts? Is it for these fields a historically constant parergon or simply one among other defining limits? Looking to ancient Greek philosophy, it is plausible to argue with Stephen David Ross that "art was born in [the] struggle with philosophy, born from exclusion" (1996, 125). Kant makes this relationship systematic in his doctrine of disciplinary autonomy, and it lives on in the reception of his ideas up to the present. But this is not to claim that philosophy has been the only or even the most important "other" in these contexts.

The concern with disciplinarity in general is increasingly present in art history, as it is across the humanities.[20] Recently, art history has been portrayed as remiss in its belated acceptance of new methodologies pioneered in adjacent domains, particularly those defined as "literary."[21] Significant change in art history, this argument asserts in typically spatial terms that I have thematized here (and that I develop in the following section on plasmatics), is usually initiated from "outside" the discipline. As Norman Bryson – who, along with another former "outsider" from literary studies, Mieke Bal, has changed the practice of current art history profoundly – wrote in 1988: "There can be little doubt: the discipline of art history, having for so long lagged behind, having been among the humanities perhaps the slowest to develop and the last to hear of changes as these took place among even its closest neighbours, is now unmistakably beginning to alter." He goes on to

describe the innovations brought to the field by a number of art historians, each of whom, "to varying degrees, . . . brings art history into relation with another field of inquiry" (1988 xiii). Serge Guilbaut is more blunt:

At a time when literary criticism went through an exciting autoanalysis, producing serious theoretical discussion about its goals and tools of analysis (from New Criticism and Barthes in the 1950s to the new texts by Edward Said, Terry Eagleton and Frank Lentricchia) liberating, shaking a field of study always on the verge of academicism, Art History was superbly purring along in the moistness of salons and museums. [It] did not produce a similar array of critical texts, of serious debates about the purpose of the profession, or of its tools of analysis. (1985, 44)

Art history has its own theoretical traditions, and there are what might be called disciplinary reasons for its sometimes reluctant associations with other areas of inquiry (Holly 1994). Increasingly, too, discussions of the discipline revolve around what is done in its name – and attacked by others "in" the field – rather than around what might be imported into an impoverished area (Bal 1996a). Nonetheless, since the early 1980s, art history's connections with literary studies have often been claimed to be its most vital link with another field of study.[22] Methodologies from semiotics to psychoanalysis – as developed largely in literary theory – are often seen to have reinvigorated art history, which has been in turn deprecated in comparison with advances in literary fields.

Art and art history's close relations with the literary are not new. They have been expressed constantly in the *Ut pictura poesis* tradition and more recently by connections made in the late nineteenth and early twentieth centuries between art history and the field of philology. Joan Hart has noted that "philology was the most valued and privileged discipline in Germany" when art history was forming as an academic pursuit (1993, 559). If we look at the early mapping of art history's place among its disciplinary neighbors found in Hans Tietze's *Die Methode der Kunstgeschichte: Ein Versuch* (1913), we find confirmation of art history's propinquity with both history and philology but also an emphasis on associations with "Naturwissenschaft," "Ästhetik," and "Kunst." As Goethe admiringly acknowledged in his "Einwirkung der neueren Philosophie" of 1820, Kant's philosophy deftly mediated all three areas. The poet found Kant's ability to *shape* seemingly disparate materials in the third *Critique* its most powerful aspect. "Here I saw my

most diverse thoughts brought together, artistic and natural production handled in the same way; the powers of aesthetic and teleological judgment mutually illuminating each other" (1891, 31).[23]

Historically and theoretically, it is indeed Kant's philosophical imperative to define and arrange juridically the disciplines that keep these areas in mutually defining play. Philippe Lacoue-Labarthes and Jean-Luc Nancy have contended that Kant's articulation of the interaction of aesthetics and philosophy generally in judgment defined the concept of literature for the Romantics and later generations (1988, 29).[24] My point is not that philosophy is necessary to literature, art, or art history in an a priori fashion, but that it has historically been the primary fulcrum around which these fields have turned and defined themselves (and thus also philosophy). But these fields are only contingently and metaphorically outside one another. The logic of the parergon elucidated by Derrida draws our attention to heightened activity along disciplinary borders, not to radical boundaries or separations. The experience we may have in crossing many of today's political borders illustrates the point. Disciplinary definition and change is *not*, as Stanley Fish argues persuasively, "the process by which something from outside penetrates and alters the inside of a community." "To put the matter in what only seems to be a paradox," he goes on to say, "when a community is provoked to change by something outside it, that something will already have been inside, in the sense that the angle of its notice – the angle from which it is related to the community's project even before it is seen – will determine its shape, not *after* it has been perceived, but *as* it is perceived" (1989, 148, 147). In ways that I will make more specific in the chapters that follow, Kant has never been outside the disciplines of art history and art and their historical narratives are not external to his philosophy.

For art and art history, Kant is both a perpetual boarder and the architect of borders. If we think of the movement of the parergon in this context as the overarching form of his philosophical architectonic, we can appreciate how, for Mark Wigley, following Derrida, art and especially architecture are foundational, not ornamental, for philosophy (1993, 64). It is, however, the history of reception that articulates the immediate shapes of Kant's definitive parergonal activities. Bill Readings examines the considerable historical impact of what he tellingly labels Kant's "University within the Limits of Reason": how the philosopher's disciplinary ideals as expressed in *The Conflict of the Faculties* came to work historically through state institutions.[25] It would in fact

be surprising if Kant's ideas, methods, and patterns of thought had not been decisively influential in other fields. As Fritz K. Ringer writes of the German academic community circa 1890–1933, "the Kantian critique," for example, "was so generally taught as a point of departure for all philosophical thinking that it influenced many scholars who were not professional philosophers themselves. On some level of theoretical coherence, Kant's position then affected almost every aspect of German learning" (1969, 91). This testimony notwithstanding, however, we need to ask whether it was specifically Kant who played this role or rather philosophy more generally. Just as philosophy is not the only bordering discipline that defines art and art history, so Kant is not the only philosopher. Before proceeding to articulate more fully the shape of Kant's reception, we should therefore ask if I claim too much in his name.

Relations among philosophy, art history, and the visual arts are literally ancient, however we define these three areas. These relationships are by no means exhaustively interpreted by any individual philosopher's receptions by artists or art historians. An array of philosophers has been instrumental for artists and artistic communities. It has become a commonplace in art history to credit Hegel with the greatest philosophical impact on the field. Gombrich's considerable theoretical efforts to counteract the evolutionary historicist thinking that he sees as Hegel's main legacy are a case in point (1984). Melville (1990), Moxey (1998), and Wyss (1999) especially have added depth to the image of Hegel's considerable influence in this context. I myself have written extensively on Hegel's hold over Piet Mondrian (Cheetham 1991a). Here, I am in no way attempting to award Kant a prize thought to have been won by Hegel. But a case can be made for Kant's role as the author and paradigm of many such disciplinary interactions. An examination of his fundamental if not unique place vis-à-vis these fields is made all the more pressing by the systemic neglect of his roles in these precincts, which, as I have suggested, is also a function of Kant's thinking about philosophy's secret dominion over other disciplines. Even more than Hegel, Kant has bequeathed a method to both artists and art historians. The procedures of critique, the promise of freedom and autonomy,[26] and the primacy of form in its putative universality define Kant's ever-seductive architectonic,[27] which has in part shaped, through reception, everything from individual canvases and their interpretation – I am thinking of Greenberg's theoretical relationship to what he saw as painting's essential delimitation of space in American shaped abstract paintings of the 1960s – to the disciplinary hierarchy in which Kant and

other philosophers become acceptable authorities for art historians. Derrida has written that "Every time philosophy determines art, masters it and encloses it in the history of meaning or in the ontological encyclopedia, it assigns it a job as medium" (1987, 34). He is troubled by this apparent disenfranchisement and colonization as it appears in Kant, Hegel, and Heidegger especially, though, as he also notes, it is a pattern established in its negative dimensions by Plato when he banished artists from his Republic.[28] But it is surely Kant who makes systematic the philosophical use of art by aesthetics, as described by Derrida's logic of the parergon discussed above. Art and nature, whether beautiful or sublime, for him become in the third *Critique* the occasions for his examination of judgment, which is in turn the potential bridge within his philosophical system as a whole between the practical and scientific worlds. Both aesthetic judgments and the aesthetic as a subset of philosophy as a discipline are for Kant the mediums of reason. I have suggested that both the visual arts and art history have, at different spatiotemporal moments, received and adapted these Kantian patterns of thought. These moments can be imagined and described in terms of a model of disciplinary spatial affiliation that I call plasmatics.

Plasmatics

I hope in this section to adumbrate a model of disciplinary interaction and change based on Kant's reception in the visual arts and art history, which I will detail in the following chapters. The thought experiment that I present here has been inspired and shaped by recent philosophical examinations of the nature of space and place, Foucault's ideas on the author function and discipline, Pierre Bourdieu's sociology of intellectual capital and the purity of art, Michael Ann Holly's discussions of formal prefiguration in art historiography, and Brian Massumi's articulation of a non-Euclidean space for the interaction of variables. The considerable resources of these strands of thought notwithstanding, new terminology helps me to mark my adaptations of these ideas to the specific disciplinary and historical matrix in focus here. I propose the term "plasm" and its cognates. Any paradigm of disciplinary space can only approximate the complexity of interactions that occur, but in most instances what the architect and theorist Greg Lynn calls "relative geometric assumptions" (Lynn 1995, 41) will govern and partially reveal the nature of the model proposed. "Plasm," "plasma," and "plasmatic" connote an organic, inclusive, and constantly dynamic system, an alterna-

24

tive to theories based upon Leon Battista Alberti's highly influential scheme of one-point, mathematical, "Renaissance" perspective, a system that is designed to secure the illusion of three-dimensionality on a two-dimensional plane and is constructed around the dialogic poles of subject and object. *Plasm* is defined as "a mould or matrix in which something is cast or formed"; *plasma* refers to the "living matter of a cell" and to the "liquid part of blood in which corpuscles float"; *plasmatic* is that which relates to plasm or plasma (*OED*).[29] By referring to disciplinary interactions as "plasmatic," I mean to emphasize that they take place within a "space" of multidimensional and shifting cultural intensities, and that the specific contours of this matrix are inflected historically and theoretically by the forces of which it is comprised. I believe that a model of this complexity and flexibility allows us to understand more fully how an active element in the system, "Kant," can shape and be shaped by both art history and the visual arts.

My vision of disciplinary space follows in part from Brian Massumi's rich musings on "Interface and Active Space," ideas that he in turn has developed from Greg Lynn as well as Gilles Deleuze and Felix Guattari. Massumi portrays active space negatively at first, in opposition to what he sees as an ultimately "Cartesian" version of computer screen space in graphic design software. Traditionally, "screen space is treated as a preexisting three-dimensional matrix into which figures can be plopped. Pre-plop, the space is empty. Filling it does not change its spatial characteristics. It is inert. Its three dimensions are invariant axes against which the figure can be plotted and measured. This is a Euclidean space of geometrical projection." In this model, what we see on-screen is related to off-screen objects by "formal analogy."[30] Massumi and others find this space restrictive. To plot an alternative, he describes how Lynn "tactically misapplies" a very different animation procedure to his own architectural designs. I will in turn misapply this model to the disciplinary space articulated by Kant's interactions with the visual arts and art history. Lynn speaks of "blobs," defined by Massumi as

active elements or "primitives" which combine to *generate their own space*. Each blob is internally differentiated. It is assigned [by the programmer] a circumference, a mass, and a corresponding force of attraction. The force of attraction defines a field of influence outside the perimeter of the blob, and that field is in turn differentiated into zones. Closest to the perimeter is a zone of fusion. Any blob entering it will combine with the first blob to form a larger blob. Beyond the fusion zone is a zone of inflection, the area within which the attractive force of the blob will alter the shape, and therefore the field of

25

influence, of a neighboring blob. Put a number of blobs together, and their differential influences on each other produce unpredictable reciprocal deformations. (Massumi 1995)[31]

I want to try to think of "Kant" as a "blob" within a disciplinary matrix, but "blob" is the wrong term, suggesting as it does amorphousness and certainly lacking the respect which it is difficult not to feel when working with Kant's writings. "Kant" is more defined, more akin to the corpuscle within the plasm, more like a Leibnizian monad in his individuality and concomitant effects on and responses to his surroundings.[32] "Kant" – like the philosophical "concept" as defined by Deleuze and Guattari – behaves as "a heterogenesis . . . an ordering of components by zones of neighborhood" (1994, 20). Disciplines are similarly contoured and inflected. They are not wholes but "field[s] of variation" (Massumi 1995). They are not containers or invariant forms into which variables are placed and then removed but rather displacements and intensities of forces. They have no insides and outsides. They are endogenous, not exogenous. Mediation from "outside" the plasm is impossible; there is only (but always) transformation from within, as we have seen Stanley Fish argue from very different premises (Fish 1989). They are in these ways "sublime."

We should recall that art history as a field (like other disciplines) is routinely pictured in what Massumi and Lynn would characterize as a Euclidean and Cartesian way and that we might in turn see as loosely Kantian.[33] Art history's complexity is mapped on a two-dimensional plane derived in part from the powerful model of perspective construction set out by Leon Battista Alberti in the fourteen hundreds. One aspect of this model is its insistence on clear and definitively structured boundaries between inside and outside, between the world or object as it exists independently of perception and its representation on the picture plane. As I noted above, when Bryson or Guilbaut discusses change in art history, it is in terms of conflict, of foreign invasion,[34] of outside and inside. Michael Ann Holly concurs that recent critiques seeking to revise art-historical practice have largely "originated outside the confines of art history proper" (1996, 67), and though Holly is anything but a traditionalist, she does place herself tactically vis-à-vis art history by using these spatial metaphors. I have also exercised these geometrical assumptions to the same ends and in no way wish to dispute their commonsense accuracy (Cheetham 1992). Pictured as a bo(a)rder in these terms, Kant may be seen as both inside and outside art history and

the visual arts, but in developing the logic of the parergon, I have also suggested that we should be suspicious of this dichotomy. Can we move instead toward the vision of spatial complexity imagined by Massumi? Can such a model help us to understand Kant's reception and does his reception itself articulate a model of such interactions? Answers may be possible after we read in detail Holly's remarkable theory of "prefigurement" in art historiography, her powerful elaboration and defense of an Albertian-Lacanian version of the relations between object and subject, artwork and art historian.

In *Past Looking: Historical Imagination and the Rhetoric of the Image*, Holly argues "that historical artifacts, particularly visual ones, are themselves always laboring, more or less successfully, to systematize their own historical accounts, as signs producing other signs" (1996, 100). As she rightly points out early in the book, "what I argue . . . is something so fundamental to history writing that it lies at the origin of historical insight itself: that there are both temporal and spatial ways in which the figural patterns of meaning or syntactical ideology of a work of art 'sneak into' the structure of argumentation of the art historian" (9–10). Artworks structure what is written about them. Because they possess and employ "an agency that compels viewers to respond in certain ways" (11), the art historian's relation to these works is, I would add, one of "transference," defined by Dominick La Capra (one of Holly's acknowledged inspirations) "in the modified psychoanalytic sense of a repetition-displacement of the past into the present as it necessarily bears on the future" (LaCapra 1985, 72). Holly readily grants that her ideas are also adapted from Hayden White's notion of "prefigurement" (35), but its use in describing the interactions between subject and object in art making and art writing – her intricate historiographic context – requires the considerable theoretical elaboration she provides.[35] Because both subject and object are posited as active, she takes it as "axiomatic that our words and those images from the past meet in some in-between realm" (112). She examines the connected spatial theories of Leon Battista Alberti and Jacques Lacan, first to illustrate diagrammatically how this hermeneutical meeting occurs, and ultimately to establish her contentions about prefiguration.

Alberti's theory of emanating rays of vision meeting the projections of the object halfway on a screenlike veil, the picture plane, is illustrated by Holly. Unlike Euclid, who characterized vision as conical, Alberti famously used the pyramidal structure, seen here in its "chiasmic crossing" (Holly 1996, 21). But, as she explains, Alberti's text was not illus-

trated: her diagram is actually adapted from Jacques Lacan's way of visualizing the reciprocity of the gaze and the look, the dynamic relationships between the individual, subjective projections of the look and the shadow of their inevitable powerlessness, even death, thanks to the always prior existence of the gaze. Lacan explicitly follows Alberti, and Holly further modifies Lacan's ideas to imagine the connection between the historian and the work of art, which meet on the "screen" (all too accurate in the age of personal computers and, of course, slide projection) that replaces Alberti's canvas and Lacan's image screen (Fig. 1). The correlation among object/work of art/artist and among artwork/historical account/art historian is thus dialogic, to use another term theorized by LaCapra. Holly claims that Alberti's model of vision is at least partly responsible for the form and pervasiveness of this interaction. "If any one historical individual could be assigned responsibility for legislating the way successive generations throughout the centuries have regarded *le regard,* it would be Alberti" (1996, 19). What she emphasizes in his account and that of Lacan is the active role of the object in the process of prefigurement. In attempting thus to balance what she sees as poststructuralism's one-sided account of the subject–object relation, however, Holly frequently personifies the object and the art work and gives them independent agency. "Works of art 'work' at interpellating their own critical history," she claims (185). A work "throws *itself* into time" and shapes its reception (27; my emphasis).

Works can do this for the art historian – just as objects can for the artist – because they are both received within the formal coordinates of the Albertian-Lacanian model. Holly shows brilliantly how the form of prefiguration works for Wölfflin, Panofsky, and others, but perhaps her most compelling evidence is the structure of her own argument, which in its geometry mirrors that which it examines. Like any geometry, however, the form implies conscious and unconscious choices, benefits and limitations. Holly emphasizes on several occasions that she does not want to split the visual off from the textual in a rigid way, yet her diagrams polarize these realms and speculate only on their interaction. Although she *claims* that the art object is not purely visual, that its makeup is in part textual, given a history of reception, the crossing triangles she delineates require that art be set over against the historian with a textual screen in between. Despite her stated sympathies with a poststructuralist position, she reverts – perhaps because of the power of the model – to a sense of "the original order of things" (56). She is not after objective truth and follows Lacan's crucial modification of

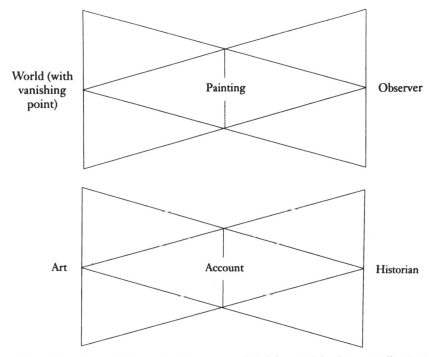

1. Two adaptations of a lacanian diagram, reprinted from Michael Ann Holly, *Past Looking: Historical Imagination and the Rhetoric of the Image.* Copyright ©1996 by Cornell University. Used by permission of the publisher, Cornell University Press. Diagrams by Mario A. Caro.

Alberti's screen by insisting on the opacity rather than the transparency of the gaze. Yet "just as the gaze preexists the look, the painting preexists the narrative about it, no matter what the role of the later historical account in bringing the work of art back to life may have been" (23–24). The historian of art, she contends, is indeed "compelled to repeat . . . [the art work's] conceits of spatial and temporal positioning, [its] logic of figuration" (24). Painting is essentially visual, writing is essentially textual. They interact only after these initial positions are plotted.

If *Past Looking* is prefigured – as its arguments demand – it is by Burckhardt, Wölfflin, and Panofsky, the writers whom Holly treats in detail, more than by the art they discuss. Or it is by both, because the two elements – visual and textual – have never been separate. Holly also reenacts two disciplinary priorities found in Alberti as well as in the writings of these (and other) historians. On the side of art, she tacitly

agrees with the Albertian view-through-a-window model that the artist should initially respond to nature and then develop it into a *historia*. Nature is "outside" and comes "inside," as the geometry of the model dictates. The art historian, she suggests by likening his or her position to that of the donors sitting "outside" on the left panel of the Merode Altarpiece, duplicates what I would call, with Holly, this "naturalistic" priority (Holly 1996, 161), one emphasized by the placement of this detail from the altarpiece on the dust jacket of Holly's book. Equally fundamental is her sense – paradoxical in a book so versed in theory yet often heard in the chambers of art-historical practice – that as art historians we should respond first to the picture, as if it were a simple visual "other" that must take priority. "Rather than referring to a text, or even trying to write another one," she claims in her reading of the Merode Altarpiece, "to explain a fifteenth-century painting, we can read a Renaissance painting for the insights it may afford us." "Always and forever the figural imagination has been there before us," she says, extending Lacan's insights about the gaze (151). Granted. But does this realization entail that objects for the artist and artworks for the historian have agency of their own? To insinuate a Kantian suspicion, if they do, how do we know? Alberti likens the "median rays" in the visual pyramid to the chameleon. They respond to the natural world as does this "animal which takes to itself the colours of things near it" (1966, 48). There is no question that the chameleon reacts to a natural world that preexists its response and somehow triggers it. But I would argue that, just as Kant's judgments of the beautiful and sublime properly refer to a subjective state confined ultimately to the cognitive possibilities of the species, so too it is the historian who has agency, though only within the possibilities of the "field." The chameleon reacts to stimuli according to its biological makeup; the art historian's reception and historical account are similarly governed by his or her "place" in the fullest sense. S/he is certainly not an autonomous subject with limitless choice, so we must ask how the historian is "programmed" to respond *as if* prefigured by the object or work of art.

Massumi and Lynn suggest that "blobs" are indeed programmed in and through human culture, even though a high degree of chance exists in the ways these entities will then interact and develop. On this model, it is misleading to suggest, with Holly, that a work "throws itself into time" (Holly 1996, 27). It is thrown and received through the mechanisms of programming. With Peter Bürger (writing in a Kantian vein), I would claim that it is in general "neither the boundary nor the object

that is active, but us" (1991, 5). This movement is less a matter of pre-figuration or of intention and will than of the sociology of institutions, fields, and habitus as examined by Pierre Bourdieu. As his diagram showing the interactions of "class tastes and life-style" demonstrates (1984, 262), Bourdieu's spatialization of the variables in the production and reception of artworks, or, by implication, art-historical texts, is tremendously complex. He attempts to map a high number of pertinent variables, and while believing in the scientific objectivity of his statistical methods, also warns that he is presenting an abstract model that can only be tested with data focused on the most minute level. Accuracy and comprehensiveness are illusive, though it is difficult to deny the structural correspondences Bourdieu documents between social "positions and dispositions" (1993, 64), or the parallelisms between class and taste presented in his thorough discrediting of the would-be purity and universalism of Kant's theory of taste, *Distinction: A Social Critique of the Judgment of Taste* (1984, 48).[36] His analysis of why "the most culturally deprived people tend to lean towards a taste described as 'realist,'" as opposed to "abstract" or "avant-garde" (Bourdieu 1996, 315) – coming as it does in a rather patronizing form from the center of European high culture, a position in the "field" not readily acknowledged by Bourdieu – also rings true, especially if, as I do, one performs the pedagogical role of initiating students into the assumptions of this high culture so that they may "appreciate" abstract art, for example. Unlike the initiated, Bourdieu claims, those who automatically prefer "realism" "do not possess in a *practical state* the *specific categories* stemming from the autonomization of the field of production . . . and so can apply to works of art only the practical schemas they use in daily existence." These observers have not developed what he adroitly calls a "'Kantian' eye," a habitus that allows them to see art as autonomous from quotidian concerns (1996, 315). If one objects that Bourdieu's numbers and analysis are out of date or hopelessly biased in the direction of French high culture, it is salutary to examine the contemporary Russian-American artists Komar and Melamid's extensive, hilarious, and revealing project, *The Most Wanted Paintings* (1995–97). Their findings are remarkably consonant with those of Bourdieu.[37]

Whatever the importance of the structure of fields and the interactions of their variables, Bourdieu shows that it is always people in their society – their assumptions, prejudices, attitudes – who "program" the "space of possibles" in question. To return to the context of the gaze established by Holly in her discussions of Lacan and Alberti, even (or

perhaps especially) the "pure" gaze – that which claims to see works of art or nature without prejudice and timelessly in their essence, a vantage point assumed by both Alberti and Kant in their different ways – is for Bourdieu "linked to the *institution* of the work of art as an object of contemplation" in museums and by professional historians (1993, 36).[38] Commenting on art theory, philosophy, and the institutional framework of their interactions, Bourdieu writes:

Everything inclines us to think that the history of aesthetic theory and of the philosophy of art is closely linked (without being its direct reflection, since it, too, develops in a field) to the history of the institutions suited to fostering access to pure delectation and disinterested contemplation. . . . The theoretical writings which the history of traditional philosophy treats as contributions to the knowledge of the object are also (and more especially) contributions to the *social construction of the very reality* of this object. . . . (1996, 294)

Historicizing the emergence of these objects "leads one to a rigorous understanding of the historical conditions of the emergence of transhistorical logic" (Bourdieu 1993, 190), which is exactly what I hope to provide through an examination of several moments in Kant's reception.

While Holly's Albertian model of reception acknowledges in *theory* the import of temporally intervening historical accounts of a painting in question and focuses on these textual accounts in Burckhardt, Wölfflin, and Panofsky, in *practice*, she tends to work as if one could simply be addressed by the Merode Altarpiece, for instance, and be directed by its prefiguring form. She thus presents – however unintentionally – a theory of pure, unmediated vision, an ideal of "transparent specular exchange" to which she returns in her less Lacanian and poststructuralist moments (Holly 1996, 64). Again, perhaps her repetition of her predecessors' model of reception substantiates her theory of prefiguration; it certainly makes it both persuasive and appealing rhetorically. But I find it more likely that her position, like mine or anyone's, has instead arisen from the ultimately unspecifiable complexities pictured by Bourdieu's fields, from the unspoken and pervasive habitus of her discipline. Donald Preziosi claims that art history's "disciplinarity is fundamentally bound up with a *dialogic concern* with the human past; works of art are of interest primarily insofar as they may have evidential value with respect to particular questions about the past's relation to the present," an interest slanted "so that the present might be framed as the product of the past" (1993, 224). Is this not precisely the neglected per-

spective on past art that Holly enjoins us to consider anew, the claim that historical objects lay down "a substructure of aesthetic design" that perdures and prefigures our historical accounts of these works (Holly 1996, 63)?

In concert with most art historians and common sense, Holly appears to assume that across time historians are interpreting the same work of art when speaking of the Merode Altarpiece or the other Renaissance works she considers. David Carrier has called for "some theory of the identity of paintings that permits us to make [the] intuitively obvious distinction" between a work that has changed materially in significant but ultimately minor ways and a work that is not the "same" (Carrier 1991, 21). While he argues that we cannot gain access to works as they are essentially, like Holly he assumes a large measure of sameness across time and in different interpretive systems. With Bourdieu, I want to question the latent universalism of this assumption. "Two persons possessing each a different *habitus,* not being exposed to the same situation and to the same stimulations," he speculates, ". . . do not see the same paintings since they construe them differently, and so they are bound to bring forth different value judgements" about the works in question (1996, 298–99). He defends this radical proposition as historical, not relativistic:

historicizing [cultural products] is not only (as some think) to relativize them, recalling that they have meaning only with reference to a determined state of the field of struggles; it also means giving them back their necessity by tearing them out of the indeterminacy which stems from a false eternalization and relating them back to the social conditions of their genesis – a truly generative definition. (1993, 298)

If the identity of works of art through time and across different places – or of "nature," if we think of the artist/model relation – in reception is open to legitimate question, then so too is what I would call the strong version of Holly's prefigurement thesis. When the "rhetoric" of an art work *must* "determine the array of things that can be said about it . . . [and] also formally or perhaps semiologically legislate *how* these things are organized in the first place" (Holly 1996, 81), then the case is put too categorically. Insufficient space is left for the effects of the practically innumerable variables working across Bourdieu's *"space of possibles,"* or the field "that tends to orient . . . research, even without [historians] knowing it, by defining the universe of problems, references, intellectual benchmarks," and so on (Bourdieu 1993, 176). Holly's "weak" thesis –

that prefigurement is a significant but not exclusive variable pro-
grammed into relationships in the disciplinary field – nonetheless re-
mains vitally important to an understanding of the process and results
of art historiography.

To elaborate and test the plasmatic model of reception that I have
been developing, let us consider two recent works of art that not so
much prefigure but participate in this organic system of reception and
circulation. Murray Favro's "projection" works from the early 1970s
present for their observers both the fundamental sense that, as Favro
claims, we project meaning onto objects and also the complexity of this
abiding process. If we take Kantianism to imply, minimally, "that con-
sciousness constitutes its world" (Summers 1989, 373) – which is indeed
how Kant has frequently been interpreted by artists whatever the spe-
cifics of his doctrine – then Favro's work offers an unselfconsciously
Kantian corrective to the Albertian model of vision. Essential to these
works are the "neutral" monochromatic, model-like receptors Favro
built to receive the specific visual information projected from a colored
slide. His most elaborate work in this genre is *Van Gogh's Room* (1973–
74), a scale version of the artist's room in the yellow house at Arles. In
the most dramatic sense, Favro's installation helps us to see that
different viewers – or indeed the "same" viewer at different times –
cannot see the "same" work of art. Neither do we have unmediated
access to this famous piece of art history. The physical and metaphorical
angle of approach to the room is crucial; we can even temporarily
obliterate all or part of the image by walking in front of the projected
beam of light. Neither the work nor the viewer literally projects this
anti-Albertian beam. Like the Lacanian gaze, it exists before and after
any individual look, but it is clear that its characteristics are also pro-
grammed by human agency during the specifics of reception, as well as
by the artist, who in effect establishes the possibility and form of this
reception. The role of chance in the construal of the work is also palpa-
ble; the aleatory is crucial in plasmatics as it is in Massumi's theory.
Chance is minimized by Bourdieu's scientific sociology, and all but fully
excised by the controlling and exclusionary precision of Albertian
geometry.

Alberti's fascinating discussion of the "veil" he used to construct his
paintings illustrates his desire for perceptual control over the visual
manifold. In *On Painting* (1435–36) he extols the practical virtues of this
"thin veil, finely woven . . . [that] I place between the eye and the thing
seen, so the visual pyramid penetrates through the thinness of the veil."

2. Joanne Tod, *Temporary Installation,* 1993. Oil on two layers of polyester, 60 × 84. Private collection. Photo courtesy the artist.

This "intersection," as he calls it, is functional for the artist especially because it fixes the transience of that observed: it will be "very useful to you, since it is always the same thing in the process of seeing. Secondly, you will easily be able to constitute the limits of the outline [of objects] and of the planes" (Alberti 1966, 68–69). The canvas of the picture plane is of course substituted for the veil in Alberti's account. For Lacan, it is the "image screen" that intervenes between the gaze and the observer, and for Holly, the veil becomes the historical "account," the chiasmic meeting point of the historian and the work of art (Holly 1996, 20–23). In Joanne Tod's painting *Temporary Installation* (1993; Fig. 2) and other "screen" paintings she did at this time, we may think we see a marvellous revision of Alberti's veil. Looking down the then newly installed European nineteenth-century galleries in the Metropolitan Museum of Art in New York, in her painting the eye encounters (but also passes through) an opaque rectangular membrane that seems to float partway within the deep perspectival space. The extensive gallery space itself, as

35

well as several Rodin bronzes, can be seen through the veil. Has Tod's painting been preformed by the Albertian system? I think not, for several reasons. She claims not to have known about Alberti's veil when composing her painting.[39] More important, given that we can be formed by elements not present to our consciousness, the painting is ultimately anti-Albertian in its vision. Only part of the depicted space is on the screen, which is in fact a second layer of polyester that sits on top of a larger plane of the same material. The veil does not capture all that we see. It frustrates Alberti's purpose. Tod also sets us in a museum space, certainly one of the main sites of meaning-construction in the visual arts and a reminder that art history is much "more than a singular institution" (Preziosi 1993, 217). Importantly, what lies outside the veil's borders to our left in Tod's image is a large painting by Rosa Bonheur, a work and artist here given new – but potentially temporary, as Tod's title warns from a feminist angle – prominence in the canon of nineteenth-century European art. We see the Bonheur "directly," not through the veil as we do the Rodins, but our approach to her work is decidedly tangential within the rigorously "Renaissance" perspective of the gallery space. In Tod's painting, the museum space itself is thematized as necessarily transient and politicized,[40] as it also is in the photographs of viewer behavior in museums by Thomas Struth:[41] we move through it but do not see "fixed" works of art. While Struth reveals the social dimensions of such looking, in Tod's work the veil arrests the view of the ideal disembodied spectator, s/he who is not pictured here but whose position we as beholders of her image adopt. Especially if one looks at the image turned on one end so that the pull of the spatial organization is suspended, her translucent screen can easily appear as a bizarre floating object, almost a free-standing monochromatic abstract painting, uncomfortable and anachronistic in the midst of this older "realism" of Bonheur and Rodin. But Tod's point is finally that all views are slanted, even aleatory, and certainly motivated by their physical and metaphorical place in the fields of culture.

Tod's point? No. It would be more accurate to claim this as my account, one that I can "find" in the picture because *Temporary Installation* is (at most) "amenable"[42] to this reading, which I articulate or project because of my interests, the contexts developed here, and many factors of which I can have little cognizance: my "habitus" in the sense of an "oriented space" (Bourdieu 1996, 235) or, with Stanley Fish, my "interpretive community." Holly's theory of prefiguration becomes part of my "programming" in a plasmatic space of reception, an elective

affinity to some extent, but also one that in its relation to Massumi's spatial theories originated by chance. I heard versions of Holly's views on the Merode Altarpiece (now chapter 6 of *Past Looking*) and Massumi's "Interface and Active Space" at a conference held at the University of Western Ontario in 1995, a gathering titled "Incomparables." That I have since compared their views makes the conference title ironic for me, but only within and because of my partly personal, partly institutional field of possibles. The Alberti-Lacan model does not allow for chance, nor in Holly's hands does it seem to permit what we might call *resistance* to the prefiguring structure of art works. What I envision is not the resistance of the ideally and impossibly free Kantian, liberal "subject" who chooses to act in certain ways, but rather that which presents alternatives to Holly's "Renaissance perspective" on reception. Her "strong" argument insists that historians are "compelled" to repeat these structures (1996, 24). I hope that I have here productively *reacted* to her arguments – the requirement of her weak version of rhetorical prefiguration – in part by bringing them into the same orbit as Massumi's and Bourdieu's more expansive fields. But resistance has figured in my reception of Holly's ideas, just as I trust it does in the following meditations on Kant's reception in art history and the visual arts. As we shall see in Chapter 2, chance also played an important role in this history of reception.

2

Place and Time

Kant in Rome, c. 1800

Erst in Rom habe ich . . . Kant's *Kritik der ästhetischen Urteilskraft* ganz verstehen gelernt . . .

Carl Ludwig Fernow, Rome, December 1796

The "objects" of our research cannot be detached from the intellectual and social "commerce" that organizes their definition and their displacements.

Michel de Certeau[1]

Kant did not like to travel, yet in 1974 his speculations on the "heavens" earned him the highly ironic honor of having his name chosen to mark a place on the Earth's moon. Although he was sociable within his circle of friends, he was also a notorious stay-at-home who rarely left his birthplace of Königsberg and never journeyed beyond East Prussia. Given the penchant for order and regularity habitually remarked upon by his biographers, anecdotes about his life that have become part of the Kant lore, we can speculate that he resisted travel because of the disruption it entailed. More positively, he felt that the world came to him in the port of Königsberg, and perhaps the routine that he established and protected there allowed him to be the adventurous mental traveler that he surely was.[2] Indeed, he presented theoretical arguments that align with his personal proclivities. Living in the busy and potentially cosmopolitan Baltic port of Königsberg and reading instead of traveling, Kant was self-reliant and self-sufficient. He was disciplined. As he put it in the third *Critique*, "To be sufficient to oneself and hence have no need of society, yet without being unsocia-

ble, . . . is something approaching the sublime, as is any case of setting
aside our needs" (1987, §29, 275). Thus Kant was not simply stubborn,
nor was he fearful of the world. Yet his transcendental method seemed
to obviate the specifics of place in favor of a universal vision of human-
ity, a position that has been criticized in our own time as both masculi-
nist and Eurocentric.[3] But Kant's rootedness in his *place* is more com-
plex than it might at first appear to be. He was an avid reader of travel
literature, which he cited often and significantly in his publications. He
was also one of the first to lecture on what we would now call human
geography, and his writings on cosmopolitanism were influential across
Europe in his time and continue to attract controversy (Bohman and
Lutz-Bachmann 1997). With characteristic hyperbole and a spectacular
disregard for historical detail, the poet Heinrich Heine lauded Kant's
daring as a thinker by likening his Copernican revolution in the *Critique
of Pure Reason* to the French Revolution: "Just as here in France every
privilege must be justified," he wrote in Paris in the early 1830s, "so, in
Germany, must every thought be justified" (1985, 200). Despite its inac-
curacies, Heine's claim does have the virtue of bringing into proximity
Kant's epistemological and political thought, a propinquity often
denied but important to my arguments in this book.[4]

While Kant wrote and lectured tirelessly in Königsberg, his ideas
traveled swiftly across much of Europe,[5] especially during and after the
mid-1780s, when Karl Leonhard Reinhold published his influential
Briefe über die kantische Philosophie (1786; Beiser 1987, 232ff.), and
when Kant himself presented both the second, revised edition of the
Critique of Pure Reason (1787), the *Critique of Practical Reason* (1788),
and many of his "popular" essays on history and politics that were, as I
will argue, particularly influential for the reception and elaboration of
his ideas on aesthetics. As Goetschel has shown, Kant was very much of
this world. He self-consciously fashioned and presented himself as an
author and worked to disseminate his ideas effectively. Of course he
could neither predict nor control where and how his writings would be
received. Such is the productive impurity of dissemination and recep-
tion. When some of his books were brought to Rome in the late 1790s,
they were employed in a manner specific to the political and personal
circumstances of their receivers, as (against Kant) I believe is always the
case. There is no evidence that Kant ever learned how consequential his
theories were for art and the writing of its history in what I will call the
"Fernow circle" in Rome at this time.[6] He did not intend, nor would he
likely have sanctioned, the interpretation given there to his thoughts on

aesthetics and related matters. Nonetheless, Kant's reception in this context remains largely consistent with his writings and can reveal much that is latent in them and pertinent both historically and theoretically, both in his time and in ours. It is also, I believe, the first major example of his profound legacy for art history and the visual arts.

Before turning to this "first moment" in the reception of Kant's ideas in this context, however, it is important to establish in more detail why I am focusing on this relatively little-known episode in European art and cultural history. The artist turned critic and historian Carl Ludwig Fernow (1763–1808) lived in Rome for only a decade – from 1794 to 1803 – but this was an auspicious time and place for the positive reception of Kant's ideas. It is difficult to imagine a more qualified or committed Kantian. He self-consciously promoted the strain of German classicism consolidated in Rome by J. J. Winckelmann (1717–68) and Anton Raphael Mengs (1728–78), both of whom had created their definitive pictorial and textual works there in the 1760s, but who were working too early in the century to be influenced by Kant's critical and later political writings. Temperamentally, as well as in their aesthetic theory and artistic practices, Fernow and his companions were – like Kant – *Aufklärer* and much more in tune with this earlier generation of Germans than with the more famous Romantics of the Nazarene circle, who came to Rome in the early part of the nineteenth century.[7] Central in this later group is Friedrich Schlegel (1772–1829), who was not affiliated directly with the Nazarene painters in Rome but whose "Letters on Christian Art" (?1806) spoke to the spiritual concerns of these painters.[8] As I mentioned in Chapter 1, Schlegel evolved an empirical and Christian approach to art's history; this radically separates him from Fernow. In conscious opposition to Kantian transcendental methodology, Schlegel claims, for example, that he will not pass judgment on works of art "until I can study the *actual works* . . . since, without consulting the existing examples, I could not attempt any comment on the general style of the compositions" (1860, 41). Kant, of course, sees nothing but contingency in such empirical observations. He is not concerned with individual judgments of Schlegel's sort, but with the grounds and possibility of a universal, necessary aesthetic sense. In the *Preface* to the third *Critique,* as I have noted, Kant writes that because his "inquiry into our power of taste . . . has a transcendental aim, rather than the aim to [help] form and cultivate taste . . . I would like to think that it will be judged leniently as regards its defects for the latter purpose" (7). All he shares with Schlegel here is a sense of irony, for Kant does not see the

lack of empirical work with artistic objects as a defect. As we shall see, Fernow departs from Kant in taking an interest in individual artists and works in a way that the philosopher could and would never do, but he does so from the a priori perspective of Kantian critique. Whereas Friedrich Schlegel also criticized Kant's political writings because they proceeded from the principles of an ahistorical faculty of reason (Geiman 1996, 519), Fernow again in this important moment of reception worked explicitly from the transcendental perspective. As I will argue, by synthesizing Kant's ideas on aesthetics and politics, he enacted the controversial Kantian premise that beauty is the symbol of morality.

Kant in Rome

Kant's political ideas arrived in the German-speaking artists' colony in Rome in an unusual way. The Danish sculptor Bertel Thorvaldsen came to the city from Northern Europe in March of 1797. Despite the volatile and dangerous political situation in Italy – where Napoleon's troops were increasingly successful in "liberating" the locals from Austrian domination – Rome remained a necessary training ground for an aspiring artist. Thorvaldsen hoped to be welcomed and promoted by a circle of German-speaking artists there, of whom Jakob Asmus Carstens (1754–98) was the most prominent.[9] As a gift for his hosts, he brought a little book called *Perpetual Peace: A Philosophical Sketch*, first published in 1795 by Immanuel Kant (Schoch 1992, 17). This book was explicitly requested by Fernow, Carstens's close friend and biographer, who arrived in Rome in 1794.[10] The immediate circumstances surrounding Thorvaldsen's delivery of the book exemplify the imponderables and aleatory nature of historical specificity that Martha Woodmansee has evocatively named "intrusions of contingency" (1994, 21, n.18); such details are of crucial importance in any attempt to narrate a pattern of reception. And though Thorvaldsen was a timely messenger, Fernow did not receive the book through mere good fortune. In fact, he had asked friends in Germany for it some time earlier, and in letters he expresses frustration at its slow progress to Rome. We have no indication that Thorvaldsen ever read this or any other of Kant's works, and I am not about to interpret his sculpture as somehow Kantian. What is remarkable is, first, that an artist would use a philosophical text to gain entry into this artistic community, and second, that the text he delivered – anxiously sought after by Fernow – was political in theme. This is to me the crucial point, one that has to my knowledge not been

addressed. Kant had indeed traveled to Rome, but was this the Kant who wrote on beauty and the sublime?

Fernow's passion for Kant and the work of other contemporary German thinkers was formalized during his studies in philosophy at the University of Jena from 1791 to 1793, just before his arrival in Rome in 1794. He worked with the most famous Kantian philosopher of the time, Karl Leonhard Reinhold (1758–1823) – whose prominence I pointed to above – with whom he maintained a lifelong friendship and correspondence. Reinhold was appointed to the chair in philosophy at Jena in 1787 largely because of the success of his series of articles titled "Briefe über die Kantische Philosophie," which appeared in 1786–87 in the influential journal the *Teutsche Merkur*. Although he later departed significantly from Kant's doctrines, Reinhold was at this time very much responsible for the wide dissemination and influence of his ideas. In 1788, Kant publicly sanctioned the contents of the "Briefe," making Reinhold his foremost disciple (Beiser 1987, 236). Although Fernow clearly learned much about Kant from Reinhold – and borrowed also from Reinhold's later philosophy – it is also likely that he wanted to study in Jena precisely because Reinhold was a recognized Kantian (von Einem 1944, 38). We know from Johanna Schopenhauer's 1810 biography of Fernow that he trained in Germany as an artist and never lost his passion for the practicalities and issues of art making. Around 1790, however, Reinhold's studies of Kant encouraged Fernow to read philosophy systematically. Fernow was by his own account a passionate Kantian and as a result decided at this time to devote himself to the theoretical and historical study of art (Schopenhauer 1810, 49–50, 239). For the rest of his life, Fernow was lavish in his thanks to Reinhold for setting him on this path. In letters from Rome, he detailed the application of his Kantian ideals, as we shall see. In a July 1796 letter to Reinhold, Fernow described the philosophical library that sustained him in Rome and that he tried to expand by requesting the newest publications from Germany. Johann Pohrt had brought him works by Friedrich Schiller and Reinhold's "Briefe." But Fernow carried Kant's *Critique of Judgment* there himself: about this book he claimed, "I have studied [it] thoroughly more often here, and I can truly say that it is here that its spirit first imbued me with brilliant clarity" (Schopenhauer 1810, 258).[11] It is important to note that Fernow goes on immediately in this letter to discuss Kant's essay *Perpetual Peace,* but before returning to his concomitant reception of seemingly disparate Kantian texts, we must look briefly at how his Kantianism relates to that of Friedrich Schiller.

Schiller taught at Jena while Fernow was studying there. They knew one another, and it is probable that Fernow attended Schiller's lectures on aesthetics given in the winter term of 1792–93 (von Einem 1944, 38). In addition to books by Kant and Reinhold, Fernow frequently asked friends in Germany for publications by Schiller. While Fernow was receptive to Schiller's ideas, he was less passionate about them than he was about those of Kant. To Reinhold, he wrote that "Schiller has certainly brought much light to the field of aesthetics, and I thank him for clarifying many things, about which I was until then in the dark" (Schopenhauer 1810, 257).[12] "From [what I know through] Schiller's letters and essays in the *Horen*, I am for the most part in agreement with him," he reported to his friend Baggesen (Schopenhauer 1810, 263).[13] Yet he was more critical of Schiller than of Kant. Perhaps surprisingly for us – accustomed as we are to complaints about Kant's prolix texts[14] – Fernow was especially disapproving of Schiller's writing style.

For all my aesthetic appreciation of it, . . . it would be highly undesirable if such a style were to become predominant in the language and manner of philosophy . . . [Schiller's] power is unique in him; and I would hope that his manner of presentation would remain unique to him too. What I am afraid of is *imitators*. They will inundate us with a flood of flatulent philosophy.[15]

As von Einem argues in his study of Fernow, Schiller was in his early years as a student of Kant when Fernow first met him in Jena. Although his 1795 letters on aesthetic education were in many ways different from Kant – departures that are central in specialized Schiller scholarship – Fernow for the most part interpreted Schiller from a Kantian perspective or employed Schiller's ideas to buttress his own modifications of Kant's positions (von Einem 1935, 116–19). It is, however, reasonable to assume that Fernow was attracted to Schiller's explicit linkage of beauty, art, and politics and that the connection of these themes influenced his reading of Kant. In the second letter of his 1795 book, Schiller claimed that "if man is ever to solve [the] problem of politics in practice he will have to approach it through the problem of the aesthetic, because it is only through Beauty that man makes his way to Freedom" (Schiller 1967, 9). Even though Fernow adopted this position against Kant's strictures, he continued to identify himself as a Kantian.

Fernow's education in contemporary aesthetics was central to his transition in Rome to a career as an art critic, historian, and theoretician rather than a portrait painter, his first vocation. He came to the city with the conviction that art production and its history needed to be placed

43

on the secure foundations of Kantian critical philosophy. As he put it in a letter to Reinhold of July 1796, "my entire study of art concentrates on the reduction of the fine arts according to philosophical principles and the mutual application of one to the other in judgment" (Schopenhauer 1810, 251).[16] Throughout his decade in Rome, Fernow read and reread Kant to this purpose. In the winter of 1795–96, he presented a series of lectures on Kant's aesthetics to a group of no fewer than thirty-six artists and other colleagues. The series was titled "Vorlesungen über Ästhetik nach Kantischen Prinzipien" (Lectures on aesthetics following Kantian principles; Schopenhauer 1810, 242). Carstens attended, as did the later famous landscape painter Joseph Anton Koch, whose work I will discuss in Chapter 4. We do not have the text of his talks, but in "Über das Kunstschöne," written at about this time though published in 1806 as part of his *Römische Studien*, Fernow claimed that art's essence could and must be understood through critique, not initially through the empirical study of individual works of art or knowledge of artists' biographies, as Friederick Schlegel later recommended and as practiced in most of what passed for art history up to but excluding Winckelmann (Fernow 1806, 1:291–95). He followed the Kant of the *Critique of Judgment* quite closely in his belief in art's autonomy and dignity, its creation through genius, and in his understanding of the beautiful as a powerful and pleasurable feeling of harmony within the perceiver. The clearest evidence of Fernow's Kantianism is found in his theory of beauty. Conventionally Kantian is his claim that "Only through the feeling of the beautiful can we be aware of the free activity of our minds – and only through the free activity of our minds can we be conscious of the beautiful. . . . We call beautiful," he goes on to say, "all objects that produce in us the impression of the free harmony of our mental powers, and through this effect stimulate in us the feeling of the beautiful" (Fernow 1944, 295). Clearly Fernow is basing these ideas on Kant's third *Critique*, though it is important to remember that in any reception history, a "pure" influence is nearly impossible. Fernow's analysis in "Über das Kunstschöne" leads him to separate natural and artistic beauty. Following Kant in the later sections of the *Critique of Judgment*, he sees artistic beauty as controlled by purpose or intention (Kant 1987, §50). Unlike Kant, however, Fernow – ever the artist's champion – values artistic beauty over our aesthetic response to nature.

Perhaps again because of his own beginnings as a painter, Fernow constantly stressed that his philosophical formulations were for the benefit of artists, rather than abstract speculations aimed at philoso-

phers. Thus he argued against Kant's preference for line over color. His detailed plans for a book entitled *Eines ästhetischen Handbuchs für Künstler* (An aesthetic handbook for artists) (Fernow 1944, 70), which he described in a letter to Keller in 1795 and which Keller in turn passed on to Henry Fuseli (von Einem 1935, 208–13), show his intent to write on the aesthetics of art in a manner useful to practicing artists. His commitment to artists may even explain his comment to the poet Jen Baggesen, the first epigraph to this chapter, that only in Rome could he understand Kant. Similar to Thorvaldsen's delivery of Kant's *Perpetual Peace*, this seemingly incidental comment has important connotations. In the *Critique of Judgment*, Kant was at pains to prove that aesthetic judgment was both universal and necessary, that it did not depend on time or place but only on "formal," a priori human powers. To be autonomous, the aesthetic judgment of beauty had to be the same in Rome as in Königsberg. Any cultural relativism, historical perspective, or other "interest" disqualified the experience from the realm of a pure judgment of taste. While Fernow accepted this now unpopular argument, the particularities of his reception of Kant help us to see that the dissemination and influence of these philosophical ideas were much more inflected by place than Kant's universalist aesthetic theory dictated. Rome was, on the one hand, *the* cosmopolitan city at this time, a place where intellectual freedom and the unparalleled mix of artists spawned new ideas. On the other hand, nationalist groups and sentiments were also potent.[17]

The Concurrency of Reception

Fernow read Kant in a way and in a "place" that we cannot replicate today. As his letters indicate, he engaged with Kant's texts as they were published, and of course he read them alongside those of other philosophers, notably Schiller and Reinhold, as part of ongoing debates. Our late-twentieth-century Western habits of receiving Kant reflect the much greater specialization of our time: justified by Kant's own architectonic in the *Critiques*,[18] we tend to separate his epistemology from his aesthetics and ethics, and even his *Critiques* from the so-called popular essays. Despite the increasingly large number of scholars who work against these divisions and read Kant both more historically and wholistically,[19] current disciplinary habits and assumptions cannot be exposed or bracketed completely. Nor should they be. Rather, if we can recognize our own ways of reading Kant as conventional and necessarily historically inflected, we can in turn discern qualities of difference

in the "moment" in which Fernow received these texts. I would like to resurrect the little-used noun "concurrency" to emphasize how Fernow particularly absorbed and elaborated Kantian ideas in ways that may seem foreign to our methods. "Concurrency" is defined in the *OED* as "A running together in place or time; meeting, combination." Secondary meanings include "consent" and "joint right or authority." The concurrency of Fernow's reception of Kant in Rome was unique. As we have seen, he was rereading the *Critique of Judgment* at the same time that he first delved into *Perpetual Peace*. He relates these books consciously by discussing them together in a letter to Reinhold (Schopenhauer 1810, 258), and, as I will argue, he also brings them together (largely unconsciously) by treating Kant's aesthetics politically and his politics aesthetically. As a German artist, a Kantian theoretician, and a historian of art in Rome during the ongoing French Revolution and Napoleon's invasions of the Italian states, Fernow was singularly placed.

Why did Fernow want to read *Perpetual Peace?* The explanation is both historical and biographical. Kant's text – even with its ironical title ("perpetual peace" could be achieved more readily in the cemetery than in our daily existence; Kant was no optimist about politics) – dealt with topical state politics and the virtues and possibilities of republican government.[20] Kant was widely – and dangerously, given the censorship of the time – identified as a Jacobin sympathizer. He was a controversial and courageous supporter of the principles of "freedom" that he saw in the French Revolution, in spite of the terror and even during Napoleon's attempts in the 1790s to conquer Europe. While his public proclamations on the revolution were apparently self-contradictory – he spoke in favor of the revolution as an instance of progress in world history but categorically denied the right to revolution itself – Frederick Beiser (1992) has argued effectively that the threat of censorship of the press kept Kant from endorsing revolution directly as a political tool, but that Kant's philosophy was nonetheless, from the time of his encounters with Jean Jacques Rousseau's texts in the 1760s, fundamentally political.[21] The French Revolution encouraged Kant in his essays of the 1790s to break what had been his silence on the subject of politics (Beiser 1992, 37).[22] He wanted to apply reason to the interaction of states. His cosmopolitan message was especially pertinent in Italy, occupied in part by French troops during much of Fernow's time there.

I have sketched Fernow's philosophical affinities with Kant. What needs to be added to this picture, however, is their shared zeal for

politics. In a letter of December 1796 to Baggesen, Fernow describes himself as "extremely" political. We know from other letters that he followed troop movements carefully and was enthusiastic about the short-lived Roman Republic set up on the French model in 1798. Fernow was also a fervent supporter of the French Revolution, of Napoleon, and – largely because of Kant's arguments (which were more sanguine on this score than those of either Schiller or Reinhold) – of republicanism. We know, too, from the testimony of his contemporary, the Danish archaeologist Georg Zoëga, that "Fernow, like a popular preacher, proclaimed the gospel of human rights and duty from the rostrum of the *Circolo constituzionale* [constitutional circle]" (von Einem 1944, 53).[23] The image most of us have of Kant is that of a cool intellectual, a purveyor of absolutist moral theory who did not even write a full treatise on politics. But in the opinion of many of his contemporaries and a few scholars today, he was both more passionate and politically engaged than this caricature allows. Not only did he follow closely and publish on the French Revolution, but also in his theory of judgment in the third *Critique* – according to Hannah Arendt (1982) – we may discover the basis of our political being.[24] The eminent art historian Herbert von Einem, on the other hand, in what remains the definitive study of Fernow, suggests that the critic's proclaimed allegiance to republicanism and cosmopolitanism was merely of the moment and, in its utopian hopefulness, was also in conflict with the realities of Fernow's time (1935, 13). Invoking the received view of Kant as apolitical, von Einem also finds a conflict between Fernow the "abstrakte Kantianer" (abstract Kantian) and Fernow the politically engaged witness to human rights and duties. But neither Kant nor Fernow was so "abstract." For those who believed in the ideals of the French Revolution, it was a time in Rome when one could hope that Kant's cosmopolitan model would be realized. *Perpetual Peace* was written during a relatively optimistic period, when the Treaty of Basel between France and Prussia was signed and Prussia withdrew from the First Coalition of European States against France. Kant chose this moment not to praise the accord but to press for a more rational and lasting peace. But this optimism faded quickly for both Kant and Fernow. Europe continued to be besieged by Napoleon, and the Roman Republic had dissolved again by the turn of the century. In retrospect, even Joseph Anton Koch, another prorevolutionary and also a bitter critic of academies of art, labeled Fernow a "modern republican pedant." In the same breath, however, Koch significantly takes us back to the period in

focus here, when he mentions that Fernow had expounded Kantian republican ideals in his 1795–96 lectures on Kant's aesthetics (von Einem 1935, 183, n. 58).

In Fernow's interpretation, then, Kant's aesthetics of beauty and his politics were indeed actively related, despite the autonomy that the philosopher always – and necessarily in his own terms – sought for each. If we consider Fernow's description of artistic beauty against Kant's assertion of beauty's timelessness and universality, we see that Fernow, following Kant, emphasizes the "free harmony of our mental powers" as the productive cause of the feeling of the beautiful, which is of course in us, not in works of art, and certainly not in nature, whose teleological necessity he opposed to the freedom definitive of human subjecthood. Fernow stresses that aesthetic freedom is necessary for the beautiful at a time when he actively sought political freedom in a republican form. Put bluntly, he was reading Kant's *Perpetual Peace* and *Critique of Judgment* simultaneously and in terms of one another. Fernow's reading helps us to see a different Immanuel Kant, not the abstract thinker but one whose ideas engaged fundamentally with the work of historians and artists. At the same time, Kant's strictly philosophical priorities shaped the way in which Fernow understood beauty and what he wrote about contemporary art. The notion of "freedom" is central in this symbiosis between the "abstract" and "political" realms.

"Freedom" is a notion fundamental to Kant's thinking on aesthetics, morality, and politics, and one that is also central in Schiller's writings of the 1790s.[25] In theory, Kant wanted to keep the freedom of ethics and morality separate from that of state politics and to segregate it again from its incarnation in aesthetic and teleological judgment. As he demonstrates even in his late *Conflict of the Faculties* (1798), only carefully legislated interactions between ultimately autonomous jurisdictions can guarantee their existence and freedom.[26] As early as 1764 in the *Observations on the Feeling of the Beautiful and Sublime*, and more thoroughly in the *Critique of Judgment*, Kant sought to disentangle the aesthetic from the sorts of "interested" moral judgments that had defined it in the British eighteenth-century tradition of Shaftesbury. Yet there are hints, especially in the third *Critique*, that while the beautiful is decidedly not, for Kant, the same as the morally good, the two may productively be related. The "beautiful is the symbol of the morally good," Kant writes (1987, §59, 353); as such, it allows the union of taste and reason, which in turn "enables us to use the beautiful as an instrument for our aim regarding the good" (1987, §16, 231). Freedom's con-

nections with morality were a central concern for Kant's mentor, Rousseau, who, as Charles Taylor points out, "also recovers the links with the ancient view of republican freedom" so important to Kant's political thought (1985, 321). As John H. Zammito (1992) has shown so effectively, Kant's ideas evolved considerably as he conceived of and wrote the third *Critique* during the years 1787–90, the same brief period in which he revised his first *Critique* (second edition, 1787), published the *Critique of Practical Reason* (1788), and was very active as an essayist on matters of history and politics. During this period he became increasingly willing to bring the beautiful (the aesthetic) and the good (morality as a function of Kantian reason) together. As we have seen, he hints at the connection in section 16 of the *Critique of Judgment,* develops it somewhat in section 42, and by section 59 defines beauty as the symbol of morality. In the *Anthropology* (1798) – another Kantian text that we find Fernow asking for in a letter to Germany in mid-1797 and that, we can assume, he finally received (Fernow 1944, 259) – Kant states unequivocally that "taste could be called morality in external appearance" (1963, 69).

Fernow could only understand Kant's aesthetics "completely" in Rome because only there did he feel the immediacy of Kant's ideas of aesthetic and political freedom. His commitment to both Kant's aesthetics and his republican political vision as articulated in *Perpetual Peace* relies on a close and functional analogy between, first, the free play of the faculties in aesthetic judgment that leads to the pleasure of the beautiful and the "practical" freedom that defines morality as a function of reason.[27] Fernow in effect draws a further analogy between the freedom of morality – the sphere of the individual subject – and the political freedom of the state's citizens necessary for republican government. Fernow's work with Kant's ideas is, I believe, justified in the very texts that he invokes and to which he refers. Fernow uses the analogy between the freedom of aesthetics and that of politics in a *regulative* way, a technique that, like the use of analogy, is specified carefully by Kant. Kant always distinguishes "constitutive" principles that belong to his faculty of understanding – which deals with the empirical world and our knowledge of it, with "reality" used in the quotidian sense – and "regulative" principles of the faculty of reason, which do not deal directly with the perceptual world but only order (in a full sense) what is presented to the mind by the understanding. "An analogy of experience," he suggests in his usual abstract way in the *Critique of Pure Reason,* is "only a rule according to which a unity of experience may

arise from perception. It does not tell us how mere perception or empirical intuition in general comes about. It is not a principle *constitutive* of the objects, that is, of the appearances, but only *regulative*" (1965, A180/B223). The importance of regulative ideas is made clear by Kant in a section of the first *Critique* titled "The Regulative Employment of the Ideas of Pure Reason" (A643/B671ff.), and again in the preface to the third *Critique,* where he argues that the regulative ideas of reason both check the knowledge claims of the understanding and lead it toward certain (usually metaphysical) goals (1987, 4–5). As we have seen, teleology is the regulative principle by which we can assume that nature is purposive. God is a regulative idea. So is freedom, and increasingly in Kant's writings during and after the mid-1780s the regulative idea of freedom is cast as acting in the world politically.

I emphasized above Fernow's habit of discussing Kant's third *Critique* and political writings in the same immediate context. Remarkably, there is one instance in the *Critique of Judgment* where Kant does the same, precisely when he attempts to illustrate the process of analogy.

Symbolic exhibition uses an analogy . . . in which judgment performs a double function: it applies the concept to the object of a sensible intuition; and then it applies the mere rule by which it reflects on that intuition to an entirely different object, of which the former object is only the symbol. Thus a monarchy ruled according to its own constitutional laws would be presented as an animate body, but a monarchy ruled by an individual absolute will would be presented as a mere machine (such as a hand mill); but in either case the presentation is only *symbolic.* (1987, §59, 227)

In this manner, Kant (and, following his example, Fernow) can legitimately discuss matters that technically must be separated. Through analogy, concerns that belong in different parts of Kant's philosophy may be considered together without committing the error of "subreption," whereby we claim knowledge of that we cannot know. As Rudolf Makkreel has pointed out, Kant's "aesthetic ideas" engender just this sort of "imaginative cross-referencing between different levels of system," in this case, the aesthetic and political (1990, 127). Beauty becomes the symbol of morality in a regulative sense. In his often cited response to Kant's third *Critique* found in his retrospective essay "Einwirkung der neueren Philosophie" (1820), Goethe underscores the power of analogy as he makes sense of the whole of the book, including its critiques of both aesthetic and teleological judgment. "Here I saw my most

diverse thoughts brought together," the poet wrote, "artistic and natural production handled in the same way; the powers of aesthetic and teleological judgment mutually illuminating each other" (Cassirer 1981, 273). It is worth noting, too, that Goethe in the next sentence explicitly notices the principle and process of analogy at work in Kant's thinking. "Act and thought [are] entirely analogous; the inner life of art like that of nature, their bilateral effect from within to without was clearly expressed in the book" (1891, 31).[28]

"We should not call anything art except a production through freedom," writes Kant in section 43 of the third *Critique* (1987, 170). In *Perpetual Peace*, he describes his ideal of freedom as a cosmopolitan, reasoned relationship among states. Kant contends that a *"republican constitution* is founded upon three principles: firstly, the principle of *freedom* for all members of society (as men); secondly, the principle of the *dependence* of everyone upon a single common legislation (as subjects); and thirdly, the principle of legal *equality* for everyone (as citizens)" (1991b, 99). We know from his letter to Pohrt in April 1797 that Fernow translated this passage on republicanism for an Italian friend (Fernow 1944, 231). Its insistence upon social freedom – defined here by Kant in terms of the state as that "which no-one other than itself can command or dispose of" (1991b, 94) but consistent with his definition of reason throughout his philosophy as self-motivating and self-defining – is closely allied to the freedom of the judgment of taste in the beautiful, which Kant says cannot be other than a social power, a communal phenomenon and force among world citizens. "Taste is a faculty of *social* appraisal of external objects in imagination," he argues in the *Anthropology*. "The soul feels here its freedom in the play of images (hence, of sensibility); for sociability with other men presupposes freedom, and this feeling [of freedom in the play of images] is pleasure" (1963, 64–65). "The state is a society of men, which no-one other than itself can command or dispose of," he writes in *Perpetual Peace* (1991b, 94). Fernow follows Kant exactly in this context: "Only through the feeling of the beautiful can we come to know the independent activity of the mind and only through the independent activity of the mind can we come to know the beautiful," he claims near the beginning of his essay on beauty. "For both are inseparably bound like cause and effect; and we call an object beautiful, whose impression causes within us the free harmony of the powers of our mind, and through this effect excites within us the feeling of the beautiful" (1806, 295).[29] Clearly, for Fernow

too Kant's import went beyond aesthetic theory. Providing another testimonial to the philosopher's significance to him and to others in his milieu, Fernow wrote to Pohrt in October 1796:

According to the teaching of our great master Immanuel Kant, when we act, we should have our eye only on the sublime command of duty, without regard for contingent results; because the latter are always subject to chance, – every motive is, however, entirely in our power. Imbued by the great truth of this teaching I confidently want to begin and complete my letter. (Fernow 1944, 150)[30]

Freedom in its inclusive sense was basic to Fernow's art theory and to his work as a historian of art. We have seen that he did not stop at a thoroughly Kantian theory of art but used the notion of beauty as the symbol of morality in the world, in the political sphere, as he proclaimed the virtues of Kant's republican, cosmopolitan vision. We can see the same concurrency of the aesthetic and the political in his discussions of Carstens's life and art. Strange as it may seem to conceive of Carstens's rather arid drawings as in any way "political," his a priori search for linear and human essence was, in at least one important instance, based as much on Kant's theory of space and time in the first *Critique* and on his declarations of social freedom as on the philosopher's neoclassical preference for line over color or on his formalist strictures expressed in the *Critique of Judgment,* a preference famously demonstrated in Carstens's work. Kantian freedom was fundamental to the production of and controversy surrounding Carstens's *Raum und Zeit* (Space and Time, 1794; Fig. 3) as it was to the self-definition of the Roman *Künstlerrepublik* established by Fernow and Carstens at the time of Roman Republic mandated by Napoleon.[31]

The Politics of Beauty

In his notorious letter of February 1796 to his administrative superior in Berlin, the Prussian minister of education Baron von Heinitz, Carstens asserted:

I must tell you Excellency that I belong to Humanity, not to the Academy of Berlin. . . . It is only here [in Rome] that I can properly train myself, . . . and I shall continue with all my strength to justify myself in the eyes of the world through my own works. . . . I am ready, if necessary, to assert it in *public,* to justify myself to the world, as I feel justified in my own conscience. (Eitner 1970, 109; my emphasis)[32]

Carstens expressed himself so emphatically only after a lengthy exchange with von Heinitz over the artist's fiscal and moral responsibilities.[33] Carstens was employed by the Berlin Academy and was on stipendiary leave for two years to study and work in Rome. He was requested to give evidence of his work in reports and, eventually, to return to his teaching post. But he refused to acknowledge obligations of any kind to his position as an employee of the state, proclaiming only his duty to himself and to "humanity." I am not the first to suggest that his position has Kantian overtones. Werner Busch has pointed to paragraph 47 of the third *Critique* as the source for the artist's insistence on his independence and the priority of his creative genius (82).[34] Fernow championed a Kantian view of genius in "Über das Kunstschöne" and was Carstens's closest friend.[35] Even more significantly, Busch has also flagged Carstens's emphasis in his letter to von Heinitz on the theme of the public versus private man, which takes us to Kant's political and historical essays of the 1780s and 1790s. What I want to underscore, in turn, is the way in which these two strains of Kant's thinking came and worked together for Carstens and Fernow to produce a decidedly political sort of Kantian aesthetic. "By the public use of one's reason I mean that use which anyone may make of it *as a man of learning* addressing the entire *reading public*," Kant stated in his 1784 essay "An Answer to the Question: 'What Is Enlightenment?'" (1991a, 55).[36] Here he uses the terms "public" and "private" in exactly the opposite way that we and his contemporaries normally do. Like Kant, Carstens asserts the "public" primacy of his conscience over the strictures of what Kant labeled any "private" civil post or office. In "public," both Kant and Carstens argued, reason and the freedom of the individual to think and express himself are primary. In "private," however – as a civil servant, for example, which Carstens was – one must obey authority.

Kant explicitly links the public right to freedom with political liberty: "The *public* use of man's reason must always be free, . . . the *private use* of reason may quite often be very narrowly restricted, however, without undue hindrance to the progress of enlightenment" (1991a, 55). As we saw in the passage from *Perpetual Peace* cited above (1991b, 99), freedom – like aesthetic judgment – operates only in the context of rules, a framework of what Kant calls "legislation." Kant would have ratified Carstens's right to express himself freely and publicly in his art and in the letter to von Heinitz, but he would not have sanctioned the artist's resignation from his "private" duties in the Academy. For Kant, Carstens acted as a "private subject" who was dependent upon and

subject to legislation from his superiors and from a state structure. But Carstens uses Kant's arguments to justify his complete autonomy.[37] Just as Fernow actively sought *Perpetual Peace* because he followed the evolution of Kant's thought, so Carstens's use of Kant's authority was no accident. Fernow notes approvingly the artist's familiarity with Kant while also remarking that he was no theoretician: "He worked in the field of philosophy for a time, although he was of a concrete turn of mind, too practical to grasp speculative ideas other than in pictorial terms" (1867, 81).[38] Similarly to the critic Daniel-Henry Kahnweiler, who said almost the same thing about the painter Juan Gris and whose Kantianism I will investigate in Chapter 3 in relation to cubism, Fernow had enough of the philosopher for both of them. In fact, we have every reason to believe that he was the instigator of Carstens's Kantian response to von Heinitz (Kamphausen 1941, 78). We can also imagine that Fernow introduced Carstens to Kant's *Critique of Pure Reason*, because Carstens was sufficiently earnest about the ideas in that text to produce *Raum und Zeit* in 1794 (Fig. 3).[39]

Raum und Zeit is an outline drawing that depicts an old man holding a sphere and a young man holding an hourglass and a scythe. Both figures are "floating" in space, arms around each other's shoulders as if flying, with drapery billowing behind them. The artist's own description, included in Fernow's review of the Carstens exhibit that took place in Rome in April 1795, describes *Time and Space* as "a painting in tempera. A graphic representation of these abstract forms of material existence, all phenomena are located in them. Space embraces the cosmos; Time is eternally young, only the things in it change" (Fernow 1979, 59). Fernow reports that the drawing is after the lost painting[40] that was exhibited in Carstens's exhibition, disproving the often heard opinion that Carstens was only a draftsman. Fernow's account of the exhibit appeared in June 1795 in Weimar's *Der neue teutsche Merkur.* Here he praises Carstens's genius in terms close to Kant's account of this quality in the third *Critique.* The artist's "discipline," his "judgment," he claims, "forfeits none of its freedom under the necessary restraint of rules" (Fernow 1979, 62). For Kant, "*Genius* is the talent . . . that gives the rule to art." And while "every art presupposes rules," freedom is actually guaranteed by these limits (1987, §§45–46, 307–8). Fernow underlines Carstens's exercise of freedom in the selection of the themes for the works in this exhibition, *Raum und Zeit* included. Ultimately, this freedom of artistic judgment is modeled on and an example of Kant's notion of political freedom within the limits necessarily imposed by the state.

3. (After?) Asmus Jakob Carstens, *Raum und Zeit*, 1794. Pencil on paper, 56 × 65 cm. Formerly Sammlung des Prinzen Johann Georg, Herzog zu Sachsen. Photo courtesy the Witt Library, Courtauld Institute, London.

In his 1806 biography of Carstens, Fernow first discussed the image as an example of the artist's familiarity with Kant. "Afterwards he also began to study Kant's *Critique of Pure Reason,* in which, however, he came no further than to the doctrine of space and time; and the outcome of this brief survey was a symbolic representation of both these forms in a pictorial composition, for the sake of which he must have endured a variety of challenges in jest and in earnest" (1867, 81).[41] Once we know that this allegorical rendition of the fundamental categories of space and time from the first *Critique* was the topic of correspondence between Goethe and Schiller at the time of Fernow's 1795 review, an exchange in which they lampooned the artist's flat-footed response to Kant, Fernow's description may seem somewhat defensive. He is clear to note that it is a "symbolic presentation," not the literalization of what cannot be shown, as Goethe and Schiller seemed to think.[42] At the time, Schiller quipped: "The latest from Rome: Time and Space are really

painted! Now with equal luck we may expect the Virtues to dance for us" (Fernow 1979, 59, n. 6). It is possible that Fernow used the term "symbolic" here as a synonym for "analogous," as Kant did (1987, §59, 227). If so, Fernow is justifying Carstens's seemingly simplistic reference in sophisticated Kantian terms. Even if this reading is plausible, however, it remains clear that Carstens employed Kant's political thinking to greater effect than he did his reading of the first *Critique*. It is nonetheless significant that he would use Kant as a source for his artistic work and that Fernow would attempt to legitimize his effort.

Carstens's and Fernow's recognition and prophetic construction of Kant's name as an authority in art and art history has another salient dimension: German nationalism. The three figures on whom I have focused in this chapter – Kant, Fernow, and Carstens – figure critically and across two centuries in the development of a German culture of nationalism. Fernow makes allusions to an evolving German nationalism in a letter to Pohrt in December 1796: "Since Kant's *Critique of Pure Reason* the German spirit has gained a decided lead and traveled up to heights, whose existence the majority of the other European peoples know only obscurely. He is thus alone in fertilizing and reviving the seed for many excellent works; it is he to whom all the excellent minds of our nation owe their inspiration" (1944, 163).[43] The notion of *Aufklärung* is here personified in a most literal way at a time when unified German statehood was not yet envisioned but when German culture was becoming a reality. The pattern continues in the late 1860s with the publication in 1867 by Riegel of Fernow's biography of Carstens, a time when Prussia especially was asserting its military and cultural precedence over France. Again in 1867, Friedrich Eggers wrote the following in *Jakob Asmus Carstens:*

Kant's philosophy, the insight of the great poets, the ideas of humanity, this more than anything else interested the German people, this is the content, which infused the German people's spirit, with which the painter impregnated his soul, which was . . . to solve the problem which, since Winckelmann, so many had posed for themselves and so many had attempted. (22)[44]

What can be seen as a third wave of interest in Fernow, Carstens, and also Joseph Anton Koch, occurred at another, though clearly very different, time of German cultural nationalism – the 1930s and 1940s. Von Einem's work on Fernow appeared in 1935 and 1944. In his introduction to Fernow's letters, he states that "Kant was to him a pioneer and figurehead of German achievement,"[45] implying that both men

continued to carry this mantle in the 1940s (1944, 53), as Kant also had for many Germans during the First World War.[46] Kamphausen's study of Carstens and Otto von Lutterotti's large book on Koch were both published in 1941.[47] Other scholars have of course written on these artists at other times and in other terms. Nonetheless, when we wonder why Fernow used Kant in the ways he did at this time – or, as I shall ask implicitly in the following chapters, why Kant's name continued to function as an authority in art history and the practicing visual arts in the nineteenth and twentieth centuries – the identification of Kant as paradigmatic of a uniquely "German" culture associated with the intellect and the philosophical is historically significant.

An argument could be made that Kant himself began this practice of identification in his 1764 *Observations*.[48] The final section of this book is titled "Of National Characteristics, so far as They Depend upon the Distinct Feeling of the Beautiful and Sublime." Kant's measure of national types ultimately favors the Germans, not because they better appreciate the beautiful (which he reports that the French do) or indeed the sublime (in which realm they are runners-up to the English), but because the German "surpasses both so far as he unites" the feelings of the beautiful and the sublime (1960, 104). In retrospect, this anecdotal theory itself harmonizes remarkably with Kant's later reflections on the judgment of taste. The feelings of the sublime and beautiful are, in the third *Critique*, the result of the seemingly purposive attunement and (ultimately) cooperative synthesis of the mind's faculties, which again implies the superiority of the German marriage of both feelings. In addition, in 1764 Kant makes it clear that the Germans' penchant is for the sublime (98), and it is this feeling that in 1790 he definitively links with reason. Reason in turn was for him, at least from the time of the first edition of the *Critique of Pure Reason* in 1781, the epitome of philosophy itself (1965, A839/B867).[49] But Kant did not have to make himself into the personification of German philosophy. Madame de Staël's widely read discussion of his writings – however imaginative her interpretation may have been – certainly gave that impression. Kant "spent his whole life . . . meditating on the laws of human intelligence," she enthuses (1987, 302).[50] Heinrich Heine may have set out in part to correct impressions left by de Staël, yet he too characterizes Germany as philosophical: "Germany had been drawn by Kant onto the path of philosophy, and philosophy became a national cause" (1985, 213).

Whatever we may think of the personification of Kant as philosophy and of philosophy in turn as German, the reception history is there to

read. It is by definition a superficial reading, one taken only from a glance at appearances. But it is this very superficiality that makes Kant's name – and as I will argue in Chapter 5, his portraits – so easy to use, and thus influential. Reading the surface was a profound pastime in the eighteenth century, as Barbara Maria Stafford has memorably shown. Kant was a master of the art; his observations on national types, for example, are drawn from travel literature rather than firsthand experience. These same observations were quoted at length in Johann Caspar Lavater's extraordinarily popular writings on "physiognomy," lending Kant's authority to the "science" that in turn sanctioned the construction of individual, disciplinary, racial, and national stereotypes. I shall return to physiognomy and to the "phrenology" of Frans Joseph Gall and others in Chapter 5. Here I want to argue that Kant's reception constantly flies in the face of his theory of universal types and the universality of reason. His transcendental categories of space and time, while arguably always operative for the human viewer, are not absolute but rather historical and cultural coordinates, the specifics of which very much inflected the version of "Kant" passed on to art and art history by figures such as Carstens and Fernow. That Carstens could attempt to make concrete such abstract categories in *Raum und Zeit* helps to prove my point. Both Carstens and Fernow used Kant "politically." To this end they employed his arguments about state and individual freedom from *Perpetual Peace* and "What Is Enlightenment?" and his assertions about the perogatives of genius from the *Critique of Judgment*. To be a "political" artist in Rome circa 1800 meant to have the freedom to depict beauty as an essential inner harmony. This is not escapism, as the examples of Carstens's practice and Fernow's writings should show. For these men as for Kant, the aesthetic was one product of freedom. It was therefore a paradigm and symbol of morality, which in turn assumed the personal autonomy of the Kantian subject initially and fundamentally, but also autonomy of the political sort. Ronald Beiner generalizes this crucial contiguity: "If the beautiful view of the world leads to the idea of progress in history and to the related notion of a mechanism by which the good regime will be brought about despite man's radical evil, the sublime perspective shifts the emphasis to the free will and its political expression, public law and justice" (Beiner and Booth 1993, 4). The practical separation of art and politics was, I believe, a fiction maintained in theory by Kant and his followers precisely so that judgments of the beautiful pertaining to art and nature could exist as regulative models for our behavior as human beings. Art for Kant

could not be didactic or "political" in any direct sense, as it increasingly was at this time for the painter Jacques-Louis David, for example. Such a purpose would disqualify it as art. But the "aesthetic ideas" generated by art and nature did operate as touchstones of human independence. As always, for Kant this was an independence that arose from and was subject to "legislation." For art, the rules come from reason, from critique, from the discipline of philosophy.

A telling instance of philosophy's ideal role in society is to be found in the so-called Secret Article of Kant's *Perpetual Peace*. The form of this text is modeled closely on "real" political treaties, which often included such secret articles, agreements that were seen by only some of those states affected by the terms. I have noted that Kant's book was written in the context of the Treaty of Basel, concluded between France and Prussia on April 5, 1795. Here the secret article allowed Prussia to approve the permanent annexation of the right bank of the Rhine to France in return for the secularization of church lands. Kant's secret article concerned the position of philosophers and philosophy in the state, where politics are of a disciplinary sort. The state, he writes, should allow philosophers "*to speak* freely and publicly" (1991b, 115) to give purportedly unbiased advice from the vantage point of reason. We have seen that Carstens exercised this prerogative in his correspondence with von Heinitz, with the difference that, in Kantian terms, he performed "publicly" when he was in a "private" position at the Berlin Academy. Another way to describe Carstens's actions would be to say that he behaved as a philosopher in this letter and thus claimed the right to speak out publicly. As a "mere" artist, he arrogated this privilege by using Kant's authority.[51]

For Kant and many others, the goal of enlightenment as a necessarily ongoing process was "freedom" of a certain sort, freedom guaranteed and governed by reason's legislation. In "What Is Enlightenment?" and elsewhere, Kant claims that to protect and maintain our public right of autonomous thought and speech, other freedoms must be restricted. As we see in *The Conflict of the Faculties*, philosophy itself – the paradigm of the "lower" faculty in the German Protestant university system, as opposed to the "higher" professional faculties of medicine, law, and theology (whose members, as I have remarked, Kant endearingly and prophetically calls the "*businessmen* or technicians of learning") – is the only voice independent enough to govern the others, to decide where the limits to human behavior and institutions must stand. Philosophy, Kant maintains, deals only with "the free play of reason" and thus,

"having no commands to give, is free to evaluate everything" (1992b, 35, 27). Kant frequently envisions philosophy as a judge, and his writings on a wide range of topics exemplify the notion that his is indeed a philosophy of detached, critical judgment, of reception rather than creation. For Hannah Arendt, Kant holds that "the public realm is constituted by the critics and spectators, not the actors or the makers." This is certainly true when we think of Fernow, but it applies also to artists, because, as she elaborates, "this critic or spectator sits in every actor or fabricator" (1982, 63). Of course in the *Critique of Judgment,* this enlightened, critical philosophy turns its gaze, not on art specifically, but on the judgment of taste from which beauty and art ultimately arise after Kant's Copernican revolution. Art is a synthetic a priori matter, dependent on subjective judgment. We have read Kant's ironic boast about what he calls the book's "deficiency" in empirical details and applicability. He is concerned with the empty but necessary form of judgment, not content. He does not seek to evaluate or influence individual judgments of taste. It is this position – one that Kant argues for well in terms of the virtues of transcendental critique – that sanctions philosophy's relationship to art and its history, that makes philosophy their necessary authority.[52] Fernow applies this authority to art. Using a technique as thoroughly Kantian as it is new for his time, he begins essays such as "Über das Kunstschöne" and "Über die Landschaftsmalerei" in *Römische Studien* with critiques of first principles. The second sentence of "Über das Kunstschöne" reads: "A complete and satisfactory clarification of the beautiful is therefore only possible from the essence or the idea, not from appearances themselves" (1806, 1:291).[53] Fernow established for art history the authority and indeed the seductiveness of philosophy's Kantian claim to epistemological security through the technique of reason, autocritique. This technique's epistemological hold remained firm in Clement Greenberg's famous Kantian confessions and is still potent today, as we shall see in Chapter 3. Michel Foucault claims that Kantian critique is "the art of not being governed so much" (1990, 384), a mode of subjective activity that has as its concomitant the notion of the man of reason governing only himself. Kantian critique as the name, form, and method of philosophy is therefore ultimately a "political" idea and practice, because it seeks to order all human activity through its judgments.[54] Carstens uses Kant's critical technique to argue that, as an artist of genius and as a "public" citizen, he should not be governed by the bureaucracy of the Berlin Academy. Fernow uses critique to understand the beautiful. But the irony of the Kantian position is that these

moments of "autonomy" depend on limits, the limits set by reason and philosophy. Thus, for Fernow, the emerging discipline of art history had in its yet unwritten charter the "secret article" that it must be advised by philosophy. Art history could only be free if it was the willing, republican "subject" of Kantian philosophy.

If my description of this disciplinary relationship is persuasive, it is easy to protest against what seems like an unequal and even colonially structured affiliation among art history, the visual arts, and philosophy. This complaint would be warranted if voiced from the perspective of gender. For example, the passages on "freedom" from Kant's *Perpetual Peace* cited above are literally and blatantly applicable to men only, as were the privileges of reason and public speech.[55] But more generally, can "word" be seen to dominate "image" improperly here? Before I say why I do not think that Kant's or philosophy's interests in art and art history are imperialistic in this sense, let us look closely at a juncture in the third *Critique* where he in effect chooses between the virtues of philosophy and the arts. His judgment in section 50, titled "On the Combination of Taste with Genius in Products of Fine Art," turns again on his special characterization of freedom. "If we ask which is more important in objects of fine art, whether they show genius or taste," Kant writes, "then this is equivalent to asking whether in fine art imagination is more important than judgment" (1987, 188). He finds both qualities important, but sides with the judgment of taste as a prerequisite for fine art. Judgment in effect supplies the laws of beauty: "the imagination in its freedom [must] be commensurate with the lawfulness of the understanding" (1987, 188). "Taste," he concludes significantly, "like the power of judgment in general, consists of disciplining (or training) genius" (1987, 188).

As we have seen, aesthetics for Kant is about the judge, not what is judged (Geiman 1996, 529; Arendt 1982, 63). But to claim against Kant that this reasoning makes philosophy imperialistic toward art and art history is to adopt a rigidly Kantian tendency to see the disciplines as properly distinct and hierarchical, to suggest, for example – as many have done and continue to do – that philosophy has no place in art or vice versa because the two are fundamentally different. I will work against this purist vision in the chapters that follow and argue with Pierre Bourdieu and others that what he calls "distinction" as a process of differentiation and ranking is a necessary but always historically specific part of aesthetic and disciplinary judgment. In fact, Kant's use of art in his writings and his ideas' various effects on art and art history

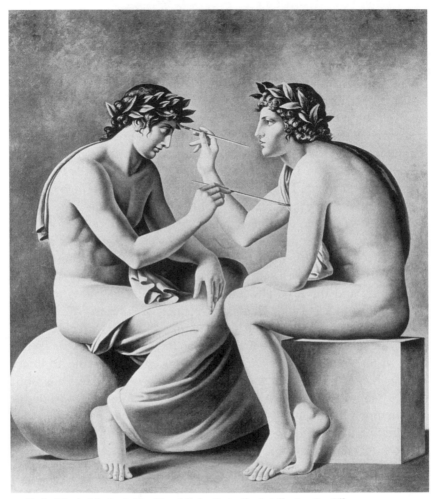

4. Carlo Maria Mariani, *The Hand Submits to the Intellect*, 1983. Oil on canvas, 200 × 175 cm. Private collection, Chicago. Photo courtesy the artist.

can lead us to reconceive the spatiality of disciplinary relationships among art, art history, and philosophy. Instead of imagining a top-to-bottom geometrical grid of lines, boundaries, and borders, or the stable architecture of a well-constructed edifice, we can better envision a multidimensional and radically pliable space that could conceptualize the "places" of art history, those locales where it is practised and provisionally defined. Kant clearly did imagine the relations among fields in the former, very structured way, and this led him to posit clear and rigid

5. Carlo Maria Mariani, The Artist at Carstens' Tomb, Rome, 1980. Photo courtesy the artist.

distinctions between fields. But his vision cannot do justice to the complex dynamism of spatial relationships at work in the definition of disciplines and their interests, whether in his own work or in his reception.

I have argued that Fernow combined Kant's political and aesthetic writings. I have also claimed that this occurred because of the specificity of reception, of Fernow's place in Rome, as opposed to the abstractness of space/time. There is a recent painting that articulates visually and in its analogies some of these issues about the relations among art, art history, and philosophy. *The Hand Submits to the Intellect* (Fig. 4), by the Italian artist Carlo Maria Mariani (1983), raises a question about the priority of the intellect over the hand in its title and its pictorial doubling

63

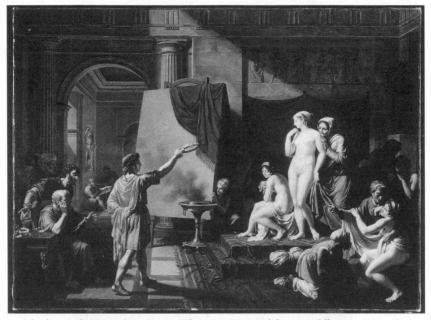

6. Nicolas-André Monsiau, *Zeuxis Choosing His Models,* 1797. Oil on canvas, 96 × 129 cm. Art Gallery of Ontario, Toronto. Gift from the Volunteer Committee Fund, 1988. Photo courtesy the Art Gallery of Ontario.

of the creative process. One artist's hand creates the other's head at the same time that his companion's hand paints his "heart." We can interpret this doubling as a symbolic vision of the competition between the rational (philosophy) and the senses (art). Mariani returns explicitly – and literally, as we see from his visit to Carstens's tomb in Rome (Fig. 5) – to the work of German artists in Rome circa 1800, to their linear, neoclassical style, but equally to their preoccupations with the theory of art. Specifically, the sphere and cube on which respectively the two artists sit are a direct reference to the Platonic solids in Goethe's famous *Altar to Agathe Tyche* in Weimar (1777), where the two geometrical forms allude to the harmonious dynamic of stasis (the cube) and change (the sphere). In Carstens's *Raum und Zeit,* the older man, the allegorical figure of space, also carries a sphere. In a complex way, what Mariani offers in our age of theory is a contemporary version of the origin-of-painting theme that truly obsessed artists in Rome in the second half of the eighteenth century and made explicit notions of how beauty was to be realized in art. Mariani plays with ancient theories about art's origins: he combines the Platonic, humanist vision of painting as an

7. Komar and Melamid, *The Origin of Socialist Realism,* 1982–83. Oil on canvas, 183 × 122 cm. Courtesy Ronald Feldman Fine Arts, New York. Photo credit: D. James Dee.

intellectual and liberal art, pictured in the numerous images of Zeuxis choosing his models, such as Nicolas-André Monsiau's *Zeuxis Choosing His Models* (1797; Fig. 6), with the more materialist and historically recessive image of art's origin in copying and physical making, captured in Joseph Wright of Derby's well-known *Corinthian Maiden* (1784). According to the textual sources, the young woman pictured in Wright's painting sought to memorialize her lover by tracing his shadow's outline as he slept. Her father – a potter – then filled in the outline, made a relief, and fired it. Significantly, the painting was commissioned by Josiah Wedgwood, perhaps the most famous and successful "potter" in the European tradition, who we can assume liked the notion that art originated in the material and craft of porcelain production (Watson

65

1969, 15–16). Mariani's two artists also depict one another, but they do so simultaneously in an impossible and thus ironic process that refuses to adjudicate between the priority of the hand and intellect. Mariani was also likely aware of the political reverberations of this "origin" theme, exposed humorously in Komar and Melamid's *The Origin of Socialist Realism* (1982–83; Fig. 7), where the woman's hand is no doubt guided by the decrees of Stalin. In Mariani's painting, the hand submits to the intellect only insofar as he presents us with a conceptual vision of the issues of art in Rome circa 1800, issues of beauty and origin that he clearly feels remain relevant. Art is pictured as self-creating, free because autonomous, true to the modernist myth established in part by Kant. But just as it is impossible for two figures to create themselves ex nihilo, so it is impossible for art or philosophy – the heart or the head – to exist without one another. Paradoxically, their visions of beauty as autonomous and timeless are intertwined and historically specific.

It remains to be asked to what extent Fernow's novel uses of Kant are typical of the philosopher's reception in the visual arts and art history in the nineteenth and twentieth centuries. One constant is the authority of Kant's name, though as I shall continue to argue, the Kant we see and the influence he has vary radically according to context.

3

The Genealogy of Authority

Kant and Art's History in the Twentieth Century

An immanent meaning can be discovered in the objects of aesthetics. . . .

Erwin Panofsky

Juan Gris "was preparing to read Kant when he died."

Daniel-Henry Kahnwelier

Every civilization and every tradition of culture seem to possess capacities for self-cure and self-correction that go into operation automatically, unbidden.

Clement Greenberg[1]

Kant's name is associated with art history and the visual arts with increasing regularity in the twentieth century by an eclectic range of artists, critics, historians, and theorists. Two of the most influential art writers of any period, Erwin Panofsky and Clement Greenberg, famously invoked Kant's authority to ground and develop their apparently antithetical contextual rather than formal understandings of art. How can Kant's ideas underwrite these seemingly divergent methodological commitments? In addition, to what different uses is his thought put by less prominent figures? It is tempting to dispel apparent contradictions by saying, as many have of Greenberg, that inheritors of Kant do not adequately understand his theories, that some are right and others are wrong. Put bluntly, this view holds that many do not truly follow Kant at all. Sometimes the situation is this simple, but in judging too readily in this way, we take the risk of failing to recognize the plasmatic complexity of reception. Ideas that from a certain point of view misrepresent Kant may nonetheless be influential and may even

help us to rethink his texts as well as the various works – textual and plastic – of those receiving his ideas. As we have seen in discussions of Kantian reason, it is crucial to ask the disciplinary question "Who is judging and from what perspective?" when we claim that Greenberg, say, misapplied Kant's ideas. In examining Kant's authority and its effects, I will thus again look more to the (however improbable) life of these doctrines in their historically contoured specificity than to the philosophical "correctness" of the tenets elaborated in Kant's name. To this end I will reexamine three well-known moments in Kant's twentieth-century reception: Panofsky's art theory, the remarkable use of Kantian concepts and nomenclature around cubism, and Greenberg's notorious formalism. Each of these cases has been studied extensively and by very able commentators, but largely in isolation from one another and from related theoretical questions about Kant's extensive influence. In establishing a new framework in which to compare and link them – among themselves and also with the antecedent and subsequent moments that I examine in other chapters – I will provide not only a (purposefully partial) chronological history of Kant's reception from the late nineteenth century[2] to the third quarter of the twentieth, but also another opportunity to think through the disciplinary hierarchies that would, for example, see as inappropriate a comparison of Panofsky, the august historian and theorist of high art, with Greenberg, the art critic attuned primarily to recent art. In this case, an institutionally based ranking habitually allows Panofsky's recourse to Kant to be seen as appropriate and constructive while Greenberg's is censored as pretentious and wrongheaded, very much as an artist's might be. As we shall see in the middle section of this chapter, Kant's reception in cubism proves to be a paradigm for the putatively contradictory ends to which his authority has been lent as well as for the methodological protocols that shape what will and will not be countenanced in his name.

"Immanent Meaning" and the Historicity of Art: Panofsky and Kant

Kant frames much of Panofsky's prodigious work in art history in the fundamental sense that the *Critiques* and the *Prolegomena* are, in Panofsky's early "theoretical" essays, the explicit theoretical reference points for a rigorous sort of art history based upon philosophical first principles. I will argue that in the later, "American" essays too – usually

held to be less theoretical in part as a response to the empiricism typical of his adopted country's art-historical traditions and, more importantly to my mind, as a response to the notion that such overtly philosophical exercises should be eclipsed in a mature art history – Panofsky relies equally if not more on Kant's ideals of critique, freedom, and the authority of philosophy. It is with respect to his work as a whole, then, that Panofsky is most "appropriately remembered as a philosopher of art rather than simply an art historian" (Holly 1998, 436). The story of Panofsky's Kantianism – much of which he developed from the theories of Ernst Cassirer, himself a pupil of the famous Marburg neo-Kantian Hermann Cohen, and which is more explicit than his predecessor Wölfflin's[3] – is well known; I will only summarize it here in the hope that greater attention to his use of Kant within the contexts developed in this book can add to our understanding of this moment in Kant's reception.[4]

Panofsky's knowledge of Kant was extensive, but what he took from the philosopher may be reduced to a few interlocking emphases. The freedom of the judging subject was central to both Kant's and Panofsky's humanism. The subject was for both men stable, and, as the self-aware center of all ideational activity, in this sense "objective." Thus, in Panofsky's writing, art-historical judgments could be objective *because* they were immanent to the "subject" in a Kantian sense. Concomitantly, Panofsky – again following Kant – did not believe in the accessibility of a "thing in itself." Objects exist independently, but the conventions governing their perception and artistic manipulation come from us. For Panofsky, as for many art theorists of the time, the correct balance between subject and object was a constant goal. In his famous 1924–25 essay "Perspective as Symbolic Form," though less so elsewhere, as Keith Moxey has shown (1995), Panofsky views one-point, "Renaissance" perspective as a cultural convention that mediates in a Kantian sense between subject and object. "Perspective," Panofsky argues,

subjects the artistic phenomenon to stable and even mathematically exact rules, but on the other hand, makes that phenomenon contingent upon human beings, indeed upon the individual: for these rules refer to the psychological and physical conditions of the visual impression, and the way they take effect is determined by the freely chosen position of a subjective "point of view." (1991, 67)

He made his reliance on Kant even more evident in *Idea: A Concept in Art Theory,* first published during the same period as the essay on per-

spective. Referring to paragraph 38 of Kant's *Prolegomena*, Panofsky claimed that "artistic perception is no more faced with a 'thing in itself' than is the process of cognition." He notes that in "epistemology the presumption of this 'thing in itself' was profoundly shaken by Kant" and that "in art theory a similar view was proposed by Alois Riegl" (126). The subject can be secure in its judgments because it makes and perceives its own rules through critique. Freedom in the sense of humanist aesthetic choice is also crucial in Panofsky's account of artists' use of perspective (Podro 1982, 6). Artists' perspective, it seems, was for Panofsky analogous to Kant's a priori intuition of space itself.[5] The "struggle for control" that perspective entails, he argues in "Perspective as Symbolic Form," results in "a consolidation and systematization of the external world, as an extension of the domain of the self" (67–68). "Domain" is of course a crucial term for Kant, for whom even the idea of freedom can only be guaranteed by the boundary work of reason, by the law of the categorical imperative. For Kant, critique can only be effective by legislating the proper domains of art, science, religion, and so on. Panofsky was concerned throughout his long career with mapping the proper relations between art theory and its history in this very Kantian manner. He reveals in the passage cited on perspective above that freedom is necessary for this boundary work to be effective. Initially conceived as a "formal" property or relation, this self-defining freedom was seen by artists circa 1800 as "political," as a foundation for the autonomy of art and artists' groups within society. It is integral to Kant's vision of cosmopolitanism. Can we say the same of Panofsky? In other words, could his use of Kant's "formalism" in part be political, as it was for those writers and thinkers I considered in Chapter 2? My answer will be yes.

A crucial thread of Panofsky's choice of Kant as his philosophical mentor is drawn out by Stephen Melville. Picturing the art historian very much as a Hercules at the crossroads, and thus referring to Panofsky's famous monograph *Hercules am Scheidewege und andere antike Bildstoffe in neueren Kunst* of 1930, which details the iconography of Hercules' choice, Melville claims that in the early years of the twentieth century, "Panofsky could, in effect, have moved either toward the neo-Kantian tendencies that culminate in the work of Ernst Cassirer or toward the more radical revision of Kant set in motion by Heidegger" (1990, 10).[6] These were options available in the hugely influential neo-Kantian movement. Panofsky's allegiance to the more conservative Cassirer, and thus to Kant rather than Heidegger, was more literal than

even Melville claims. In a 1931 lecture before the Kantgesellschaft in Kiel, Germany, Panofsky made his affinity for Cassirer public in explicit opposition to the controversial interpretation of Kant offered in Heidegger's 1929 *Kant and the Problem of Metaphysics* (Summers 1995, 10). As his audience would have known, Cassirer and Heidegger debated publicly the appropriate reception and use of Kant. For Melville, Panofsky's choice of Cassirer's Kant over Heidegger's had the important consequence that "the explicit problematic of historicality recedes" in Panofsky's art theory and art-historical writings (10). Melville asserts that the interest in history is replaced in Panofsky by the ahistorical certainties allowed by Kant's formalism. By choosing Kant, Melville argues, Panofsky simultaneously turned away from both Hegel and Heidegger, for whom history as a problem was fundamental.[7] He argues that this choice had important consequences for Panofsky's art history. The supposed verities of Italian Renaissance perspective, to which Panofsky devotes himself with Kant at his shoulder, both signal and embody this decision (11). But one sweeping assumption subtends this part of Melville's reasoning. The formalism of Kant's ideas, and indeed any reference to Kant at all, is assumed to dictate the adoption of an ahistorical theoretical model. John McGowan has rightly claimed that, in general, "postmodern writers inevitably find themselves continually at odds with Kant. Ironist theory wants to repudiate the bias toward the universal that Kant built into theory and wishes to argue that . . . the effect of designating universal conditions of rationality that define the essentially human is to exclude various differences." This and other Kantian propensities lead to his "resolute ahistoricism" (1991, 42, 43). In Melville (certainly a postmodernist writer), Panofsky's art history is seen to be similarly unconcerned with the inflections of history. "The way to Panofsky's understanding of the objectivity of art history," he writes, "lies through the Renaissance because that Renaissance provides the means to elide questions of the becoming historical of art" (11).

Melville recognizes more than most commentators that the "Kant" inherited by Panofsky (or, we should add, anyone else at other times and in other places) is "quite particular" (10). In this spirit, I want to suggest that there is an additional Kant received by Panofsky, a Kant whose formalism is sometimes "political" and historical, both in its theoretical contours and reception. This Kant can be seen to ground historical procedures in Panofsky, though whether or not this proclivity is dominant in either thinker – whether Melville is ultimately right in his assessment of Panofsky – remains an open question. Kant himself ar-

gues that reason has a history, but as I showed in Chapter 1, he favors the formal, transcendental embodiment of reason for the historical reason that this faculty was under attack in the late eighteenth century because of its general uncertainty and weakness. More specifically in the context of his political thought, he believed that a lasting European peace could only be obtained through the employment of irrefragable, that is, extra-empirical, principles. This is the background to Kant's plea in *Perpetual Peace* and elsewhere for philosophy as reason to act as a secret advisor to governments, rulers, and other disciplines, especially the historical ones (Kant 1991b, 115).[8] For Kant, philosophy as critique is never ideally quiet or secret. It is similarly active and "public" in its Kantian guises throughout Panofsky's early writings, especially "The Concept of Artistic Volition" (1920), "Über das Verhältnis der Kunstgeschichte zur Kunsttheorie" (1924–25), and, as we have noticed, in "Perspective as Symbolic Form" (1924–25) and *Idea* (1924). When in the 1920 essay Panofsky calls for "serious scholarship" as the hallmark of a new and rigorous art history (1981, 19), he argues that this foundation can only be built on (Kant's) philosophical method: "In considering art we are faced with the demand (which in the field of Philosophy is satisfied by epistemology) for a principle of explanation by which the artistic phenomena can be recognized not only by further references to other phenomena within its historical sphere but also by a consciousness which penetrates the sphere of its empirical existence" (19). He soon explains that art history needs a priori principles of a Kantian sort. Examples from the *Prolegomena* help him to conclude that such "formal" considerations undergird those of "a historical or psychological nature" (27), which are typical of the current art-historical practices that he criticizes in the essay.

Many commentators have remarked that these explicitly Kantian reference points seem to have disappeared from Panofsky's writing after he arrived in the United States in the 1930s. He appears to have dropped the theory and become more empirical, an adaptation that in the United States of the time also signified that one was becoming more art-historical.[9] Holly calls the change his "practical turn" (1998, 437). As Moxey puts it, "the move from Hamburg to Princeton seems to have coincided with a profound change in his attitude towards history and method." Certainly there is a contrast between "the restless theoretical search" that characterizes the early essays noted above and the "attainment of certainty" that we find later (Moxey 1995, 777). But I would claim that the profundity of this apparent change is of a different sort.

Panofsky the American – whether he did so consciously or not – can be seen to have taken on Kant in a deeper sense, to have adopted him as his "secret" advisor, rather than rejecting "theoretical" art history. Panofsky was indeed no longer restless, and he became so certain of his principles that he no longer needed to demonstrate them. In a brilliant reading of Panofsky's possible identification, as a German emigré, with the Albrecht Dürer of *Melancholia I,* Moxey establishes the relevance of social and historical motivations to Panofsky's art-historical practice (Moxey 1994). Is it not possible also to see Panofsky's later development of a "humanist" art history as his personally and historically inflected deployment of a specifically Kantian version of the powers of reason enacted in the realm of world events, a version easily derived from Kant's political writings of the 1780s and 1790s? Such a humanist use of philosophy requires both that the theory be present as a foundation and that it remain hidden.[10]

Kant became so much part of Panofsky's thinking that he appears anecdotally in the opening paragraph of "The History of Art as a Humanistic Discipline" (1940). This crucial beginning point for Panofsky's "American" art theory deserves to be cited in full:

Nine days before his death Immanuel Kant was visited by his physician. Old, ill and nearly blind, he rose from his chair and stood trembling with weakness and muttering unintelligible words. Finally his faithful companion realized that he would not sit down again until the visitor had taken a seat. This he did, and Kant then permitted himself to be helped to his chair and, after having regained some of his strength, said, . . . "The sense of humanity has not yet left me." The two were moved almost to tears. For, though the word *Humanität* had come, in the eighteenth century, to mean little more than politeness or civility, it had, for Kant, a much deeper significance, which the circumstances of the moment served to emphasize: man's proud and tragic consciousness of self-approved and self-imposed principles, contrasting with his utter subjection to illness, decay and all that is implied in the word "mortality." (1955, 1)

Very much like the portraits of Kant that I will examine in Chapter 5, the anecdote as a compressed genre "engenders an impression of the real" (Soussloff 1997, 147), in this case, the real Kant as humanist. In other words, Kant as the personification of humanism is made to frame – in the most economical way – Panofsky's last manifesto of art-historical method.[11] The placement of the anecdote is crucial. With this carefully delineated "picture" of Kant before us, to which Panofsky then adds the image of Erasmus for good measure, we are able to see that humanist values – reason, freedom, and tolerance above all others – can be effec-

tively deployed against the "authoritarians" (1955, 3) from whom Panofsky and many others were forced to flee at this time. Reason for Kant and Panofsky is "formal" in the sense that it requires a constant and before-the-fact relationship of questioning and critique vis-à-vis the other faculties, and specifically of our entire empirical, mutable existence, whether aesthetic or political. One must always maintain a faith in reason's *potentially* universal validity. At the same time, for the Kant of *Perpetual Peace*, for the German-speaking artists' colony in Rome circa 1800, and for Panofsky, reason works in history because it alone guarantees freedom and dignified human interaction, the forms of communication on which the traditions of art depend. Its demands and requirements have practical consequences. This principle as well as that of universality are basic to Kant's vision of cosmopolitanism. It subtends Panofsky's version of a seemingly contradictory Kantian "historicism," one that holds that human beings are "fundamentally" historians *and* that "from the humanistic point of view, human records do not age" (Panofsky 1955, 5, 6). Panofsky proclaims a cosmopolitan[12] art history in the face of the then current destruction of European culture. He refuses to lose his humanity, in the full Kantian sense, and through this personal gesture also seeks to maintain these values for the transplanted discipline of art history. Consonant with his earlier Kantian theorizing, the discipline must be objective but also based on an individual subjectivity that disavows any compromising collectivity, the "hive, whether the hive be called group, class, nation or race" (1955, 3).

Just as Kant insisted on the need for reason in human affairs in the context of the French Revolution and its aftermath, so too Panofsky in both his earlier and later work used the apparently formal and ahistorical Kantian imperative to ground art history in the a priori. His ends were strategic and ultimately historical. We have seen that in his 1920 and 1924–25 essays he sought a more rigorous, less empirical or psychological art history in the security of Kantian a priori procedures. Riegl's notion of "Kunstwollen," artistic volition, for example, if it is to be "distinguished from both the artist's volition and the volition of his time," according to Panofsky, must "be grasped by an interpretation of phenomena which proceeds from a priori categories" (1981, 31). Two decades later, in "The History of Art as a Humanistic Discipline," he remained convinced of the need to "build up art history as a respectable scholarly discipline" by the same means (1955, 15). True to Kant's transcendental procedures, the a priori for Panofsky guarantees what he calls "immanent meaning . . . in the objects of aesthetics" (1981, 28).

Only with the initial "Hilfe der kunsttheoretische gebildeten Grund" (1974 [1924–25], 65), the epistemology of art history inspired in Panofsky's thought by Kant's first *Critique* and *Prolegomena,* can historical work proceed with a sense of objectivity. As in Kant's examination of metaphysics, then, critique is applied here in a quasi-negative sense, so that art history may know its objects and field and thus avoid "errors and delusions" (1981, 31). Implying Kant's distinction between the "analytic" discussion of principles and a priori grounds and the "deduction" where these are put into play, Panofsky writes, of "The Concept of Artistic Volition" of 1920: "The present essay aims not to undertake the deduction and systematization of such transcendental aesthetic categories but merely to secure the concept of artistic volition in a purely critical manner against mistaken interpretations and to clear up methodological presuppositions . . ." (1981, 28). In Panofsky's hands, Kant disciplines art history. Is the renewed discipline thus formal and ahistorical, as Melville claims?

It is not difficult to find passages that would lead to this interpretation. "The work of art whose immanent meaning is to be perceived must also be understood, first of all, in the concrete and formal sense of its phenomenal appearance which contains this meaning," Panofsky claims (1981, 31). But this meaning, which is traditionally Kantian in its insistence on the fundamental categories of time and space as the possibility for perception and of art's existence as such, does not preclude history.[13] Indeed, Panofsky's essay opens with the question of the historicality of art history: "It is the curse and blessing of the academic study of art that its objects necessarily demand consideration from other than a purely historical point of view." We need another perspective, Panofsky claims, that of the a priori, but that does not mean that "historical study [must] draw on a higher source of perception" outside history (1981, 18). On the contrary, we only have the historical perception of art because of and through these immanent categories.[14] The categories are universal, but the works of art and interpretations of them remain historical. Panofsky asserts that even the most empirically based art history, a "Dingwissenschaft" (science or rigorous study of things), needs theoretical discipline. At the end of the 1920 paper he calls for cooperation between art theory and art history, a plea he reiterates in 1940 and which his extraordinary career embodies.

The art historian . . . cannot describe the objects of his re-creative experience without re-constructing artistic intentions in terms which imply generic the-

oretical concepts. In doing this, he will, consciously or unconsciously, contribute to the development of art theory, which, without historical exemplification, would remain a meager scheme of abstract universals. The art theorist, on the other hand, whether he approaches the subject from the standpoint of Kant's *Critique,* of neo-scholastic epistemology, or of *Gestaltspsychologie,* cannot build up a system of generic concepts without reference to works of art which have come into being under specific historical conditions; but in doing this he will, consciously or unconsciously, contribute to the development of art theory, which, without theoretical orientation, would remain a congeries of unformulated particulars. (1955, 21–22)

The humanist art historian is one who can balance theoretical sophistication with historical investigation, as Panofsky himself did in an unparalleled manner. Like feeling and form, space and time, the two are for Panofsky ideally in constant "conversation." They should not be divided artificially as theory and practice.

If for Panofsky the art historian is a humanist who "rejects authority" but "respects tradition" (1955, 3), how are we to understand the commanding authority Kant's ideas clearly had in his work? I think the key is again found throughout Kant's political and historical writings, that of cosmopolitanism and its associated values of freedom and reason. Kant defined the cosmopolitan as that most general level of concern for others, "the welfare of the human race as a whole" (1991c; italics removed). The *humanitas* demonstrated by Kant in the anecdote with which Panofsky inaugurated his 1940 essay, and which Kant theorized extensively, is properly "an attitude which can be defined as the conviction of the dignity of man, based on both the insistence on human values (rationality and freedom) and the acceptance of human limitations (fallibility and frailty); from these two postulates result – responsibility and tolerance" (1955, 2). As Summers has aptly pointed out, Panofsky's ideal of iconology is based on human communication (1995). The "public" use of reason as philosophy in Kant – critique – has the responsibility to question as potential dogma all authority in human affairs, whether in religion, state politics, or the judgment of taste. The examination and potential rejection of authority is for Kant and Panofsky alike the basis of enlightenment, the betterment of the human race.

As a "secret" advisor, Kantian political philosophy revealed to the Carstens and Fernow circle in Rome the possibility of an autonomous art and an artists' "republic." The immanent structures and ultimate autonomy of art history came to Panofsky initially through a very public reading of Kant in the early essays I have cited, and he artfully recalled these inspirations and lessons in "The History of Art as a Humanistic

Discipline." But during his American period, Kantian discipline became so thoroughly internalized that he no longer needed to invoke it directly. One possible example can be seen in the revisions Panofsky undertook for a famous essay theorizing iconography. In the introduction to *Studies in Iconology* (1939), he distinguishes two distinct levels of iconographic analysis. Reconstituted in 1955 as "Iconography and Iconology: An Introduction to the Study of Renaissance Art," the term "iconology" is clearly subtended by Kant's terminology: "Iconology . . . is a method of interpretation which arises from synthesis rather than analysis." No longer are the two terms to be separated, but they must work together as "integral part[s] of the study of art" (1955, 32). Subtle though this shift is, it suggests an internalization of the art theory that was so prominently displayed in Panofsky's earlier essays.[15]

So secret were Panofsky's theoretical principles by this time that for later generations of art historians committed to the theoretical investigations of "the new art history," Panofsky came "to be regarded as the burdensome father figure from a bygone period of humanistic scholarship" (Sauerländer 1995, 385). There is in this reception of Panofsky a lesson about becoming too comfortable with theory, as we might say Panofsky did. In Kant, critique never rested: it was a perpetual propaedeutic, and even a way of life. As he wrote in 1793, "philosophy must act (therapeutically) as a *remedy* (*material medica*) for whose use . . . dispensaries and doctors . . . are required" (1793, 84). Yet Panofsky's later relegation of Kant and philosophy to an unspoken if foundational role within or alongside art history is in a sense un-Kantian, despite its lineage. But if this silence on matters theoretical allowed later art historians to see Panofsky's theoretical heritage as eclipsed by the practical, it was no barrier to his own constant invocation of principled Kantian critique on the most minute plane. In arguing for the need to understand artistic volition in much more than the sense of individual artistic intention, for example, Panofsky in passing notes his opposition on these grounds to the "opinion that it is the impression of contemporaries and not our own which is definitive in the evaluation of works of art," a view proclaimed in 1919 by one Daniel Henry, otherwise Daniel-Henry Kahnweiler, the contemporary friend, interpreter, and Kantian critic of the cubists.

Kant and Cubism Revisited

Given that Kant's texts and ideas might seem an unlikely inspiration for artists and critics of a new art movement – as we have seen, the *Critique of Judgment* purposefully provides little direct commentary on the arts – how should we understand their remarkable influence within the visual arts generally and around cubism especially? Kant's name was dropped with notable regularity in France during the formative years of cubism.[16] Many of the most prominent critics and art dealers of the time employed his terminology and concepts, putatively to explain what was widely perceived as a new and radical art form, and certainly also to garner the authority any reference to the philosopher seemed to bestow on their views of cubism. Less often, Kant's name was invoked by artists to the same ends. But these references to Kant were not univocal and in fact divided contemporary commentators. Daniel-Henry Kahnweiler – the most important dealer and historian of cubism in the early part of the last century, a man who represented in the broadest and most influential ways the work of Braque, Gris, and Picasso until the beginning of World War I – encapsulated the power of the Kantian interpretive frame to which he was a convert when he claimed that cubism's

> new language has given painting an unprecedented freedom . . . coloured planes, through their direction and relative position, can bring together the formal scheme without uniting in closed forms. . . . Instead of an analytical description, the painter can . . . also create in this way a synthesis of the object, or in the words of Kant, "put together the various conceptions and comprehend their variety in our perception." (1949, 12)[17]

Kahnweiler read Kant and neo-Kantian texts by Wilhelm Wundt, Heinrich Rickert, and others in Bern from 1914 to 1920 during his exile from France because of his German patrimony (Gehlen 1966). For him, the analytic/synthetic distinction, the notions of the thing-in-itself and disinterestedness, and the formal autonomy of the work of art provided nothing less than a way of conceptualizing and justifying cubism. Kant's ideas and terminology were also crucial for several of the central French critics who helped to define cubism in its early years. Léonce Rosenberg, Pierre Reverdy, and especially Maurice Raynal used Kant to present and lend weight to their vision of cubism as a breakthrough to essential reality and to a form of artistic creation exemplifying personal as well as aesthetic freedom. These and other commentators used Kant recurrently to articulate what has come to be known as a "conceptual-

ist" or "idealist" reading of cubism, one that underlines its departure from the appearance of things and movement toward the comprehension of a supposedly more profound reality (Crowther 1987; Nash 1980). In 1912, the critic Olivier-Hourcade expressed a variant of this view – and the complexity of its provenance[18] – by citing approvingly a well-known reference to Kant made by Schopenhauer: "The greatest service Kant ever rendered is the distinction between the phenomena and the thing in itself, between that which appears and that which is . . ." (Fry 1966, 74). Taken to its extreme, on this interpretation, the cubists present what they conceive, not what they see.[19]

At the end of the twentieth century, the invocation of Kant in the cubist context was traced in greatest detail by Christopher Gray, Lynn Gamwell, and Edward F. Fry, all of whom largely accepted – with important qualifications – the explanatory power of Kant's ideas in the context of cubist painting. In a recent reevaluation of cubism and his own seminal collection of writings on this movement, Fry even proclaims a new Kantianism:

The problem with the Kantian approach until now is that it has not been sufficiently historical or critical, and also that the emphasis on aesthetic autonomy has overshadowed the implications of Kant's synthetic *a priori* for the critical evaluation of past historical traditions. It would seem today to be desirable and even necessary that Kantian aesthetic autonomy be provided with a more powerful critical and historical focus, in what might be called a move towards a detranscendentalized, neo-Hegelian transformation of Kantian aesthetics. (1988, 296)

Historians and critics are still polarized around Kant's relation to cubism. There are those who continue to revive Kantian terminology and ideas to explain and legitimize the aesthetic experiments of the cubists. Again, the reference to "analytic" and "synthetic" compositional procedures – referring, as Gamwell notes, to a Kantian "dual process" in the conception of the object studied by the artist (95) – and, by extension, to a chronological development from Analytic to Synthetic as stylistic and chronological designations, are the most prevalent examples. On the other hand, many continue to question Kant's role in cubism. The "idealist" interpretation did not satisfy all contemporary historians of or apologists for the movement, nor does it tell a complete story from our later vantage point.[20] Invoking Kant was and remains a way to emphasize the "purity" of cubism, its self-sufficiency or autonomy, which is not a universally popular option, especially among the many

recent critics who would attend in detail to the social and even political influences on the cubist painters.[21] There is also the very important question of whether Kant's ideas can indeed describe accurately what the cubists aspired to and did. Nash and others argue forcefully that Kantian concepts do not work effectively to this end.[22] They counsel us to drop Kant's name entirely from considerations of cubism.

Most outspoken in this vein is the philosopher Paul Crowther, who in a landmark 1987 article published in *Word & Image,* set out "to challenge . . . the whole Kantian interpretive tradition" around cubism (195). In arguing that "the link between Kant and Cubism is wholly untenable" (199), Crowther is at once carefully analytical and revealingly polemical. With the goal of revising yet again our understanding of the Kant–cubism relation, I will first undertake a belated response to Crowther's article that attempts to recalibrate the angle from which we judge the debates around Kant's relationship to cubism and its criticism.[23] This response is crucial to *Kant, Art, and Art History* because, I will argue, important *disciplinary* interests and hierarchies motivate and color Crowther's analyses as well as much of the received opinion about Kant's role in cubism. As I hope to demonstrate, Crowther writes from the privileged position of a confirmed Kantian philosopher/judge as he adjudicates the merits of what he calls "the continued use of Kantian jargon in relation to Cubism" (195). In this he is representative of many who write about artists' uses of philosophical texts and ideas. I want to work against what I see as his arrogation of disciplinary privilege, his performance of philosophy's habitually juridical role vis-à-vis the visual arts. Because I will attempt instead to articulate new questions, I will not be concerned with the issue of whether or not Kahnweiler, say, got Kant "right" in a technical sense, or even with the problem of whether or not the "idealist" interpretation of cubism adequately accounts for what we might want to emphasize in this art. Taking a wider view, I will consider why so many actors around cubism chose Kantian terms and concepts as their talisman and why Crowther should seek to preserve a "pure" Kant in the face of perceived "misappropriations." What I will draw is a preliminary outline of a complex territorial dispute epitomized by Crowther's position on Kant's relations with cubism, a multidimensional map of disciplinary hierarchies and conflicts. It is my hope that a delineation of these coordinates will help us to adjudicate anew not only cubism's specific interests in Kant but also his complex relationships with the arts in general.

Crowther begins "Cubism, Kant, and Ideology" by announcing that

his focus is one of method, a concern that makes his arguments crucial to my own ends. "One of the most difficult problems in the methodology of art history," he claims, "is the question of deciding whether or not an established tradition of interpretation . . . actually obscures a *proper* understanding of the works it is purporting to explain or describe" (195; my emphasis). We gather from his tone that the Kantian slant on cubism is one of these obscuring traditions. How do we regain a correct understanding and clean up this area? Crowther sets out in admirable detail three central interpretive matrices for cubism in which Kant is used and that require philosophical attention: the "conception thesis" mentioned above; the "simultaneity thesis," wherein cubism purportedly brings together multiple views of its subjects into one synthesis; and the "autonomy thesis," which holds that cubism is about its own processes of analysis and thus both free of external reality and exemplary of the artist's self-sufficiency. He argues that all three frameworks have been linked to Kant in ways that are ultimately "untenable." For example, we learn that Olivier-Hourcade's use of Schopenhauer to underscore a cubist interest in Kant's thing-in-itself, cited above, rests on a mistaken conflation of the "essence" of appearances with the unknowable *Ding an sich.* Schopenhauer's remark, Crowther claims,

is true of Kant, but hides an ambiguity. The essence of a perceived object is a function of the understanding's role in unifying appearances. This "essence," however, is not in Kant's terms identical with the thing-in-itself as Olivier-Hourcade, Nash and Gamwell imply. The thing-in-itself is the unknown source of perceived objects, whereas the concept of essence is a form imposed by understanding which serves to constitute perceived objects. (1987, 196)

Not only does Crowther establish that Olivier-Hourcade missed this important detail in Kant's argument, but by following the French critic, Gamwell and Nash make the same error. All three commentators thus misapply Kant's thinking to cubist practice.

I do not doubt that Crowther is correct in this and other precisions he adds throughout his article to critics' and historians' decidedly undisciplined use of Kant. As historians we must attend to the "mistakes" of our predecessors. What I do want to take issue with, however, are the conclusions he draws, what we might in his own words deem the "ideology" of *his* new use of Kant in the context of cubism. Crowther proceeds from his distinction between essences and the thing-in-itself cited above with the extraordinary words "this misunderstanding out of the way!" (196). Keeping the territory clean, *propre* in French, he sweeps much of

value under the carpet with stunning alacrity. In his urge to purify cubism of Kant's influence – and indeed, as we shall see, of philosophical speculation generally – he dismisses the *historical* use or abuse of Kant too easily. His move is paradoxical in the extreme, because he has just complained that Gamwell and Nash *follow* Olivier-Hourcade's mistaken interpretation and thus must be seen to construct a longer historical as well as conceptual record in the Kant–cubism debate, a record that he is aware of and that arguably motivates his work in this essay, but that he seeks to sidestep. Even though he devotes the well-considered conclusion of his paper to the seemingly historical question of "why it is that art-historians and critics have persisted in the use of such an unhelpful interpretive scheme" (200), Crowther finally wants to put an end to this pattern by controlling Kant's reception. From the ahistorical perspective of logic, he adjudicates the "aptness" even of analogies to Kantian terms and also overvalues the supposed phenomenological "truth of the [cubist] canvas itself" (198) which, for him, appears to exist as raw fact without any interpretation or frame. He reiterates this position in a more recent account of the same topic: "having so emphatically denied Cubism as a self-consciously philosophical movement," he writes in *The Language of Twentieth-Century Art: A Conceptual History* (1997, 45), it remains the case that "Cubism's true intellectual affinities lie not with Kantianism, or . . . with the pure phenomenology of Husserl, but rather with the existential phenomenology of Heidegger, Sartre and more particularly Merleau-Ponty" (1997, 44 – 45).[24] Affinities there may be, but again history has been dismissed.

As his reference here to self-consciousness implies, Crowther typically invokes artists' intentions as a final arbitrator of meaning. He uses Kahnweiler's testimony that Picasso "never, never spoke of Kant" as the epigraph to his paper. But this report is easily squared with Picasso's general silence about cubism during the years of its inception and his habitually anti-intellectual rhetoric in those statements he did make.[25] Crowther might have noted that we also learn from Kahnweiler the curious fact that Juan Gris "was preparing to read Kant when he died" (1947, 27), which suggests that the central cubists were at the very least divided about the philosopher's importance to their work. We must thank Crowther for demonstrating that "the 'simultaneity thesis' cannot be justified by Kant's notion of synthesis" (198) and that the "autonomy thesis" fails because cubism cannot be disinterested if it seeks to reveal the "primary qualities" of its subject matter (199), but the significance of the *historical* repetition of these and other theses about cubism does not

therefore vanish or even diminish in importance. On the contrary, they are foregrounded as issues because Crowther, too, carries the Kantian baggage into the present even as he tries to unburden cubism and himself of this heritage. He is inevitably complicit with that which he seeks to purify, a state that he would find improper but that I would suggest is potentially productive of theoretical insights if acknowledged and used effectively. Crowther's arguments at most allow us to say that Kant and cubism *should* not be brought together if our goal is to employ Kant's theories carefully or if we hope to describe cubist compositional processes and chronological developments accurately. But versions of Kant *were* and are still used repeatedly and have determined some of what we say about, and likely how we see, cubist works.

Crowther refers to the ongoing references to Kant as "jargon," implying that they are not appropriate invocations but, in his revealing words, "critical mystification[s] [that] . . . quickly *infected* the work of other practicing artists" and critics (201; my emphasis). Although he does not put it so baldly, he seems to conclude that in the face of a lack of philosophical, and specifically phenomenological, reasons for the use of Kant in relation to cubism, the ongoing interaction of "Kant" and "cubism" can only be explained in an inferior, sociological manner, by recourse to what he calls the "ideology" of modernism and also the cachet that high-powered German metaphysics lends to cubism. Though they remain partial, I agree with such explanations for Kant's popularity in this context, but not with their relegation to a secondary status. I would argue that there are *only* "ideological," historically inflected and thus "infected" explanations for Kant's reception as well as for Crowther's rejection of this traditional linkage. Crowther works, however unconsciously, with an ideology that places philosophy in the position of judge over the other disciplines, a position justified in detail by Kant in the 1798 *Conflict of the Faculties*. Here Kant sought to legislate a "proper" disciplinary hierarchy universally, but we may recall that his ranking arose within and was colored by specific historical circumstances involving the censorship of his theological writings and the rapidly evolving university system in the German states.

In the first *Critique* as well as the *Conflict of the Faculties*, Kant speaks of reason in terms of the freedom of the liberal, judging subject,[26] and of jurisdictions surveyed and governed. Kant first discusses reason's dominance and priority within philosophy itself, then moves to the relationship of philosophy to other disciplines and faculties, and finally to the interaction of the state, ruler, and philosopher. Adequate gover-

nance on any of these strictly parallel and analogous planes, Kant argues, demands a "lower" and truly independent judge, "one that, having no commands to give, is free to evaluate everything" (1992b, 27). Reason and philosophy are "lower" in the hierarchy of the university faculties – the stated context of Kant's analysis – because they are not directly useful, practical powers compared with the concerns of those he memorably deems the "businessmen or technicians of learning," the lawyers, doctors, and theologians who populate the higher faculties in his scheme (1992b, 25). But precisely because philosophy lies outside these domains and is answerable to no authority but itself, it may, for Kant, "lay claim to any thinking, in order to test its truth" (1992b, 45). In ways that preview his 1798 division and ranking of the "lower" faculty of philosophy into its pure and historical subsections, Kant, near the end of the first *Critique,* compares philosophy studied historically with the method of doing philosophy according to the dynamic principles of reason. Proceeding historically, the pupil may have "learnt well," Kant says, but he remains "merely a plaster-cast of a living man" (A837/B805). He speaks of the painter in a similar vein in the *Lectures on Logic:* if "one is not skilled in thinking for oneself, then one takes refuge in others and copies from them completely faithfully, as the painter copies the original . . ." (1992a, 128). History and art are opposed to philosophy in principle and in the university, even though they exist in close proximity in Kant's texts as well as in the new, eighteenth- and early-nineteenth-century German university system.[27] Crowther's analyses demonstrate that this Kantian division remains fundamental to the relationship between philosophy and art history today.

For Kant and for Crowther after him, then, the philosopher has a responsibility to clean up the muddle we are in if we think that Kantian ideas can explain (cubist) art. Ultimately, for Crowther and many others, philosophy does not belong in art but stands critically apart. Cubism's "real significance" for him is "as a profoundly materialist art" (201). Going too far with philosophy, Crowther complains at the end of his article, can "lead us into the inanities of 'conceptual' art without objects, and 'minimal' objects, without, as it were, art" (201). Highly informed as he is about both the philosophical and art-historical sides of the Kant/cubism issue, Crowther wants to separate the two disciplines. He is a disciplinary purist, as his pejorative reference to infection suggests. This is why he especially values Kahnweiler's testimony that Picasso "never, never spoke of Kant," and why he stresses both the materialist and expressive qualities of cubism over any of its

possible conceptualist strains. Here we see in action an un-acknowledged, and both historically and theoretically Kantian "auton-omy thesis," the separation of the disciplines that guarantees the suita-ble jurisdiction of each. With some important differences to which I shall soon turn, his is a principle of purity that behaves very much like Clement Greenberg's putatively Kantian judgments about the essential qualities of each art and their avoidance of "kitsch," a view that Crowther elsewhere attempted to debunk for its false Kantianism (1985). Art, Crowther implies with his valuation of cubism and extraor-dinarily sweeping denigration of both minimalism and conceptualism, is properly materialist, not conceptualist. We are to believe that philoso-phy's analyses – Kant's if not Crowther's – really do not explain much in this realm but *can* tell us who may legitimately have authority in which context. Raynal, Kahnweiler, and the rest did not get far using Kant according to this view. Yet we are to believe that Picasso understood cubism *because* he did not theorize about it. Even in his few and reluc-tant statements, his anti-intellectual rhetoric is seen as fitting for a mate-rialist project. On this account, even Kahnweiler's highly informed reading of Kant and unmatched knowledge of cubism and the cubist artists is rejected. Crowther employs an unacknowledged and hackneyed hierarchy that, a priori, accords artists' comments about their work more credence than the commentaries of critics or histo-rians.[28] What is arguably no less but also no more than a *moral* obliga-tion to acknowledge an artist's unique perspective on his or her work is given preeminent epistemological value. And again there is a concern with autonomy and jurisdiction. Artists are obviously inside the field of art; critics are peripheral to it. Philosophy is outside but gains its author-ity from that very remove, from its supposed autonomy and disinterestedness.

I am suggesting that the very autonomy of philosophy that Crowther invokes in "disciplining" the separation of Kant and cubism is one that stems historically from Kant and specifically from his struggles with the juridical proprieties that attend the construction of interactions among art, artists, critics, and philosophers. The vagaries of reception suggest that there can be no purity in history, or indeed philosophy, only the desire for it. That desire often carries the name "Kant." In manifesting that desire, Crowther's analyses, for all their local revelations about Kant's ideas, cannot help but perpetuate an unequal relationship be-tween philosophy – here personified by Kant – and the visual arts, a relation that Kant himself established formally in 1798 and that he had

previously enacted in the third *Critique* (1790). We have seen how his transcendental critique established philosophy as the "lower" judge of all other disciplines and faculties, the only free court in which to assess merit and position. It was precisely this aloof philosophical expertise that made Kant's name so powerful an authority for those in and around cubism, an authority that has led, paradoxically, to the inevitable crossing of boundaries at issue in Crowther's analyses and in the historical reception of Kant's ideas in this and other art contexts. As a Kantian judge, Crowther is free to assess the invocation of Kant by critics of cubism. He even has a disciplinary responsibility to do so. But his judgment – one seconded in this case by Bois and Nash and representative of the majority opinion about the relationship among art, artists, and philosophy – is that artists and critics did not and cannot speak adequately of Kant.[29] There must be no reciprocity in the visas granted to academic units in Kant's and Crowther's scheme. Picasso is praised for staying within the limits of his competence, but philosophy's appropriate realm is unbounded, universal.

Unlike Derrida and Danto, who in very different ways worry about the "disenfranchisement" of art by philosophy,[30] I do not wish to restrict but rather to democratize philosophy's rights of inspection. If I am correct in suggesting that Kant's disciplinary hierarchy gave his name an authority that led to its use beyond the boundaries of propriety defined by his theories, then in studying the *history* of his reception we must acknowledge a vividly eclectic pattern of influence. Artists, critics, and historians do not often attend to Kant "philosophically." They typically employ his ideas in a way that the symbolist critic Albert Aurier memorably described – in a different though cognate circumstance – as "savage."[31] His approving reference was to Paul Gauguin's use of Neoplatonic ideas in the French artist's theoretical exploration and justification of his painting and sculpture circa 1890, a use that Aurier praised as free, creative, and legitimate. As a critic and poet, Aurier demanded the same right of access to this philosophical tradition. Gauguin's and Aurier's reference to Plato and Plotinus especially was "primitive" in what they saw as the beneficial sense that they broke the rules of professional, academic philosophy. But, again paradoxically, an eminent philosopher such as Crowther and an equally esteemed art historian such as Bois seek to return us to the materialism of cubism by banishing what they imply is amateur philosophy from that movement and its defining discourses. They restrict the philosophical affinities of artists and critics in the name of art's freedom from philosophy. They revive Kant's hier-

archy of the disciplines and invoke his principles to keep philosophy out of art and art criticism.

What would it mean to allow "savage" Kantianism a voice in the advent and historical interpretation of cubism? First, it would recognize as crucial in any hermeneutical project the centrality of historically documented commentary. Nash summarizes the plethora of idealist commentary concerning cubism and notes its frequently Kantian authority, but, like Crowther, he would prefer to cleanse the territory of any "wooly version of Neo-Kantian idealism" (439). As I noted at the outset, in different ways, Fry, Gamwell, Gray, and Green all give considerable credence to a pro-Kantian line of interpretation. These contributions allow us to adjudicate between different understandings of what cubism sought to do and accomplished. I would claim in addition that close attention to Kant's reception in the context of cubism exposes for our critical reckoning a paradigm of the conventionally approved relations among art, artists, critics, art historians, and philosophers that strongly influences what we attend to in cubism and indeed any other art. Developing (or blindly adopting) a theory of the sort of disciplinary autonomy that would have philosophy judge art yet remain disinterested has consequences. As we have seen, this position leads Crowther to ignore much of Kahnweiler's expert opinion on cubism. Kant established – and then in this and other contexts became exemplary of – philosophy's primacy in the disciplinary hierarchy. To exclude his name from the cubist context is both to override history and to ignore the important sense in which his own strict system of "conflict" among the faculties depends on art as a material and empirical other opposed to transcendental philosophy. Kant also relies on the existence within the philosophy faculty of historical inquiry as the counterpoint that legitimizes reason's correct, a priori application. Stated more simply, Kant, in his own inadvertent way, legitimated and even necessitated the interaction of art and his discipline of reason. Philosophy practised on this paradigm is no more (or less) free than its historical others.

Clement Greenberg's Strategic Formalism

David Carrier has observed that Clement Greenberg (1909–94) managed to be "the critic with whom everyone could disagree" (1987, 51). If Greenberg's often polemical views could polarize his readers so consistently, as they have done since the 1960s, so too will a new commentary on his ideas that breaks with most currently held opinion. Even to pose

the limited question of why and with what results he famously made reference to Kant's aesthetics is to enter contested territory. Did Greenberg really know his Kant or was he merely dropping the name? Even if he did (sometimes) "get Kant right" in a technical sense, should an avowedly intuitive and stereotypically pragmatic American art critic need recourse to such a difficult if authoritative philosophical figure? Greenberg often enough made claims of the ilk that there was "no greater thinker on art" than Kant.[32] But given that so many readers of Greenberg have commented on the latent Hegelianism of his evolutionary model of art's development in modernism,[33] was Kant truly important to his thinking? Greenberg made reference to quite a range of philosophers throughout his long and eclectic writing career – a partial list would include Aristotle, Hegel, Marx, Nietzsche, Pierce, Dewey, and Croce – and he used them freely. As John O'Brian has noted, Greenberg first cited Kant in print in 1943 and more often subsequently (Greenberg 1993, xxii). While Greenberg was anything but a systematic reader of Kant, he shows a greater familiarity with the philosopher's ideas than is usually acknowledged. More important, Kant was indeed fundamental to Greenberg's theory of modernism and the avant-garde, though not always in the manner claimed by the critic. Thierry de Duve has asserted that Greenberg both "never disavowed his Kantianism . . . [and] never understood Kant either," at least not the transcendental aspects of his aesthetics (1996b, 322). Yet Greenberg did have what we might call an "intuitive" sympathy for Kant, not least because he felt that no one else theorized so effectively the involuntary and absolute nature of aesthetic judgment. What Greenberg took to be Kant's position harmonized – as if purposively, perhaps – with his cherished critical apperceptions.[34] More broadly, Greenberg was in tacit agreement with the ultimately humanist purpose of Kant's interest in the purity of disinterestedness and aesthetic autonomy. As was the case with Panofsky, the recognition and elaboration of this "secret" affinity should make us see both Kant and Greenberg quite differently.

Greenberg saw himself as a practicing art critic, not as a scholarly art historian. The resulting informality, immediacy, and passion of his writing has often been praised; it secures its dynamism in part by refusing to be interrupted by notes or even quotations. Thus he prefers to paraphrase Kant, giving the reader the sense – judging from the paucity of critical engagement with these references – that the allusion is quite casual. What, for example, could he possibly be doing citing Kant in a 1943 review of van Gogh?

A roomful of van Goghs has an impact. Yet all but some seven or eight of the paintings here lead to the question whether the impact has as much to do with art as with that emotion or quality or strikingness which Kant *distinguishes* as analogous to the beautiful, but only analogous, in that its presence makes us linger on the object embodying it because it keeps *arresting* our attention. (1:160; my emphases)

Yet in addition to invoking Kant's authority here, Greenberg demonstrates both a close reading and subtle employment of the *Critique of Judgment*. His aim is to criticize van Gogh's excessive emotionalism, a general theme to which Greenberg returns in his later promotion of "post-painterly abstraction" as the evolution of painting beyond the self-destructive heat of American abstract expressionism. A page further on in the van Gogh review, we are told that, affecting though these works are, "mistakes of temperament, not of craft, account for most of the disappointments. [His shortcoming] . . . lay precisely in [his work's] failure to react upon and discipline his temperament" (1:162). Thus Kant makes it possible for Greenberg to imply that van Gogh's paintings, in their heightened emotional register, are not beautiful but merely arresting. Clearly he is thinking of this text from section 12 of the "Analytic of the Beautiful": "We *linger*[35] in our contemplation of the beautiful, because this contemplation reinforces and reproduces itself. This is analogous to (though not the same as) the way in which we linger over something charming that, as we present an object, keeps arresting[36] our attention, [though here] the mind is passive" (Kant 1987, 222).

It is anything but a casual point that Greenberg makes with this passage. He relies on an accurate paraphrase of Kant's meaning and a grasp of the general sense in which Kant is a disciplinarian. Following Kant's spirit and letter, Greenberg over the years applies a tough discipline to his own perceptions of art, frequently distinguishing the merely charming or arresting from the beautiful in its purity. Unlike Kant, however, Greenberg habitually relies in the first instance on his intuitive judgments of art – of van Gogh's weaknesses in this case – and substantiates these views with philosophy. Kant proceeds a priori, from the transcendental necessities and thus certainties of judgment. Typically he ignores any material example of art, more on principle than from ignorance. In his later work, Greenberg is happy enough to try to borrow Kant's a priori certitude to secure what both see as the necessary "objectivity" of taste. But in "tak[ing] my life in my hands when I dare to say that I've seen something better than Kant did" (1973a, 92), Greenberg asserts a thoroughly un-Kantian empiricism and warps

Kant's notion of the *sensus communis*[37] into a cumulative and clichéd judgment of history and tradition. In the same breath, he realizes that he has parted company with his mentor: "It's Kant's case, I believe, that may offer the best clue as to why the consensus of taste hasn't been taken seriously enough: it was solely a matter of record, too simply an historical product. To found the objectivity of taste on such a product would be proceeding too empirically, and therefore too un-philosophically" (1973a, 23). For Kant, the artistic traditions that we may perceive in history are accidental byproducts of a priori judgment. Kant is interested in examples of taste only insofar as they may give him purchase on the a priori processes of judgment. For Greenberg, art alone (never nature) is subject to aesthetic judgment and always remains both empirical and material. He consciously misunderstood Kant by esteeming judgment only insofar as it revealed the specific values of taste.

I have paired Greenberg's use of Kant in writings produced thirty years apart to suggest an important continuity between these references. Thierry de Duve has criticized Greenberg's writings of the 1970s, with their frequent disquisitions on Kant, as the pedantic exercises of a man ill-suited to the role of theorist that he tended to adopt at this time. For de Duve, the tripartite Greenberg was a better critic and historian than theorist.[38] While there is ample documentary and anecdotal[39] evidence to suggest both a shift in Greenberg's emphasis in these later essays and their rather tedious tone, it nonetheless strikes me that the theorist was part of Greenberg from the start. His sophisticated use of Kant to generalize a negative judgment of van Gogh's painting suggests that he had been reading the philosopher for some time. Whether or not there was a direct influence, it is productive to think of Greenberg's evolving position on the necessary autonomy of art in "Avant-Garde and Kitsch" (1939) and "Towards a Newer Laocoön" (1940) in Kantian terms, a topic he would later make explicit in the justly famous and controversial opening pages of "Modernist Painting" (1960). These are Greenberg's three best-known and most influential essays. In the early ones, he conceived the autonomy or separateness of "high" art as a requirement to preserve the efficacy of art itself within society.[40] As Orton and Pollock have noted, "Avant-garde and Kitsch" is "an essay not on painting and sculpture but on culture" (1985, 169). By 1960, this sequestering of art within its own putative areas of expertise seemed to have become for Greenberg a purely formal and distant elitism, one exemplified by American abstract art and again inspired by Kant.

However, one can reconsider Kant's reception in Greenberg's work by thinking of the following parallels. Kant's *Critique of Judgment,* as we saw in Chapter 2, was written during the French Revolution. As I have emphasized, Kant was at the same time writing explicitly political essays such as "An Answer to the Question 'What Is Enlightenment?'" Taken on its own, the third *Critique* is certainly a "separatist" document: the autonomy of aesthetic judgment is guaranteed solely by its removal from all "interest." But when one looks at Kant's thinking more inclusively in this period – and at the concurrent reception of his political and aesthetic ideas – the preservation of judgment in autonomy begins to look like a strategy for the preservation of that highest of all human values for Kant, freedom as it is expressed in morality. As we have seen, Kant has to discipline himself most strictly in his last *Critique* to avoid becoming Schiller, that is, to see the aesthetic not only as the symbol but the embodiment of morality on the world stage. Kant's political and ethical writings of the period do this work but also help him to keep the aesthetic pure and autonomous. Like philosophy in the struggle between faculties, the aesthetic can only be understood fully and then held up as an example of freedom if it is purely and only itself. Despite what Kant would have to assess as a lapse into empiricism, Greenberg's work from the time of the essays of 1939 and 1940 and his polemics of the seventies and eighties can be read not only as an increasingly doctrinaire formalism, which it is in part, but also as a similarly disciplined refusal to comment on art's interests beyond its own formal limits. He can be seen to be carrying out Kant's mission to preserve humanity through the universality and purity of the aesthetic.[41] Kant hints at such a structural application of the aesthetic; only his followers – especially Schiller, Fernow, and Carstens – put it into practice. Perhaps it is time to see Greenberg's work as a whole in a similar way. His crucial debts to Kant – the notions of autocritique, aesthetic autonomy, and the primacy of form – could then be judged as interdependent components of a strategic humanism shared by both.

Orton and Pollock adroitly observe that the "tactical implications" of "Avant-Garde and Kitsch" in 1939, and much of Greenberg's writing thereafter, have a distinctly Kantian ring (Frascina 1985, 175).[42] Kant helped Greenberg to come to terms with the kitsch of "middlebrow" culture (3:132ff.), the dross of "cultural production as a whole under developed capitalism," as Thomas Crow has it (1985, 239). As others have noted, Greenberg is here contemplating the interaction of art and society, what he describes as "the relationship between aesthetic experi-

ence as met by the specific . . . individual, and the social and historical contexts in which that experience takes place" (16).[43] It was in large measure because Greenberg saw art in its social context in his early essays that his later work is repeatedly criticized for its contrasting formalism. In Kant's case, the accusations of disinterested purity in the aesthetic come in part out of an ignorance of the larger context in which he wrote. Ironically, the standard reading of Greenberg as a blinkered Kantian has significantly influenced this reading of Kant himself, which is easily enough substantiated in the *Critiques*. But in "What Is Enlightenment?" and elsewhere in the essays of the 1780s and 1790s, Kant reasoned that the times demanded a self-conscious use of reason to achieve individual and societal maturation. If they are allowed their freedom, "men will of their own accord gradually work their way out of barbarism so long as artificial measures are not deliberately adopted to keep them in it" (1991a, 59). For Kant, barbarism results from the inability or unwillingness to think for oneself, to exercise reason. When he takes his own advice to have the "courage to use [his] *own* understanding" (1991a, 54), the result is a carefully disciplined and demarcated critical philosophy in all its structural independence. Kant reiterates that his historical moment is both right and necessary for individuals and nations to become enlightened in this way. Enlightenment is both a noun and a verb, a goal and a process. Greenberg bases the advent and continued vitality of modernism on the timely attempt to dispel kitsch, which he describes vividly as a tempting yet degenerate "popular" cultural form that thrives on our culpable laziness in judgments of taste. It is his barbarism. In ways analogous to those of Kant before him, Greenberg seeks to combat kitsch – and thus to use his own understanding to preserve a high aesthetic culture – through *historical*/self-consciousness, what amounts to critique. Abstract art is for him the best manifestation of and ally in this struggle, because more than any other form of art it refuses to spare its observers the efforts of understanding. *Sapere aude* (Dare to Know) becomes Greenberg's credo as much as Kant's.[44]

For Greenberg in essays as early as "Toward a Newer Laocoön" of 1940, then, abstract painting best epitomizes the self-consciousness of artistic "disciplines" successfully "hunted back to their mediums, [where] they have been isolated, concentrated and defined" (1:32), and, in short, purified. He argues that abstraction answered a need within modernism for a resistance to kitsch, and that this answer was a historical response. Kantian critique acts within very confined disciplinary

boundaries (the scientific, ethical, and aesthetic, primarily) by forget-
ting, as it were, its overarching historical necessity. Significantly, Green-
berg did *not* in this later work forget the larger social and historical
context for Kantian autocritique. But his constant call for an awareness
of art's traditions – analogous to Kant's promotion of the processes of
enlightenment – is in tension with another idea borrowed from Kant,
that of the involuntariness of the judgment of taste. "A precious freedom
lies in the very involuntariness of aesthetic judging," he wrote in 1967
(4:265). In "Seminar One," he discusses at some length Kant's insistence
on this point (1973a, 45–46). Working as always from the empirical, he
nonetheless allies himself with Kant's call to enlightenment by extend-
ing Kant's notion that aesthetic judgment is initially spontaneous:
"Every civilization and every tradition of culture seem to possess
capacities for self-cure and self-correction that go into operation auto-
matically, unbidden." Thus for Greenberg it is a historical fact – not his
own prescription, as he constantly repeated – that abstraction "has
emerged as an epitome of almost everything that disinterested con-
templation requires" (4:76, 80).

Abstraction in all its apparently arcane and autonomous purity
arose, unbidden but necessary, as a cure, an "antidote . . . to the ex-
cesses of realist painting," as Greenberg put it in 1959 (4:79).[45] In 1940,
he was well aware that "abstract art like every other cultural phenome-
non reflects the social and other circumstances of the age in which its
creators lived, and that there is nothing inside art itself, disconnected
from history, which compels it to go in one direction or another" (1:23).
It is not so much that he forgot the historical factors that inspired both
the avant-garde and his own defenses of it, though a selective reading of
his essays can easily give this impression. Rather, and this is where his
theory is most open to criticism, he continued to believe in the *same*
threats defined early on as kitsch, and thus also in the same separatist
solution to it, which was to be realized through formalist "purity." In
"The Plight of Our Culture" (1953) and "New York Painting Only Yester-
day" (1957), for example, he developed a notion adumbrated in earlier
essays that "isolation is . . . the natural condition of high art in America"
and "alienation" its "true reality" (2:193). In 1948, he noted the "con-
tradiction" between the "very very private atmosphere" in which pro-
gressive abstract art was then being produced and the more "public"
"social location" for which it was destined in the art of Mondrian, for
example (2:195). Because the "ultimate causes" of the tension between
production and reception for Greenberg "lie outside the autonomy of

art," it is to be expected that abstraction would appear arcane and be misunderstood except by those in the highest circles of culture, those who have had the liberty to exercise the aesthetic disinterestedly (2:195). Historically, then, Greenberg surmised in 1953 that "the avant-garde . . . tends to make a virtue of its isolation and to identify this with high culture by definition" (3:139). Showing how guided he was by his critical judgments and their expression in his theory of modernism, Greenberg based an odd opinion about Newman's relation to Mondrian on this ultimately Kantian notion of production and reception. Newman "has little to do with Mondrian," he claimed in 1952 (3:103), because Mondrian is public (a negative for Greenberg) and Newman is hermetic.[46] But we know that Newman struggled both with Mondrian's theories and his plastic work, seeing himself as both an agonistic inheritor of this European abstraction and as its liberated, American successor. To overcome the provincialism all too typical of American art to this point, Greenberg argued in 1957, more and more abstractionists in New York "stood apart from the art politics and the political politics in which so many American artists . . . were then immersed" (4:20). Without a label, this statement is nonetheless an inheritance from Kant. Greenberg intimates that there is a "politics" apart from and above art politics and state politics. It is the politics of the aesthetic and an expression of freedom. In the counterintuitive Kantian employment of these terms that I have traced in Chapter 2, art's freedom is rightly expressed in its "public" autonomy while it is still restrained "privately." Genius for Kant is public in this sense. It gives itself its own rules and is opposed to the state-legislated norms of the Academy. Whatever we may think of the result, like Kant's artistic genius, Greenberg tried to maintain a similar remove and self-sufficiency by writing mostly from the unverifiable, inner convictions of his unbidden aesthetic intuitions.

In "Modernist Painting," Kant is hailed in the introductory paragraphs as the "first real Modernist" because he initiated disciplinary autocriticism. In a subtle and I believe unremarked way, Greenberg slides from the example of Kant and philosophy to that of modernism and abstraction by using a (very freely conceived) historical argument that is related to the public ("outside") versus private ("inside") hierarchy. "The self-criticism of modernism grows out of, but is not the same thing as, the criticism of the Enlightenment," he claims. "The Enlightenment criticized from the outside. . . . Modernism criticizes from the inside, through the procedures themselves of that which is being criticized. . . . Kantian self-criticism, which had arisen in philosophy . . .

was called upon eventually to meet and interpret [that which] lay far from philosophy" (4:85). Philosophy and the arts were indeed "outside" one another in Kant's time, especially in the *Critiques*. Very much in the spirit of Kant in *The Conflict of the Faculties,* Greenberg wants to maintain this disciplinary separation, the same tendency we perceived with Panofsky and also in the context of cubism. But historically, Greenberg claims that modernist culture made self-criticism its own, made it "immanent" in a way that was impossible in Kant's time. Modernism is in Greenberg's argument the inheritor of the Enlightenment, not of Romanticism:

Having been denied by the Enlightenment all tasks they could take seriously, [the arts] looked as though they were going to be assimilated to entertainment. . . . The arts could save themselves from this levelling down only by demonstrating that the kind of experience they provided was valuable in its own right and not to be obtained from any other kind of activity. (4:86)

With increasing stridency, Greenberg believed that culture and history still demanded the rites of purification exercised only in contemporary abstract painting. Form was the arena in which these rites took place, so that – as he pointed out himself in a phrase that is less trite and less circular than it sounds – "content and form disappear into one another" (1979, 85).[47] Thus, form for Greenberg, akin to beauty in Kant, was – against both men's principles – ultimately socially purposive.[48] In "Seminar Eight" of 1979, Greenberg reiterated that "art is autonomous; it's there for its own human sake, sufficient to its own human self." Significantly, he adds: "but this doesn't seal it off from society or history. What its autonomy does mean is that it serves humanity on its own terms, i.e., by providing aesthetic value or quality" (84). As late as 1973, in "Seminar One," Greenberg held to the orthodox Kantian view that "aesthetic value is never instrumental or relative" (1973a, 45). But his ongoing reading of Kant suggests that he could not resist the teleology of autonomy.[49]

In a late essay, "Modern and Post-Modern" (1980), Greenberg married the inside/outside dichotomy to his long-held, motivating – and by now paranoid – conviction that "threats to aesthetic value" demanded as much as ever the purifying means of high modernism as he had defined it. "Now the threats to aesthetic standards, to quality, come from closer to home, from within as it were, from friends of advanced art" who promote the chimeras of postmodernism. Again he called for a strenuous vigilance with respect to issues of aesthetic quality as a re-

sistance to the "urge to relax" with "less demanding art" (1980, 66). But kitsch in the eighties was not popular culture or "low" art, as it was in 1939. It was an insidious infection "within," one supposedly initiated in art by Duchamp, spread by pop art, and rampant in postmodernism. In Greenberg's mind, postmodern art was no longer self-critical enough to perceive what in its own tradition was of sufficiently high quality to serve as a necessary reference and testing point. We may observe in this context another (and partly Kantian) principle maintained by Greenberg from "Avant-Garde and Kitsch." The "superior consciousness of history" that he invoked in this essay manifests itself as (Greenberg's) understanding of which art is important historically to the evolution of modernism. Awareness and protection of this tradition are the preconditions of its ongoing life. As he put it in one of his most memorable phrases, American artists especially must "live partly by time transfusions" (2:160). Writing on the dangers of the postmodern in what had – even by 1980 – become clichéd terms, Greenberg fears the future because he holds that postmodernism has forgotten the past. But postmodernism no more neglected its predecessors than did Greenberg's vision of modernism. More accurately, postmodernism remembered differently and recalled reference points not allowed on Greenberg's map of the modern.[50]

One way to understand the mechanism of Greenberg's resistance to what he perceived as loss in the postmodern and kitsch is to see that for him Kant was tradition. More than any other thinker, we hear from Greenberg, Kant understood what happens in aesthetic experience; so just as a painter must look at cubism, a critic, it seems, must engage Kant. Kant's critical method could establish the independence – more precisely, the "heautonomy" or self-legislation and self-regulation[51] – of the aesthetic through attentive apperception.[52] As we have seen, Greenberg casts Kant as an "outsider" from philosophy who could in his own time only speak to art from this remove. He suggests that modernism in the arts internalized Kant's already immanent critical discipline, or that, spatially, Kant moved inside the arts. And Greenberg makes this process sound both inevitable and innocent, even in its sweeping implications: "Modernist art does not offer theoretical demonstrations. . . . It happens to convert theoretical possibilities into empirical ones . . ." (4:92).

Greenberg received and digested Kant in exactly this manner, and in using Kant from his place securely *in* the New York art world, he challenged the separation between philosophy and the arts characteristic of

the late eighteenth century. But, in a crucial sense, Greenberg's ability to make Kant his own for art was anathema to the Kantian principle of the distinction and separation of the traditional disciplines. As we saw in *The Conflict of the Faculties,* philosophy for Kant must always remain outside (and above) the other disciplines, especially historical ones, in order to legislate competently. It must maintain secrecy, or at least discretion, in order to advise effectively. By bringing Kantian immanent criticism into art, Greenberg is able to argue in "Modernist Painting" that "The task of self-criticism became to eliminate from the specific effects of each art each and every effect that might conceivably be borrowed from or by the medium of any other art. Thus would each art be rendered pure, and in its purity find the guarantee of its standards of quality as well as its independence" (4:86). For Greenberg the individual disciplines of art must traffic only in their own, homogeneous materials. To be pure they must recognize and reject what is different. What is expelled in this ongoing process with the greatest urgency, however, is not something from "within" art, such as "the modernist sensibility . . . [that] rejects sculptural painting of any kind" (4:59). What Greenberg excludes with the broad terms "kitsch" and "postmodernism" is non-art, that which pretends to be art but is found insufficiently rigorous. There is, then, in his would-be Kantianism an urge for purification that makes nearly impossible the ongoing life of "tradition" that he praises. Increasingly, if unwittingly, he blocks the possibility of an ongoing relation with history or tradition because the self-definition of art established through the recognition of difference, of an outside or that which is not avant-garde or not even high art, becomes difficult. Because Greenberg will not tolerate differences, the dynamism central to his image of the avant-garde and modernism finally implodes. More simply and empirically, Greenberg is wrong about the value of postmodernism because he cannot recognize its new – not inadequate – relations with past art (see Cheetham 1991b). If the vitality he ascribes to modernism is to last, artists must be free to react to late de Chirico, for example, rather than to Manet or to cubism, as Greenberg prescribes in what became his inadvertent version of the Alexandrianism and academicism that he deplored.

Greenberg establishes the same pattern of identity and purity in his reception of a Kant who is no longer "borrowed" from philosophy. His need for purity required that the philosopher's ideas be one with "the enterprise of self-criticism" in the visual arts, part of their "medium," truly immanent (4:86). But again, this re-placement of Kant into a new

discipline undercuts the critical authority he could maintain only in detachment. The "transfusion" over time of Kant into the body of art – what Greenberg characterizes as the evolution from Enlightenment to modernism – cannot restore or support art's health, because, for Kant, philosophy and art are different types. Pure reason within Kant's system and philosophy within the state demonstrate that metaphysics or politics must be advised (secretly) from without. The distressed "health" of art cannot be improved by self-purification, but only by an antidote whose potency is guaranteed by difference. Ultimately, Greenberg did not follow Kant in this prescription, but he believed that he did apply the notion of autocriticism to art. To be more than strictly personal and ephemeral, self-critique had to rely on form alone, conceived, not as in Greenberg as the material essence of a given artistic "discipline," but as a formal *relation* – the seeming purposiveness of beauty for our human awareness – that we must think of as universal in a *regulative*, not empirical sense. For Kant, "the beautiful is above all else a form in which the theoretical mind encounters the given world" (Heinrich 1992, 243). Though Greenberg may not have understood – or as I have argued, may not have been willing to comply with – Kant's transcendentalism in this context, he did in his criticism perform the two connotations of the idea of "discipline" that follow from Kant's emphasis on formal relation. Nowhere is he more Kantian than in his insistence on the purity of what he deems the "disciplines" of painting and sculpture. Less obviously, Greenberg also follows Kant in the personal discipline needed to achieve his vision of modernism and describe its details.

In both the early and later moments of his critical philosophy, Kant describes reason's legislative activities as "negative" in that they assure what we can know, can do, and can hope for by perceiving only what we cannot properly understand. Late in *The Conflict of the Faculties*, he speaks candidly and personally about philosophy's "panacea," its ability to save the philosopher. "This panacea, however, is only a *regimen* to be adopted; it functions only in a negative way, as the art of *preventing* disease. But an art of this sort presupposes, as its necessary condition, an ability that only philosophy, or the spirit of philosophy, can give [that is], . . . the art of formulating a regimen" (1992b, 177). Though I doubt that Greenberg read this book or passage, he did adopt a Kantian regimen in applying constantly the principles of self-criticism and regulative formalism to art. Practically, for both Kant and Greenberg if they were to live up to these precepts, this would mean the sequestering of art from its social and political matrix to avoid impure disciplinary

mixtures. It is too simple to accuse Kant of ignorance about the arts and suppose that this is why he failed to discuss them empirically. Similarly, it is a very limited view that would find fault with the avoidance of a "political" role for art in the third *Critique*. As we have seen, Kant spoke of politics in what he considered to be its place. Greenberg did the same. Most of Greenberg's essays are relentlessly "formal" and, in this important sense, pure. But he also reviewed books by Ernst Cassirer and the famous social historian of art Arnold Hauser. And he referred frequently to his "interest" in the perceived decline of his culture. Kant's and Greenberg's formalism shared a fundamental humanism, a conviction, as Greenberg claimed, that art's necessary autonomy can be explained by saying "it's there for its own human sake" (1979, 84). In a late essay, Greenberg relents and uses Kantian terms to put art back in its place within society. Moral value is higher than aesthetic value: "a real categorical imperative operates here" (1978, 97).

We have looked in this chapter at three moments when Kant was taken up actively in art history, the practicing visual arts, and art criticism. His influence has been profound, a fact underlined by those who wish it otherwise. In a recent paper, the prominent American critic Thomas McEvilley proclaimed that "Kant and Greenberg are both things of the past and we should just get over them. Yet somehow, they keep arising from the grave like zombies."[53] Yet Kant's authority and his name's resonance have, if anything, increased in the twentieth century. Panofsky, cubism, and Greenberg have, for a variety of reasons, all enjoyed renewed and intense critical discussion over the past decade or so.[54] Each found Kant fundamentally useful, as we have seen, yet their connection through Kant reception has gone unremarked. Various structural relationships attend this otherwise heterogeneous tripartite linkage. For example, whereas Panofsky tended to conceal his Kant after coming to the United States, Greenberg's later work uses him more openly and extensively. The different disciplinary starting points of these two most influential writers on art in part explains this difference. While Panofsky in part responded to the empiricism of American art history by keeping Kant "secret," Greenberg in his own way typified the increasing interest in "theory" found in art criticism. Kahnweiler and the French critics of cubism mentioned above were "savage" in their employment of Kant's ideas, as was Greenberg. Panofsky was more professional and scholarly. Yet in all three moments, Kant appealed because of his humanism. Rather than censoring their attraction to

Kant in McEvilley's terms, at our historical remove from Kant, cubism, Panofsky, and Greenberg, we should instead applaud its manifestation as a paradigm of how the discipline of art history may work from its own past into its future. It is in the savage application of philosophy that the humanist, to recall Panofsky's formulation, "rejects authority. But he respects tradition" (1955, 3). If Kant still seems too much the disciplinarian, the setter of boundaries and regimens within art and art history that might well raise hackles against Panofsky, Kahnweiler, or Greenberg as they adopt his priorities, then to amend the stereotype we must look at the form-breaking, discipline-crossing category of the sublime, which has been so widely influential at the end of the twentieth century.

4

The Sublime Is Now (Again)

French Theory/International Art

For it is a law (of reason) for us, and part of our vocation, to estimate any sense object in nature that is large for us as being small when compared with ideas of reason. . . .

Immanuel Kant

The grafting of one art on to another, the contamination of codes, the dissemination of contexts, are . . . moments of what we call history.

Jacques Derrida[1]

T
he sublime, wrote James Usher in the late eighteenth century, "takes possession of our attention, and of all our faculties, and absorbs them in astonishment" (1778, 102). My aim in this chapter is to examine how the notion of the sublime continues to absorb and astonish contemporary theorists and to explore how this putatively unpresentable category can be "exemplified" in the plastic arts. I have mentioned that my concern with recent and contemporary examples of Kant's reception will lead in these final two chapters to a complex layering of moments of Kantian influence in and around art history and the practicing visual arts. In the interests of concinnity, I will focus initially on Jacques Derrida's captivation by Kant's versions of the sublime. This reinvigoration of Kant and his ideas has not, of course, gone unnoticed, nor is Derrida alone today in his insistent retheorization of the sublime.[2] But Derrida's interest in the Kantian sublime throws dramatically into relief two issues that are both typical of the widespread return[3] to the sublime and also perhaps causally related to the resurgence of this concept. First, Derrida and Kant are obsessed with

borders and the legislation of conceptual boundaries. Both thinkers, I will argue, employ the term "sublime" – despite its putative boundlessness and uncontrollability – as a cipher of circumscription. Second, and in an equally paradoxical manner, Derrida uses Kant's sublime in *The Truth in Painting* as a way to think about the authority that philosophical aesthetics and philosophy have had historically over the visual arts, a border dispute that finds its articulation in his machinations about genealogy and descent.[4] Jean-François Lyotard claims, too, that it has been with the vehicle of the sublime "that aesthetics asserted its critical rights over art" (1989a, 199). Looking to the contemporary art scene of the 1970s and 1980s, he elaborates: "Recently in France, philosophers have made enough of an incursion into art to prove pretty irritating to critics, gallery directors, curators, and occasionally artists. . . ." What these new experts like about art, he explains further, is the "gap through which the work escapes being converted into meaning," its resistance to system (1989a, 181–82). Such issues are pressing when we look at art that attempts to embody the sublime and its textual traditions. In the second section of this chapter, I will examine the links between the theorization and materialization of the sublime, first circa 1800 in the work of Joseph Anton Koch and then through Lyotard's writings about Barnett Newman. Finally, I will look briefly at examples from the remarkable range of contemporary visualizations of the sublime.

Before I turn to Derrida's reading of the Kantian sublime, it is worth commenting on the oddity – even the anachronism – of the striking current interest in this discourse and thus also articulating the (perhaps unanswerable) question "Why the sublime, and now?" Lyotard asserts that "one cannot avoid returning to the 'Analytic of the Sublime' in Kant's third *Critique*, at least . . . if one wants to have an idea of what is at stake in modernism" (1990, 197). Cannot avoid? These are surprisingly strong words from a thinker who, in *The Postmodern Condition,* warned against the sway of the past's metanarratives. Yet in supporting his claim he invokes the concerns with boundaries that Derrida embraces in his theorizations of the "parergon": "the frame of aesthetics, aesthetic commentary, built by pre-romanticism and Romanticism," Lyotard proposes, "is completely dominated by (and subordinate to) the idea of the sublime" (1986, 8). In one of the earliest studies to signal the renewed critical interest in the sublime since the 1970s, Thomas Weiskel claimed, more modestly, that even though the notion of the sublime's "structure still undergirds our imaginative intellection," we "no longer share in the hierophany of the sublime which was un-

questioned in nineteenth-century critics" (1976, 5:36). I would suggest that Weiskel's attempt here to distance himself from the revelatory power of the idea of sublimity is undone by the insights of his own study and by the frequent revisiting of the notion by other contemporary thinkers. Jean-Luc Nancy, for example, another prominent commentator on the sublime, states in totalizing terms that "there is no contemporary thought of art and its end which does not, in one manner or another, pay tribute to the thought of the sublime" (1993a, 26). The sublime must be seen to bring something to light in late-twentieth-century contexts. The question is, what? Thought of the sublime seems to encourage sweeping – and historically inaccurate – claims. Another peculiarity of the contemporary concern for the sublime arises when we recall that, historically, the category has had strong gender identifications. In 1785, for example, Frances Reynolds claimed that "the masculine [character] partakes of the sublime" (29), and her opinion is widely echoed today by more negative voices. For Patricia Yaeger, the "Romantic sublime is . . . a masculine mode of writing and relationship." While this might make it worthy of revision as a relic of hegemony, it is therefore for her "a genre that is – in the present age – of questionable use" (1989, 182).[5] Yet it continues to be used frequently and explicitly. My own meditation on Derrida's reading of Kant in *The Truth in Painting* will seek to show that the sublime is an idea that works to fix boundaries of genre and discipline during a time of great border anxiety within theoretical discourses and the discipline of art history, and that this instrumentality is seductive enough today to override most writers' reservations about the concept's history.

Derrida's Sublime

Derrida's examination of the Kantian sublime is found in "The Colossal," the fourth section of "Parergon," Derrida's title for the first chapter of *The Truth in Painting*. The "Parergon" is prefaced by the "Passe-Partout," a section that Derrida is at pains to describe neither as a "master key" nor an introduction to his book. Nonetheless, if one reads in a more linear fashion than Derrida seems to want, the "Passe-Partout" contains hints about the import of the notion of the parergon and about the category of the sublime as an example or illustration of parergonality, that "remainder" which is "neither work (*ergon*) nor outside the work (*hors d'oeuvre*) . . . [yet which] *gives rise* to the work" (1987, 2, 9). I will read Derrida's text *as if* it builds toward the section on

the sublime, which means that I will focus on the "Passe-Partout" and on the first and fourth divisions of the "Parergon." My excuse for this partial and slanted reading is encapsulated in Derrida's own expression of the spirit of the parergon in the context of his reading of Kant: "I do not know what is essential and what is accessory in a work" (63). In other words, I am not trying to read Derrida correctly, whatever that would mean, but rather to deploy his reflections on the sublime within a narrative about disciplinarity.

One of the meanings of "parergon" is "frame," both in the sense of a physical limit around a painting and also in the more conceptual sense of a "frame of reference."[6] One such reference point in what I will claim is Derrida's discussion of the sublime *as* parergon is the notion of "remainder," the supplement (in the Derridean sense) that can always be found after any reading of a text or image and which is therefore, for a moment, outside the initial definition of that work and its reading. Derrida notes that he writes "around" painting in this text "for the interest – or the grace – of these remainders" (4). On a general and quite grand level of implication, his concern is with the limits imposed on the visual arts by philosophical aesthetics and with what escapes its would-be borders. More specifically, he looks for the troublesome details in Kant's third *Critique* (and in the aesthetic theories of Hegel and Heidegger) and makes these seemingly marginal issues central to his reading. "I am occupied," he writes, "with folding the great philosophical question of the tradition ('What is art?' 'The beautiful?' 'the origin of the work of art?' etc.) on to the insistent atopics of the *parergon*" (9).

After discussing Kant for over fifteen pages, Derrida introduces Kant's own brief reference to the parergon in the third *Critique* by saying: "so I begin with some examples" (52). Some of these examples are Kant's own instances of parerga in art, those "extrinsic addition[s]" such as "picture frames, or drapery on statues, or colonnades around magnificent buildings" (§14, 226). Predictably but brilliantly, Derrida uses Kant's examples to show how difficult it is to determine where a parergon begins or ends and thus what is and is not parergonal in a work of art. With Kant's final "example of the columns," says Derrida, for example, "is announced the whole problematic of inscription in a milieu, of the making out of the work in a field of which it is always difficult to decide if it is natural or artificial and, in this latter case, if it is *parergon* or *ergon*" (59). Earlier Derrida stated what I take to be the major implication of this movement between parergon and work: "The permanent requirement – to distinguish between the internal or proper

sense and the circumstance of the object being talked about – organizes all philosophical discourses on art, the meaning of art and meaning as such, from Plato to Hegel, Husserl and Heidegger" (45). What Derrida objects to in this tradition and in the examples from Kant is not the identification of a line or limit between parergon and ergon but rather the a priori rigidity of this separation that is typical, he thinks, of philosophical discourses as they bear on art and its history. From his analyses of Kant's three examples, it might seem that Derrida wants to collapse the distinction between work and frame and in effect do away with the parergon. But as his admonition that "deconstruction must [not] . . . dream of the pure and simple absence of the frame" (73) suggests, his concern is more to show the necessary and fluid interpenetration of work and border. Referring to what is supposedly extrinsic in Kant's illustrations, Derrida argues that "what constitutes them as *parerga* is not simply their exteriority as surplus,[7] it is the internal structural link which rivets them to the lack in the interior of the *ergon*. . . . Without this lack, the *ergon* would have no need of a *parergon*. [But] the *ergon*'s lack is the lack of a *parergon*" (59–60). Put more prosaically, there cannot be a work without an outline for definition. Outside and inside are mutually definitive.

If I am right in suggesting that the necessity of a relation between work and frame is argued for by Derrida in the opening section of the "Parergon," then it becomes clear why the notion of the sublime is so fascinating for him. In the text of the third *Critique* and in the many versions of the sublime generated in the nineteenth century, the sublime has the character of unboundedness. In his initial comparison of the beautiful and the sublime in the "Analytic of the Sublime," Kant introduces this idea: "The beautiful in nature concerns the form of the object, which consists in [the object's] being bounded. But the sublime can also be found in a formless object, insofar as we present *unboundedness* . . ." (§§23, 98). Derrida picks up on this seemingly rigid difference by commenting that "there cannot, it seems, be a *parergon* for the sublime" (127). The phrase "it seems," however, works rhetorically here to offer the possibility that the sublime as a discourse is not only bounded in Kant's text but is also the consummate legislator of limits in what Derrida sees as philosophy's mastery of art and art history.

Derrida's entrance to these issues is through the "mathematical sublime," the species of sublimity that arises from measurement and is thus quite different from formlessness, the "dynamically" sublime in Kant's parlance, a category familiar from Burke and earlier theorists. For the

emotion of the mathematically sublime to be produced in us, by the pyramids for example, Kant says, we must fix our line of sight at precisely the right place. It is as if we must draw a line around these edifices at the ideal viewing distance in order to be overwhelmed by their immensity. "For if one stays too far away," he suggests, "then the apprehended parts . . . are presented only obscurely, . . . and if one gets too close, then the eye needs some time to complete the apprehension from the base to the peak" (§26, 108). The need for precise placement of this line is suggested by Kant on the next page, in a passage on the "colossal" taken up by Derrida. "*Colossal*," as Kant defines it, "is what we call the mere exhibition of a concept if that concept is almost too large for any exhibition (i.e., if it borders on the relatively monstrous)" (§26, 109). Derrida puts pressure on the notion of the "almost too," asking how one could ever specify its locale, and he concludes that the "almost too," as an indication of sublime size, is not for Kant empirical at all. Yet I would argue that Kant's example of the pyramids seems to suggest that there is an exact place, a frame, from which and only from which these monuments can occasion the feeling of the sublime in an observer. The sublime of the colossal, we might say, literally "borders . . . the relatively monstrous," by circumscribing and thus identifying that which is either parergon or ergon, depending on the line of sight one takes.

Kant of course backs up this physical manner of controlling the seeming unboundedness of the mathematically sublime with "critical," a priori arguments: because the power of reason aids that of the imagination, which cannot itself adequately "exhibit" colossal vastness to the mind, he in effect suggests that the ability thus to *present* our very inability to comprehend the excesses of "raw nature" – in their unpresentability – *is* the sublime. Kant makes the mathematically sublime edifying for the human subject by having it simultaneously reveal and consist in our awareness of "our supersensible vocation" (§27, 115), that is, the mind's ultimate intellectual control – through reference to morality – over anything it perceives. In Derrida's reading, "the true sublime . . . relates only to the ideas of reason. It therefore refuses all adequate presentation. But how can this unpresentable thing present itself?" His answer: "The inadequation of presentation is presented" (131). In the experience of the Kantian sublime, the imagination thus is bounded by the "unbounded" power of reason (§27, 117). What would seem to be the limitless power of the imagination and the confined exercise of reason reverse their roles and relative strengths; ergon can become parergon and vice versa.

With Kant and Derrida, then, we can hypothesize that the sublime is that elation arising from the consciousness of our ability to delimit colossal size or even a notion like infinity. Though Derrida does not emphasize the language of bordering and limiting in Kant's discussion of the sublime, these metaphors suggest the inexorable activity of the parergon to which Derrida has pointed. In a long passage in which Kant is working up to the triumph of reason in the experience of the mathematically sublime, he writes: "Hence it must be the *aesthetic* estimation of magnitude where we feel that effort, our imagination's effort to perform a comprehension that surpasses its ability to encompass the progressive apprehension in a whole of intuition . . ." (§26, 112). The imagination cannot "encompass" or measure or bound that which stimulates our sublime response. But reason can put such a border in place and take emotional pleasure from this accomplishment. That pleasure – not the glimmering awareness of something incommensurably "other" – is the sublime for both Kant and Derrida. The experience and pleasure of the sublime do not stem from the promise of something noumenal outside a given frame but rather from the perpetual, yet always provisional, activity of framing itself, from the parergon.

Kant's critical philosophy is dedicated to legislating proper boundaries between and limits to what we can know, do, and hope for. The introduction to the *Critique of Judgment* lays out the fundamental divisions of "Philosophy" and specifies its "Domain." "Legislation through concepts of nature," he posits, "is performed by the understanding and is theoretical" and inhabits the realm of science examined in the first *Critique*. "Legislation through the concept of freedom is performed by reason and is merely practical" and falls under the jurisdiction of the second *Critique* (Preface, 13). In Kant's thinking, these fields must be autonomous, yet they act on the same area of human experience. But how can theoretical knowledge, which works a priori, present to itself the realm of the sensible? It cannot, but practical knowledge must, according to Kant, and to do so – to allow us to act in freedom as rational subjects – he argues that we must assume the existence of "a realm that is unbounded . . . the realm of the supersensible" (Introduction, 14). This argument takes Kant to the point where his system needs the aesthetic, the critique of judgment, to bridge the "immense gulf [that] is fixed between the domain of the concept of nature, the sensible, and the domain of the concept of freedom, the supersensible" (Introduction, 14). While in the early part of this text he laments that "no transition from the sensible to the supersensible . . . is possible" (Intro-

duction, 14–15), we have seen that the sublime emotion, through its recourse to reason, does present the supersensible through the sensible. The sublime spans the "gulf" Kant envisages by setting a limit, thereby presenting the unpresentable. Its legislative power of delineation is typically Kantian.

Commentators are perennially intrigued by the paradox of the Kantian sublime, its presentation as unpresentability. Kant seems to be able to live with this tension: in a little-noticed passage, all he claims to need to do is *"point* to the sublime" (§26, 252; my emphasis), which in turn is all the feeling of the sublime can do vis-à-vis the supersensible.[8] He "points" with (always inadequate and thus parergonal) examples and, as I suggested with reference to the experience of the pyramids, his examples tend to mark out a territory for experience by inscribing a physical point from which the identifying boundaries of a work can be properly apprehended. With Nancy, we can argue that any notion of pointing is inadequate to Kant's thought because it invokes an aesthetically impure teleology:

For dialectical thought, the contour of a design, the frame of a picture, . . . point beyond themselves to the teleological absolute of a (positive or negative) total presentation. For the thought to the sublime, the contour, the frame, and the trace point to nothing but themselves – and even this is saying too much: they do not point at all, but present (themselves), and their presentation presents its won interruption, the contour, frame, or trace. (1993, 42)

Yet while we may applaud Nancy's development of Kant's ideas, his precisions do not accurately describe what is indeed the end of the sublime in the "Analytic of Teleological Judgment" of the third *Critique,* its crucial revelation of our dominion over nature as the basis for scientific inquiry. This purpose can legitimately be read in some German landscape painting contemporary with Kant, as I will argue in the second part of this chapter.

We have seen that Derrida makes much of Kant's art examples and of Kant's writing as an exemplar of philosophical aesthetics.[9] But what of Derrida's own use of visual illustration in *The Truth in Painting*? Are these examples always and by definition as inadequate as any putative instance of the sublime, implying that the activity of division – of inscribing the parergon – is somehow undesirable or avoidable? Derrida could be thought to "dream of the . . . absence of the frame" or to "reframe" (73) if we notice that the first picture in *The Truth in Painting* is of God's hand using dividers to circumscribe the earth, an image

taken from Johannes Kepler's *De Nive Sexangula* (25). Given the scientific context, could this image of territorial surveying be as negative as Blake's famous 1795 "portrait" of Newton as a serpentlike monster bent on containing knowledge through mathematics? Should we understand Derrida to be the sort of "romantic" who thinks that something essential in art is always missed when one "limits" a work by writing about it or presenting it through illustration? A comparison of Kant's and Derrida's uses of examples of the sublime tells a great deal about their mutual concern for boundaries in philosophy and between philosophy and other disciplines, especially those which concern art. Both men see the activity of limiting – figured by the sublime – as necessary, but where Kant seeks distinct, immutable, and transcendentally verified divisions (whether between frame and work, reason and imagination, or Philosophy and Art), Derrida prefers the play of parergon and ergon, the provisional and instrumental demarcation of work or discipline. For Derrida, and especially when he thinks about the sublime, examples from the history of art contained in his book are instances of the sublime, not in the sense that they picture what art history has nominated as a sublime image, nor in the sense that they point toward a highly valued but ineffable something outside language and the visual arts, but because they present the unpresentable *as* the necessity of framing, again, of the parergon.

Derrida hints at this reading in a note that precedes the text of the "Parergon." He mentions that the first version of this text "was not accompanied by any 'illustrative' exhibition" (16). Already with the unusual use of the term "exhibition," we are reminded of the frequent references to what the imagination and reason can and cannot "exhibit" in discussions of the sublime in the third *Critique*. As Derrida goes on, the Kantian context becomes even more clear. Referring to his text's pictures, he aays, "here, a certain illustrative detachment, without reference, without title or legitimacy, comes as if to 'illustrate,' in place of ornament, the unstable *topos* of ornamentality. Or in other words, *to 'illustrate,' if that is possible*, the parergon" (16; my emphasis). Where Kant will excuse his examples as mere parerga in a transcendental enterprise, Derrida seems to use illustrations to underscore the impossible yet undeniable activities of circumscription, a bounding performed by authors, readers, institutions, and disciplines. Although they are without the usual identifying captions and thus lack the overt authority of the artist's name, two of Derrida's illustrations in the section on the colossal appear to be carefully placed in the text to comment on – to

work as possible parerga for – his analysis of the Kantian sublime. These visual examples are from Goya's late series of "dark" paintings. The first, *The Colossus* (130), faces Derrida's gloss on the unpresentability of the sublime (131). What he thus provides is not only an image of a giant but also one that is, in art history, commonly taken as illustrative of Goya's "sublime" madness. So Derrida does frame and reframe the sublime, but with an image of unreason rather than only with Kant's transcendental reason as analyzed in the text. Derrida's unremarked illustration, however, leaves many remainders.

We could say that Derrida's example of the parergon as sublime leaves remainders specifically in art and that the border which the philosophical notion of sublimity erects is not seamless. Whereas Kant's text demonstrates the urge to control art with an a priori discourse that is proud not to be about objects, Derrida worries that "every time philosophy determines art, masters it and encloses it in the history of meaning or in the ontological encyclopedia, it assigns it a job as medium" (34); Hegel is singled out as the prime offender. Art, that is, becomes one parergon or defining edge for philosophy's self-appointed work. Nancy echoes this concern with specific reference to Kant:

Kant is the first to do justice to the aesthetic at the heart of what one can call a "first philosophy": but he is also, and for this very reason, the first to suppress aesthetics as a part or domain of philosophy. . . . It is as if "aesthetics" as object, as well as the aesthetic object, had dissolved upon the touch of philosophy . . . to leave room for something else (nothing less, in Kant, than the sublime destination of reason itself: freedom). (1993, 27)

Derrida seems to want not to "use" art in this way, yet he realizes that for there to be any question of impropriety, a distinction between art and philosophy must be perceivable; each must have recognizable borders. But can Derrida escape the traditional framing of art by philosophy when his critique of the questions asked by the "masters" is still imaged through a commonplace and strictly disciplinary genealogy that descends from Kant to Hegel and Heidegger?

Richard Rorty has written that "it is difficult to tell who the parents of a child or a philosophy are" (1989, 128). While his contention may be granted, it remains the case that philosophers – like those who recognize themselves as members of other disciplines – frequently (as here) use genetic and genealogical metaphors as a way to adumbrate how they or an idea came to be. Rorty and Derrida imagine family trees of philosophers where ideas are inherited and passed on from generation

to generation. It is an effective way to image descent and to secure the authority and privileges of noble birth, and I have no quarrel with Derrida's point that philosophers such as Kant – even the discipline of philosophy – have bounded art by saying just what may and may not be art. This effect is inevitable if one stays within the frame of philosophy chosen by Derrida, but the genealogical model as conceived by Derrida has at least two consequences that should be made apparent. First, it tends to construct the discourse of the sublime as an ahistorical history of ideas passed down genetically through one line, that of philosophy as it thinks about the arts. Derrida certainly does not want to obviate historical specificity or materiality, as exemplified in the history of art, for example. But we need to question the extent to which his discourse on the sublime in *The Truth in Painting* does just this precisely because it engages primarily with the tradition of philosophical aesthetics. Even though his philosophers' family tree grows through time, it is presented all at once as a pattern. In Derrida's picture of the sublime, for example, we are given no historical sense of thinking about the phenomenon between Kant's and Hegel's reflections. There are no other parerga for the notion, such as its manifestations in the visual arts (which are denied as a possibility by Kant even though he exemplifies the mathematical sublime with the example of the pyramids and St. Peter's basilica in Rome) or in travel literature. I am not positing these parerga as more truthful to something called the sublime but simply as other frames for the theory.[10] Derrida cannot be expected to consider them all, but why does he then complain about the strictures of the philosophical containment of art, and why are these constraints implicitly more important rather than simply different or additional? A second implication of the genealogical model is the fantasy of male procreation, of keeping art "pure" by thinking of it as a consequence of male generation.[11] On this model, Derrida and Kant are free to be each other's "fathers" and to reissue texts. Derrida need not be concerned, for example, with historical details that fall outside the frame of philosophers talking to one another, such as whether Kant's notion of "contour" used in defining sculpture was derived from Winckelmann's reflections on this idea, reflections that grew out of a concern for the history of Greek art. If, as Naomi Schor (1987) suggests, the "detail" has historically been the realm of what is called the "feminine," then not only Kant's definition of judgment as "the ability to think the particular as contained under the universal" (Introduction, 18) but also Derrida's elision of historical specificity in his genealogy of the aesthetic remain

within a masculinist frame, defined here as a tendency to abstractness at the expense of "mere" details.

The sublime as philosophical discourse certainly delimits art practice in some cases, as with Barnett Newman's quotation of Burke's theories in the painter's 1948 manifesto "The Sublime Is Now," to which I shall return below. But there is no absolute, genetic standard by which philosophy somehow dictates what art should be. Newman's textual and painterly discourse of the sublime is more an elective affinity than a misuse of art by philosophy. Giving art "a job as medium" should not be as much of a problem as it seems to be for Derrida, because the parerga of art (and philosophy) cannot help but be plentiful and fluid. But I think that Derrida's views on boundaries have changed since he composed the essays in *The Truth in Painting*, changed to become more consistent with his ideas in that text on the parergon. He has indicated recently the importance in architecture of "the law of the threshold, the law on the threshold or rather the law as the threshold itself . . . the right of entry, the introductions, the titles, the legitimization from the opening of the edifice" (1989, Aphorism no. 19). It is the sublime more than any other idea in this context that is the (ever adaptable) law of the "threshold," of the "limen,"[12] and the sublime operates in both Kant and Derrida to open and frame both the "architectonic" of philosophy, as Kant calls it, and art. J. M. Bernstein makes the same point: "Sublimity is but the working of the frame, of what is neither inside (presentation) nor outside (without size/cize, and unpresentable)" (1992, 171). In my terms then, the "plasmic" – a way of conceiving spatial relationships as neither simply inside or outside – also partakes of the sublime. Derrida's reflections on the remainder left by any framing should dissolve worries about art somehow being (genetically) deformed by philosophy. He shows that there will be "art" defined inside and outside the bounds of philosophy and that these bounds do in part define what will count as a discipline on either side of the parergonal marker. There will always be borders, so art both is and is not philosophy's child. Derrida has insisted on the perspective particular to disciplinary sight lines: "you cannot simply mix philosophy with literature, with painting, with architecture. There is a point you can recognize, some opening of the various contexts . . . that makes Deconstruction possible." For Derrida more recently, "the most efficient way to put Deconstruction to work [is] by going through art and architecture" (1989, 75, 71), as he has in his work with architects Tschumi and Eisenman, leading to his 1990–91 exhibition at the Louvre and a text *Memoires of the Blind: The Self-Portrait*

and Other Ruins (1993b). By getting away in his more recent thinking about art from the genealogy of the fathers of philosophical aesthetics, Derrida can be seen to reenact the parergonal activity of the sublime in new and (for a philosopher) "impossible" (and never completed) projects such as the La Villette town design outside Paris. Here he displays new frames for both art and philosophy; yet there should be no more guilt about improperly using art, because there is nothing but its use. As Derrida himself puts it, "this crossing, this going through the boundaries of disciplines, is one of the main – not just stratagems but *necessities* of Deconstruction. The grafting of one art on to another, the contamination of codes, the dissemination of contexts, are . . . most importantly . . . moments of what we call history" (1989, 73). The history of such parergonal activity is also the history of the sublime.

Let me conclude this section with speculations that return us to the issue of disciplinarity. If the sublime has been used habitually as a way of making and figuring distinctions, then its parergonal activities may be seen as both a powerful metaphor for – and agent in – current debates about the limits of disciplinary structures, the borders that Derrida suggests are crossed by deconstruction. In his introduction to *The Textual Sublime: Deconstruction and Its Differences* – a collection of essays that itself exemplifies the present return to the sublime that I have thematized – Hugh J. Silverman writes that "the literary seeks to articulate and express the sublime; philosophy names and appropriates the sublime for itself – in effect, philosophy removes the sublime *from its proper place* and makes use of it for its own purposes" (Silverman and Aylesworth 1990, xii; my emphasis). But how can the sublime have a "proper place" in the universal sense implied by Silverman, especially if it typically defines borders and is the occasion – as here – for territorial disputes? In equating the sublime with the parergon, Derrida has shown how the "use" that Silverman fears is the very life of the sublime. At different times and from different perspectives, even large and imprecisely defined constructs such as disciplines will have their own sublimes, "objects" or "subjects" that are at once feared and desired and which, through the disciplinary attention they garner, work to mark the provisional limits and flash points of individual disciplines. Philosophy – if we can make a monolith of it for the sake of argument – seems to be this sort of sublime for Silverman in the passage just cited. The same could be said of the discipline of art history, which has characteristically turned to capital *P* Philosophies to determine its own ends (Panofsky's interest in Kant is an apposite example), only subse-

quently to secret such influences within the protocols of the apparently empirical study of art. In Derrida's own reflections on Kant's sublime, we see what may be the sublime for philosophy, that which it is fascinated by and even needs according to its own theories (we can think of Hegel here), but which remains supplemental and defines a border: material and historical specificity in the form of art. Derrida's increasing concern with the visual arts exemplifies this movement of the parergon; it is no accident that he chooses the sublime as a primary vehicle in his redefinition of philosophy.

The Sublime Is Now (Again)

Art should not be able to present the sublime. As Ad Reinhardt put the point with his usual terseness, "sublimity in art is not sublimity" ("Art-as-Art Dogma," V). In Kant, nature alone properly has this power to provoke our mental faculties, though as we have seen, his examples also provide a parergonal sense in which the plastic arts may potentially evoke this emotion.[13] But if we are thinking of the reception of Kant's ideas, we cannot, because of theoretical scruples, exclude the many historical attempts to materialize at least a recollection of the sublime in the visual arts. To do so would indeed be to frame art with philosophy in a restrictive manner. There can be little question that Burke's theory of the sublime affected how both his contemporaries and ours saw and represented nature in art, as Andrew Wilton has amply demonstrated in *Turner and the Sublime*. The case is less clear with Kant's more extensive and technical formulation of the sublime. In general, as I have emphasized, it is difficult and counterproductive to try to isolate a "pure" Kantian strain to trace in the visual arts. Kant did, after all, respond to the many current discussions of the sublime, Burke's especially. Yet we may speculate that Kant modified and expanded his predecessor's ideas from an identifiably German cultural perspective. Concurrently – and in accord with Kant's theories, if not under their direct influence – German landscape painters opened up possibilities for the depiction of the sublime that were radically different from those of their British contemporaries, who in general tended in the early nineteenth century to adapt Burke's theories of the overwhelming vagueness and inchoateness of natural phenomena to their canvases. In short, some German landscape painters around the turn of the nineteenth century embodied the visual specificity and sublime detail theorized by Kant as "mathematical." The result was an unexpectedly vis-

ible "nationality" of sublimity.[14] My argument will return us first to the German-speaking artists' colony in Rome considered in Chapter 2, as it was there that Joseph Anton Koch, creator of the most mathematical of all sublime landscapes,[15] heard about Kant from Fernow. My perspective on this eighteenth-century context anticipates my subsequent treatment of the thematics of time and space in Lyotard's discussions of Newman's abstract sublime. But let me first think through Kant's important revisions of Burke on the theme of infinity, one of the touchstones of the sublime.

Kant discharges his considerable debt to Burke in section 29 of the third *Critique*.[16] His praise for the man "who deserves to be mentioned as the foremost author" on the topic turns out to be backhanded, for Burke's theories are for him "merely empirical" (§29, 277) and cannot therefore claim universality. Kant finds no security in the homogeneous human physiology supposed by Burke to guarantee judgments of the sublime. Kant insists instead on a "transcendental discussion" of taste in all its facets (§29, 278). Kant's critical investigation of both the beautiful and the sublime yields his most famous innovation in the aesthetic: whereas Burke (and almost all other commentators)[17] hold that sublime qualities can be predicated of objects, Kant's Copernican analogy casts them as functions of our own mind. But I want to look more closely at Kant's subtle and crucial distinction between the "mathematical" and "dynamical" sublime (a terminological difference introduced in the first *Critique*), a difference that is emphasized by the specific placcment – or, we could say, the timing – of his references to Burke. His nod in Burke's direction comes very late in Kant's examination of the species of sublimity and specifically after his summation of the dynamically sublime, the version closest to Burke's. "If we are to judge nature as sublime dynamically, we must present it as arousing fear," Kant writes (§28, 260). The movement or agitation of the mental apparatus when fear or terror is upon us is fundamental to Burke's theory of the sublime: "whatever is qualified to cause terror, is a foundation capable of the sublime" (1958, 131). For both men, fear must be genuinely felt, yet its source also safely distant, as of course it typically was in the arts of the later eighteenth century.[18] Burke develops his entire theory around this premise, emphasizing that vagueness and the inability to see (or imagine) precisely that which makes one afraid is crucial to the experience of the sublime. Kant endorses a transcendental version of this position: "the sublime can . . . be found in a formless object, insofar as we present *unboundedness* . . ." (§23, 244). But he also offers what can

be considered a conscious alternative, the mathematical sublime, a new category introduced, not only to follow the pattern established in the *Critique of Pure Reason* of distinguishing dynamical and mathematical judgments, but, more important, to revise Burke along specifically German lines.

"We call *sublime* that which is *absolutely large,*" Kant writes at the beginning of his section on the mathematical sublime (§25, 248). This greatness is not empirical. It involves measurement but not comparison. It invokes no principle of cognition from the understanding and is thus an aesthetic judgment. It is accomplished in "intuition (by the eye)," not by logic (§26, 251). Reason would seem to be left out of this aesthetic estimation, but as we saw in Derrida's reading of Kant, the opposite is the (surprise) result. The advent of the mathematical sublime is for Kant a transcendental drama among the faculties. Large or small, he claims at the end of section 25, empirical reality as "an object of the senses" is never sublime (250). The appelation Sublime is reserved for what happens when "our imagination strives to progress towards infinity, while our reason demands absolute totality as a real idea." Thus, he declares, "our power of estimating the magnitude of things in the world of sense, is inadequate to that idea. Yet this inadequacy itself is the arousal in us that we have within us a supersensible power" (§25, 250). Ultimately for Kant, our ability to intuit infinity in art and nature – and thus our own supersensible superiority as human beings – is what is sublime. Recall that this is the very drama played out in front of the pyramids and at St. Peter's. In these examples, the feeling of the sublime relies upon the perfect harmony of "apprehension" and "comprehension," which in turn depends upon the correct physical placement of the human observer. Clarity of perception is the goal of and the spark for the mathematical sublime, a quality relying on a perceptual distinctness antithetical to Burke. "To see an object distinctly," Burke claimed, "and to perceive its bounds, is one and the same thing [and] a clear idea is thus another name for a small idea" (1958, 63). For Kant, on the other hand, the final boundedness *in reason* of even the seemingly boundless pyramids or the Milky Way is the source of their sublimity in us. Again, the sublime is for Kant a technique for circumscription.

Kant's use of the sublime of the pyramids is parergonal in both his and Derrida's terms. For Kant, the example is conventional and merely supplemental, yet it opens the possibility, theoretically and historically, for artists to exploit the mathematical sublime. As in Derrida, then, what is in one context peripheral, an outside border, becomes central.

8. Joseph Anton Koch, *Der Schmadribachfall*, 1811. Oil on canvas, 123 × 93.5 cm. Leipzig, Museum der Bildenden Kunste. Photo courtesy AKG, London.

Kant's references to art in the "Analytic of the Sublime" suggest both possibilities. We are shown that the sublime may be engendered by aesthetic objects, but Kant immediately recoils from his own unusual enthusiasm to warn that, contra Burke, the sublime cannot truly inhere

117

in "products of art (e.g., buildings, columns, etc.), where both the form and the magnitude are determined by a human purpose," or even in natural objects that are teleological by definition. Only "rude nature" qualifies, and only as an occasion for the feeling of the sublime in the judging subject (§26, 252). But typically, Kant has made it possible for us to think of the sublime *as if* it were produced by art and nature. If we apply this possibility to the mathematical sublime, we could imagine nature in all her fecund detail as sublime. An example could then be the *Schmadribachfall* by Joseph Anton Koch, the first version of which he painted in 1811 (Fig. 8).

We are meant to have an extraordinary view of nature in this image. According to the artist, we see "a true portrait after nature," and he was proud of the amount of detail included. Koch's claim is found in a detailed written description of the work presented to Johann Peter von Langer, a potential buyer. His words capture the painting's most significant characteristic – and that which filiates it with Kant's mathematical sublime – the way in which each part of the surface is clearly and equally visible. The scene, he writes,

> presents a view in the Swiss Alps . . . [A] magnificent wilderness with glacial cascades [and] clouds – which in part veil the mountains – make up the background. In the middle you find an impenetrable forest of firs and other wild vegetation, and rock fragments intermixed with rushing water. The foreground is the depth of the valley . . . into which the water pictured above rushes. (Lutterotti 1940, 148)

But as other commentators have noticed, the traditional divisions of fore- middle-, and background noted by Koch do not function in the usual way. Instead of leading the eye easily into the distance, the diagonal lines created by the riverbanks, the edges of the forest, and the sharp cliffs in the upper parts of the canvas form a surface zigzag pattern that leads our gaze from bottom to top, or vice versa, in planimetric fashion. There is little sense of depth or volume. The supposedly distant mountain peaks are shown in as much detail as the ducks in the immediate foreground. The result has been confusing, both to Koch's contemporaries and to twentieth-century critics, but I would suggest that this is because Koch was presenting a new (not an incompetent) vision, an aesthetic of particularity. His emphasis is in harmony with Kant's mathematical sublime in its ability to overwhelm with detail. With the staffage figure in the painting's foreground, we as observers view nature's magnificent, seemingly infinite detail. We can see so much that

our effort to absorb it all is defeated, pleasurably. As in Kant's lesson about the pyramids, if we place ourselves correctly, we can see "everything" whole in reason's idea of the infinite and see that whole in one "intuition," as Kant required. Reason can operate in Koch's painting by responding to the demand for measurement in one unit. Because the entire image is focalized through the inclusion of the small human figure whose relationship to the whole is a crucial theme, it would be possible to think of infinity, as pictured here, in terms of humanity's supersensible vocation, as Kant put it. Though Kant does not explicitly link landscape painting, as what we might call the symbol of nature, with moral edification, he does in the "Critique of Teleological Judgment" supply the necessary ingredients for just such a theory. Speaking of how we must "discipline" our animal instincts in the face of nature, he suggests that our proper nature in effect reveals that nature "strives to give us an education that makes us receptive to purposes higher than what nature itself can provide" (1987, §83, 433). He then explains that we also have the fine arts to remind us again of this "higher vocation" and prepare us "for a sovereignty in which reason alone is to dominate" our lives (§83, 433). As Crowther has aptly pointed out in essays on Newman and on the contemporary sublime, the emotion of the sublime is fundamental to Kant's humanism (1985b; 1995). We may begin by measuring nature, but the sublime is finally a positive estimation of ourselves. All of this can be realized in Koch's landscape paintings.

As I noted in Chapter 2, Koch was one of the artists who attended Fernow's lectures on Kant at the Villa Malta in Rome in 1795. Whether or not he heard about Kant's sublime in this context, Koch embraced in his own work what the contemporary natural philosopher Heinrich Steffens identified as fascination for the exact details of physical nature that were the subject of the nascent science of geology, a field that he held was German in origin. This scientific preoccupation with particularity stands behind the mathematical sublime in theory and in landscape depiction.[19] Kant was an important philosopher and teacher of science, including geography and geology. As his reference to Benedict de Saussure's *Voyages dans les Alpes* (1779–96) in the third *Critique* suggests, he was well aware of the literature on geography and geology. He was concerned with the details of nature as well as with its grand operating principles. As a result, Kant's theory of the sublime significantly expands the opinion of the Scottish philosopher Alexander Gerard, typical of its time in its generalizing impetus vis-à-vis nature. For Gerard, the "sublime of science lies in universal principles and

general theorems" (1759, 17). Kant includes the "particulars" of nature, as they were called at the time. More important in this context, the second part of Kant's final *Critique*, the "Critique of Teleological Judgment," brings scientific and aesthetic judgment into close and often analogical proximity. I have mentioned before that Goethe found this combination very potent: "the results of both art and science were discussed, and aesthetic and teleological judgments were mutually clarified," he noted. Certainly Koch was not as theoretically inclined as Goethe or Kant. Yet he recorded that one of his two favorite books (along with the Bible) was A. F. Büsching's then famous *Neu Erdbeschreibung* ("New Description of the Earth," 1766–69) (Lutterotti 1940, 4). It should not be a surprise, then, that the *Scmadribachfall*'s extraordinary detail was of scientific import for the period. He illustrates the effects of water erosion, important at the time to theories of the earth's development. The picture's precision also allows us to notice the clouds that hang near the mountain's summit. In his *Italian Journey* (1786–88), Goethe suggested that "the most manifest atmospheric changes are due to [mountains'] imperceptible and secret influence" (31–32). Koch may not have known Goethe's theory that gravitational force attracts clouds to mountains in this way, but in his own careful travel records he often recorded the interactions of land and atmosphere. Seeing the systematic, seemingly purposive interactions of nature in this landscape painting, we can speculate that for contemporary viewers the image encapsulated the sublime. Kant wrote:

when in intuiting nature we expand our empirical power of presentation (mathematically or dynamically), then reason, the ability to [think] an independent and absolute totality, never fails to step in and arouse the mind to an effort, although a futile one, to make the presentation of the senses adequate to this [idea of] totality. [That] this effort . . . is unable to attain to that idea, is itself an exhibition of the subjective purposiveness of our mind . . . for the mind's supersensible vocation. (§29, 268)

For both Kant and Koch, extensive visibility in the empirical sense makes vision in a transcendental sense possible. In general and by contrast, British practitioners and theorists sought the effects of the sublime in indistinctness and the resulting inability to measure what one confronted in nature. Referring to Turner's 1812 *Snow Storm: Hannibal and His Army Crossing the Alps*, Wilton claims that "here indistinctness is the essence of the sublime" (72), which is one of Burke's central tenets.

The vortex of clouds engulfs Hannibal's troops, whose disarray and terror are barely seen even though it is daytime. In theories of the sublime as expressed in Sir Joshua Reynolds's contemporary reflections on the grand manner in history painting or Gerard's and Burke's aesthetics, too much detail is held to spoil the sublime effect. William Gilpin, another central theorist of landscape from this period, wrote in 1791 that "many images owe their sublimity to their *indistinctness;* and frequently what we call sublime is the effect of that heat and fermentation, which ensues in the imagination from its ineffectual efforts to conceive some dark, obtuse idea beyond the grasp. Bring the same within the compass of its comprehension, and it may be *great;* but it will ccasc to be *sublime*" (Wilton 1980, 72). Kant's dynamical sublime agrees with this model, but his mathematical species trades precisely on visibility. British artists of the time expressed their difference from (and supposed superiority to) German nationals in exactly these terms. The Welsh landscapist Thomas Jones, for example, after visiting the studio of Philipp Hackert (a very successful German landscape paintcr working in Italy in the latter half of the eighteenth century), complained that, "like most German artists, [Hackert] stud[ies] more the *Minutiae* than the grand principles" of art (117). Wilton conveys this negative judgment to our own time with reference to Turner, who he claims "does not attempt, like a club bore, to recount endless little incidents in detail" (74). But for many German artists, theorists of the earth, and Kant, details were anything but small in import.

The mathematical sublime was specific to Kant's time and its geological discoveries. Paradoxically, it also depended in part on the experience of mountainous places he never visited but (only) read about. And initially, its cognate in landscape painting was identifiably German. Though it is a leap, let us move now to the abstract sublime of Barnett Newman, who in an exemplary and instrumental manner also insisted on the priorities of place and time. It was just over fifty years ago that Newman published "The Sublime Is Now" (1948), proclaiming that in the sublime "we are reasserting man's natural desire for the exalted, for a concern with our relationship to the absolute emotions" (1967, 53). He asserted that only in the "America" of the 1940s could this powerful mode of painting be reawakened. His inflated rhetoric bespeaks both his personal vision of a transcendent abstract art and the cultural swagger of postwar America. Newman combined a sense of the cultural specificity of the sublime and his calling to express it with a paradoxical proclamation of his impossible freedom from such boundaries:

I believe that here in America, some of us, free from the weight of European culture, are finding the answer, by completely denying that art has any concern with the problem of beauty and where to find it. . . . If we are living in a time without a legend or mythos that can be called sublime, if we refuse to admit any exaltation in pure relations, if we refuse to live in the abstract, how can we be creating sublime art? (1967, 53)

Newman was as powerful a thinker as he was a painter, but we should not look for philosophical consistency in his texts. Another "savage" art writer, in his article on the sublime he refers to Burke and to Kant only as a way to articulate a vision of art equal to his own aspirations.[20] If he was "free" from European culture, it was because he worked assiduously, dialectically, away from Mondrian's "pure relations." Refusing Mondrian's key term, "plastic," Newman exalted the "plasmic" quality of the sublime. To the new abstract painter he wrote, "it is not the plastic element that is important; [it is not] the voluptuous quality in the tools [color, line, shape, space] that is his goal, but what they do. It is their plasmic nature that is important," that is, "the subjective element in them that will in turn stir a subjective reaction" in the viewer (1992, 143). The plasmic is indeed very Kantian.

American versus European, the "now" versus tradition: these were Newman's coordinates for a new sublimity. For Lyotard, however, Newman's "now" is much more immediate. It is the phenomenological perception of the "instant" rather than a large and historical emplacement. It responds to the effects of Newman's paintings rather than to the sweeping contextualization of "The Sublime Is Now." "For Newman," Lyotard speculates, "creation is not an act performed by someone; it is what happens (this) in the midst of the indeterminate. . . . What is sublime is the feeling that something will happen, despite everything, within this threatening void, that something will take 'place' and will announce that everything is not over. That place is mere 'here,' the most minimal occurrence" (1989b, 243, 245). Lyotard uses Newman's work as his example to demonstrate that, as Kant implied with his notion of mental agitation, the sublime "now" "dismantles consciousness" (1989a, 197). But in Kant and Newman, consciousness recovers in a spectacular manner to reassert its anthropocentric authority. Lyotard is similarly emboldened – perhaps by the triumphs of the sublime he sees in Newman – to figure the movement of the sublime transhistorically as the germ of the modern and avant-garde. In passages that articulate a theory of history and art-historical progress surprisingly consonant with those of Greenberg, "the possibility of nothing happen-

ing" becomes for Lyotard, not the impass an artist might encounter in beginning or completing a painting, but rather a pause in the self-renewing traditions of art. Newman's sublime "instant" becomes historical (again): "Thus, when he seeks sublimity in the here and now he breaks with the eloquence of romantic art but he does not reject its fundamental task, that of bearing pictorial or otherwise expressive witness to the inexpressible" (1989a, 199). Ultimately, Lyotard employs the sublime of Newman as a basis for his claim, materialized in his 1985 exhibition *Les Immatérieux,* that "today's art consists in exploring things unsayable and things invisible" (1989a, 190). It seems to me that Lyotard should have known better than to be seduced by his own rhetoric of the sublime into a claim so broad as to be meaningless. Looking back, surely the sublime as a goal for art's aspirations qualifies as one of the West's classic "grand narratives of speculation and emancipation," which, as I have emphasized, Lyotard thinks are – or at least should be – failing us in the postmodern era (1984, 38). Nonetheless, there has in recent art been a decided return to aspects of the sublime articulated theoretically and plastically since the eighteenth century. Commentaries on this resurgence of the sublime in the visual arts began to appear in the mid-1990s; essays, artists' statements, and exhibitions on the theme show no sign of stopping for the millennium.[21] Considered as examples of the sublime, any of the many works we might choose to discuss focus our attention on the theoretical difficulty of presenting the unpresentable. But why should artists heed the prohibitions of Kant's philosophy or of contemporary theorists of the sublime? Perhaps there can be a plastic (or plasmic) "theory" of the sublime that is not restricted by the contradictions of presentation that Kant, Derrida, Lyotard, and others have seen. To explore these possibilities, and to give a sense of the range of responses to the historical sublime now current, I will proceed to the most concrete of examples.

The term "sublime" is commonly invoked today to express the "exalted," as Newman said, or the ineffable – that which is present to consciousness but beyond language. True to its eighteenth-century sources, the contemporary sublime is also usually thought of as unpresentable, if not unimaginable. In addition to these traditional connotations, the sublime in the visual arts today can be understood as a figure of limits or boundaries. Even though the sublime is usually cast as limitless, it is in fact always at work at the extremes of a particular discourse or art practice, defining its provisional contours. If this sounds like a transhistorical description, one as applicable to Newman

as to artists today, I hope to show that the extremes defined and re-defined through the sublime are always made present in particular, historically contingent, and material ways. The sublime in the visual arts manifests itself along a scale from the explicit to the almost impercept-ible, from its detailed theorization and materialization by Christian Eckart and Sheila Ayearst to its tangential intimation by Andy Patton or General Idea. References to Kant are surprisingly common but of course not always present. But rather than proceed on a scale from overt to covert, I want to articulate three thematic areas in which we can observe the sublime in recent art and that will allow us to compare artists not often brought together in a critical context.

Scapes

Why would Toronto painter Andy Patton go to the trouble, discomfort, and considerable danger of painting the inside of an abandoned con-crete silo blue (Fig. 9)? Of course there could be many credible explana-tions that have nothing to do with the coordinates of the sublime, from his longstanding interest in the properties of blueness in light and pig-ment to a desire to assert the nonmonetary value of art works by putting them where most people cannot find let alone buy them. But Patton's silo work also points toward the attraction of difficulty in what he calls the "terrain" – both physical and intellectual – perhaps even to the pleasure that attends a certain type of disquiet associated with that difficulty. As we have seen, both Burke and Kant rely on danger and pain in discussing the sublime. In Patton's *Grand Valley Silo*, the ex-treme physical effort required to paint the structure during the summer heat can be construed as "terrible" in Burke's sense, or productive of psychological "terror." At the same time, the prior awareness that one's efforts will cause pain provides the psychic distance that converts pain to pleasure and makes the overall experience compelling, one that an artist might want to repeat. Mystery and ineffability are also qualities that Patton values highly and seeks in the deliberate obscurity of his work. He wants us to experience art before we ascribe particular mean-ings to it, and he is mistrustful of language both in and about art. One result – signaled by the contrast between the inside and outside of this piece and its existence, seen from afar, as a mere abandoned farm struc-ture versus its metamorphosis into an articulate work of art when one notices the interior – is the blurring of borderlines between art and non-art. In Patton's site works generally – partly because they are in a land-

9. Andy Patton, *Grand Valley Silo (interior)*, 1993. Silo 24 feet tall × 12 feet in diameter; painted area 12 feet tall × 12 feet in diameter. Photo courtesy the artist.

scape or a derelict industrial site, public places that at once reference the economy of the "real" world *and* a traditional art genre – the extreme emotion of the sublime derives from the "obscurity" and "difficulty" of their execution and placement. Both the artist and viewer(s) can feel this emotion, which pushes us to a limit of linguistic comprehension and generic identification. *Grand Valley Silo* simulta-

neously crosses and proposes a new, though provisional, border between art and non-art, landscape as an artistic tradition and as part of the extended world that always lies beyond – and thus frames – art. Finally, Patton's silo can function successfully as a nonlinguistic presentation of the sublime in part because its author nowhere makes explicit the possible links between this landscape tradition and his work. This presentation was only indirectly framed by Kant, Burke, and the devices of the sublime in art.

Paterson Ewen's "phenomascapes" function more explicitly than Patton's art works along the borderlines between art and the physical environment, limits marked by the extreme condition called the sublime. The corporeality of these works makes reference to and serves the traditions of the landscape sublime. The phenomena presented by Ewen – a tornado, a shipwreck, a typhoon (see Fig. 10) – tie his work clearly to the iconography of the landscape sublime of the early nineteenth century. In addition, the danger of his working process itself mimics the sublimity of his subjects. He describes his routing technique as a "struggle" and underlines the frisson of the process. Describing the making of *Rain over Water* (1974), he says:

You have to remember that up on two saw-horses about four feet high [the plywood on which I work] is a platform. . . . When I move to one side and I feel it tipping I must be careful to shift my weight back and stretch out my arm as far as I can. And this is [a] very *exciting* and very *physically demanding* process, the machine is very noisy and dangerous at 25 thousand revolutions a minute, I have to be careful not to get my clothes caught or gouge the side of my knee. (Monk 1987, 25–26; my emphases)

Although not consciously, Ewen's habit of reproducing the sublime when he works ("my hands and eyes are ready for the attack on the plywood, . . . the adrenaline flows and the struggle begins" [Monk 1987, 28]) parallels J. M. W. Turner's notorious propensity for experiencing the sublime in nature as a prologue to his work. About his 1842 *Snow Storm* (whose full title includes the phrase "The Author was in this Storm on the Night the Ariel left Harwich"), Turner reported that he was lashed to the mast for four hours to observe the effects of the sea and storm. The resulting image overpowers the viewer with its swirling vortexes of spray and precipitation and its overall obscurity. John Ruskin's impassioned contemporary description of this painting functions as both an actual and an ideal audience response to the scene. He

locates its sublimity in the disorientation and blurring of quotidian boundaries:

conceive the surges themselves in their utmost pitch of power, velocity, vastness, and madness, lifting themselves in precipices and peaks, furrowed with their whirl of ascent, through all this chaos; and you will understand that there is indeed no distinction left between the sea and the air; that no object, no horizon, nor any land-mark or natural evidence of position is left; that the heaven is all spray, and the ocean all cloud. . . . (Ruskin 1987, 158)

This description is as apt today for Ewen's *Typhoon* (1979; Fig. 10) as it was for Turner's *Snow Storm*. A reproduction of Ewen's image rationalizes it through the compression of what is, when one views the work, a welter of visually and psychologically disorienting gestures made by Ewen's router and his application of pigment. In the reproduction, we seem to see three quite distinct spatial bands: an area of sky with the veiled sun in the top third; a dark middle band that can be read – though not definitively – as a shoreline or breakwater; and the smoother and predominantly blue bottom third of the image, which can be seen as the sea. But standing near the work, the physical interpenetration of gouges and color across the entire surface disrupts this conventional organization. The sun, for example, is stripped away on the right side, sucked into the storm. The foreground is smoother than most of the rest of the surface; we feel closer to it than to the balance of the image, with the result that one-point perspective is felt to be suspended here, in spite of the pull of the orb in the "background." Ewen emphasizes the relation of all his router works to his own body, and to the fact that he is in the middle of these pieces as he makes them. If we imagine this corporeal viewpoint as we look at *Typhoon*, the spatial disorientation that results from conventional looking is in a sense resolved, but only in favor of a radical experiencing of the violence of the storm (as phenomenon and as art making) as we imagine ourselves to be in it, looking around rather than at it from outside. We are implicated in the phenomena of the sublime. Are we meant to be in the world or (merely) within a landscape painting? Ewen exploits this uncertainty to bring phenomena into art, momentarily moving a limit that we know must exist.

It is not surprising that much of the return to the sublime in recent art has happened in painting, the medium in which the discourse of the sublime definitively materialized in the early nineteenth century. But even in the context of "scapes," traditionally painting's territory, artists

10. Paterson, Ewen, *Typhoon*, 1979. Acrylic on plywood, 228.6 × 243.8 cm. Collection of McIntosh Gallery, The University of Western Ontario. Purchase, McIntosh Fund with assistance from Wintario, 1980. Photo courtesy the artist and the McIntosh Gallery.

today are using other media to bring the sublime up to date. Jan Peacock's multimedia installation *Nuits Blanches: Dark Days, Sleepless Nights, Voice and Nothing More* (1989–90; Fig. 11) employs satellite weather maps and an image of a tornado to reference the landscape and meteorological phenomena. She is concerned especially with our society's obsession with technologized images of these phenomena, images of putative rationality and control (which, ironically, we might see after a nightly news report on the uncontrollable effects of such a storm). As in Ewen's phenomascapes, Peacock makes sure we partici-

11. Jan Peacock, *Tornado Machine,* video projection from the installation *Nuits Blanches: Dark Days, Sleepless Nights, Voice and Nothing More,* 1989–90. Photo: Sheila Spence, courtesy the artist.

pate in the phenomena of the sublime. Not only do we see an effect of a tornado, but to enter the installation onc must walk along a tin sidewalk with microphones below that are connected to speakers in the corners of the room. We hear the "thunder" of our own progress through the work. In the catalogue accompanying the installation at the Macdonald Stewart Art Centre (Guelph, Ontario), Peacock superimposes a text over some of her images, a text that makes explicit the reference to the sublime. Not knowing where we as individuals are on these maps, or indeed in her installation, but seeking to place ourselves amid the rush of information, "we are overwhelmed by the potential of inclusion, awash with the impossible promise of the sublime," she writes. What is this promise? It is the sense of omniscience, of understanding and seeing more than one person ever truly can. "Everyone has a night," Peacock continues, "when they are, suddenly, seeing *all* the stars (your breath catches)." Her simulated sublime underlines both our desire for

ultimate experience and the futility of this desire. The sublime promises limitlessness of vision – as the technology of meteorology does – but finally, the work of art can only construct new borders for experience and art.

The Limits of Pointing

New York artist Christian Eckart has since the mid-1980s sustained an intense relationship with the thematics of the sublime. Though he is well aware of the history of this discourse, his main concern is with its present potential. In the most general terms, he wants to "address the viability of the spiritual in art, despite the fact that it's been rejected by most of my contemporaries," as he put it in a recent, published interview. Pointing to religious art's historical role "as a doorway to the transcendent and/or the sublime" (Seliger 1990, 51), Eckart has constructed abstract paintings that allude to the spiritual sublime but also question its presence in contemporary society. Thus, even though he works in monochromatic abstraction, he has an aversion to Newman's aggressive rhetoric in "The Sublime Is Now": rather than reinstate the sublime as a transcendent discourse, he seeks to "re-direct the seeing, looking and thinking that we've inherited from that period."

The titles of two of his series from the late 1980s – the "Andachtsbild" pieces and the "Eidolons" – are themselves recondite enough to promise the mystery of the spiritual and sublime. "Andachtsbild" translates as "devotional image": in these works Eckart simultaneously tries to expose the tools, as it were, of the sublime's effect – how it transports the viewer through the evocative use of color and shaped space – and to recapture a critical belief in the existence and power of that extreme phenomenon of the sublime. In *Andachtsbild no. 716* (1990, Fig. 12), for example, we see the multiple framing typical of this series. These paintings are mostly frame, at least if we consider the "empty" space(s) through which we see the gallery wall. The frame (gold leaf in this case) presents this space to the viewer in its preciousness, a meditation not only on the religious and sublime as exalted forms of experience, but also on the beatifying role of the gallery system, especially in New York, where many of these works have been shown. For Eckart, like Patton in *Grand Valley Silo,* the frame "manages" that which is inside (art) and outside (the world): "it becomes a boundary between the profane and the sacred." We could even speculate that in these paintings, the frame, as the manager of boundaries and the liminal, *is* the "incarnation" of the

sublime. Of course the sublime cannot literally be shown – it is conventionally theorized as beyond our grasp – but perhaps Eckart can with his framing point to its inside limit, the places where it borders our experience. In a sense he tries to touch the sublime's surface or edge and thus sets up an interrogative experience in which a viewer may ask, "Am I near the sublime?" For Eckart, however, such a question is anything but a statement of blind faith. "You get there only with a lot of doubt," he claims.

In another ongoing series, called *Eidolons* ("phantoms") (Fig. 13), the void, that place where we project our needs and desires, seems to push the frame away by making it thinner than in an *Andachtsbild*. We are left with a gold-leaf frame bounding a distorted, seemingly dynamic, cruciform. By setting this work well away from the wall, Eckart is able to frame the space as well as the shape and color of his "empty" image. The activity of framing here lets us see again that it is not the void which is the sublime (or that points to this unpresentable beyondness). The sublime is figured in the production of boundaries, in the limit, or, more prosaically, in the changing *uses* to which we put this discourse of the ultimate: it is in the viewer if it is anywhere. It is in this context that we can understand Eckart's assertion that he is "interested in . . . the political economy of the sublime," in its "socio-cultural utility" (Seliger 1990, 53). For him, the exalted emotions and gestures of the sublime have been transferred in our society to forms of mass culture, whether that of sports, pornography, or what he calls the "scientific sublime," popularized concerns with natural forces and disasters such as the hole in the ozone layer and exploding asteroids. Thus he has recently moved from the production of abstracts to a series he calls "veils," images of specific mass-culture themes that he partially obscures visually by screening several layers of white pigment over the represented forms. For Eckart, then, the sublime is now, but with many differences from its past incarnations. No longer does the image he constructs invite transcendent reverie. More likely, as in *Drag Racing Mishap* from the "Veils" series, for example, we see a frozen portrait of a car in flames, an image of what he calls the masculine desire for danger as source and receptacle of extreme, exalted emotion – the sublime. Eckart takes his images for the veils from commercial electronic media and embalms them for our scrutiny. In other examples from this series, the eroticized body as produced and manipulated by commercial pornography also points toward the desire for that ineffable maximum of human experience.

It is in this context that we find a surprising confluence between

12. Christian Eckart, *Andachtsbild no. 716*, 1990. 23-carat gold leaf on gel medium on birch plywood panel and 23-carat gold leaf on pine and poplar molding, 96.5 × 60.5 inches. Collection: Laage Salomon. Photo Patty Wallace.

Eckart's ideas and recent work by the now disbanded collective General Idea. GI's slick yet trenchant exposés of the art world's pieties and commercialization might seem like the last place to look for interest in something as weighty as the sublime. While they have always made serious comments in their work, up to the later 1980s their unique irony and humor certainly blocked any concern for Burke's "strongest emotion which the mind is capable of feeling." But their recent focus on environmental and medical concerns takes us directly to the historical

13. Christian Eckart, *Eidolon no. 1103,* 1989. 23-carat gold leaf on poplar molding with iron hardware, 96 × 78 inches overall. Collection: Robert Feldman and Parasol Press, New York. Photo: Patty Wallace.

discourses of the sublime, providing one framework for the interpretation of GI's "Fin de Siècle." Where they formerly pictured themselves as preening poodles, GI famously changed its emblem to that of the seal-pup-as-victim for the recent *Fin de Siècle* exhibition. The installation of the same name shows these pup-artists marooned on a sea of polystyrene ice floes (1990, Fig. 14), a direct allusion – as GI themselves point out – to the nineteenth-century German painter Caspar David Friedrich's *Sea of Ice* (1823–24, Fig. 15). The ship devoured by natural

14. General Idea, *Fin de Siècle,* 1990. Three elements of acrylic, straw, glass; unaltered sheets of polyexpanded styrene. Installation view: Württtenbergischer Kunstverein, Stuttgart. Private collection, Turin. Photo Reinhard Truckenmüller, courtesy A. A. Bronson.

forces is also a classic of the sublime in landscape painting. Not only does it rely on Burke's notion of terror in the face of unimaginable power, but the image can also be seen to invoke a variant on the sublime conceived by Kant, the mathematical sublime. In Friedrich's painting, because we can see plainly each block and shard of ice and what they have done to the ship and its crew, we have an idea of nature's infinite power. Here Friedrich drew on contemporary newspaper accounts that identified the ship as the *Hope;* the image has often been allegorized as the "Wreck of the *Hope.*" In *Fin de Siècle,* the seals appear intimidated by the "ice" that should be their chosen home but that now works as a metaphor for the fate of such helpless creatures in the commercial and physical environment of the 1990s. Polystyrene is anything but a natural habitat, and in the installation they are pitifully small and decidedly cornered. In Kantian terms, viewers are here overwhelmed by imaginings extending from what can be seen and measured. How can these poor pups survive? Can there be hope for them? GI has transmuted Friedrich's meditation on human frailty in the face of all powerful nature into an allegory of environmental ruin.

The magnitude and finality of a fin-de-siècle pessimism take on sublime proportions in GI's sea of allusions, especially when they turn to medical themes, such as "pharmacopia" and AIDS. Again these works invoke the mathematical sublime: how can one measure the effects of AIDS? Yet in *One Year of AZT and One Day of AZT* (1991, Fig. 16) and related works, the group offers the hope of comprehension, just as medicine offers the hope of a cure. We can count the capsules, but we are

15. Caspar David Friedrich, *The Sea of Ice*, 1823–24. Oil on canvas, 38.5 × 50.5 inches. Photo courtesy Hamburger Kunsthalle.

overwhelmed by the "answer." GI do not capture the sublime, but they do employ the pleasure/pain dyad so important to Burke and to Kant. Embedded in the narration of their career in the 1992 *Pharm©opia* catalogue is a lengthy passage from Burke, a passage that emphasizes both the importance of pain and the necessity that it can be distanced aesthetically. "When danger or pain press too nearly, they are incapable of giving any delight, . . . but at certain distances, and with certain modifications, . . . they are delightful" (1992, 61). We know that many people pleasurably witness the pain or pleasure of others *if* this distance obtains: Eckart's *Drag-Racing Mishap* exploits this embarrassing truth. Through art, GI constructs a certain distanced relationship to AIDS, one that circumvents autobiography and perhaps allows us to sense the scale of the medical tragedy as we cannot do if we are "too close." In their invocation of the sublime, GI thinks through the relation of art to real-world cataclysms and sets down new borders between these

16. General Idea, *One Year of AZT and One Day of AZT,* 1991. 1,825 units of vacuum-formed styrene with vinyl, 12.7 × 31.7 × 6.3 cm. National Gallery of Canada, Ottawa. Purchased 1995.

realms. "We were experienced enough to know our art-filled illogical solutions were not the warriors required to battle biological enemies," they write. Yet "we set our mind on a cure. And the lack of one!" Eventually, the "solution" found is the capsule that we see in Figure 16, the "perfect little pleasers that you could hang on the wall and *distance yourself from*" (1992, 61; my emphasis).

Intimations of a Countersublime

In response to the clear increase in interest in the sublime of late, critic Meaghan Morris has responded, "a new Sublime: what a terrible prospect" (1988, 214). Her sentiment can be seen in some visual responses to the category as well. Each of the artists I have looked at is closely and critically (though sometimes indirectly) involved with discourses of the sublime that first became important in the visual arts in the latter half of the eighteenth century. A more overtly oppositional encounter with the

sublime is found in the painting of Sheila Ayearst. The sublime has been gendered male since its inception, as we saw with reference to Frances Reynolds, long-suffering sister of the "sublime" Sir Joshua. In art, partaking of the sublime turns out to be quite a privilege, given that such subjects are by definition the most exalted. The sublime has been the discourse of insight and transcendence, a mode in which one may break and remake the rules of art. Sheila Ayearst sustains a complex inquiry into the protocols of this discourse on its home ground: landscape. Since 1989, she has been working with imagery and sites canonized – in the Canadian context – by Jack Chambers's *The 401 towards London No. 1* (1968–69). Chambers initially saw the view painted here in the rear-view mirror as he was driving from London, Ontario, to Toronto on the highway recorded in his title. He wanted to capture the scene, so he drove onto an overpass and took a series of photographs to work from later. For him, the original perception was a "wow!" experience, a realization that "anything that one *sees* is in its actual presence also more than we can in any one way understand it to be" (Chambers 1982, 114). The completeness and perfection of the experience overwhelms us; Chambers's artistic response, which he called "perceptual realism," attempts to record this sublimity, and the resulting painting therefore conveys an inclusive, commanding presence. Ayearst feels both attracted to and barred from the epiphany encapsulated in this sort of painting. She believes that her position as a woman in the late twentieth century makes "this kind of personal 'religious' vision of art unavailable."[22] But she does not simply reject Chambers's vision, or indeed the medium of painting. Compelled by the promise of this privileged access yet ultimately ambivalent toward it, she records "the other artist's sublime experience with nature." But even though she works in the same size and medium, she changes Chambers's presentation in ways that alert us to her differences from his enabling attitudes.

Chambers's *401* has the specificity of an overview: many of the thousands who drive along this highway will recognize the spot he records in the painting – even today, with all the changes in the area – but in a sense the scene is short on details because particulars have been sacrificed to inclusiveness. Ayearst, by contrast, often takes us very close to the road. In *The 401 towards London: Median* (1991; Fig. 17), for example, the viewpoint is low, near to the grass covering the median strip. In the distance, we see the bridge from which Chambers composed his view. Up close on the left, we see tire tracks in the gravel. Not only has Ayearst literally and metaphorically reversed Chambers's image, but in

this and others in her series, she marks where her source photo does not fit with his "original." *The 401 towards London: Verge* (1990) is even more explicit about the difference in "viewpoint": we see a car stopped on the verge, a vehicle with which Ayearst announces the overriding theme of this and much of her other recent work: "misplaced perceptions of security." In the early 1990s, four women were abducted from or near Highway 401. All were murdered. "The failure of the 'modern' (superhighways/suburbia) to efficiently deliver security," she writes, "is paralleled with the disintegration of the painted representation moving out from the centre of the canvas." With this perspective in mind, Chambers's view begins to look naïve or at least innocent, and sublime transcendence offends us with its willful blindness to reality. Ayearst's 401 paintings both subvert and exploit the aesthetics of the sublime. She refutes the transcendent view cherished by Chambers by insisting on specifics, both of appearance and history. As Naomi Schor has convincingly argued, in art, "the detail is gendered . . . as feminine," and it can therefore counter the "anti-particularist aesthetic" of the sublime (1987, 4, 5). On the other hand, Ayearst presents the danger in an "ordinary" scene and perhaps even relies – like the crime photos in which she is interested – on a viewer's morbid pleasure in looking at such disasters from a relatively safe vantage. No doubt we all sometimes wish to avoid or even forget the horrors of contemporary society. Ayearst's ambivalent sublime does not let us get away so easily: where, her images force us to ask, *is* the line between art and "real" experience?

When Newman's "The Sublime Is Now" was published in 1948, the editor of *Tiger's Eye* appended a short commentary to the six responses on the sublime: "of the two general rooms of thought, whether sublimity is a *beyondness* signifying man as eternal, or whether it is a *hereness* denoting a reverence or rare understanding of life, this magazine readily enters into the latter" (1967, 57). The contemporary sublime as I have found it also insists on the here and now, but it is skeptical about any "rare understanding of life." The promise of understanding connotes a special role for art; the artists I have looked at are more concerned with art's social functions – the possibility that it might have a role – than with a privileged access to truth. If I am right in claiming that the sublime for them works along the guarded borders between art and the social, defining both, then contemporary manifestations of interest in the sublime attest to this discourse's ongoing adaptability and functionality in the visual arts. Apparently, art, art history, and philosophy still need the sublime, partly because they continue to define themselves

17. Sheila Ayearst, *The 401 Towards London: Median,* 1991. Acrylic and oil on canvas, 6 × 8 feet. Photo Cheryl O'Brien, courtesy the artist.

in terms of one another. Lyotard has written, in his usual provocative way, that "sublimity is no longer in art, but in speculation on art" (1989a, 210). While he is right to include his own speculations and those of other – frequently French – theorists, the implication that the production of the sublime has somehow migrated between disciplines and settled in "speculation" is misleading, at least on the empirical plane. Differences between art and philosophy are less clear than in the past, but, as I have shown, the sublime works today to mark and perpetually remake such boundaries in a plasmatic way, not to legislate simply defined insides and outsides.

5

Kant's Skull

Portraits and the Image of Philosophy,
c. 1790–1990

The history of Immanuel Kant's life is difficult to portray, for he had
neither life nor history.

Heinrich Heine

Kant and Greenberg . . . keep arising from the grave like zombies.

Thomas McEvilley

The history of philosophy is comparable to the art of the portrait.

Gilles Deleuze and Felix Guattari[1]

A gainst Heine's quip that Kant had neither an outward life
nor a history, I will argue that Kant did have a life – and
especially an "afterlife" in the sense of a *Nachlass*. Kant's
place in the visual arts and art history has been emplotted through the
machinations of his reception. It is only within the necessarily unstable
and unpredictable contours of this inheritance that he lives. I have
sought to show that, despite his great authority and the wide range of
uses to which his name has been put in and around the visual arts and
art history, there is no stable, originary "Kant" – neither a "subject" nor
a collection of doctrines – from which these spatial and temporal rever-
berations emanate or to which we might seek to return. But "Kant"
endures. To investigate further his circulation within the elastic, plasma-
tic disciplinary space that I have been describing, I will offer in this final
chapter not conclusions but rather another perspective on Kant's effects
on art and its history. The history of Kant portraiture, the changes in his
"image" from the late eighteenth to the late twentieth century, provides

a unique trace of what I will theorize as his disciplinary "genealogy." Kant portraiture over the past two hundred years is both part of his reception and emblematic of it. Here we find the philosopher literally *in* art. Reciprocally and as evidence of the imbrication of word and image that I have stressed in opposition to Kantian calls for disciplinary autonomy and purity,[2] portraits of Kant are frequently embedded in the mainly textual and conceptual context of his doctrines and commentaries on them. I will look at three temporal/geographical moments in which visual images of Kant seem especially important. These are moments of "discipline," in the personal and institutional senses, among which his image moves in what I called in Chapter 1 a plasmatic manner. I will consider the portraits painted and sculpted in Königsberg in the late eighteenth century, along with the use of some of these images by artists working in our own time. As a frame for these discussions, I will focus on another set of "portraits" made in Kant's birthplace, but this time specifically at his grave site. It was here, in 1880, that the most unusual and decidedly macabre images of Kant were made – namely, the photographs of his skull that were part of the record of a detailed phrenological analysis. These are the first and only photographs of Immanuel Kant (Fig. 18).

Photos of Immanuel Kant

Kant died in 1804. More startling than the existence of photos of (part of) him – eerie given that they are of a dead man's skull – is the unusual occasion of their production and dissemination. These photos are crucial in the history of Kant portraiture not because of their medium but because they develop to an extreme the obsession with Kant as a powerful intellect. Two eighteenth-century sciences worked more or less in unison here, a century after their inception, to figure Kant as the new personification of philosophy, as he had been in the late eighteenth century and seems to be again in our own time, though often in a more negative sense. Johann Caspar Lavater's theory of physiognomy elaborated the ancient belief that character traits were written on the face; Frans Joseph Gall's and Johann Caspar Spurzheim's slightly later and competing theory of phrenology understood the skull as the external expression of the brain and its many individual components.[3] Lavater's own definition of physiognomy as "the talent of discovering the interior of Man by his exterior, . . . the Science of discovering the relation between the exterior and the interior . . ." (Allentuck 1967, 108), captures

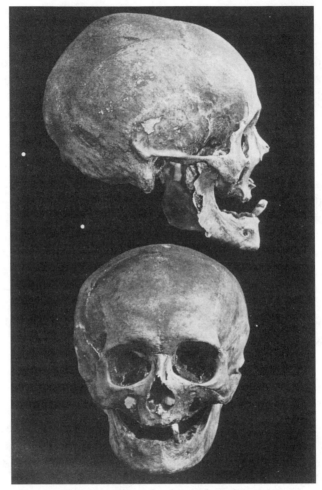

18. Immanuel Kant's skull, from the *Archiv für Anthropologie* XIII, 1881.

much of what physiognomy and phrenology had in common in the popular imagination of the Victorian era and well before. Both theories relayed the widespread eighteenth-century view that, as Barbara Stafford puts it, "any 'skin' or material 'dress' carried imprints of a hidden, subcutaneous realm" (1987, 185). In the late nineteenth as in the late eighteenth century, this core notion of physiological expression was "all but universally believed in" across Europe (Cowling 1989, 9). To emphasize the sometimes grim popularity of the received theory and the extremes to which it was frequently taken, we could call this belief that fundamental inner states are expressed and legible on the outside of

the head "the Pinocchio theory." Carlo Collodi's *Pinocchio* was in fact written at about the same time as the book in which these photographs of Kant first appeared, *Der Schädel Immanuel Kant*'s by the professor of anatomy Carl Kupffer and his student assistant, Friedrich Bessel Hagen. The scene in *Pinocchio* in which the wooden boy's nose grows when he lies can be seen as a darkly comedic, fast-forward version of phrenological theory, which is based on the literal expression of character and on the belief that there are meaningful, measurable ratios between different facial and cranial features. If we are tempted to smirk at our ancestors' gullibility, we might recall that since ancient times people have sought to understand human nature by its external, and – increasingly – internal signs. As I write, the discovery that the anatomy of Albert Einstein's brain is unique is front-page news and tempts the most respected scientists to explain his genius in these terms.[4]

But it was not Kant's nose that particularly interested Kupffer and Bessel Hagen, though phrenologists and physiognomists habitually calibrated this feature and its mathematical relations of proportion with other parts of the face and skull. They were looking for physiological evidence for the superiority of his intellect, not of his foibles. In keeping with phrenological and physiognomical theory about intelligence, they were obsessed with Kant's skull and believed that on it were imprinted the traces of his unequaled mind. Anticipating the focus of phrenology, which Gall originally called "crainoscopy," Lavater claimed that "inspection of the bones of the skull, of their forms and contour, speak, if not everything, at least most frequently, much more than all the rest," especially about the intellect of the subject (Stemmler 1993, 157).[5] How did these men come to have access to Kant's remains, interred on February 28, 1804? They are careful to explain that the state committee for the restoration of Kant's grave site had decided to erect a new and more elaborate memorial to the philosopher.[6] Thus *respect* for Kant motivated his exhumation and merely presented an opportunity for a scientific examination of his head.

We are also given the details of the team assembled to extract Kant from his original resting place. Alongside Kupffer and Bessel Hagen stood representatives of the city, of the philosophy faculty in which Kant had taught at the University of Königsberg, the university's librarian, and – literally up to his elbows in earth while removing the coffin – one "Maler Heydeck," a professor in the local Kunstakademie (Kupffer and Bessel Hagen 1880, 8). Kant's remains were thus simultaneously in the "private" hands of the city of which he was the most

famous citizen – in Kant's terms, of officials bound by their stations and disciplines – of the philosophy faculty whose superiority and responsibility he theorized in *The Conflict of the Faculties,* of medical people whose business he had also written about in that book, of a librarian, and, last but not least, of an artist. It is also important to note one additional disciplinary context: after its debut as a monograph in 1880, *Der Schädel Immanuel Kant's* was also published in 1881 in a German journal of anthropology,[7] a discipline that he greatly influenced with his *Anthropology from a Pragmatic Point of View* (1798).[8]

From the perspectives of their various interests and jurisdictions, then, all these men set to work on the paradoxical task of measuring Kant's head to discover the ratios of intelligence that in him had so famously championed the disinterestedness of reason in scientific, moral, and aesthetic affairs. In the *Anthropology*, Kant wrote that while "it cannot be disputed that there is characterization by physiognomy . . . there is now no longer any demand for physiognomy as an art of investigating the human interior through external, involuntary signs" (Kant 1978, 208, 209). Yet as a special and very intense sort of reception, his disinterment was "living proof" of how wrong he was. Phrenology and physiognomy were vital in Kant's time and during the Victorian era, when Kuppfer and Bessel Hagen worked.[9] Phrenology especially lives on today in rather chilling ways, recommending itself, as in the past, as a method to identify and thus control criminals, for example.[10] Kant himself elaborated nationalistic physiognomical stereotypes of European and "other" racial and political groups as early as his 1764 *Observations* and as late as the *Anthropology*, where he remained convinced that there was "something like a national physiognomy" (1978, 215) that showed up, for example, in "German" traits. Indeed, versions of phrenology and physiognomy – and specifically Kant's portrait as conceived through these filters – are employed most vigorously in the German context at times of intense nationalistic posturing and positioning: around 1800, as we saw in the German-speaking artists' colony in Rome examined in Chapter 2, and as I will suggest in this chapter with reference to another phrenological study of Kant, that performed by Dr. Kelch in 1804; between circa 1860 and 1880, when the German classical heritage is vaunted with reference to Carstens and Fernow, again as we saw in Chapter 2; when Kupffer and Bessel Hagen accomplished their study of Kant's skull; and when, in 1871, Germany officially became one political unit; from circa 1930 to 1945, when we witness a third phase of interest in Fernow and Carstens, one example of which is the remark-

ably phrenological discussion of a Carstens self-portrait in nationalistic terms by Hans Ludwig Oeser;[11] and the reappearance and circulation of eighteenth-century Kant images in today's Germany generally and in the former Königsberg, now Kaliningrad, Russia. Without eliding the differences among these disparate historical contexts or implying causal links between them, it is surely more than a coincidence that Kant's image would be deployed with vigor during these moments in German cultural history.

Although not doctrinaire physiognomists or phrenologists, Kupffer and Bessel Hagen attempted to make the basic premises of these would-be sciences as they might apply to Kant more precise and scientific. Like both Lavater and Gall, they saw the forehead as the head's most important feature, the prime sign of intelligence or its absence. The skull was thought to express the brain, as we see in the frontispiece of Johann Gaspar Spurzheim's highly influential book *The Physiognomical System of Drs. Gall and Spurzheim* (Fig. 19). Kant did indeed have a high, broad forehead and a notable brain capacity. Kupffer and his colleague also confirmed the remarkable relationship between his small physique – he was about five feet tall – and his large head, a ratio habitually emphasized by Kant's early biographers and his eighteenth-century portraitists, as we shall soon see. *Der Schädel Immanuel Kant*'s acknowledges some of these earlier textual and visual sources and claims to improve on them, mainly because Kant's skull itself, rather than casts of his head, was used in the calculations.[12] The coauthors correct the measurements recorded by Dr. Carl Gustav Carus, for example, who in his memorable *Atlas der Crainoscopie*, published in two lavish volumes in 1843 and 1845, had recourse only to a plaster cast made of Kant by the local artist Andreas Knorre immediately after Kant's death on February 4, 1804. Knorre actually made three casts of Kant (Clasen 1924; Malter 1983). Together they were fundamental to the phrenological-physiognomical understanding of Kant. Just as Kant's remains were handled – physically and institutionally – by representatives of the public and private bodies noted above, so too these casts were distributed across several disciplinary territories. One version went to the anatomical museum in Berlin, a second to the Altertumsgesellschaft of Prussia, and the third to the Staatsarchiv, Königsberg (Clasen 1924).

Carus illustrated the cast with an 1844 engraving by Moritz Krantz (Fig. 20). The doctor claimed that "The structure of the skull is in its entirety very remarkable" (1845, Plate 1, n.p.) and went on to specify the

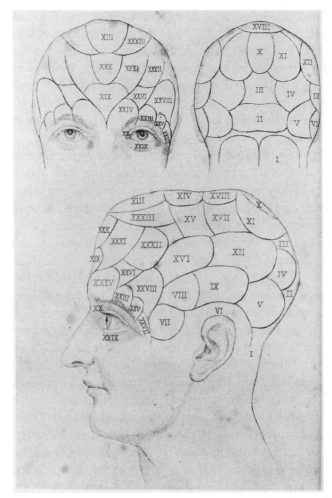

19. Frontispiece from *The Physiognomical System of Drs. Gall and Spurzheim*, 1815.

large capacity of the forehead and to comment yet again on the head's large size in relation to Kant's body. But there is also an important difference between Carus's analysis and that of the anatomists who later analyzed Kant's skull itself. Where Kupffer and Bessel Hagen drew on statistical reports of hundreds of other skulls to detail the uniqueness of Kant's, Carus's approach was from the outset less statistical and was comparative in a different way. Kant is just one of the "Bereuhmter oder Merkwuerdiger Personen" (famous or remarkable people) studied, as the subtitle to his atlas claims. Schiller's skull is also featured. In fact,

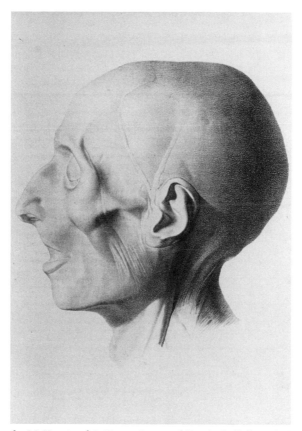

20. Engraving by M. Krantz of A. Knorre's cast of Kant's skull, from C. G. Carus, *Atlas der Crainoscopie* (Leipzig: August Weichart, 1845).

just as he traces the intimate geography of skulls, so too Carus – an accomplished amateur geologist and landscape painter who worked alongside his friend Caspar David Friedrich – provides a more expansive human geography, nothing less than two parallel "grand tours" of the surfaces of human heads and of the globe.[13] The book includes comparative tables (Fig. 21), and also diagrams of the outlines of four heads. The contours of Kant's skull line up against those of Baron von Rumhor – an early art historian – the contemporary poet C. A. Tiedge, and a mummy (Fig. 22). Throughout his book, Carus also displays and analyzes the skulls of cretins, suicides, and peoples of non-Caucasian races. In conformity to the theories of Johann Friedrich Blumenbach (1752–1840) and Petrus Camper (1722–89), race as well as character typ-

Tabelle

der nach Pariser Zollen gemessenen Schädelmasse der hier abgebildeten acht Köpfe.

Tableau de la Mesure des Crânes, en pouces du pied de France, des huit Têtes representées ici.

Name der Person. Nom de la personne.	Vorderhaupt. Sinciput.		Mittelhaupt. Vertebre du milieu.		Hinterhaupt. Occiput.		Länge der Wirbelbögen. Longueur des vertebres du crâne.			Augen-breite. Largeur de la région des yeux.	Ohren-breite. Largeur de la région des oreilles.	Nasen-länge. Longueur du nez.
	Höhe. Hauteur.	Breite. Largeur.	Höhe. Hauteur.	Breite. Largeur.	Höhe. Hauteur.	Breite. Largeur.	Vorder-haupt. Sinciput.	Mittel-haupt. Vertèbre du milieu.	Hinter-haupt. Occiput.			
Kant. TAF. I.	5" 4'''	4" 10'''	5" 8'''	5" 10'''	4" 7'''	4" 2'''	4" 0'''			4" 3'''	6" 1½'''	2" 1'''
Rumohr. TAF. II.	5" 3½'''	4" 4'''	5" 6'''	6" 0'''	4" 1'''	4" 8'''				4" 3'''	6" 1'''	2" 1½'''
Tiedge. TAF. III.	5" 3'''	4" 2'''	5" 7'''	5" 11½'''	3" 9'''	3" 9'''				4" 6'''	5" 8'''	2" 6'''
Mumie. TAF. IV.	4" 4'''	4" 1'''	4" 8½'''	5" 3'''	3" 10'''	3" 7'''				4" 2'''	5" 0'''	
Grieche. TAF. V.	4" 9'''	3" 0'''	4" 9'''	5" 1'''	3" 7'''	3" 0'''	4" 3'''	4" 1'''	3" 7'''	3" 9¼'''	4" 6'''	
Selbstmör-derin. TAF. VI.	4" 8'''	4" 7'''	4" 9'''	5" 10'''	3" 11'''	3" 6'''	4" 3'''	4" 3'''	3" 6'''	3" 9'''	4" 7'''	
Albrechtin. TAF. VII.	4" 5½'''	4" 4'''	4" 6'''	5" 3'''	3" 6'''	4" 1'''	4" 2½'''	3" 8'''	3" 6'''	3" 11'''	5" 2'''	
Kretine. TAF. VIII.	4" 0'''	2" 5'''	3" 8'''	4" 2'''	3" 1'''	3" 0'''	3" 6'''	3" 3'''	2" 7'''	3" 6'''	4" 1'''	

21. Comparative table from C. G. Carus, *Atlas der Crainoscopie* (Leipzig: August Weichart, 1845).

ically were read as a function of the size and angle of the forehead. Carus also included perhaps the most famous of all heads at this time, Napoleon's.[14] One feels that Kant and Schiller are placed in nationalistic competition with Napoleon's statistics, especially because Carus's elaborate *Atlas* features facing German and French texts and was clearly intended for international circulation.

We have moved from the 1880s back to the 1840s as we trace the interest in Kant's skull. But the earliest systematic reading of this potent artifact was by Dr. Wilhelm Gottlieb Kelch of Königsberg, who in April 1804, only two months after Kant's death, had written a substantial text titled *Ueber den Schädel Kants* that follows Gall's theories, as its subtitle

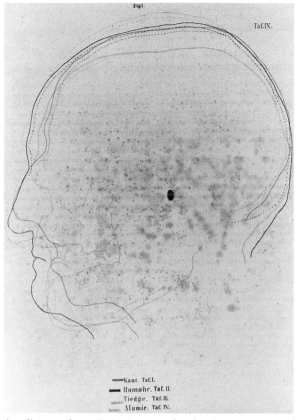

22. Comparative diagram from C. G. Carus, *Atlas der Crainoscopie* (Leipzig: August Weichart, 1845).

tells us. Like Carus, Kelch had access only to the cast of Kant's head. Nonetheless, he was able to determine, for example, that the philosopher's so-called Organe . . . der philosophischen Speculation was very well developed! (Kelch 1804, 38). Given that Kant's reputation was such that there was a strong desire to measure his skull, it is difficult to imagine that Kelch did not begin his study with this in mind. He clearly knew of Gall and Spurzheim's theories – first called "crainoscopie" – before they were published, thanks to their extensive lecturing across Europe. Remarkably, Spurzheim used Kant's skull to illustrate the philosophical prowess expressed by the forehead (see Fig. 23). In his commentary to this illustration, Spurzheim notes that Gall had emphasized "that persons who like metaphysical study have the superior part of the forehead much developed" (1815, 389; see Fig. 19). Gall's examples are

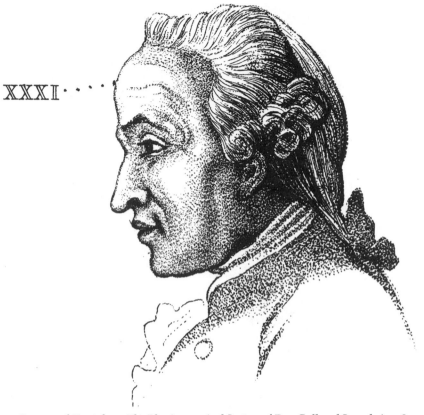

23. Immanuel Kant, from *The Physiognomical System of Drs. Gall and Spurzheim*, 1815.

Moses Mendelsohn and Kant, the latter suggested, we may assume, by Kelch's study of 1804. Because the image of Kant used by Spurzheim clearly derives from Hans Veit Schnorr von Carolsfeld's 1789 drawing of the philosopher (Fig. 24), we can also say with assurance that visual records of Kant's head led back into the interpretative loop that saw his skull as the record of a powerful intellect. For Spurzheim, who formalized and extended Gall's insights, this protuberance specifically designates a highly developed capacity for understanding the intricacies of "causality," an ability he deems fundamental to metaphysical inquiry. "This special faculty," he wrote, "examines causes, considers the relations between cause and effect, and always prompts men to ask Why?" (Spurzheim 1815, 390). For our purposes, it is most important to emphasize that none of the three doctors – Kelch, Gall, or Spurzheim – could

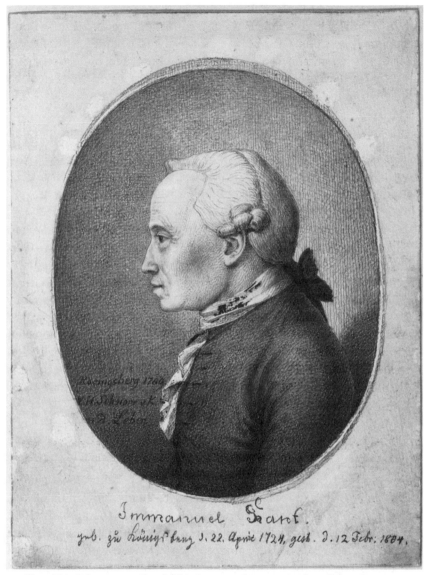

24. Hans Veit Schnorr von Carolsfeld, *Immanuel Kant*, 1789. Pencil drawing, 10.9 × 14 cm. Dresden, Kupferstich-Kabinett der Staatliche Kunstsammlungen Dresden. Photo courtesy Staatliche Kunstsammlungen Dresden.

or would have used Kant as such an exemplar without the existing framework of phrenological-physiognomical theory that in part regulated Kant's reception. Again, there is a nationalistic as well as a scientific subtext for this use of Kant, especially in Kelch's case, coming as he

did from Kant's birthplace. Beginning in the context of the conflicts between Prussia and France in the 1790s – fundamental to Kant's book *Perpetual Peace*, published in 1795, as we saw in Chapter 2 – Kant was increasingly championed as a German thinker, and philosophy as a typically German prerogative. As I noted in Chapter 2, in 1867 Friedrich Eggers wrote the following in his book *Jakob Asmus Carstens:*

Kant's philosophy, the insight of the great poets, the ideas of humanity, this more than anything else interested the German people, this is the content which infused the German people's spirit, with which the painter impregnated his soul, which was . . . to solve the problem which, since Winckelmann, so many had posed for themselves and so many had attempted. (22)

This process of identifying philosophy with German culture, and eventually nationhood, reached its apogee in the 1870s when "great (German) men" of genius were memorialized in public statuary particularly as part of the shift from a sense of German culture to that of a German nation (see Lang 1996, 195). For better or worse, the latter was an attitude still alive in the twentieth century. In *Germany: A Companion to German Studies,* for example, we are reminded of Fichte's dictum that the kind of philosophy a man chooses reveals the kind of man he is, and that this holds "not only for individuals, but also for peoples," and is chosen "according to . . . national character" (Bithell 1962, 406).

Kant's Head: Early Portraits

Carus, Kupffer, and Bessel Hagen – and, we can assume, Kelch too – were informed or affected by artistic images of Kant. Conversely, I would argue that many of these portraits were themselves animated by a knowledge of physiognomy and phrenology, both in their creation and their reception well into the nineteenth century. Some of those artists who portrayed Kant had documented knowledge of physiognomical and phrenological theory. More generally, Kant's image in the broad sense – his reputation as the embodiment of that paradoxically disembodied quality, reason – was in part understood in these "scientific" terms associated with such theories. One of the earliest and, from a technical and stylistic perspective, most accomplished, pictures of Kant was painted from life by Johann Gottlieb Becker in 1768 and offers an exception that proves this rule (Fig. 25).[15] Here we see the forty-four-year-old Kant, a confident though still struggling author, in an image

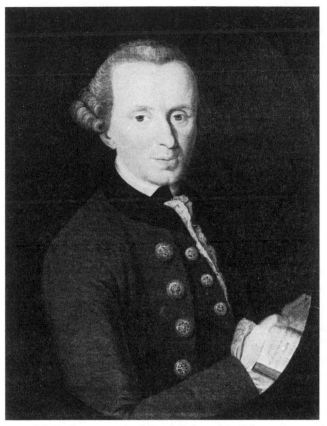

25. Johann Gottlieb Becker, *Immanuel Kant,* 2nd version. Oil on canvas, 46 × 60 cm. Königsberg, Kant Zimmer. Photo courtesy AKG, London.

commissioned by the Königsberg bookseller – and Kant's onetime landlord – Kanter, who was building a portrait collection of those whose work he published (Minden 1868, 25 n. 'a'; Scheffler 1987, 514). Here the forehead is prominent but the relationship between Kant's head and body is normalized. It is a flattering picture painted prior to the publication of Lavater's, Gall's, and Spurzheim's theories. Kant owned a copy made by the artist and gave another one to his brother (Clasen 1924, 10–13), giving the lie to the often repeated and supposedly revealing "fact" that Kant owned only a portrait of his mentor, Rousseau. Kant also responded favorably to the publication of an engraving of Becker's portrait (Minden 1898, 26) and negatively to an unauthorized 1784 (?) picture of him by Johann Michael Sigfried Lowe

(1756–1831; Malter 1982). In general, Kant was anything but disinterested when it came to his own appearance and health. It is salutary to view his critical philosophy through such quotidian concerns and thus to see his critical project as motivated throughout by the "interests" of reason, whether in an attempt to rationalize medicine in the final part of the *Conflict of the Faculties* and in his own compulsive bodily self-regulation or in the deployment of "disinterestedness" to guarantee the purity and autonomy of aesthetic judgment in the third *Critique*. That Kant only had his mind on more important things than himself or on artistic judgment is largely a fiction promoted by the Anglo-American, analytic tradition of Kant scholarship.

In its stylish conventionality, the Becker portrait is atypical of the many painted and sculpted images of Kant executed in the following decades as the philosopher's reputation grew, spurred on in part by the publication in 1786 of Karl Leonhard Reinhold's influential *Briefe über die kantische Philosophie*. Coincident with his growing reputation was the publication and dissemination of physiognomical and phrenological theory. As Kant increasingly took on the role of *the* German philosopher, portraitists emphasized his forehead. The much copied drawing by Hans Veit Schnorr von Carolsfeld (1764–1841; Fig. 24), mentioned above, is the model for the Kant illustration in Spurzheim's book – the original taken from life in 1789 and widely circulated in an engraving of 1791 by Johann Friedrich Bause (1738–1814; Fig. 26) – displays the head in profile in a way that (however unintentionally) emphasizes the extent and angle of this all-important feature. In an extant letter, Schnorr describes his meeting with Kant and his decision to pose the philosopher's head in profile in this way. Kant had mentioned that his face had two sides, "one more spare than the other," because, he speculated with typical fascination with his own body and health, he had always sat and slept with that side of his face nearest the cold of a window, a fact that he felt compelled to tell and also show Schnorr on a tour of his home during the portrait sitting (Distel 1909, 144). The profile is similarly revealing in Lowe's miniature of circa 1784 and in Heinrich Collin's miniature relief of 1782. An unusual high-viewpoint image of a most pensive Kant – probably executed by Elisabeth von Stägemann (1761–1835) in 1790 (Vaihinger 1901a) – also accentuates his forehead. Most striking of all, however, are two miniatures by the itinerant Berlin artist Charles Vernet (sometimes referred to as "Wernet," the artist who depicted Kant most often)[16] of the early 1790s, one of which emphasizes the unusualness of Kant's head (Fig. 27). The second[17] is doubly excep-

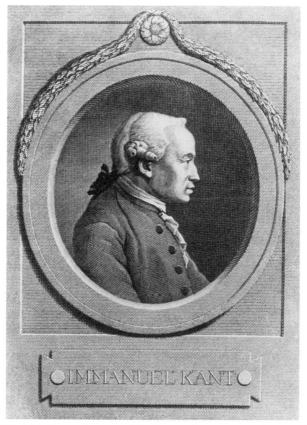

26. Johann Friedrich Bause, *Immanuel Kant*, 1791. Copper engraving, 9 × 6.3 cm. Coll. Archiv f. Kunst und Geschichte, Berlin. Photo courtesy AKG, London.

tional in this context, for here we are allowed and even encouraged to measure visually all of Kant's head because he is not wearing his wig (Fig. 28).

In what is perhaps the only commentary on this picture, the writer claims that the wigless sitter is not unusual, because men of Kant's generation often dressed in this way at the time (Anderson 1932, 310). While it is true that European men were wearing their own hair from the 1760s (Ribeiro 1984, 148), it is – as we have seen in the other paintings of Kant – not the case that they were normally depicted in so informal a manner. Although there are exceptions – pictures of Samuel Johnson, for example, and of Hogarth at work or, in Germany, of Salomon Gessner – wigs were usually shown in portraits throughout the eighteenth century, in part because they were so clearly signifiers of status

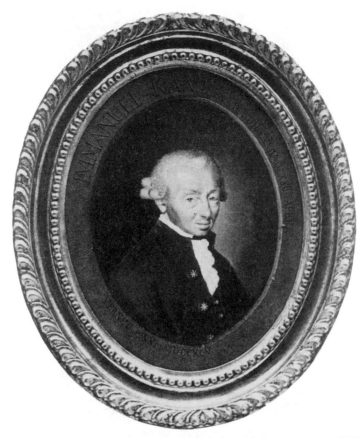

27. Charles Vernet, *Immanuel Kant,* 1795. Miniature with frame. Staatgeschichtliches Museum Königsberg / Kaliningrad. Photo courtesy AKG, London.

and occupation, especially for men (Pointon 1993). Wigs were not yet out of fashion in a provincial town such as Königsberg in the 1790s, and Kant is not here posed or dressed in a particularly informal way. More tellingly, his head is shaved *because* he usually wore a wig. If he had suspended this custom, he would most likely at this time have styled his "natural" hair to look like a wig (Corson 1971, 296ff.).[18]

Given the conventions of the time and even Vernet's other image of Kant illustrated above, we cannot help but notice the philosopher's whole skull. Because Vernet remains an obscure artist, it is impossible to know with certainty whether or not he composed his Kant "ohne Perücke" to facilitate the application of the prevailing physiognomical-phrenological theories of the time. Certainly other contemporary and

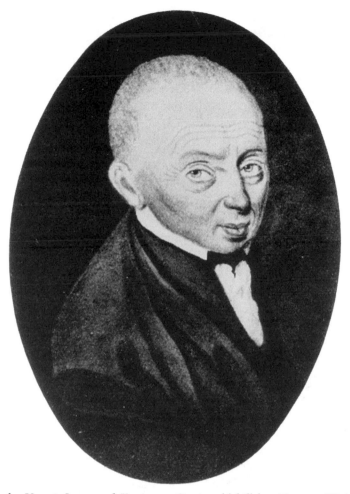

28. Charles Vernet, *Immanuel Kant,* 1792. Staatgeschichtliches Museum Königsberg. Miniature. Photo courtesy Staatgeschichtliches Museum Königsberg / Kaliningrad.

later artists did just this: Fuseli worked closely with Lavater (Mellor 1978), as did Johann Heinrich Lips, who engraved one of Vernet's Kant images for Lavater (Kruse 1989) and whose powerful image of Fuseli shows him without a wig (Kruse 1989, cat. no. 41). Lavater himself claimed, in his lengthy reflection on the links between his new science of physiognomy and the arts, that portrait painting is "the representation of a particular acting human being, *or of a part of the human body* – the communication, the preservation of his image; the art of saying in a moment all which one says of a partial form of human being and can

really never say with words" (Stemmler 1993, 165; my emphasis). He was clear about why portraitists might cover parts of the heads of certain sitters: "*Erasmus* is always represented with his head covered. Could he be under the apprehension, that his forehead was not sufficiently open, sufficiently bold, to be displayed?" (Lavater 1810, vol. 3, 2: 383). Spurzheim similarly compelled portraitists to know their phrenology. Taking this advice, the famous nineteenth-century phrenologist George Combe encouraged artists in Edinburgh to work according to his principles of what we might call revealed character by showing inner character through its bodily expressions (Pearson 1981). Lips made a study of Kant for Lavater's large collection of famous heads, though the image was not among those used in Lavater's publications.[19] William Blake was inspired by the theories of both Lavater and Spurzheim (Mellor). Somewhat later, the American sculptor Hiram Powers expounded at length on the physiognomical-phrenological ends of his portrait sculptures (Colbert 1986).

By far the greatest number of Kant portraits are paintings or engravings, but we must not neglect the often more public category of sculpted representations of the philosopher, particularly because these depictions figure centrally in the use of Kant's image that is my fundamental concern in this chapter. The sculptures may be grouped according to size and function: miniatures and statuettes, busts, and public monuments.[20] As was the case with the paintings and engravings, only some were executed from life and many idealized Kant's features. J. Mattersberg's bust of 1795 makes him both more youthful and "timeless" by alluding to Greek and Roman portraits of philosophers and statesmen. The close-cropped hair and toga-like garment in Emanuel Bardou's 1798 bust (Fig. 29) also place Kant in this ancient lineage. Kant sat for Bardou, but the result is nonetheless idealized, especially in comparison with Vernet's images. According to one commentator, who considers this bust *the* portrait of Kant, Bardou was careful to correct the "Milssverhältnis" in Vernet's image (and Kant himself?) between the prominent forehead and the lower part of Kant's face (Demmler 1924, 319), the very relationship that can be interpreted in terms of physiognomy and phrenology. Bardou's teacher was Christian Daniel Rauch (1777–1857), the most successful and acclaimed German sculptor of his generation. In Rauch's immense equestrian monument to Friedrich the Great, situated on Unter den Linden in Berlin, Immanuel Kant is included as one of the life-sized figures "supporting" Friedrich's rule. He is shown in (fictitious) conversation with the philosopher Lessing. Con-

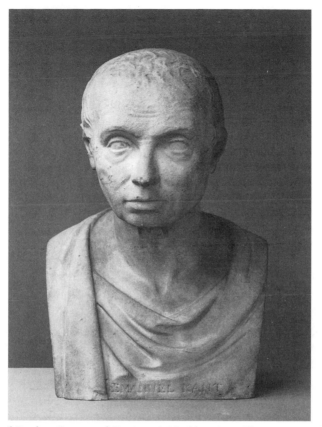

29. Emanuel Bardou, *Immanuel Kant*, 1798. Marble, 46 cm. Photo courtesy Staatliche Museen zu Berlin – Preussischer Kulturbesitz Skulpturensammlung.

ceived as early as 1779, this commission occupied Rauch from circa 1835 to 1851. The king's patronage of German culture's two most prominent Aufklärer is highlighted in the work. In the context I have established for Kant as a model of cosmopolitan political values, we may read Rauch's presentation of a "public" conversation or dispute between Lessing and Kant in terms of Kant's all-important distinction between the public autonomy of reason and private obedience to the monarch. "Only one ruler in the world says: *Argue* as much as you like and about whatever you like, *but obey!*" Kant famously wrote in "An Answer to the Question: 'What Is Enlightenment?'" (1991a, 55). Even in the Romantic period when he was less popular as the image of philosophy, Kant is memorialized in Rauch's statue as a national and transnational figure precisely according to the inverted hierarchical relationship of the fac-

ulties that he set out in the *Conflict of the Faculties*. The philosopher – personifying reason – may be under and subject to the king in a "private" sense, but as an autonomous, "secret" advisor, he guarantees the "right" of the monarchy. So too in this example, philosophy underwrites the value of art by establishing the supposedly transcendental subtext upon which this material memory of Kant is built.

Kant's head was used to legitimate a very different political regime in 1901, when the kaiser erected four new *Markgraffengruppen* in the Berlin Siegesalle to mark the new century, his own primacy, and their supposed connection with selected recollections of the German past (Vaihinger 1901b, 138). One of those commemorated was Friedrich Wilhelm II, nephew of and successor to Friedrich the Great. It was, as we have seen, Friedrich Wilhelm's repressive regime that Kant reacted so outspokenly against and that finally censored his religious writings. That a bust of Kant by Adolf Brütt should buttress the power of this memorial and the memory of this anti-Enlightenment ruler is ironic in the extreme. Nonetheless, the sculptor's use of Kant makes the point that the kaiser – along with many rulers before and since – was, or at least wished to be, supported by philosophy conceived as a prime part of national self-identity. In Kantian terms to which I shall return later in this chapter, the "form" of the relationship between philosophy and art is unchanged despite the fact that the political messages differ in Rauch's monument to Friedrich and in the kaiser's *Markgraffengruppen*. The details of history do not matter. If we think of these public monuments as a category of reception for Kant's ideas, however, it becomes clear that only through the specifics of historical usage may Kant's "transcendental" principles find their realization or contradiction.

Not all three-dimensional portraits of Kant were employed in so public a context or with such overtly political purpose. Heinrich Collin's aforementioned relief miniature is just one of the many small likenesses of Kant made around 1800, a category of works that would also include the statuettes of several monumental portraits of the philosopher. We should also include miniatures painted by Vernet and others when we ask how such images – probably the most populated grouping of Kant portraits – were used or received. Whereas the monumental sculptures of Kant often served what for him was the "public" function of reason and philosophy, or at least worked as a mnemonic of this function, I suggest that the miniatures were most often "private" in Kant's terms, talismans of his principles and of his discipline. In these

works his likeness was intimate with its owner's body and domestic sphere, realms that Kant sought to legislate for himself and in general, as we have seen. Kant's image could remind its keeper that reason and philosophy judge everything. His image allowed him to move through many disciplinary contexts and to cross the often assumed border between the visual and textual that I have sought to problematize throughout this book. I have mentioned, for example, that Kanter collected and displayed portraits of "his" authors in his Königsberg bookshop. This was the initial reason for Becker's famous painting of Kant. We have also seen that images of Kant illustrated – pictorially and textually – both Spurzheim's and Carus's phrenological treatises. We also know that Lips's depiction of Kant was used by the well-known doctor and originator of "macrobiotics" Christoph Wilhelm Hufeland (1762–1836) to put a face to philosophical theories in the *Allgemeine Literatur Zeitung,* a journal published in Jena, in 1794, a fact noted by Friedrich Schiller (Kruse 1989, 204). Hufeland was coeditor of this journal and later a correspondent with Kant over questions of dietary self-regulation. Kant's opinions on the medical "faculty" and his attempts to organize its behavior according to reason are set out in *The Conflict of the Faculties* in the form of a letter to Hufeland.

What we witness continually in the uses of Kant portraits is *prosopopeia,* the figure of giving face to an idea (Jay 1990). Many ideas of course pass as Kantian, as we have seen in the preceding chapters. Because "Kant" is not a unified source, neither are they necessarily consistent with one another. What passes in different processes of reception as "Kant" is, unavoidably and productively, as different as the many representations of his head. "Kant" – like any cultural icon – is formed and reformed through this sort of dissemination; the range of likenesses of him is readily available these days on the worldwide web. There is no better illustration of this plasmatic process than a recent mail-art exhibition initiated in Kant's hometown, now the Russian city of Kaliningrad. Titled *Kant Perfo-Ratio,* the exhibition began its circulation through the international postal system in 1994 at the local History and Art Museum (Fig. 30). No fewer than 105 artists from twenty-eight countries took part in this very self-conscious remembering and scattering of Kant's image.[21] Many of the works circulated used stamps bearing Kant's face (of which there have been several in Germany). And for Kaliningraders today, Kant's statue is once more prominent in the city (Fig. 31). The title "Perfo-Ratio" itself makes reference to perforations, the regular yet easily broken edges of stamps that can well be taken as a

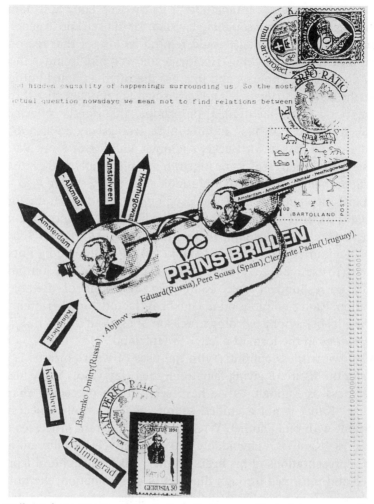

30. Mail Art from *Immanuel Kant: Perfo-Ratio,* 1994. Photostat on paper, 8.5 × 11 inches. Photo courtesy Staatgeschichtliches Museum Königsberg / Kaliningrad.

metaphor for the constant play of borders enacted by the exhibition and, in the context developed in *Kant, Art, and Art History,* by the uses of Kant in art and art history. A text in the catalogue to the exhibition plays with the homonymic relationship in Russian between "Kaht," the name of the philosopher, and "Kaht," defined as "edging, piping . . . [a] mount for a picture."

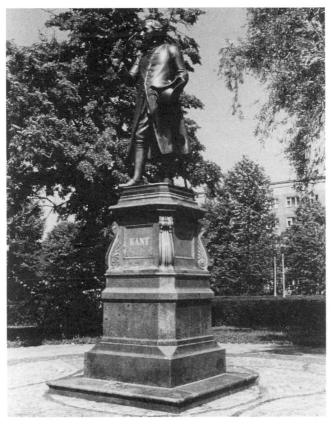

31. Christian Daniel Rauch, *Immanuel Kant,* 1857 (1992 copy by Harald Haacke). Bronze. Monument with base, 18 feet high; figure, 9 feet. Kaliningrad. Photo: Claudia Quaukies, courtesy AKG, London.

Frame, "KAHT," contiguous, that belongs completely neither to a wall, nor to a painting, is the whole point of the mail-art project. Kant as a mount of the European civilization. A stamp is a painting that has perforation at the edge of canvas as frame. It is impossible to hang, but possible to glue. Let's glue every imperative to its place and time.[22]

Place and time are again ruled by the political specificities that affect one moment of Kant reception. The mail-art exhibition is evidence of a resurgence of interest in him ("devotion" would be a better term) in Kaliningrad, a city overlaid after 1945 with Russian history and ideology after the forced expulsion of its earlier citizens, the people of Königsberg. Rauch's Kant statue at the university – deposed and likely

melted down under Soviet rule – has been replaced (Fig. 31). "Lots of kids, rock fans, pop-culture fans, visit Kant's grave" these days, reports Vladimir Gilmanov, who also suggests that the turn to an ideal German past through Kant's emphasis on free will and cosmopolitanism is an explicitly nationalistic rejection of the more recent Soviet regime (Benjamin 1994, A4). Newlyweds now place flowers on Kant's grave at the city's cathedral, perhaps because of the hope suggested by the fact that these monuments were among the very few left intact after the bombing of 1945. Tour guides suggest a miracle: "The dead Kant had spoken," says a Russian showing tourists this most famous site (Brinks 1998, 611). From the beginning of the Soviet period until 1991, the Kaliningrad area was heavily militarized because of its strategic importance and was thus closed to outside visitors. With the current expansion of NATO to include countries bordering Russia, Kaliningrad remains critical in post–Cold War political machinations. "Kant" plays an important mnemonic function in this context; he is frequently cited in Western and Russian speeches about the future of this area. Because his images are used today as prosopopeia of the idea of reason in history, we are perhaps also again seeing a version of the expression theory fundamental to physiognomy and phrenology. Art is closely involved in this expression. V. K. Pokladova writes in the introduction to *Kant Perfo-Ratio* that the exhibit's "main aim is to express new ideas and feelings, to represent visually complicated things of [the] inside world of modern human being." I have argued that in early portraits of Kant it was the "ratio" of his skull that suggested the primacy of rationality in philosophy. Here it is the ratio suggested by the relationship of his circulating image to the conditions of its multifarious reception and redeployment in the exhibition that guarantees his ongoing vitality and influence.

Both physiognomy and phrenology rely on measurable ratios of the skull for their putative scientific status. They proceed first from the assumption of the physical expression of mental capabilities and then by comparison across a geography of "famous or remarkable" examples, to cite Carus. In this spirit of comparison, one dear to art history as well, we should display Kant in a fictive gallery of others who could be seen to contend for the mantle of the personification of philosophy in his time and since. Aware that I am keyed to look for images of Kant and that any "discoveries" revealed in this cursory comparison are rhetorical, it remains accurate to say that no other philosopher received the attention trained on Kant. Both Goethe and Schiller were portrayed more frequently and in many cases by better-known and, frankly, more

talented artists.[23] To generalize, there is also a much greater range of mood in pictures of these two men, a variety attributable not only to the skill of the artists but more to the polymaths they painted. Some pictures of Schiller are overtly political, following on the success of his play *Die Räuber*. Many images show him as a "Romantic" poet, lost in thought. Others – especially Johann Heinrich Dannecker's colossal bust – literalize his stature as a cultural figure and tie him to the ancients. Goethe is pictured in even more guises, given his extraordinary abilities as poet, dramatist, and scientist. Although both men were at times philosophical, neither seemed as right for the role of philosophy as did Kant, who after all defined the philosophical spirit in terms of disciplinary borders, despite his own wide-ranging interests. I have mentioned that Spurzheim championed Fichte in his writings, but there are rather few images of this philosopher. And what of Hegel, who like Kant but in a much more extensive way, dismissed physiognomy and phrenology in the *Phenomenology of Spirit?* Hegel is pictured, often and memorably, as teacher in a lithograph by F. Kugler, and as darkly brooding thinker in the famous painting by Jack Schlesinger.[24] To generalize freely, this portrait is representative of a trend in most images of "great men" in the early nineteenth century, a stylistic trend encompassed by the fraught term "Romantic." Here it is Hegel's eyes that are emphasized. They suggest introspection, whereas Kant's skull was associated with reason and liberation.

Let us return to the eighteenth-century representations of Kant. How different Vernet's image is from what was, in mid-eighteenth-century Germany, a standard emblematization of philosophy and the philosopher, Johann Georg Hertel's 1758–60 engraving of Philosophy in Cesare Ripa's *Iconologia* (Fig. 32). Here Philosophy is richly allegorized and embodied as a woman, supposedly because Boethius spoke of "Lady Philosophy" and abstract concepts are gendered as female in Greek and Latin (Most 1996, 146ff.). But because of its emphasis on a masculinist version of reason, Philosophy was changing sex in the Enlightenment.[25] The most famous artistic example of this shift in gender is David's extraordinary *Death of Socrates* in 1787, in which we see that the philosopher values his philosophical ideals over the emotions of his followers, his wife and family (seen in the background in more ways than one), and over his own life. Of course the Vernets are in all senses very small works in comparison with David's machine, but their subject, Kant's head, came to overshadow even Socrates as the personification of philosophy.[26] We have synecdoche and metonymy instead of Ripa's

allegory in Vernet's works, where the forehead stands for the active, universal principles of reason as championed by Kant and where Kant's head as Reason, in turn, suggests Philosophy. Reason as a virile, self-replicating force was crucial to Kant's thought. Near the end of the first *Critique,* he compares philosophy studied historically to its treatment according to the dynamic principles of reason. In the former case, the pupil may have "learnt well," Kant says, but he remains "merely a plaster-cast of a living man" (A837/B805). He speaks of the painter in a similar vein in the *Lectures on Logic:* if "one is not skilled in thinking for oneself, then one takes refuge in others and copies from them completely faithfully, as the painter copies the original . . ." (Kant 1992a, 128).[27] Would Kant – famous in his time for his irony – have appreciated that in becoming a "plaster-cast" himself, he was able to remain alive and indeed to incorporate Philosophy as dynamic, masculine, and supposedly autonomous Reason? Perhaps, especially when we recall that he was careful in his characterization of German "national physiognomy" – those typical traits which are not innate but which through "long practice" are "stamped" upon a national group's faces "with lasting outlines" (Kant 1978, 215) – to emphasize that "industry" is more important than "genius" (Kant 1978, 234).

Industry rather than genius also distinguishes the many eighteenth-century portraits of Kant. He did not sit for any of the leading artists of his day, not because he lacked the fame, but because he did not travel and none of the important portraitists of the time came near Königsberg.[28] Kant's depictors were habitually eclipsed by their "subject," the subject of Philosophy, with the advantage that their relatively low status today exposes the disciplinary hierarchy that operates in the images. Philosophy dominates Art in these cases, as it typically did in Kant's Germany. Edgar Wind memorably demonstrated in 1932 a different paradigm of how "portraiture shows [the] give and take between artists and philosophers especially clearly," how a portraitist such as Reynolds or Allan Ramsay may actually take a philosophical position in both his choice and his depiction of his sitters (Wind 1986, 3). Wind underlines the elevated station of the famous painters he examines. Despite his pathbreaking concern for the philosophies embodied by sitters, Wind behaves within disciplinary parameters as an art historian and focuses on the art and artists' rather than on philosophy's superiority over them. Images of Kant are arguably more successful as personifications of philosophy than is Ramsay's image of Hume examined by Wind, for example, because the "part" – whether Kant the man

32. Johann Georg Hertel, engraving of Philosophy for his edition of Cesare Ripa's *Iconologia*, 1758–60.

as Philosophy or his forehead as a synecdoche for Reason – so completely betokened what was important in what Lavater called in portraiture generally "the preservation of [the sitter's] image." Given the relative obscurity of Kant's portraitists,[29] we are more likely to concentrate on the "image" in all its ramifications.

Talking Heads

Marcia Pointon has astutely noted that "the head as an artefact [is] open to appropriation" in portraiture (1993, 112), that it can mean in many

ways. Encouraged by a widespread pattern of contact between physiological-phrenological theory and the fine arts, Kant's image was widely disseminated and popularized. We could say that his body, especially his head, was "disciplined" in Foucault's sense, disciplined to be read as the epitome of philosophy, that discipline formed or even deformed by the power of Kant's own vision of reason. Kant was of course notorious for disciplining his own body, believing, for example, in the healthfulness of daily exercise but having as a goal never to perspire, and his discipline of reason was a parallel system for the mind. Philosophy and reason were for him explicitly and indeed personally therapeutic, as I noted earlier. Kant wrote in the "Announcement of the Near Conclusion of a Treaty for Eternal Peace in Philosophy," published in 1796 and obviously alluding to his monograph *Perpetual Peace*, that

philosophy must act (therapeutically) as a *remedy* (*material medica*) for whose use . . . dispensaries and doctors . . . are required; here, the police must also be on watch so that those who arrogate to themselves the task of *recommending which philosophy one should study* are doctors trained in their discipline and not mere amateurs or quacks who bungle around in an art of which they do not even know the first elements. (1993, 84–85)

We can imagine reason in its institutionalized form, the discipline of philosophy, as a "public" discipline in the Kantian sense and therefore carrying with it a duty to be an autonomous and sometimes secret advisor and legislator both to the state and to other fields of inquiry. The discipline of the body is concomitantly "private," directed by rules, laws, and social conventions. But the two levels are not as clearly distinguishable as Kant wished. They merge in his portraits, where the picture of his head and image of his principles combine the duties of independence and subservience. What we also see in Kant portraiture is one version of his "genealogy," his descent figured as what Foucault called the "articulation of the body and history" (1977, 148). For Foucault, "discipline" is not simply a function of an institution – the discipline of art history as prescribed by art museums or departments of art history, for example – nor is it strictly personal. For him "it is a type of power," a network of forces in which we necessarily live and with which everyone is complicit to some extent, however unwittingly (1979, 215). But he is careful to warn against paranoia, the sense that disciplines manipulate us as helpless objects. "We must cease once and for all to describe the effects of power in negative terms," he writes, an insight relevant to my

critique, in the introductory and concluding parts of this book, of what Arthur Danto calls the philosophical disenfranchisement of art. Foucault describes disciplines further as "techniques for assuring the ordering of human multiplicities, . . . [as techniques to] define compact hierarchical networks" (1979, 218, 220).

That Kant's head can be said to have been disciplined in this way by the discourses of phrenology and physiognomy is to claim that these theories helped to define and, to that extent, control what "Kant" meant in certain contexts, literally how he was conceived and reconceived through a genealogical descent from the Enlightenment to the present. As we saw in Chapter 3 in a discussion of the authority of Kant's name, it is not Kant as a source or originary force that shapes these shifting meanings. "Kant" can only be what Foucault calls an "author-function," a function of what he also deems a "historicophilosophical" (1990, 391) questioning or attitude that constructs a subject's history, not as an ideal unity or seamless narrative, but rather in terms of unfamiliar jumps and gaps revealed as this subject – "Kant" – is manipulated historically. It is this type of "experimental" history of Kant in and around the visual arts and art history that I have sought to present by analyzing discontinuous moments in his ongoing reception (1984b, 46). Foucault names this practice "genealogy,"[30] a process of historical recollection that restores only the appearance of a unified subject, in this case Kant, but works in ironical acknowledgment of that provisional unity (1990, 396). My own elaboration of a disciplinary "plasmatics" as an organic field of ultimately arbitrary and unpredictable but historically meaningful events and forces contouring a subject such as Kant comes very close to Foucault's practice of "genealogy."

With these ideas in mind, let us return to Kant's ongoing life in portraiture via an intriguing proposition by Deleuze and Guattari in their book *What Is Philosophy?* "The history of philosophy is comparable to the art of the portrait," they write. In an elaboration that could have come directly from the passage in the *Critique of Pure Reason* where Kant reviles the possibility of becoming a plaster cast,[31] they suggest that the history of philosophy should not try to make past thought "lifelike" by reproducing its arguments but rather should produce a contemporary "resemblance" (1994, 56). This sounds very much like the sort of eighteenth-century theory of portraiture at work in many images of Kant, images in which "resemblance" frequently meant an emphasis on his reputation as a "brain" and thus entailed a peculiar accentuation of his head. For Kant, reason is explicitly productive, not

reproductive like a plaster cast or a painting or perhaps even history. In this spirit perhaps, Deleuze and Guattari have been brave enough to sketch textually and visually a new portrait of Kant, based in part on Jean Tinguely's machine portraits of other philosophers (Fig. 33). Here is their lengthy gloss on their subject:

The components of the scheme are as follows: (1) the "I think" as an ox head wired for sound, which constantly repeats Self = Self; (2) the categories as universal concepts (four great headings): shafts that are extensive and retractile according to the movement of (3); (3) the moving wheel of the schemata; (4) the shallow stream of Time as a form of interiority, in and out of which the wheel of the schemata plunges; (5) space as a form of exteriority: the stream's banks and bed; (6) the passive self at the bottom of the stream and as a junction of the two forms; (7) the principles of synthetic judgments that run across space-time; (8) the transcendental field of possible experience, immanent to the "I" (plane of immanence); and (9) the three Ideas or illusions of transcendence (circles turning on the absolute horizon: Soul, World and God). (1994, 57)

The reference to the ox head in number 1 is reminiscent of Picasso's famous *Bull's Head* (1943), a sculpture using a bicycle seat and handlebars, and the entire evocation of Kant seems like a description of the parts of Duchamp's *Large Glass* animated by Tinguely. This is certainly a playful Kant portrait, though one to take seriously especially because of its irony. Kant's almost caricatured doctrines are arranged as a provisional unity that functions as a "portrait" of his thought. For Kant, critique is the engine of renewal and philosophical creativity: it is productive, not reproductive as history is for him. As Foucault has argued, critique promises autonomy: "critique is the movement through which the subject gives itself the right to question truth" (1990, 386). But just as Kant does not in Deleuze and Guattari's book portray himself, so too the Enlightenment principle of critique must be understood as historical. It was historical when Clement Greenberg adopted a version of it to legitimize the self-critical abstract painting he saw as progressive at midcentury, as we saw in Chapter 3. Critique will remain historical even if, with Foucault, we find it useful today.

The sense of Kant-as-philosophy-as-critique is important in recent work by the German artist Anselm Kiefer. In two of three versions of his *Wege der Weltweisheit* (Ways of worldly wisdom; Fig. 34), a series executed from 1976 to 1980, Kiefer includes Kant in a tour of figures consequential in the construction of German cultural and national identity – some ancient, some more modern. He employs another Kant portrait,

33. Giles Deleuze and Felix Guattari, *Immanuel Kant*, from *What Is Philosophy?* trans. Hugh Tomlinson and Graham Burchell (New York: Columbia University Press, 1994), p. 56.

that painted by Gottlieb Döbler[32] in Königsberg in 1791, a year after the publication of the *Critique of Judgment* when Kant's writings were widely debated (Fig. 35). For Kiefer in our time – as it was for many of Kant's contemporaries – this is Kant the man of reason, the cosmopolitan liberal and supporter (most of the time) of the French Revolution. Kiefer's three versions of the *Ways of Worldly Wisdom* involve references to "die Hermanns Schlacht," Arminius's Battle, in which "German" defenders were victorious over the Roman invader Varus in the Teutoburger forest in 9 c.e. (Schama 1995, 128). In the image we see

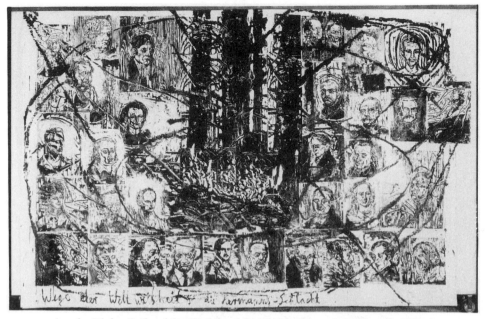

34. Anselm Kiefer, *Paths of the Wisdom of the World: Herman's Battle*, 1980. Woodcut, with additions in acrylic and shellac, 344.8 × 528.3 cm. Restricted gift of Mr. and Mrs. Noel Rothman, Mr. and Mrs. Douglas Cohen, Mr. and Mrs. Thomas Dittmer, Mr. and Mrs. Ralph Goldenberg, Mr. and Mrs. Lewis Manilow, and Mr. and Mrs. Joseph R. Shapiro; Wirt D. Walker Fund, 1986.12. Photograph © 1996, The Art Institute of Chicago, All Rights Reserved. Photograph courtesy of the artist.

here, Kiefer boldly conflates this defining moment with references to the more recent past in the form of portraits, including Kant's. And in a reference to the disseminative potential of the print medium, he has either reversed the image of Kant he appropriated from the eighteenth-century portrait painting, or else worked directly from a contemporary print after Döbler. Kant is not the only philosopher brought by Kiefer in this woodcut to a mnemonic meeting in the forest, the forest of and as history, and the symbol – as Simon Schama argues brilliantly – of Germanness. Fichte is here too, perhaps to remind us of how a philosopher's nationalism can later be skewed to gruesome effect, as Fichte's was by his Nazi champions. Kiefer's image is in fact something like Carus's atlas, a spatial and temporal lesson in cultural geography that places philosophy – also called "Weltweisheit," as we saw in Hertel's illustration of Ripa – as a force among other disciplines. As in phrenology or physiognomy, Kant's quirky appearance as an excrescence on

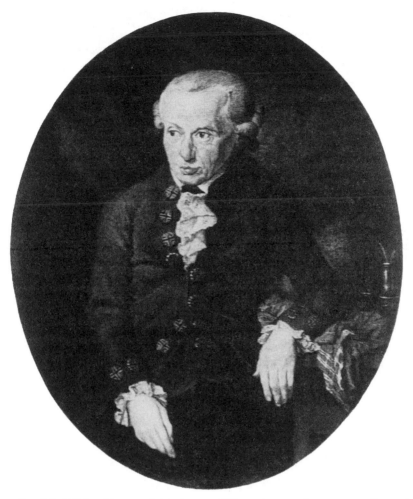

35. Gottlieb Döbler, *Immanuel Kant*, 1791. Oil on canvas. 28.5 × 33 cm. Formerly Königsberg, Todtenkopfloge. Photo courtesy AKG, London.

Kiefer's surface can not be interpreted as accidental, either in this image or in general.

Conclusion: McEvilley's Dream, Danto's Nightmare

The American art critic Thomas McEvilley is one of the most astute chroniclers of Kant's ongoing and often deleterious presence in contemporary art and art writing. I have already quoted him saying that

"Kant and Greenberg are both things of the past and we should just get over them. Yet somehow, they keep arising from the grave like zombies." McEvilley here realizes that Kant will not disappear, even though he thinks the art world would be better off without his influence. In 1993, he asserted with more certainty that "the overthrow of the Kantian theory of art which dominated Modernism with its ideas of universality and unchanging quality . . . [was] the most significant event in recent art history" (McEvilley 1993a, 202). For McEvilley, then, it is this Kant – mostly the clichéd side of Greenberg's version of the philosopher – that we must abandon. Yet McEvilley himself is an excellent example of how a reconstituted Kant continues to be employed in and around the visual arts. Not unlike Kahnweiler when he looked to Kant to help formulate his take on cubism, McEvilley frequently invokes Kantian reference points. Central to Kant's theory, he writes, "is a model of the human personality as made up of three separate faculties, the aesthetic, the ethical, and the cognitive" (1993a, 204). Where many minimalist and conceptualist artists tried to eliminate the distinctness of the aesthetic, he claims, more recently, "over a broad spectrum of art making, a new formula has emerged: the artwork should express all three of the Kantian faculties about equally" (206). Kant's purity and border work has been challenged, but he remains influential. As we saw in the previous chapter, the category of the sublime – revived by so many contemporary artists and theorists in what we could call a deconstructive manner – actively challenges the formalist and universalist Kant by using another Kantian category.

McEvilley's dream that Kant's formalist legacy can be eclipsed does not finally demand that we turn away from the philosopher or from philosophy itself. He does not indulge in what I would call the "domination" argument entertained, as I have mentioned, by Danto, and to a lesser extent by Derrida. Derrida frets over how philosophy trespasses on or, in Danto's famous term, "disenfranchises" art by making it other than it properly is. Danto claims that "there is an incentive in philosophically curing art of philosophy: we by just that procedure cure philosophy of a paralysis it began its long history by infecting its great enemy [art] with" (1986, 17). Paralysis? I would hold that, on the contrary, art and philosophy have vitalized each other since the time of the Greeks in ways that make them indissoluble, though of course not indistinguishable. Yet Danto's essentializing attempt to separate the two into their proper spheres is widely shared. As we have seen, philosophers often try to "clean up" what Kant himself deemed amateur philo-

sophical practices in art and art history. For their part, many art historians and artists either resent or see as irrelevant what they perceive as philosophy's intrusions into their territories. This is a political dispute among disciplines, as it was in Kant's time. Again, his name and image focus the debate. As we have seen, in the Kaliningrad of the 1990s, a replica of Rauch's Kant statue again stands in the central square (Fig. 31). Paid for by Germans keen to reestablish links with what was for many their literal and cultural home, "Kant" stands for German nationalism and German capital (*Kant* was even slang for German money in the former Königsberg). There has been talk of renaming the city Kantgrad (Elon 1993, 31), which for some Russians living there is an aggressive, imperialistic suggestion. In the fields of art and art history, Kant stands today with similar memorial potency. His influence is widespread and diverse. Typically, in critique he has willed to us the techniques to both understand and continue to benefit from his presence.

Notes

I. INTRODUCTION: BO(A)RDERS

1. Adorno 1997, 334. Kant 1987, §58, 350; Lyotard 1989c, 356. References to Kant's *Critique of Judgment* are to the section of the book followed by the pagination of the German edition used by the translator, Werner S. Pluhar (1987).

2. Needless to say, Kant has been instrumental in other fields in the humanities, especially literature, where his impact has been more fully studied. In focusing on the interrelationships between philosophy, art, and art history, I am working consciously from the concerns of the present in the field of art history. I do not pretend to trace the historical development of Kant's influence across the humanities, nor do I maintain the fiction that any of the areas I discuss are coherent, easily bounded disciplines. But, to use a ploy Kant invented, we must, I think, behave "as if" there is art history, philosophy, and the visual arts, even though it is in part the very definition of their boundaries that I will examine.

3. This is not the context for a detailed discussion of the nature of neo-Kantianism in all its guises, nor will I attempt to provide an overview of the many documented and possible influences of these strains of thought on the development of art history. Where neo-Kantian ideas directly affect the narrative of Kant's place in art and art history that I am developing – with Daniel-Henry Kahnweiler or Erwin Panofsky, for example – they will be noted. In very general terms, we may think of a "Kantian" concern for the very possibility of perception and knowledge and a "neo-Kantian" interest in accounting for this perceptual and epistemological activity in terms that emphasize the historical and hermeneutical aspects of the Kantian subject or that concentrate on that subject's psychology. On neo-Kantianism, see Köhnke 1991 and Willey 1978.

4. For a defense of the tradition of aesthetic purity that I implicitly criticize, see Lorand 1992.

5. This view was expressed with conviction by Stephen Melville during comments he made at the Getty Summer Institute in Art History and Visual Studies at the University of Rochester, July 8, 1999. Melville added that Kant only became important to Greenberg belatedly and as a heavy-weight justification for the critic's ideas. Thus, for Melville, in Greenberg's later essays, recently published as *Homemade Aesthetics: Observations on Art and Taste*, Greenberg mentioned Kant so frequently because he was merely defending earlier positions. This makes the late essays uninteresting to Melville. I will argue in Chapter 3 that Greenberg used Kant much earlier and with greater authenticity than is usually thought. The late essays, for all their faults, are interesting if we try to understand Greenberg's relationship with Kant and with philosophy generally.

6. I am in sympathy with Daniel Herwitz's successful project of reading the textual and plastic work of "artists as philosophers in art" (1993, 8). This was also my goal in my chapters on Mondrian, Kandinsky, and Klee in *The Rhetoric of Purity: Essentialist Theory and the Advent of Abstract Painting* (1991).

7. Kant 1987, §58, 350.

8. Siebers (1998) has written powerfully on the otherness of the aesthetic in Kant.

9. Loosely translated, the book was intended for "thoughtful artists who hadn't read Kant." I wish to thank Dr. Anne-Marie Link for bringing this article to my attention.

10. Cited in Cheetham 1991a, 9.

11. On the gender implications of Kantian reason, see Schott 1997.

12. Lang 1997 gives a full discussion of the Kantian subject in the context of art history. See also Bowie 1990 and Cascardi 1993.

13. See Derrida, 1983, 1984, 1992, and Readings 1996.

14. Coleman 1974 discusses in detail the "harmony of reason" in aesthetic judgment.

15. I cannot offer an analysis of Kant's relationship to modernity. John W. Tate (1997) provides a detailed reading of Kant, Habermas, and modernity that is relevant to this large set of issues.

16. For a discussion of the notion of critique as resistance in Kant and Foucault, see Cutrofellow 1994.

17. Jay 1990 examines the authority of names in humanistic studies.

18. Clearly this is a large and not infrequently contentious issue. I will return to it in Chapter 2. See also Cassirer 1947.

19. Again I would like to thank Anne-Marie Link for this information. Her research on the early institutionalization of art history significantly revises the work of Dilly and others, who situate its inception in the nineteenth century rather than in the eighteenth.

20. In a study of already frighteningly broad scope, I cannot adequately survey art and art history's disciplinary relationships with all other fields. On art history as a discipline, see Bal 1996a, 1996b; Bryson, Holly, and Moxey 1991, 1994; Cheetham 1992; Holly 1996; Moxey 1994; Preziosi 1989, 1992, 1993. Regarding the humanities generally, see Chamberlin and Hutcheon 1992;

Greenblatt and Gunn 1992; Kreiswirth and Cheetham 1990; Messer-Davidow et al. 1993.

21. James D. Herbert has suggested that "a critique of the autonomy of disciplines might well arise from the marginal position of art history, where literary criticism and history appear as each other's intractable yet enabling kernels" (Herbert 1995, 539). This book is in part such a critique of autonomy.

22. Anthony Vidler has recorded the minority opinion that "art history is and always has been a discourse based on that of history" (1994, 408).

23. The translation is from Cassirer 1981, 273.

24. On the structural and especially spatial relationships between Kant's philosophy and other disciplines, see also Cascardi 1987 and Sallis 1987.

25. Readings 1996, chapter 4. Kant's ideals were of course both in competition and agreement with those other visions that shaped the German university system in the early nineteenth century, those of von Humboldt and Fichte. See also Bahti 1987.

26. Gilles Deleuze notes that in Kant the very possibility of "the free accord of the faculties" is prior to our apperception of these faculties. Freedom is thus a universal form that allows for aesthetic judgment as well as moral action (1990, 50).

27. See Wigley 1993 for a brilliant discussion of Kant's architectonic and the parergonal interaction of architecture and philosophy. David Summers has forcefully summarized the import of Kant's notion of form for art history: "Form came to be regarded as the universal common denominator of human things. . . . It was largely under such auspices that the history of art came into existence and currency as an intellectual discipline" (1989, 375).

28. Derrida 1987, 45. See also Cheetham 1991a and Herwitz 1993.

29. It was not until about a year after writing the initial draft of this section that I recalled my acquaintance with Barnett Newman's use of the term "plasmic" as the likely source for my own usage here. "The term 'plasmic' expresses the quality in ['primitive'] work for it implies the creation of forms that carry or express abstract thought, . . . as against the term 'plastic,' which implies the heightening or glorifying of the forms we know" (1992, 146). As I send this book to press, it strikes me that my notion of plasmatic art history is in many ways close to Mieke Bal's new theory of baroque "entanglement" as a revisionary paradigm of relations between subject and object, past and present, philosophy and other cultural thinking. Bal also considers Holly's *Past Looking* in detail. See Bal 1999.

30. Massumi 1995. This reference is to a version of Massumi's article available on his website. The text is not paginated.

31. Lynn's description is very similar: Lynn 1995, 42–43.

32. Both Massumi and Lynn (1995, 42) draw significantly on Deleuze's work with Leibniz, *The Fold*. I shall return to this context in Chapter 5.

33. Elizabeth Grosz writes that "Kant, strongly influenced by the way in which Euclid demonstrated that reason alone, independent of sense-perception, is capable of providing knowledge, used Euclid's postulates to show that we have a necessary knowledge of geometry prior to any experience" (1995, 94). This was of course also one of Plato's assertions in the *Meno*.

34. See Readings 1990 for a revealing reading of the implications of the term "foreign" in current debates about the nationalities of theory.
35. To anticipate my argument, it is possible to see White's work, and Holly's in its debts to him, as "Kantian" to the extent that both scholars seek to manage historical experience via ultimately transcendental tropes and models. Ankersmit (1994, 158) makes this point about White. I would extend it to Holly's use of Albertian-Lacanian "perspective" diagrams that I discuss in this chapter. I do not claim to be consistent in my use of Kant in this section; here, as throughout the book, I work both with and against his ideas.
36. Jonathan Loesberg (1997) examines Bourdieu's theories, especially in relation to Derrida's reading of Kant's aesthetics.
37. Information and images from this project are available on the DIA Foundation's website ⟨http://www.diacenter.org⟩, from which I quote the following descriptions, first of the project in general, and then of American tastes surveyed by these artists.

The Most Wanted Paintings web site is an extension of the artists' "People's Choice" project intended to discover what a true "people's" art would look like. Initially, through a professional marketing firm, the artists conducted a survey to determine what Americans want to see in a painting. The results were then used to create the painting America's Most Wanted.

To a surprising extent, the public tends to agree on what it likes to see in a work of art. Americans generally tend to prefer, for instance, traditional styles over more modern designs; they also express a strong preference for paintings that depict landscapes or similar outdoor scenes. In addition, most Americans tend to favor artists known for a realistic style over those whose artworks are more abstract or modernistic. Americans who take a more active interest in the visual arts tend to be less definitive in matters of taste, and to welcome a greater diversity of artistic styles. As a general rule, Americans who might be expected to have a more detailed knowledge of art – those who visit an art museum with some regularity, as well as those with a higher level of academic attainment and those who are more affluent – appear to be less set in their views about what constitutes "good art." These Americans are, for instance, noticeably less likely to express a firm preference for a particular type of painting or school of art, and more likely to say that their opinion of a given artwork depends on more than one given factor.

38. Bourdieu extends this analysis in a more recent work, *The Rules of Art: Genesis and Structure of the Literary Field* (1996).
39. Telephone conversation with the author, February 23, 1998.
40. Tod is intentionally picturing an area of considerable debate in and around contemporary art history. See, for example, Bal 1996c, Duncan 1995, Sherman and Rogoff 1994, Vergo 1989.
41. Jennifer Allen has provocatively linked Struth's photographs of museum culture in the West with Kant's notion of the *sensus communis* (Allen 1995).
42. The notion of the object "amenable" to critical reading is elaborated by Jeanne Randolph from the theories of British psychoanalyst D. W. Winnicott. It may offer an alternative to Holly's use of a Freudian and Lacanian model of reception. (Randolph 1991).

2. PLACE AND TIME: KANT IN ROME

1. First epigram: "I only completely learned to understand Kant's *Critique of Aesthetic Judgment* in Rome." Letter from Fernow to his friend, the poet Jens Baggesen (Schopenhauer 1810, 263). Second epigram: de Certeau 1984, 43-44.

2. Goetschel attempts to demystify Kant's notorious aversion to travel (1994, 31).

3. See, for example, Bonfiglio 1997; Schott 1997; Serequeberhan 1996.

4. More soberly than Heine, Frederick Beiser has observed that Kant's "ethical rationalism stands for the principle of freedom, the basis of the constitution in France, while empiricism represents the principle of happiness [rejected by Kant], the foundation for the constitution of the ancien régime" (Beiser 1992, 39).

 Bart Raymaekers states clearly the connection between the political and the aesthetic that I wish to emphasize:

 Aesthetic experience is not Kant's final word. The link between nature and freedom is not finished in an aesthetic contemplation. Aesthetic experience brings up the question for the conditions of possibility of this kind of nature. Beauty of nature docs not give a direct entry to the absolute, but is referring beyond itself back to nature. Without doing any harm to the autonomy of the aesthetic judgment, this autonomy is taken up in a wider dynamics. (1998, 91)

 See also Sieber 1998.

5. See Brockliss 1996, 588.

6. It is customary in the art-historical literature to refer to those artists, critics, and patrons familiar to the critic Carl Ludwig Fernow as members of the "Carstens" circle, a reference to the Danish artist Jakob Asmus Carstens. Though I will in this chapter discuss Carstens's work, it seems to me that Fernow is of more lasting historical significance to the discipline of art history. It is an unfortunate convention to assume that artists are more significant to art history than critics, that the latter are somehow parasites. Elizabeth Holt, for example, suggests that "Fernow's importance derives from his review of the [1795] Carstens exhibit and his *Leben des Künstlers A. J. Carstens*" (1979, 56).

7. This is not the place for a detailed reading of the Enlightenment: see Porter and Teich 1981.

8. Andrews 1964, 18.

9. Thorvaldsen's subsequent interactions with the German-speaking artists in Rome are detailed in Fernow 1867, 319ff.

10. Kant's book was reprinted in 1796 in a slightly expanded version that included the "Secret Article" I shall discuss below (Bohman and Lutz-Bachmann 1997, 2). Given that Thorvaldsen came to Rome in 1797, I am assuming that it was the 1796 text that came into Fernow's hands.

11. ". . . habe ich hier noch öfter durchstudiern, und ich kann wohl sagen, dass ihr Geist erst hier in lichtheller Klarheit den meinigen durchdrungen hat." Trans. Mitchell Frank (hereafter cited as MF).

12. "Schiller hat gewiss viel Licht in das Feld der Aesthetik getragen, und ich verdanke ihm manchen Aufschluss über Dinge, die mir bis dahin dunkel waren" (MF).
13. "Durch Schillers Briefe und übringen Aufsätzesässe in den Horen bin ich grossentheils mit ihm . . ." (MF).
14. It is also true that others distinguished Kant's style in his *Critiques* from that of his more popular essays, as he did himself, and praised the latter. His contemporary commentator Madame de Staël noted that "when he is talking about the arts or morality, above all, his style is almost always perfectly clear, energetic, and simple" (1987, 315).
15. Letter to Wieland, 1795, cited in Wilkinson and Willoughby 1967, cxxxviii.
16. ". . . mein ganzes Studium der Kunst konzentrirt sich in der Zurückführung der bildenden Künste auf philosophische Prinzipien, und der gegenzeitigen Anwendung dieser auf jene in der Beurteilung."
17. Craske (1997, 144ff.) examines the international/national aspects of Rome in this period.
18. See, for example, the preface and published introduction to the third *Critique.*
19. See especially Shell 1996; Goetschel 1994; Zammito 1992; Makkreel 1990; and Kemal 1986.
20. A reading of *Perpetual Peace* in the context of Kant's other political work can be found in Reiss (1999). See also Matthew Levinger (1998), who sets Kant's political theory in the context of Prussian constitutionalism.
21. See also O'Neill (1992) for a powerful statement of this position. An examination of Kant's reputation in Hamburg as a reformer is found in Grolle 1995.
22. Kant's relationship to the French Revolution remains controversial. For a range of views, see Schmidt 1996; Neiman 1994; Beiner and Booth 1993; Reiss 1991; Nicholson 1992; Mah 1990; and O'Neill 1989.
23. "Fernow als Volksprediger das Evangelium von Menschenrecht und Pflicht von der Tribüne des Circolo costituzionale verkündete" (MF).
24. Alessandro Ferrara examines Arendt's vision of Kant (1998).
25. Kant's theory of freedom, like so many of his fundamental concepts, has attracted a daunting array of commentaries. For a thorough analysis, see Allison 1990. On Schiller, see the introduction in Wilkinson and Willoughby 1967.
26. My comments on these weighty and complex Kantian ideas can at best be an overview. Countless articles and books have been written on the nature of freedom in Kant and in the *Aufklärung* generally, on the thematic and structural relationships between his three *Critiques,* and on his moral philosophy. Here I can only offer an "apology" in the Platonic sense for my approach to them in the context of the Fernow circle in Rome and Kant's reception there. I am not claiming that Fernow consciously read Kant in this way. Fernow was an able and practiced interpreter of Kant, but his goal was to use the theory. Thus I wish to relate, in as straightforward and nontechnical language as possible, how I think Fernow adopted Kant's aesthetic and political ideas in a "practical" sense in his art theory and art-historical

writing. The sources that have most helped me to summarize these issues in Kant's writings are Geiman 1996; Neiman 1994; Beiser 1992, 1987; Zammito 1992; Kemal 1986, and of course the concurrency of my reading of Kant's third *Critique* and *Perpetual Peace*.

27. "Analogy" is a technical term and procedure in Kant's philosophy, an operation that allows him to cross over what he calls "domains" that, according to his own rules, cannot really be broached. Perhaps the ultimate example of this term's usage is the "analogy" between the operations of nature and art as discussed in the "Critique of Teleological Judgment," the second part of Kant's third *Critique*. We cannot know that nature is "purposive," designed for our comprehension and for the predictability in accordance with the natural laws essential for all scientific experimentation and knowledge. But Kant reasons that nature works "as if" it were art, as if it were purposive without a specific purpose: nature is analogous to art. I am suggesting that Fernow and also Carstens behaved as if the freedom and harmony of the beautiful were directly analogous to political freedom in the republican state. On analogy in Kant, see Caygill 1995, 65–67, Lyotard 1994, 65, and Zammito 1992, 274–75.

28. "Tun und Denken ganz analog; das innere Leben der Kunst so wie der natur, ihr beiderseitiges Wirken von innen heraus war im Buche deutlich ausgesprochen" (MF).

29. "Nur durch das Gefühl des Schönen können wir uns der freien Thätigkeit des Gemüths, – und nur durch die freie Thätigkeit des Gemüths können wir uns des Schönen bewusst werden. . . ."

"Denn beide sind wie Ursach und Wirkung unzertrenlich verbunden; und wir ne nnen alle die Gegenstände schön, deren Eindruck die freie Harmonie der Gemüthskräfte in uns bewirkt, und durch diese Wirkung das Gefühl des Schönen in uns erregt" (MF).

30. "Nach der Lehre unseres grossen Meisters *Immanuel Kant* sollen wir bey unsern Handlungen nur das erhabene Gebot der Pflicht im Auge haben, ohne auf den etwaigen Erfolg Rücksicht zu nehmen; weil dieser immer dem Zufall unterworfen, – jener Beweggrund hingegen allein ganz in unserer Gewalt ist. Durchdrungen von der grossen Wahrheit dieser Lehre will ich meinen Brief getrost beginnen und vollenden . . ." (MF).

31. Rainer Schoch has claimed that Rome was an "experimental field" for artists during the final years of the eighteenth century and that, in Kant, artists saw the model for their ideals of aesthetic, moral, and political autonomy (1992, 17). Schoch also uses the felicitous term "Kunstlerrepublik" to emphasize the parallels between political, moral, and aesthetic autonomy. Fernow's relationship with Carstens and his art, to which I now turn, corroborates this insight. A very complete analysis of the society formed by German-speaking artists in Rome in the early nineteenth century can be found in Peters 1992.

32. The German text can be found in Busch and Beyrodt 1982.

33. A fuller sense of this ongoing correspondence is found in Fernow's biography of Carstens (Fernow 1867).

34. Kamphausen has also noted this theme as crucial in Carstens's actions (1941, 260). On the theme of genius in artistic practice at this time and slightly later,

see Mildenberger 1992. It is likely that Carstens also derived his thinking from Schiller.

35. On the theme of friendship at this time and that of Fernow and Carstens particularly, see Lankheit 1952, 86.

36. Onora O'Neill has explained best the meaning of Kant's initially puzzling nomenclature of "public" vs. "private."

> [He] often speaks of reasoning that is premised on power or force as "private" [because it is] . . . deprived (*privatus*), incomplete. . . . In all such communication there is a tacit uncriticized and unjustified premise of submission to the "authority" that power of office establishes. The antithesis to private, partial exercises of reason must be a (more fully) public use of reason which steadfastly renounces reliance on powerful but ungrounded "authorities" in favour of self-discipline (1992, 65–66).
>
> Kant's counter-intuitive usage of the terms public and private was not entirely his own. Sabine Roehr claims that it is ". . . possible to trace Kant's distinction between the public and private use of reason to an anonymous article in the *Berlinische Monatschrift*. . . . There the author [Ernst Ferdinand Klein] distinguishes between the 'subordination' of a person as an officer or an official and the 'freedom to think aloud'" as an autonomous subject before the scholarly tribunal of public reason, that is, paradigmatically, as a philosopher. Klein's article also appeared in 1784 (Roehr 1995, 37). On the important theme of the Kantian subject, see Lang 1997 and Eagleton 1990.

37. On the artist's autonomy generally, see Hinz 1972 and Neumann 1968.

38. "Im Feld der Philosophie trieb er sich eine Zeitlang um, obgleich er ein conkreter, zu praktischer Kopf war, um specultaative Ideen anders als bildlich zu fassen" (MF).

39. In his biography and catalogue of Carstens's works, Fernow refers to the same drawing as *Raum und Zeit* and *Zeit und Raum*. There are actually three versions of this work. Figure 3 here is a copy – perhaps not by Carstens – of a lost painting of the theme. In another drawing of 1794 (Kunsthalle Bremen), Space is allegorized as an old man reclining in the foreground and stretching out his arm to Time, a relatively small putto. Likely with Fernow's guidance, Carstens realized that, to accord with Kant's philosophy in the first *Critique,* the figures should not be incommensurate in this way. Thus they are depicted in Figure 3 as interlocked equals. See Kamphausen 1941.

40. The painting was purchased at the time by Frederick A. Hervey (Fernow 1979, 60, n. 7).

41. "Nachher fing er auch an, Kant's Kritik der reinen Vernunft zu studieren, worin er aber nicht weiter kam, als in die Lehre von Raum und Zeit; und die Ausdeute dieses Streifzuges war eine symbolische Darstellung dieser beiden Formen in einer malerische Composition, derentwillen er mancherlei Anfechtungen in Scherz und Ernst erfahren musste" (MF).

42. For the correspondence between Goethe and Schiller on this work, see Fernow 1867, 253–54. Goethe later changed his mind about Carstens and saw his work as crucial to German classicism. No doubt Fernow was partly responsible for this change of heart, using his post as librarian in Weimar from 1804 to convince Goethe and Meyer of Carstens's importance.

43. "Seit *Kants Kritik der reinen Vernunft* hat der deutsche Geist einen entschiedenen Vorsprung gewonnen und wandelt zu Höhen hinauf deren Daseyn der grösste Theil der übringen Völker Europens nur noch in dunkeln Gefühlen [ahnet]. *Er* ist doch allein, der den Keim zu manchem trefflichen Werke befruchtet u. belebt hat; er ist es dem alle vorzüglichen Köpfe unserer Nation ihr Licht verdanken" (MF).

44. "Die Kantische Philosophie, das Verständniss der grossen Dichter, die Gedanken der Humanität, das war es, was das deutsche Volk jetze mehr als alles Andere mit Interesse erfüllte, das der Inhalt, der en Geist des deutschen Volkes erfüllte, womit der Maler seine Seele anfüllte, der bemusen war, die Aufgabe zu lösen, welche seit Winckelmann sich so viele gestellt, and der sich so viele versucht haben" (MF).

45. "Kant war ihm Pionier und Repräsentant der deutschen Bemühungen . . ." (MF).

46. A group of ninety-three cultural figures published "Aufruf an die Kulturwelt" in October 1914, stating that "we will fight to the end as a *Kulturvolk,* to whom the legacies of a Goethe, a Beethoven, [and] a Kant are just as sacred as its hearth and its soil" (cited in Marchand 1996, 236).

47. Symptomatic of the virulent strain of German nationalism rampant at this time was the use of Koch's *Schmadribachfall,* reproduced in full color in the official journal *Die Kunst im Dritten Reich* (March 1939) to mark the Koch exhibition at the Nationalgalerie, Berlin, in 1939. See White 1994, 145.

48. Kant continued and refined this line of inquiry in the final section of his *Anthropology* (1798), which I will discuss in relation to physiognomy in Chapter 5.

49. On the identification of reason and philosophy, see Neiman 1994.

50. Beiser offers a critique of de Staël's opinions on Kant (1992, 7ff.).

51. When thinking of theories of beauty at this time and of theories of genius built on Kant's subjectivism – in short, when artists in the 1790s are held to be Romantics – we should recall that Carstens's use of the term "public" stems from Kant's essay on the *Aufklärung.* He and Fernow are more figures of the Enlightenment than of Romanticism.

52. For a complex discussion of the dominance of philosophy over the idea of literature in this period, see Lacou-Labarthe and Nancy 1988.

53. "Eine vollständige und befriedigende Erklärung des Schönen ist also nur aus dem Wesen oder der Idee, nicht aus den Erscheinungen desselben, möglich" (MF).

54. Several contemporary scholars argue that Kant's entire philosophy is for this reason ultimately and consistently "political," despite its appearances to the contrary and its conventional and self-characterization as purely theoretical. See especially Goetschel 1994 and Beiser 1992.

55. For a detailed reading of Kant's views on women and freedom, see Shell 1992.

3. THE GENEALOGY OF AUTHORITY: KANT AND ART'S HISTORY IN THE TWENTIETH CENTURY

1. References for epigrams: Panofsky (1981, 28); Kahnweiler (1949, 27); Greenberg 1986–93 (4:76).
2. Because I am not attempting to present a complete survey of Kant's impact in the field of art history, I will only summarize his impact on Heinrich Wölfflin, one of Panofsky's main reference points. As Joan Hart (1982) has shown, Wölfflin was acquainted with Kantian views in part through his teachers Wilhelm Dilthey and Friedrich Paulson, a professor of philosophy and psychology in Berlin in the late nineteenth century and a biographer of Kant. Wölfflin shared Kant's idea that perception is blind without the mind's concepts, and he sought from this basis to explain in a scientific way how stylistic change in art's history occurred. He reacted against the personal, unverifiable cultural analysis of Jacob Burckhardt and developed instead an ultimately Kantian system of formal categories with which the eye historically sees and organizes the world. Wölfflin's extraordinarily influential "categories of beholding" – linear/painterly, plane/depth, closed form/open form, multiple unity/fused unity, absolute clarity/relative clarity – which he articulated in *The Principles of Art History* (1915), are not in themselves Kantian, but their necessity in our "subjective" perception of the world and art follows a Kantian pattern. Although he disputed many of Wölfflin's ideas in his early essays, Panofsky too sought the stability of what he called an "Archimedean" point of view, beyond – or perhaps prior to – the exigencies of history. Both turned to Kant's epistemology for a secure understanding of art.
3. Genealogy is frequently invoked to tell the story of Panofsky's debt to Kant, and I use it here, too, as a shorthand for an intellectual tradition. While we may quite rightly track Panofsky's authentic "relation" to Kant back through Cassirer and Cohen, however, the purity of this pedigree tells us little about how Panofsky used the Kant he received. In effect, then, the incantation of lineage merely invokes the authority of Kant/philosophy that I want to open to critique here. Intermediaries often figure importantly, as for example in Hubert Damisch's claim that Panofsky sometimes failed to understand Cassirer (Damisch, 1994, 15).
4. See, especially, the superb work done by Holly (1984), Moxey (1994, 1995), Podro (1982), and Summers (1995). For a fine discussion of Panofsky's place alongside contemporaries such as Warburg, Saxl, and Wind, see Ginzburg (1989).
5. On this point, see the excellent article by Wood (1991), who discusses Panofsky's problematic slide in his interpretation of perspective from a discussion of space to a more general *Weltanschauung*.
6. Damisch also discusses the metaphor of choice in Panofsky and urges us to be careful not to pretend that Panofsky chose, in the United States, between an empirical art history and his theoretical roots (1994, 19). On Cassirer, see Gilbert 1949 and Werkmeister 1949.
7. As I have suggested before, there is no pure Kant to be recovered by Pan-

ofsky or anyone else. Neither does Kant ever exert an exclusive influence within the philosophical spectrum. Holly (1998, 436), for example, points out the Hegelian strains in Panofsky's thinking, elements elided in Melville's account.

8. This theme – or relation – of secrecy seems to me to *be* the "secret" of the relationships among disciplines that I am fundamentally concerned with in this study. Because secrecy is by definition not transparently describable, it can be thought of as "sublime." Thus in Chapter 4, I will argue that philosophy and art are, in this disciplinary sense, functionally (even purposively) "sublime" for one another. Jacques Derrida has in a recent text meditated on the status of this Kantian secret: "the secret possibility of the secret seems to situate, in truth to prescribe, the very place of the philosophers' deliberate (premeditated) intervention in the juridico-political space. One would have to draw all the consequences. But they remain incalculable . . ." (1993a, 86).

9. In an essay on Richard Offner's articulation of an explicitly Kantian theory of art, Hayden Maginnis offers corroboration for the argument that American art history at this time was strongly empirical and positivist, and thus not sympathetic to continental theorizing. See Maginnis 1993.

10. Victoria Kahn (1986) has detailed the resistance to theory typical of the humanist tradition. Moxey (1994, 70–71) discusses Panofsky's humanism in terms of its political resistance to the Nazis.

11. As we saw in Chapter 1, Kant is often used as an exemplary humanist by art historians from Germany and Austria. His humanism is indeed fundamental to his "Copernican revolution" in philosophy. As John McGowan, building on the distinction between "internalist" and "externalist" philosophical proclivities suggested by Hilary Putnam, argues: Kant's "internalist perspective is fully, almost aggressively, humanistic, insisting that our notions of truth and of the real are products of human systems of thought, belief, or discourse. . . . This humanistic modernity is connected in his work to a liberalism that stresses autonomy and limits" (McGowan, 1991, 32).

12. I want to acknowledge that David Summers also sees Panofsky's art history as cosmopolitan in his highly informative essay for a 1995 symposium and publication on Panofsky's influence (1995, 18, 20). As will be clear below, I agree with Summers's minority opinion that Panofsky's work is historical and always theoretical. I arrive at this conclusion by a different route through Kant, however, one that depends on the context developed in Chapters 1 and 2 of this study.

13. Panofsky is explicit about these Kantian categories in art history: "The artwork, viewed ontologically, is a discussion [*Auseinandersetzung*] between 'form' and 'feeling' – the artwork viewed methodologically, is a discussion between 'time' and 'space'" (1974, 50; my trans.).

14. Summers writes that "for Panofsky, all our representations and constructions were historical" (1995, 19).

15. I wish to thank Mitchell Frank for helping me to understand this evolution. Damisch (1994) and Louis Marin (1983) also discuss Panofsky's penchant for revising his essays.

16. On issues of citation and scholarly legitimation, see Jay 1990. In bringing

Kant's name – with its complex genealogy – back into focus in this discussion, I am consciously breaking the "rule" of not mentioning philosophers' names in philosophical argumentation. On this practice, J.-F. Lyotard writes: "One striking feature of philosophical discourse in most of the forms it borrows . . . is that it avoids, on principle, any use of proper names in its arguments. The names of authorities and adversaries that nevertheless remain persist only as the names of arguments" (1989c, 346).

17. Kahnweiler's history of cubism was complete by 1915 but not published until 1920.

18. Clearly, Kant was not the only philosophical source used in commentaries on cubism nor, as this example shows, was he always presented directly. Rosenberg's idealism depends heavily on Plato, a familiar reference point at this time (see Cheetham 1991). Nonetheless, it is the case that Kant was by far the most frequently cited philosophical source for those writing on cubism.

19. See Crowther 1987, 195. Mark Antliff summarizes the point: "According to . . . a Kantian interpretation of Cubism, . . . the Puteaux Cubists abandoned the optical representation of an object by linear perspective in favor of a conceptual representation in which multiple views allow both artist and viewer to synthesize the object into a single image of the thing as it is rather than as it appears" (1988, 342).

20. The most detailed analysis of the many controversies surrounding cubism is Green 1987. Yve-Alain Bois (1990) is especially critical of the "idealist" interpretations of cubism. Green (1987) again offers a more balanced and historically complete version of events.

21. Recourse to Kant was, generally, a way to downplay the importance of subject matter in cubism, a trend increasingly rejected. For an excellent survey of recent historiography of cubism, see Leighten 1988. Looking ahead to the final section of this chapter, we could say that cubism was, for Greenberg – a self-proclaimed Kantian – *the* touchstone of modernism, and that any recent, negative response to Kant's role in cubism is likely to have something to do with a reaction against Greenberg.

22. Bois 1990 and Taylor 1985 are especially critical in this regard.

23. Crowther's many articles and books together treat Kant's aesthetics in their relations with the visual arts more thoroughly than the work of any other scholar. I am in agreement with many of his analyses and also greatly admire his interest in contemporary art. It is in the spirit of intellectual debate that his writings establish that I engage here with the unacknowledged biases of his position on Kant and cubism.

24. For a recent account of the connection with Husserl, see Slettene 1997.

25. On Picasso's and Braque's practice (and strategy) of silence concerning cubism, see Bois 1990.

26. Lang (1997) gives a full discussion of the Kantian subject in the context of art history. See also Bowie 1990.

27. Although Kant does not mention art history in the historical group, we know that Johann Dominicus Fiorillo (1748–1821), probably the first university-based art historian, who taught at Göttingen from 1781 until his

death, was a member of the philosophy faculty. I would like to thank Anne-Marie Link for this as yet unpublished information.

28. Kahnweiler's main value here seems to be as a putative recorder of Picasso's otherwise unavailable intentions. It is worth noting that the "materialist" interpretation of cubism championed by Crowther, Bois, and others stems in good measure from Picasso's retrospective statements about the early days of the new movement. He claimed, for example, that "real cubism [was] fundamentally a horridly materialistic affair, a base kind of materialism" (cited in Bois 1990, 171).

29. Bois's work on Kahnweiler's Kantianism is by far the most nuanced. "Kant is not necessarily the indispensible sesame of cubism," he writes, "although he may have been for Kahnweiler" (1990, 68). Bois's rejection of the "idealist" interpretation of cubism – and thus of the close connection between Kant and this movement – is revealed in his dismissive statements about the Kantian (and other) "clichés" used by Raynal and other French critics (1990, 68). His rejection of Kant is in the service of this larger interpretation of cubism.

30. It is perhaps unusual to speak of two such different theorists together, but in their concern for how aesthetics – especially that of Kant and Hegel – "assigns [art] a job as medium . . . every time [it] determines art, masters it and encloses it in the history of meaning or in the philosophical encyclopedia" (Derrida 1987, 34), Derrida sees how philosophy trespasses on, or, in Danto's famous term, "disenfranchises" art by making it other than it properly is. Both writers argue in temporary unison for a clear distinction between art and philosophy. Especially germane to the rhetoric of purity and infection I develop in this book is Danto's argument that "there is an incentive in philosophically curing art of philosophy: we by just that procedure cure philosophy of a paralysis it began its long history by infecting its great enemy [art] with" (1991, 17). I return to this discussion at the end of Chapter 5.

31. Aurier 1891. Though well beyond the scope of this book, it is possible to link historically both Gauguin and Aurier's search for a pure, nonmaterial, "eidetic" art in the 1880s and 1890s with that of the cubist artists and critics a generation later who claimed to be "idealists" in the Kantian tradition. Both groups partake in what I have examined elsewhere as "the rhetoric of purity" (Cheetham 1991a), as Green also argues (1987).

32. References to Greenberg's writings will in most cases be to *Clement Greenberg: The Collected Essays and Criticism,* ed. John O'Brian, 4 vols. (Chicago: University of Chicago Press, 1986–93). In these citations, the volume number will be followed by the page number. This reference is to 2:66. Citations of Greenberg's essays not collected by O'Brian are referred to in my text by the year followed by the page number.

33. Although to my knowledge no one has analyzed in detail the Hegelian (and Marxian) roots of Greenberg's way of construing history, many mention his clear influence: see, for example, Stadler 1982, Carrier 1987, and Kuspit 1979.

34. See Greenberg 1973a for a discussion of Kant on intuition.

35. Reading with Pluhar and with Bernard. See the following note.
36. Reading with Meredith. Greenberg knew German and could have been translating from the original himself. His wording is nonetheless extremely close to the English translation most readily used at this time, that of Bernard (published 1892).
37. It is abundantly clear in §38 of the third *Critique* that the universality of "common sense" is based upon the form of the "power of judgment," not upon any content such as Greenberg's appeal to the historical tradition in art formed by the accumulation of positive judgments about works and artists as they constitute a tested canon. Foisy 1998, Lyotard 1992a, and Summers 1993 have provided detailed readings of Kant's *sensus communis*.
38. These points come up several times in de Duve's *Clement Greenberg between the Lines and Kant after Duchamp*. I should acknowledge at this point my considerable debt to de Duve's subtle and sustained readings in these books. His sense of rereading Kant "after" Duchamp is one that I much appreciate. But to avoid becoming pedantic myself, I will leave it to the reader to make comparisons between his judgments and my own. The sense of recasting Kant in light of his reception explored by de Duve is also found in Lyotard's essay "Judiciousness in Dispute, or Kant after Marx." Finally, I have learned much from Donald Kuspit's pioneering *Clement Greenberg: Art Critic*, which remains the most systematic account of the critic's ideas and importance.
39. For example, Toronto painter Andy Patton has reported to me in conversation that Greenberg, in a talk at the Plug-In Gallery in Winnipeg in the mid-seventies, was dismissive of some audience questions, claiming that reading Kant was necessary before discussing all sorts of issues in art.
40. In the following pages, I will be discussing a different sense of Greenberg's "political position," what we might deem a theoretically oriented geopolitical view of how art fits within society, a perspective close, I believe, to Kant's. These analyses should complement the many very important discussions of Cold War and American painting. See especially the essays in Guilbaut 1990 and Frascina 1985. On the ideological dimensions of Kant's aesthetics, see Bürger 1984 and Eagleton 1990.
41. Deane Curtin has written that "Greenberg's formalism begins with his vision of political life" associated with a necessary, "dialectical" response to the widespread incomprehension of avant-garde art in the public sphere (1982, 317). David and Cecil Shapiro have claimed that "The act of repudiating political, moral, and aesthetic values becomes, willy-nilly, an aesthetic both political and moral." They point to Greenberg's likely affinity with an article proclaiming art's freedom published by Trotsky and Breton in the *Partisan Review* shortly before "Avant-Garde and Kitsch" appeared in that journal (1985, 139). A more detailed reading of this sociopolitical context is presented by Guilbaut and by Orton and Pollock (in Frascina 1985). While I agree with these arguments, I believe that Greenberg's motivations for adopting the stance of art's autonomy were at least in part Kantian, a point that to my knowledge has not been made. It is worth speculating that Greenberg found Kant and found him amenable because he was looking for a

theory of aesthetic detachment. In entertaining this perspective, my goal is to add to, not replace, the social histories noted here and to show that a "theoretical" move – in this case a reading of Kant – can certainly be "political."

42. Did Greenberg read Kant as early as 1939? We don't know. Florence Rubenfeld, Greenberg's recent biographer, says that he began to read the philosopher only in the early 1940s, though I suspect from the superficial view of Greenberg's philosophical affinities she supplies that she is merely surmising from the date of his first written reference to Kant (1943). If this is correct, then my suggestion is that we should read his previous essays "as if" he knew Kant's political essays of the 1780s, to use the famous bridge thrown out so often by Kant to permit passage from a transcendental, regulative necessity of thought to empirical reality. If Greenberg's terminology and arguments at this time do suggest his familiarity with Kant, then we have a strong historical as well as theoretical case for speculating that he looked to Kant in his search for a theory of detachment.

43. Greenberg saw "decay" all around him and modernist separatism as its only salvation. As he put it in an interview marking the fiftieth anniversary of "Avant-Garde and Kitsch," "with or without Spengler, I see modernism as an effort to cope with decadence" (Ostrow 1989, 57). In 1939 and consistently throughout his long career, Greenberg saw the avant-garde (which he largely conflated with modernism in its best forms) as finding and articulating "a superior consciousness of history – more precisely, the appearance of a new kind of criticism of society, an historical criticism" (17). Greenberg proceeds historically when he sees what turned out to be his own future: "it is true that once the avant-garde succeeded in 'detaching' itself from society, it proceeded to turn around and repudiate revolutionary as well as bourgeois politics" (17). It is difficult to forgive Greenberg – or Kant, given the contrast between his cosmopolitanism and purist aesthetics – for this seeming betrayal of their own perceptions.

44. On Greenberg's adoption of Enlightenment values and the political nature of his work generally, see Jachec 1998. My views are in accord with hers, though developed in a different manner.

45. It is important to recognize the peculiarly charged language that Greenberg uses to capture both the negative aspects of kitsch, described in 1939 as a "pestilence" (1:13), and the positive role of abstraction as a homeopathic cure or antidote. His discourse is medical in its reference to the body politic and consistently recommends purity over perceived social and formal infections, such as postmodernism. Greenberg unwittingly participates in a widespread "rhetoric of impurity" that divides and defines much of the production and conceptualization of abstract art from the 1940s to the present. I have begun to examine this rubric in "Recent Rhetorics of Purity in the Visual Arts: Infection, Dissemination, Genealogy" (Cheetham 1997).

46. Mondrian's work was, usually, held up by Greenberg as the paradigm of abstraction's antidote to kitsch. But the critic was nervous about Mondrian's frequent statements about the social purpose of art, about his spiritualism, and about his theoretical bent. Although the artist's "theories

were perhaps felt necessary to justify such revolutionary innovations [in art]," Greenberg wrote in 1945, "Mondrian committed the unforgivable error of asserting that one mode of art, that of pure abstract relations, would be absolutely superior to all others in the future" (2:16). Greenberg could certainly be accused of the same. On the relationship between Mondrian's theory and painting, see Cheetham, *The Rhetoric of Purity* (1991a).

47. David Summers has defined this as "a strong formalist position, one governed by the assumption that form in some sense *is* itself a kind of content." I am suggesting that the "content" is in part art's social and political efficacy in ministering to what Greenberg saw as a threatened culture. For Summers and, I think, Greenberg too, "a weak formalist position [is] one in which form is simply the vehicle of content" (Summers 1989, 377).

48. In somewhat different terms, Crowther also points to Greenberg's misapplication of "interest" to painting's formal structure (1985a, 318).

49. J.-F. Lyotard provides a detailed and nuanced reading of the connection between the aesthetic and the ethical in Kant's work (1994, 163ff.). Paul Guyer argues "that there is not an outright contradiction between Kant's conception of the autonomy of the aesthetic and the idea of using aesthetic experience as a symbol of morality . . ." (1998, 339).

50. I have argued at length in *Remembering Postmodernism* (1991b) that the postmodern does not suffer from amnesia, but rather employs types of memory different from those of modernism.

51. On this topic, see Floyd 1998.

52. A good source for the meaning of this term in the history of aesthetics is Podro 1972.

53. This memorable passage is from a paper delivered by McEvilley at the 1994 conference of the International Association of Art Critics in Stockholm. His comments came shortly after Greenberg's death. He published a more circumspect and elaborate version of this paper under the same title in 1998, which is noted in my *Selected Bibliography*. The notion of Kant rising from the grave is especially apt in light of the phrenological study of him conducted in 1880, which required the exhumation of his remains. See Chapter 5.

54. On Panofsky, see especially Reudenbach 1994 and Lavin 1995. On cubism, see Patricia Leighten in guest-edited issue of the *Art Journal* 47, 4 (1998); and, on Greenberg, see de Duve 1996b.

4. THE SUBLIME IS NOW (AGAIN): FRENCH THEORY/INTERNATIONAL ART

1. References: Kant 1987, §27, 257; Derrida 1989, 73.

2. In general, I will concentrate on the work of those contemporary theorists who discuss the intrigues of the sublime in all three of the disciplinary contexts in focus in this book: philosophy, art history, and the visual arts. I find Derrida and Lyotard the most illuminating in these contexts, though I will in passing comment on other relevant writings. Though the sublime does work critically in the larger philosophical arguments of these writers, I shall limit my remarks to a very small number of their texts. The resurgence

of interest in the sublime across many disciplines in the past two decades has resulted in an unpresentably large bibliography on the topic. By far the most complete record of this activity (to 1989) is the compilation by Peer Sporbert in Pries 1989. I am especially indebted to the work of the philosophers noted above, to Berstein 1992, to Crowther's numerous texts on the topic, and to de Bolla (1989). My bent is toward a "deconstructive" and historical sense of the sublime rather than its psychoanalytic strains (for which see Ferguson 1992, Hertz 1985, and Weiskel 1976).

3. In a suggestive overlapping of the temporal and spatial, Jean-Luc Nancy notes that "the sublime is not so much what we're going back to as where we're coming from" (1993b, 1). More specifically and controversially, J.-F. Lyotard writes that the "Kantian . . . aesthetic of the sublime is where modern art (including literature) finds its impetus and where the logic of the avant-garde finds its axioms" (1992b, 10).

4. Concern for the "use" of art by philosophy – found in Derrida, Lyotard, and Nancy especially – can also be traced to Martin Heidegger. For him, the aesthetic as frame can be so "treacherous . . . that it can capture all other kinds of experience of art and its nature" (1971, 43).

5. This debate continues. See especially Mattick 1995, Gould 1995, and many of the essays in Schott 1997.

6. On the broad implications of framing in contemporary theory, see Duro 1996.

7. Derrida has written about the economic implications of this discourse (1981), as has de Bolla 1989, from a much more materialist perspective.

8. It would be worth investigating the connections between this indication about the sublime and the final chapter of *The Truth in Painting*, which Derrida titles "Restitutions of the Truth in Painting."

9. See Caruth 1988 and Lloyd 1989 for detailed examinations of the status of examples in Kant's critical philosophy as a whole.

10. On travel literature and the sublime, see Chard 1989, 61–69. An especially rich discussion of the many contexts for the sublime in the eighteenth and early nineteenth centuries is found in de Bolla 1989.

11. A fuller discussion of this issue would need to take account of Derrida's remarks on "friendship," particularly his argument against the supposed presence and potency of the "essentially sublime figure of virile homosexuality" (1988, 642).

12. For a detailed examination of the etymology of the word *sublime*, see Cohm and Miles 1977.

13. Peter de Bolla (1989) introduces a useful contrast between discourses "on" the sublime – those which discuss the category – and discourses "of" the sublime, those which in some way present or evoke its potent effects. While my own efforts here definitely fall into the "on" category, it is in many cases difficult to make such a clear separation. We have seen, for example, that Lyotard and Nancy typically make grandiose, "sublime" pronouncements about this phenomenon even in their most technical disquisitions "about" the topic. Psychologically, it is very difficult to determine in examples of paintings of sublime themes – the many versions of Vesuvius in eruption or,

to think of human affairs, Turner's images of the burning of the British Parliament – whether the emotional effects that we can imagine by putting ourselves "in" the scene are in fact only sublime because of the psychological distance provided by the mediation of representation.

14. I am most interested here in the contrasts between British and German visual presentations of the sublime. French artists also embraced the genre, most often looking to French sources such as Boileau and to Burke as mediated by Diderot. I presented a preliminary version of these arguments in Cheetham 1987.

15. Koch was not alone in emphasizing what I shall call the scientific particularity of the landscape. Philip Hackert, Johann Christian Reinhart, Caspar David Friedrich, and Carl Gustav Carus can be seen as parties to this same trend.

16. Kant knew the 1773 German translation of Burke's *Philosophical Enquiry* published by Hartknoch. The most detailed readings of Kant's "Analytic of the Sublime" are those of Crowther 1989a and Lyotard 1994. Lyotard's especially is revelatory, but in company with most commentators, he does not sufficiently emphasize the differences between Kant's mathematical and dynamic sublime.

17. An exception is Alexander Gerard, who wrote in 1759 that objects "do not themselves possess that quality" of the sublime, but they "do acquire it, by *association*" (1759, 20). On Gerard's importance in eighteenth-century aesthetics, see Guyer 1993.

18. The situation has certainly changed, but not as much as one would think. In the late eighteenth century there were many attempts to make as real as possible the dangerous effects of nature: Phillippe de Loutherbourg's *Eidophusikon* – an elaborate machine for the staging of earthquakes, eruptions, etc. – is perhaps the best example. Whether or not we should consider as sublime those contemporary performance pieces by Dennis Burden and others where danger and mutilation are all too present is a challenging question. See, for example, the excellent article by Howard Caygill on the artist Stelarc (Caygill 1997).

19. See Cheetham 1984 and 1985 for a fuller analysis of this theme. See also Timothy Mitchell 1993.

20. Newman's famous text on the sublime has been analyzed in detail by Crowther (1985b). Michael Zakian's revisionary reading of Newman's essay is also relevant to my comments (Zakian 1988).

21. See especially Cheetham 1995 and Crowther 1995. In the balance of this chapter, I will examine artists' works that I think exemplify the current range of incarnations of the sublime. I will focus on work that I know best, but I am not seeking to deny the membership in this growing category of other artists – some of whom are identified by Crowther – nor do I seek to define a new canon of sublimity. Exhibitions on the theme of the sublime in contemporary art continue to appear. The most recent as I write is "On the Sublime," curated by Bo Nilsson at the Rooseum, in Malmö, Sweden (January 23–March 21, 1999).

22. All quotations from Ayearst are from a letter to the author of July 28, 1994, and an unpublished artist's statement dated August 1993.

5. KANT'S SKULL: PORTRAITS AND THE IMAGE OF PHILOSOPHY, C. 1790–1990

1. Citations: Heine 1985, 203; McEvilley 1998, n.p.; Deleuze and Guattari 1994, 55.
2. On the theoretical implications of this position, see W. J. T. Mitchell 1995.
3. The often subtle differences between these competing sciences were perhaps of greater importance to their various authors and promoters than to a public – including artists – that was demonstrably hungry for these theories of human character. On physiognomy, phrenology, and the arts, see Allentuck 1967, Colbert 1986, Cooter 1984, Cowling 1989, Pearson 1981, Stafford 1987 and 1991, Stemmler 1993, and Tytler 1982. Stemmler provides a complete account of the publication details of Lavater's various texts on physiognomy.
4. See "Decoded in Canada: Einstein's Brain," *The Globe and Mail* (Toronto), Friday June 18, 1999, A1, A7.
5. In citing Lavater, I have here and on other occasions used Stemmler's translations from the German original.
6. On Kant's place in Königsberg, see Gause 1968.
7. I have consulted the original monograph of 1880, a copy of which is held at Harvard University. Some confusion surrounds the publication data for this work, however. Harvard records the monograph as published in Braunschweig in 1881, but this is the place and date of the version published in the journal. I have recorded the journal citation in my *Selected Bibliography*, given that it is more accessible.
8. On Kant and anthropology, see Strack 1996.
9. "The physiognomical vogue was at its height between 1775 and about 1810. . . . By 1810, sixteen German, fifteen French, two American, two Russian, one Dutch, one Italian, and no less than twenty English versions [of Lavater's book on physiognomy] had been published" (Tytler 1982, 82). Gall and Spruzheim traveled widely in Europe speaking about their new science after its promulgation had been forbidden in their native Vienna in 1801. To make the dissemination of these doctrines concrete in terms of the artists studied here, it is worth knowing that Carl Ludwig Fernow visited Lavater in Switzerland and heard Gall lecture in Weimar (Schopenhauer 1810).
10. See Sekula 1986. There are several websites dedicated to the promotion of phrenology in contemporary society.
11. Oeser writes: "Wenige Köpfe der ganzen grossen deutschen Epoch zeigen so stark und so klar, in welche Tiefen des Volkstums damals der geist dringt, wie dieses Selbstbildnis von Asmus Jacob *Carstens*. . . . Wie man dieses ganze Lebensschicksal, seine Grösse und seine Grenzen in diesem Gesicht sieht, in diesem scheweren breiten Mund, in diesem gefruchten Brauen, den bebenden Nüstern und in diesen Augen, die gross und fast angstvoll ins Weite

dringen!" (Oeser 1932, 72). My thanks to Mitchell Frank for providing this reference.

12. Kuppfer and Bessel Hagen discuss the casts (1880, II, n.3) and include a comparative table outlining the differences between measurements of the casts and the skull. We can surmise that artists, too, were increasingly impatient with the inaccuracies of casts. Their frustrations and demands for greater accuracy in skull measurements are well documented in the case of the American sculptor Hiram Powers (Colbert 1986).

13. In an earlier source that I will examine presently, bumps on the skull are tellingly called "Schädelerhabenheiten," literally "protuberances on the skull," but including the term "erhabene," which also translates as "sublime" in contemporary discussions of the sublime in natural and painted phenomena (Kelch 1804, 26). On the relationships among Friedrich, Carus, geology, and landscape depiction, see Cheetham 1982.

14. The cultural importance of death masks at this time is underlined by the fate of Napoleon's, which was the subject of a copyright trial in France in 1834. Napoleon's image had been "stolen" after his death by Francesco Antomachi, Napoleon's physician in Saint Helena, against the orders of the British authorities. A man named Massimino made copies of this mask and was taken to court. I am indebted to Katie Scott and her paper "Crimes of Likeness: Property and Identity in French Portraiture c. 1730–1830," presented at the College Art Association of America's annual conference in Toronto, February 1998.

15. For a more complete gallery of Kant portraits, see ⟨http://www.unimarburg.de/kant/webseitn/galerie.htm⟩ and ⟨http://www.arroweb.com/philo/Imag/KantImag.htm⟩.

16. Even in a group of little-known artists, Vernet is obscure. For what information there is on him, see Kruse 1989, 204.

17. This work seems not to have been known by Clasen, whose compendium of Kant portraits was published in 1924 (Clasen 1924). An earlier source – Minden, who, in company with most of the artists who depicted Kant, seems to have left no trace of his first name – notes that Vernet painted more Kant images than any other artist (he lists nine), but he does not mention the picture of Kant without his wig (Minden 1868, 28–29).

18. Corson in fact uses a profile of Kant, adapted from the image by Hans Veit Schnorr von Carolsfeld, to illustrate typical wigs worn by men c. 1760–80 (Corson 1971, 317, illus. "G").

19. This information comes from an anonymous article in *Kant-Studien* 20 (1915): 337. We can only speculate why the image was not used publicly by Lavater. The two men were correspondents on philosophical matters, cited each other in print, and apparently had great respect for one another. Kant, however, was suspicious of Lavater's spiritualism, particularly his interest in Swedenbourg. Lavater may not have wished to engage Kant on this issue by including the portrait in his overtly spiritualist system of physiognomy.

20. There is no survey of Kant portrait sculpture equivalent to Minden's or Clasen's attempts to account for all images in their chosen categories, nor is it my purpose to present here such a compendium. The most complete

catalogue is Grolle 1995, which also contains portraits of other figures that are useful for comparison. See also Fliedl's detailed discussion of Goethe's portraits (1994).

21. I am very grateful to V. K. Pokladova of the State History and Art Museum in Kaliningrad and overseer of the exhibit for sharing this information.

22. From the unpaginated catalogue, published in English and Russian in 1994.

23. For images of Goethe, see Fliedl 1994 and Schultze 1994.

24. For other pictures of Hegel, see Biederman 1981.

25. Phrenology and physiognomy were also decidedly masculinist in their prejudices, especially when it came to the emphasis on reason supposedly betokened by the shape of the male skull. Given the extraordinary popularity of these views, it is worth conjecturing that phrenology and physiognomy were key influences on the gendering of philosophy in the Enlightenment and after. Philosophy's masculinization began well before the Enlightenment, most concertedly in the seventeenth century. See Schiebinger 1993.

26. My choice of Socrates for comparison with images of Kant arose in a complex context. In his discussions of the forehead as the seat of intelligence, Lavater praises this feature of Socrates' head (while trying to explain away his reputed ugliness). Lavater's reference point is Rubens's portrait of the Greek philosopher, underlining again the historical and theoretical links between image and text in physiognomical doctrine. Interestingly, too, Blake's portrait of Socrates draws on Lavater's observations, as Ann K. Mellor has demonstrated (Mellor 1978). De Quincey explicitly compares Kant with Socrates in *The Last Days of Immanuel Kant* (see O'Quinn 1997, 273).

27. Gammon (1997) discusses this passage in the context of Kant's theories of imitation and genius.

28. In his extraordinarily detailed *Versuch eines Geschichte und Beschreibung der Stadt Königsberg*, Baczko lists thirty-six "artists" living in the city. Most seem to have been craftspeople of various ranks. By comparison, there were over one hundred "Peruquiers"! (Baczko 1787, 1:534ff.).

29. The exception would be the statues of Kant by Christian Daniel Rauch (1777–1857), mentioned above, who was arguably the best-known German sculptor of his day.

30. Commentators on Foucault have expended much effort in drawing distinctions between his "archaeological" and "genealogical" procedures. At least in retrospect, his own position that these procedures are simultaneous and part of the same historicophilosophical process seems most apt (Foucault 1984b, 46).

31. Recall that Deleuze has written an excellent analysis of Kant's critical methodology (1990).

32. The artist is almost certainly Gottlieb Döppler, whose exact dates are not recorded and whose name is usually spelled "Döbler" in the Kant literature.

Selected Bibliography

Adorno, Theodor W. 1997. *Aesthetic Theory*. Ed. Gretel Adorno and Rolf Tiedemann, trans. Robert Hullot-Kentor. Theory and History of Literature, vol. 88. Minneapolis: University of Minnesota Press.

Alberti, Leon Battista. 1966. *On Painting*. New Haven, CT: Yale University Press.

Allen, Jennifer. 1995. "Snapshots of the *sensus communis:* Thomas Struth's Museum Photographs." *Parachute* 79 (July–September): 4–13.

Allentuck, Marcia. 1967. "Fuseli and Lavater: Physiognomical Theory in the Englightenment." *Studies on Voltaire and the 18th Century* 55: 89–112.

Allison, Henry E. 1990. *Kant's Theory of Freedom*. Cambridge: Cambridge University Press.

Anderson, Edouard. 1932. "Ein Unbekanntes Kantbildnis." *Beilage zu den Kantstudien* 37, 3/4: 309–10.

Andrews, Keith. 1964. *The Nazarenes*. Oxford: Oxford University Press.

Ankersmit, F. R. 1994. "Kantian Narrativism and Beyond." In Mieke Bal and Inge E. Boer, eds., *The Point of Theory: Practices and Cultural Analysis*, 155–60, 193–96. New York: Continuum.

Antliff, Mark. 1988. "Bergson and Cubism: A Reassessment." *Art Journal* 47, 4:341–49.

Arendt, Hannah. 1982. *Lectures on Kant's Political Philosophy*. Ed. Ronald Beiner. Chicago: University of Chicago Press.

Aurier, Albert. 1891. "Le Symbolism en peinture: Paul Gauguin." *Mercure de France* 2:159–64.

Baczko, Ludwig von. 1787. *Versuch eines Geschichte und Beschreibung der Stadt Königsberg*. 2 vols. Königsberg: Hartungschen Hof.

Bahti, Timothy. 1987. "Histories of the University: Kant and Humboldt." *MNL: German Issue* 102, 3 (April): 437–60.

Bal, Mieke. 1999. *Quoting Caravaggio: Contemporary Art, Preposterous History*. Chicago: University of Chicago Press.

———. 1996a. "Art History and Its Theories." *Art Bulletin* 78, 1 (March): 6–9.

1996b. "Semiotic Elements in Academic Practices." *Critical Inquiry* 22 (Spring): 573–89.

1996c. *Double Exposures: The Subject of Cultural Analysis.* London: Routledge.

Beiner, Ronald, and William James Booth, eds. 1993. *Kant and Political Philosophy: The Contemporary Legacy.* New Haven, CT: Yale University Press.

Beiser, Frederick C. 1992. *Enlightenment, Revolution, and Romanticism: The Genesis of Modern German Political Thought, 1790–1800.* Cambridge, MA: Harvard University Press.

1987. *The Fate of Reason: German Philosophy from Kant to Fichte.* Cambridge, MA: Harvard University Press.

Benjamin, Daniel. 1994. "A Russian Enclave Smitten with Kant Also Loves Germany." *Wall Street Journal* (Eastern ed.), Aug. 19, A1, A4.

Bennington, Geoffrey. 1994. *Legislations: The Politics of Deconstruction.* London and New York: Verso.

Berlin, Isaiah. 1996. "Kant as an Unfamiliar Source of Nationalism." In *The Sense of Reality: Studies in Ideas and Their History,* 232–48. London: Chatto & Windus.

Bernstein, J. M. 1992. *The Fate of Art: Aesthetic Alienation from Kant to Derrida and Adorno.* University Park, PA: Penn State University Press.

Biedermann, Georg. 1981. *Georg Wilhelm Friedrich Hegel.* Cologne: Pahl-Rugenstein.

Bithell, Jethro, ed. 1962. *Germany: A Companion to German Studies.* London: Methuen.

Bohman, James, and Matthias Lutz-Bachmann, eds. 1997. *Perpetual Peace: Essays on Kant's Cosmopolitan Ideal.* Cambridge, MA: MIT Press.

Bois, Yve-Alain. 1990. "Kahnweiler's Lesson." In *Painting as Model,* 65–97. Cambridge, MA: MIT Press.

de Bolla, Peter. 1989. *The Discourse of the Sublime: History, Aesthetics and the Subject.* Oxford: Basil Blackwell.

Bonfiglio, Thomas Paul. 1997. "Private Reason(s) and Public Spheres: Sexuality and Enlightenment in Kant." *The Eighteenth Century* 38, 2:171–89.

Bourdieu, Pierre. 1996. *The Rules of Art: Genesis and Structure of the Literary Field.* Trans. Susan Emanuel. Stanford, CA: Stanford University Press.

1993. *The Field of Cultural Production: Essays on Art and Literature.* Ed. Randal Johnson. New York: Columbia University Press.

1984. *Distinction: A Social Critique of the Judgment of Taste.* Trans. Richard Nice. Cambridge, MA: Harvard University Press.

Bowie, Andrew. 1990. *Aesthetics and Subjectivity: From Kant to Nietzsche.* Manchester: Manchester University Press.

Brand, Peggy Zeglin, and Carolyn Korsmeyer, eds. 1995. *Feminism and Tradition in Aesthetics.* University Park: Pennsylvania State University Press.

Brinks, J. H. 1998. "The Miraculous Resurrection of Immanuel Kant. Germany's Breakthrough to Former East Prussia." *Political Geography* 17, 5:611–15.

Brockliss, Laurence. 1996. "Curricula." In *A History of the University in Europe,* vol. 2: *Universities in Early Modern Europe (1500–1800),* ed. Hilde De Ridder-Symoens, 563–620. Cambridge: Cambridge University Press.

Bryson, Norman, ed. 1988. *Calligram: Essays in New Art History from France.* Cambridge: Cambridge University Press.

Bryson, Norman, Michael Ann Holly, and Keith Moxey, eds. 1994. *Visual Culture: Images and Interpretations.* Hanover, NH: Wesleyan University Press/University Presses of New England.

1991. *Visual Theory: Painting and Interpretation.* New York: HarperCollins.

Bürger, Peter. 1991. "Aporias of Modern Aesthetics." In *Thinking beyond Traditional Aesthetics,* ed. Andrew Benjamin and Peter Osborne, 3–15. London: ICA.

1984. *Theory of the Avant-Garde.* Trans. Michael Shaw. Minneapolis: University of Minnesota Press.

Burke, Edmund. 1958. *A Philosophical Enquiry into the Origin of Our Ideas of the Sublime and the Beautiful.* 2d ed. (1st ed. 1757). Ed. J. T. Boulton. Notre Dame, IN: University of Notre Dame Press.

Busch, Werner, and Wolfgang Beyrodt, eds. 1982. *Kunsttheorie und Kunstgeschichte des 19. Jarhunderts in Deutschland. Texte und Dokumente.* Vol. 1. Stuttgart: Reclam.

1981. "Akademie und Autonomie: Asmus Jakob Carstens' Auseinandersetzung mit der Berliner Akademie." In *Berlin zwischen 1789 und 1848: Facetten einer Epoch,* 81–92. Exh. Cat. Berlin: Akademie ker Künste.

Carrier, David. 1991. *Principles of Art History Writing.* University Park: Pennsylvania State University Press.

1987. *Artwriting.* Amherst: University of Massachusetts Press.

Carus, Carl Gustav. 1843 and 1845. *Atlas der Crainoscopie.* 2 vols. Leipzig: August Weichardt.

Caruth, Cathy. 1988. "The Force of Example: Kant's Symbols." *Yale French Studies* 74:17–37.

Cascardi, Anthony. 1992. *The Subject of Modernity.* Cambridge: Cambridge University Press.

Ed. 1987. *Literature and the Question of Philosophy.* Baltimore: Johns Hopkins University Press.

Casey, Edward S. 1997. *The Fate of Place: A Philosophical History.* Berkeley: University of California Press.

1993. *Getting Back into Place: Toward a Renewed Understanding of the Place-World.* Bloomington: Indiana University Press.

Cassirer, Ernst. 1981. *Kant's Life and Thought.* Trans. James Haden. New Haven, CT: Yale University Press.

1951. *The Philosophy of the Enlightenment* (1932). Trans. Fritz C. A. Koelln and James P. Pettegrove. Princeton, NJ: Princeton University Press.

1947. *Rousseau, Kant, Goethe: Two Essays.* Trans. James Guttmann, P. O. Kristeller, and John Herman Randall, Jr. Princeton, NJ: Princeton University Press.

Caygill, Howard. 1997. "Stelarc and the Chimera: Kant's Critique of Prosthetic Judgment." *Art Journal* 56, 1: 46–51.

1995. *A Kant Dictionary.* Oxford: Basil Blackwell.

1989. *Art of Judgement.* Oxford: Basil Blackwell.

Certeau, Michel de. 1988. *The Writing of History.* New York: Columbia University Press.

——. 1984. *The Practice of Everyday Life.* Trans. Steven Rendall. Berkeley: University of California Press.

Chamberlin, J. E., and Linda Hutcheon, eds. 1992. *The Discovery/Invention of Knowledge.* Special issue of the *University of Toronto Quarterly* 61, 4.

Chambers, Jack. 1982. "Perceptual Realism" (1969). Reprinted in *artscanada,* nos. 244–47 (March): 112–14.

Chard, Cloë. 1989. "Rising and Sinking on the Alps and Mount Etna: The Topography of the Sublime in Eighteenth-Century England." *Journal of Philosophy and the Visual Arts,* no. 1 (London: Academy Group): 61–69.

Chave, Anna. 1989. *Mark Rothko: Subjects in Abstraction.* New Haven, CT: Yale University Press.

Cheetham, Mark A. 1997. "Recent Rhetorics of Purity in the Visual Arts: Infection, Dissemination, Genealogy." *Paedagogica Historica* (Belgium) 33, 3:861–80.

——. 1995. "The Sublime Is Now (Again)." *C Magazine* (Toronto) 44 (Winter): 27–39.

——. 1992. "Disciplining Art's History." *University of Toronto Quarterly* 61, 4:437–42.

——. 1991a. *The Rhetoric of Purity: Essentialist Theory and the Advent of Abstract Painting.* Cambridge: Cambridge University Press.

——. 1991b. *Remembering Postmodernism: Trends in Recent Canadian Art.* Oxford and Toronto: Oxford University Press.

——. 1987. "The Nationality of Sublimity: Kant and Burke on the Intuition and Representation of Infinity." *Journal of Comparative Literature and Aesthetics* 10, 1–2:71–88.

——. 1985. "The 'Only School' of Landscape Revisited: German Visions of Tivoli in the 18th Century." *IDEA, Werke. Theorien. Dokumente,* IV. Hamburger Kunsthalle: 133–46.

——. 1984. "The Taste for Phenomena: Mount Vesuvius and Transformations in Late 18th Century European Landscape Depiction." *Wallraf-Richartz Jahrbuch* 45:131–44.

——. 1982. "Revision and Exploration: German Landscape Depiction and Theory in the late Eighteenth Century." Ph.D. thesis, University of London.

Clasen, Karl Heinz. 1924. *Kant-Bildnisse.* Königsberg: Gräfe & Unzer.

Cohen, Ted, and Paul Guyer, eds. 1982. *Essays in Kant's Aesthetics.* Chicago: University of Chicago Press.

Cohm, Jan, and Thomas H. Miles. 1977. "The Sublime: In Alchemy, Aesthetics and Psychoanalysis." *Modern Philology* 74 (February): 289–304.

Colbert, Charles. 1986. "'Each Little Hillock Hath a Tongue' – Phrenology and the Art of Hiram Powers." *Art Bulletin* 68, 2 (June): 280–300.

Coleman, Francis X. J. 1974. *The Harmony of Reason: A Study in Kant's Aesthetics.* Pittsburgh, PA: University of Pittsburgh Press.

Cooter, Roger. 1984. *The Cultural Meaning of Popular Science: Phrenology and the Organization of Consent in Nineteenth-Century Britain.* Cambridge: Cambridge University Press.

Corson, Richard. 1971. *Fashions in Hair: The First Five Thousand Years.* London: Peter Owens.

Cowling, Mary. 1989. *The Artist as Anthropologist: The Representation of Type and Character in Victorian Art.* Cambridge: Cambridge University Press.

Craske, Matthew. 1997. *Art in Europe 1700–1830: A History of the Visual Arts in an Era of Unprecedented Urban Economic Growth.* Oxford and New York: Oxford University Press.

Crow, Thomas. 1985. "Modernism and Mass Culture in the Visual Arts." In *Pollock and After: The Critical Debate,* ed. Francis Frascina, 233–65. New York: Harper & Row.

Crowther, Paul. 1997. *The Language of Twentieth-Century Art: A Conceptual History.* New Haven, CT: Yale University Press.

———. 1995. "The Postmodern Sublime: Installation and Assemblage Art." In Crowther, ed., *The Contemporary Sublime: Sensibilities of Transcendence and Shock,* 8–17. Art & Design Profile No. 40. London: Academy Group.

———. 1989a. *The Kantian Sublime: From Morality to Art.* Oxford: Clarendon Press.

———. 1989b. "The Aesthetic Domain: Locating the Sublime." *British Journal of Aesthetics* 29, 1 (Winter): 21–31.

———. 1988. "Beyond Art and Philosophy: Deconstruction and the Post-Modern Sublime." In *The New Modernism: Deconstructivist Tendencies in Art. Art & Design,* ed. A. C. Papadakis, 47–52. New York: St. Martin's Press.

———. 1987. "Cubism, Kant, and Ideology." *Word & Image* 3, 2 (April–June): 195–201.

———. 1985a. "Greenberg's Kant and the Problem of Modernist Painting." *British Journal of Aesthetics* 25, 4 (Autumn): 317–25.

———. 1985b. "Barnett Newman and the Sublime." *Oxford Art Journal* 7, 2:52–59.

Curtin, Deane W. 1982. "Varieties of Aesthetic Formalism." *Journal of Aesthetics and Art Criticism* 40, 3 (Spring): 315–32.

Cutrofellow, Andrew. 1994. *Discipline and Critique: Kant, Poststructuralism, and the Problem of Resistance.* Albany: SUNY Press.

Damisch, Hubert. 1994. *The Origin of Perspective.* Trans. John Goodman. Cambridge, MA: MIT Press.

Danto, Arthur C. 1986. *The Philosophical Disenfranchisement of Art.* New York: Columbia University Press.

Deleuze, Gilles. 1990. *Kant's Critical Philosophy: The Doctrine of the Faculties.* Trans. Hugh Tomlinson and Barbara Habberjam. Minneapolis: University of Minnesota Press.

Deleuze, Gilles, and Félix Guattari. 1994. *What Is Philosophy?* Trans. Hugh Tomlinson and Graham Burchell. New York: Columbia University Press.

Demmler, Theodor. 1924. "Emanuel Bardous Kantbüste vom Jahr 1798." *Kant-Studien* 29:316–20.

De Quincey, Thomas. 1912. "The Last Days of Immanuel Kant." *The English Mail-Coach and Other Essays by Thomas De Quincey,* 162–209. London: J. M. Dent & Sons.

Derrida, Jacques. 1993a. *Aporias.* Trans. Thomas Dutoit. Stanford, CA: Stanford University Press.

1993b. *Memoires of the Blind: The Self-Portrait and Other Ruins*. Trans. Pascale-Anne Brault and Michael Nass. Chicago: University of Chicago Press.

1992. "Mochlos; or, The Conflict of the Faculties." In Richard Rand, ed., *Logomachia: The Conflict of the Faculties*, 1–34. Lincoln and London: Nebraska University Press.

1989. "Fifty-Two Aphorisms for a Foreword." In A. Papadakis, C. Cooke, and A. Benjamin, eds., *Deconstruction: Omnibus Volume*, 67–69. London: Academy Editions.

1988. "The Politics of Friendship." *The Philosophical Forum* 85:632–48.

1987. *The Truth in Painting*. Trans. G. Bennington and I. McLeod. Chicago: University of Chicago Press.

1984. "Languages and Institutions of Philosophy." *Recherches Sémiotiques/ Semiotic Inquiry* 4, 2 (June): 91–154.

1983. "The Principle of Reason: The University in the Eyes of Its Pupils." *Diacritics* 13 (Fall): 3–21.

1982. "Tympan." In *Margins of Philosophy*, trans. Alan Bass, ix–xxix. Chicago: University of Chicago Press.

1981. "Economimesis." *Diacritics* 11 (June): 3–25.

Detels, Claire. 1993. "History and the Philosophies of the Arts." *Journal of Aesthetics and Art Criticism* 51, 3 (Summer): 363–75.

Devereaux, Mary. 1997. "The Philosophical Status of Aesthetics." ⟨http://www.indiana.edu/~asani/ideas/devereaux.html⟩

Dilly, Heinrich. 1979. *Kunstgeschichte als Institution: Studien zur Geschichte einer Disziplin*. Frankfurt: Suhrkamp.

Distel, Theodor. 1909. "Das Original von Schnorrs Kantbild." *Kant-Studien* 14: 143–44.

Duncan, Carol. 1995. *Civilizing Rituals: Inside Public Art Museums*. London: Routledge.

Duro, Paul, ed. 1996. *The Rhetoric of the Frame: Essays on the Boundaries of the Artwork*. Cambridge: Cambridge University Press.

Duve, Thierry de. 1996a. *Kant after Duchamp*. Cambridge, MA: MIT Press.

1996b. *Clement Greenberg between the Lines*. Trans. Brian Holmes. Paris: Éditions Dis Voir.

Eagleton, Terry. 1990. *The Ideology of the Aesthetic*. Oxford: Basil Blackwell.

Eggers, Friedrich. 1867. *Jakob Asmus Carstens*. Potsdam: Literarischen Gesellschaft.

Einem, Herbert von. 1944. "Introduction" to Carl Ludwig Fernow, *Römische Briefe an Johann Pohrt 1793–1798*, ed. Herbert von Einem and Rudolf Pohrt, 33–62. Berlin: Walter de Gruyter.

1935. *Carl Ludwig Fernow: Eine Studie zum Deutschen Klassizismus*. Forschungen zur deutschen Kunstgeschichte 3. Berlin: Des deutschen Vereins für Kunstwissenschaft.

Eitner, Lorenz. 1970. *Neoclassicism and Romanticism 1750–1850: Sources and Documents*. Vol. 1. Englewood Cliffs, NJ: Prentice-Hall.

Elkins, James. 1988. "Art History without Theory." *Critical Inquiry* 14, 2:354–78.

Elon, Amos. 1993. "The Nowhere City." *New York Review of Books* 409, May 13, 28–33.

Ettlinger, L. D. 1961. "Art History Today." London: H. K. Lewis.

Ferguson, Frances. 1992. *Solitude and the Sublime: Romanticism and the Aesthetics of Individuation.* New York: Routledge.

Fernow, Carl Ludwig. 1979. "Concerning Some New Works of Art of Professor Carstens" (1795). In Elizabeth Holt, ed., *The Triumph of Art for the Public,* 57–63.

 1944. *Römische Briefe an Johann Pohrt 1793–1798.* Ed. Herbert von Einem and Rudolf Pohrt. Berlin: Walter de Gruyter.

 1867. *Carstens, Leben und Werke.* Ed. Herman Riegel. Hannover: Carl Rümpfer.

 1806. *Römische Studien.* 2 vols. Zurich: H. Gessner.

Ferrara, Alessandro. 1998. "Judgment, Identity and Authenticity: A Reconstruction of Hannah Arendt's Interpretation of Kant." *Philosophy and Social Criticism* 24, 2/3: 113–36.

Fish, Stanley. 1989. *Doing What Comes Naturally: Change, Rhetoric, and the Practice of Theory in Literary and Legal Studies.* Durham, NC: Duke University Press.

Fliedl, Ilsebill Barta. 1994. "Über die Schwerigkeiten der Poträitkunst. Goethes Verhältnis zu Bildnissen." In Sabine Schulze, ed., *Goethe und die Kunst,* 150–92. Stuttgart: Hatje.

Floyd, Juliet. 1998. "Heautonomy: Kant on Reflective Judgment and Systematicity." In *Kants Ästhetik. Kant's Aesthetics. L'esthétique de Kant,* ed. Herman Parret, 192–218. Berlin and New York: Walter de Gruyter.

Foisy, Suzanne. 1998. "Le *sensus aestheticus* est-il ⟨quasi-transcendental⟩? (Remarques sur une apologie et un double visage)." In *Kants Ästhetik. Kant's Aesthetics. L'esthétique de Kant,* ed. Herman Parret, 275–96. Berlin and New York: Walter de Gruyter.

Foucault, Michel. 1990. "What Is Critique?" (1978). Trans. Kevin Paul Geiman. In James Schmidt, ed., *What Is Enlightenment? Eighteenth-Century Answers and Twentieth-Century Questions,* 382–98. Berkeley: University of California Press.

 1984a. "What Is an Author?" In Paul Rabinow, ed., *The Foucault Reader,* 101–20. New York: Pantheon.

 1984b. "What Is Enlightenment?" In Paul Rabinow, ed., *The Foucault Reader,* 32–50. New York: Pantheon.

 1979. *Discipline and Punish: The Birth of the Prison.* Trans. Alan Sheridan. New York: Vintage Books.

 1977. "Nietzsche, Genealogy, History." In *Language, Counter-memory, Practice: Selected Essays and Interviews with Michel Foucault,* ed. Donald F. Bouchard, 139–64. Ithaca, NY: Cornell University Press.

Frascina, Francis, ed. 1985. *Pollock and After: The Critical Debate.* New York: Harper & Row.

Fry, Edward. 1988. "Picasso, Cubism, and Reflexivity." *Art Journal* 47, 4:296–307.

 1966. *Cubism.* New York: McGraw-Hill.

Fuller, Steve. 1993. "Disciplinary Boundaries and the Rhetoric of the Social Sciences." In Ellen Messer-Davidow, David R. Shumway, and David J. Sylvan, eds., *Knowledges: Historical and Critical Studies in Disciplinarity*, 125–49. Charlottesville and London: University Press of Virginia.

1988. *Social Epistemology*. Bloomington: Indiana University Press.

Gammon, Martin. 1997. "'Exemplary Originality': Kant on Genius and Imitation." *Journal of the History of Philosophy* 35, 4 (October): 563–94.

Gamwell, Lynn. 1980. *Cubist Criticism*. Ann Arbor, MI: UMI Research Press.

Gause, Fritz. 1968. *Die Geschichte der Stadt Königsberg in Preussen*. 2 vols. Cologne: Böhlau.

Gehlen, Arnold. 1966. "D.-H. Kahnweilers Kunstphilosophie."
In *Pour Daniel-Henry Kahnweiler*, 92–103. London: Thames & Hudson.

Geiman, Kevin Paul. 1996. "Enlightened Cosmopolitanism: The Political Perspective of the Kantian 'Sublime.'" In James Schmidt, ed., *What Is Enlightenment? Eighteenth-Century Answers and Twentieth-Century Questions*. Berkeley: University of California Press.

Geldof, Koenraad. 1997. "Authority, Reading, Reflexivity: Pierre Bourdieu and the Aesthetic Judgment of Kant." *Diacritics* 27, 1 (Spring): 20–43.

General Idea. 1992. *Pharma©opia*. Exh. cat. Barcelona: Centre d'Art Santa Mònica.

Gerard, Alexander. 1759. *An Essay on Taste*. London: A. Millar.

Gibbons, Sarah L. 1994. *Kant's Theory of Imagination: Bridging Gaps in Judgement and Experience*. Oxford: Oxford University Press.

Gilbert, Katherine. 1949. "Cassirer's Placement of Art." In Paul Arthur Schilp, ed., *The Philosophy of Ernst Cassirer*, 607–30. New York: Tudor.

Ginzburg, Carlo. 1989. "From Aby Warburg to E. H. Gombrich: A Problem of Method." In *Clues, Myths, and the Historical Method*. Trans. John and Ann C. Tedeschi, 17–59. Baltimore: Johns Hopkins University Press.

Goethe, Johann Wolfgang. 1891. "Einwirkung der neueren Philosophie" (1820). *Goethes Sämtliche Werke*, 39:28–33. Stuttgart and Berlin: J. G. Cotta'sche.

Goetschel, Willi. 1994. *Constituting Critique: Kant's Writing as Critical Praxis*. Trans. Eric Schwab. Durham, NC: Duke University Press.

Gombrich, Ernst. 1992. "The Literature of Art" (1952). Trans. Max Marmor. *Art Documentation* 11, 1:3–8.

1984. "'The Father of Art History': A Reading of the *Lectures on Aesthetics* of G. W. F. Hegel (1770–1831)." In *Tributes: Interpreters of Our Cultural Tradition*, 51–69. Ithaca, NY: Cornell University Press.

Gould, Timothy. 1995. "Intensity and Its Audiences: Toward a Feminist Perspective on the Kantian Sublime." In Peggy Zeglin Brand and Carolyn Korsmeyer, eds., *Feminism and Tradition in Aesthetics*, 66–87. University Park: Pennsylvania State University Press.

Green, Christopher. 1987. *Cubism and Its Enemies*. New Haven, CT: Yale University Press.

Greenberg, Clement. 1986–93. *Clement Greenberg: The Collected Essays and Criticism*. Ed. John O'Brian. 4 vols. Chicago: University of Chicago Press.

1980. "Modern and Post-Modern." *Arts Magazine* 54, 6:64–66.

1979. "Seminar Eight." *Arts Magazine* 53, 10:84–85.

1978. "Seminar Seven." *Arts Magazine* 52, 10:96–97.

1976. "Seminar Six." *Arts Magazine* 50, 10:90–93.

1973a. "Seminar One." *Arts Magazine* 48, 2:44–46.

1973b. "Can Taste Be Objective?" *ART news* 72, 2:22–23, 92.

1955. "Greenberg on Berenson." *Perspectives USA* 11:151–54.

Greenblatt, Stephen, and Giles Gunn, eds. 1992. *Redrawing the Boundaries: The Transformation of English and American Literary Studies.* New York: The Modern Language Association of America.

Grinten, Evert F. van der. 1952. *Enquiries into the History of Art-Historical Functions and Terms up to 1850.* Delft: E. F. Van der Drift.

Grolle, Joist. 1995. *Kant in Hamburg: Der Philosoph und Sein Bildnis.* Stuttgart: Hatje.

Grosz, Elizabeth. 1995. *Space, Time, and Perversion: Essays on the Politics of Bodies.* New York: Routledge.

Guilbaut, Serge, ed. 1990. *Reconstructing Modernism: Art in New York, Paris, and Montreal 1945–1964.* Cambridge, MA: MIT Press.

1985. "Art History after Revisionism: Poverty and Hopes." *Art Criticism* 2, 1:39–50.

Guyer, Paul. 1998. "The Symbols of Freedom in Kant's Aesthetics." *Kants Ästhetik. Kant's Aesthetics. L'esthétique de Kant,* ed. Herman Parret, 338–55. Berlin and New York: Walter de Gruyter.

1993. *Kant and the Experience of Freedom: Essays on Aesthetics and Morality.* New York: Cambridge University Press.

Guyer, Paul, and Ted Cohen, eds. 1982. *Essays in Kant's Aesthetics.* Chicago: University of Chicago Press.

Hart, Joan. 1993. "Erwin Panofsky and Karl Mannheim: A Dialogue on Interpretation." *Critical Inquiry* 19:534–66.

1982. "Reinterpreting Wölfflin: Neo-Kantianism and Hermeneutics." *Art Journal* 42:292–97.

Heidegger, Martin. 1971. *On the Way to Language.* Trans. Peter D. Hertz. New York: Harper & Row.

Heine, Heinrich. 1985. "Concerning the History of Religion and Philosophy in Germany." Trans. Helen Mustard. In Jost Hermand and Robert C. Holub, eds., *Heinrich Heine: The Romantic School and Other Essays,* 128–244. The German Library, vol. 33. New York: Continuum.

Heinrich, Dieter. 1992. *Aesthetic Judgment and the Moral Image of the World: Studies in Kant.* Stanford, CA: Stanford University Press.

Herbert, James D. 1995. "Multidisciplinarity and the 'Pictorial Turn.'" *Art Bulletin* 77, 4 (December): 537–40.

1982. "Beauty and Freedom: Schiller's Struggle with Kant's Aesthetics." In Paul Guyer and Ted Cohen, eds., *Essays in Kant's Aesthetics,* 237–57. Chicago: University of Chicago Press.

Hertz, Neil. 1985. *The End of the Line: Essays on Psychoanalysis and the Sublime.* New York: Columbia University Press.

Herwitz, Daniel. 1993. *Making Theory/Constructing Art: On the Authority of the Avant-Garde.* Chicago: University of Chicago Press.

Hinz, Berthold. 1972. "Zur Dialektik des bürgerlichen Autonomie-Begriffs." In *Autonomie der Kunst: Zur Genese und Kritik einer bürgerlichen Kategorie,* ed. Michael Müller et al., 173–98. Frankfurt: Suhrkamp.

Holly, Michael Ann. 1998. "Panofsky, Erwin." In *The Encyclopedia of Aesthetics,* 3:435–40. Oxford: Oxford University Press.

1996. *Past Looking: Historical Imagination and the Rhetoric of the Image.* Ithaca, NY: Cornell University Press.

1994. "Art Theory." In *The Johns Hopkins Guide to Literary Theory and Criticism,* ed. Michael Groden and Martin Kreiswirth. Baltimore: Johns Hopkins University Press.

1984. *Panofsky and the Foundations of Art History.* Ithaca, NY: Cornell University Press.

Holt, Elizabeth Gilmore, ed. 1979. *The Triumph of Art for the Public: The Emerging Role of Exhibitions and Critics.* New York: Anchor Books.

Hoskin, Keith W. 1993. "Education and the Genesis of Disciplinarity: The Unexpected Reversal." In Ellen Messer-Davidow, David R. Shumway, and David J. Sylvan, eds., *Knowledges: Historical and Critical Studies in Disciplinarity,* 271–304. Charlottesville & London: University Press of Virginia.

Jachec, Nancy. 1998. "Modernism, Enlightenment Values, and Clement Greenberg." *Oxford Art Journal* 21, 2:121–32.

Jay, Martin. 1990. "Name-Dropping or Dropping Names? Modes of Legitimation in the Humanities." In Martin Kreiswirth and Mark A. Cheetham, eds., *Theory between the Disciplines: Authority/Vision/Politics,* 19–34. Ann Arbor: University of Michigan Press.

Jones, Thomas. 1946–48. *Memoirs. The Walpole Society,* vol. 32.

Kahn, Victoria. 1986. "Humanism and the Resistance to Theory." In Patricia Parker and David Quint, eds., *Literary Theory/Renaissance Texts,* 373–96. Baltimore: Johns Hopkins University Press.

Kahnweiler, Daniel-Henry. 1949. *The Rise of Cubism.* Trans. Henry Aronson. New York: Wittenborn, Schultz.

1947. *Juan Gris, His Life and Work.* Trans. Douglas Cooper. London: Lund Humphries.

Kamphausen, Alfred. 1941. *Asmus Jakob Carstens.* Neumünster in Holstein: Karl Wachholtz Verlag.

Kant, Immanuel. 1993. "Announcement of a Near Conclusion of a Treaty for Eternal Peace in Philosophy." Trans. Peter Fenves. In P. Fenves, ed., *Raising the Tone of Philosophy: Late Essays by Immanuel Kant, Transformative Critique by Jacques Derrida,* 83–93. Baltimore: Johns Hopkins University Press.

1992a. *Lectures on Logic.* Trans. J. Michael Young. Cambridge: Cambridge University Press.

1992b. *The Conflict of the Faculties (1798).* Trans. Mary J. Gregor. Lincoln: University of Nebraska Press.

1992c. *Theoretical Philosophy, 1755–1770.* Trans. David Walford and Ralf Meerbote. Cambridge: Cambridge University Press.

1991a. "An Answer to the Question: 'What Is Enlightenment?'" In Hans Reiss, ed., *Kant: Political Writings*, trans. H. B. Nisbet, 54–60. 2d ed. Cambridge: Cambridge University Press.

1991b. *Perpetual Peace: A Philosophical Sketch* (1795). In Hans Reiss, ed., *Kant: Political Writings*, trans. H. B. Nisbet, 93–130. 2d ed. Cambridge: Cambridge University Press.

1991c. "On the Relationship of Theory to Practice in Political Right." In Hans Reiss, ed., *Kant: Political Writings*, trans. H. B. Nisbet, 73–92. 2d ed. Cambridge: Cambridge University Press.

1987. *Critique of Judgment* (1790). Trans. Werner S. Pluhar. Indianapolis: Hackett.

1978. *Anthropology from a Pragmatic Point of View*. Trans. Victor Lyle Dowdell. Carbondale: Southern Illinois University Press.

1965. *Critique of Pure Reason* (1781). Trans. Norman Kemp Smith. New York: St. Martin's.

1963. *Anthropology from a Pragmatic Viewpoint* (1798). Second Book; excerpts. In Kant, *Analytic of the Beautiful*, trans. Walter Cerf. New York: Bobbs-Merrill.

1960. *Observations on the Feeling of the Beautiful and Sublime*. Trans. John T. Goldthwait. Berkeley: University of California Press.

Kelch, Wilhelm Gottlieb. 1804. *Ueber den Schädel Kants: Ein Beytrag zu Galls Hirn- und Schädellehre*. Königsberg: Friedrich Nicolovius.

Kemal, Salim. 1986. *Kant and Fine Art: An Essay on Kant and the Philosophy of Fine Art and Culture*. Oxford: Clarendon.

Kleinbauer, W. Eugene, ed. 1971. *Modern Perspectives in Western Art History; An Anthology of 20th-Century Writings on the Visual Arts*. New York: Holt, Rinehart & Winston.

Köhnke, Klaus Christian. 1991. *The Rise of Neo-Kantianism: German Academic Philosophy between Idealism and Positivism*. Trans. R. J. Hollingdale. New York: Cambridge University Press.

Kreiswirth, Martin, and Mark A. Cheetham, eds. 1990. *Theory between the Disciplines: Authority/Vision/Politics*. Ann Arbor: University of Michigan Press.

Kruse, Joachim. 1989. *Johann Heinrich Lips 1758–1817: Ein Zürcher Kupferstecher zwischen Lavater und Goethe*. Exh. cat. Coburg: Kunstsammlungen der Veste Coburg, Coburger Landesstiftung.

Kupffer, Carl, and Fritz Bessel Hagen. 1881. *Der Schädel Immanuel Kant's*. In the *Archiv für Anthropologie* 13: 359–410.

Kuspit, Donald B. 1996. *Idiosyncratic Identities: Artists at the End of the Avant-Garde*. New York: Cambridge University Press.

1979. *Clement Greenberg, Art Critic*. Madison: University of Wisconsin Press.

LaCapra, Dominick. 1985. *History and Criticism*. Ithaca, NY: Cornell University Press.

1983. *Rethinking Intellectual History*. Ithaca, NY: Cornell University Press.

Lacou-Labarthe, Philippe. 1993. *The Subject of Philosophy*. Trans. T. Trezise, H. J. Silvermann, G. M. Cole, T. D. Bent, K. McPherson, and C. Sartiliot.

Theory and History of Literature, vol. 83. Minneapolis: University of Minnesota Press.

Lacou-Labarthe, Philippe, and Jean-Luc Nancy. 1988. *The Literary Absolute: The Theory of Literature in German Romanticism*. Trans. Philip Barnard and Cheryl Lester. Binghamton, NY: SUNY Press.

Lang, Karen. 1997. "The Dialectics of Decay: Rereading the Kantian Subject." *Art Bulletin* 79, 3 (September): 413–39.

——— 1996. "The German Monument, 1790–1914: Subjectivity, Memory, and National Identity." Ph.D. diss., UCLA.

Lankheit, Klaus. 1952. *Das Freundschaftsbild der Romantik*. Heidelberg: Carl Winter.

Lavater, Johann Caspar. 1810. *Essays on Physiognomy, Designed to Promote the Knowledge and the Love of Mankind*. Trans. Henry Hunter. 5 vols. London: John Stockdale.

Lavin, Irving, ed. 1995. *Meaning in the Visual Arts: Views from the Outside. A Centennial Commemoration of Erwin Panofsky (1892–1968)*. Princeton, NJ: Institute for Advanced Study.

Lefebvre, Henri. 1991. *The Production of Space*. Trans. Donald Nicholas Smith. Oxford: Basil Blackwell.

Leja, Michael. 1993. *Reframing Abstract Expressionism: Subjectivity and Painting in the 1940s*. New Haven, CT: Yale University Press.

Lenoir, Timothy. 1993. "The Discipline of Nature and the Nature of Discipline." In Messer-Davidow, Ellen Shumway, David R. Shumway, and David J. Sylvan, eds., *Knowledges: Historical and Critical Studies in Disciplinarity*, 72–88. Charlottesville and London: University Press of Virginia.

Levinger, Matthew. 1998. "Kant and the Origins of Prussian Constitutionalism." *History of Political Thought* 19, 2 (Summer): 241–63.

Librett, Jeffrey S., ed. 1993. *Of the Sublime: Presence in Question*. Binghamton, NY: SUNY Press.

Lindsay, Jack. 1966. *Turner: His Life and Work*. New York: Harper & Row.

Lloyd, David. 1989. "Kant's Examples." *Representations* 28 (Fall): 34–54.

Loesberg, Jonathan. 1997. "Bourdieu's Derrida's Kant: The Aesthetics of Refusing Aesthetics." *Modern Language Quarterly* 58, 4:417–36.

Lorand, Ruth. 1992. "The Purity of Aesthetic Value." *Journal of Aesthetics and Art Criticism* 50, 1 (Winter): 13–21.

Lutterotti, Otto von. 1940. *Joseph Anton Koch 1768–1839*. Berlin: Deutscher Verein für Kunstwissenschaft.

Lynn, Greg. 1995. "Blobs." *Journal of Philosophy and the Visual Arts* 6:39–44.

——— 1993. "Multiplicitous and In-Organic Bodies." *Architectural Design* 63, 11/12 (Nov.–Dec.):30–37.

Lyotard, Jean-François. 1994. *Lessons on the Analytic of the Sublime*. Trans. Elizabeth Rottenberg. Stanford, CA: Stanford University Press.

——— 1992a. "Sensus Communis." Trans. Marion Hobson and Geoff Bennington. In Andrew Benjamin, ed., *Judging Lyotard*, 1–25. London and New York: Routledge.

1992b. "What Is the Postmodern?" In Lyotard, *The Postmodern Explained: Correspondence 1982–1985*, trans. and ed. Julian Pefanis and Morgan Thomas, 1–16. Minneapolis: University of Minnesota Press.

1990. "After the Sublime: The State of Aesthetics." In David Carroll, ed., *The States of "Theory": History, Art, and Critical Discourse,"* 297–304. New York: Columbia University Press.

1989a. "The Sublime and the Avant-Garde." In Andrew Benjamin, ed., *The Lyotard Reader*, 196–211. Oxford: Basil Blackwell.

1989b. "Newman: The Instant." In Andrew Benjamin, ed., *The Lyotard Reader*, 240–49. Oxford: Basil Blackwell.

1989c. "Judiciousness in Dispute, or Kant after Marx." In Andrew Benjamin, ed., *The Lyotard Reader*, 324–59. Oxford: Basil Blackwell.

1986. "A Response to Philippe Lacoue-Labarthe." In *ICA Documents 4: Postmodernism*. London: Institute of Contemporary Art.

1984. *The Postmodern Condition: A Report on Knowledge.* Trans. Geoff Bennington and Brian Massumi. Minneapolis: University of Minnesota Press.

Maginnis, Hayden B. J. 1993. "Ricard Offner and the Ineffable: A Problem of Connoisseurship. In *The Early Years of Art History in the United States: Notes and Essays on Departments, Teaching, and Scholars*, ed. Craig Hugh Smyth and Peter M. Lukehart, 133–44. Princeton, NJ: Department of Art and Archaeology, Princeton University.

Mah, Harold. 1990. "The French Revolution and the Problem of German Modernity: Hegel, Heine, and Marx." *New German Critique* 50 (Spring/Summer 1990): 3–20.

Makkreel, Rudolf A. 1990. *Imagination and Interpretation in Kant: The Hermeneutical Import of the Critique of Judgment.* Chicago: University of Chicago Press.

Malter, Rudolf von. 1983. "Kantaina in Dorpat (Tartu)." *Kant-Studien* 74:479–86.

1982. "Zu Lowes Kantminiatur aus dem Jahre 1784(?)." *Kant-Studien* 73:261–70.

Marchand, Suzanne L. 1996. *Down from Olympus: Archaeology and Philhellenism in Germany, 1750–1970.* Princeton, NJ: Princeton University Press.

Marin, Louis. 1983. "Panofsky et Poussin en Arcadie." In Jacques Bonnet, ed., *Erwin Panofsky: Cahiers pour un temps.* Paris: Centres Georges Pompidou et Pandora Editions.

Massumi, Brian. 1995. "Interface and Active Space: Human-Machine Design." http://www.anu.edu.au/HRC/first_and_last/links/massumi_works.htm. No pagination.

Mattick, Paul Jr. 1995. "Beautiful and Sublime: 'Gender Totemism' in the Constitution of Art." In Peggy Zeglin Brand and Carolyn Korsmeyer, eds., *Feminism and Tradition in Aesthetics*, 27–48. University Park: Pennsylvania State University Press.

, ed. 1993. *Eighteenth-Century Aesthetics and the Reconstruction of Art.* Cambridge: Cambridge University Press.

McCormick, Peter J. 1990. *Modernity, Aesthetics, and the Bounds of Art.* Ithaca, NY: Cornell University Press.

McDonald, Christie. 1992. "Institutions of Change: Notes on Education in the Late Eighteenth Century." In Richard Rand, ed., *Logomachia: The Conflict of the Faculties*, 35–55. Lincoln and London: Nebraska University Press.

McEvilley, Thomas. 1998. "The Tomb of the Zombie: AICA 1994." *Art Criticism* II, I. Available on-line: June 4/99 http://www.creview.com/artcrit/ac4mce.htm

1993a. *The Exile's Return: Toward a Redefinition of Painting for the Post-Post-Modern Era.* Cambridge: Cambridge University Press.

1993b. *Art and Discontent: Theory at the Millennium.* New York: Documentext.

1988. "empyrrhical thinking (and why kant can't)." *Artforum* 27:120–27.

McGowan, John. 1991. *Postmodernism and Its Critics.* Ithaca, NY: Cornell University Press.

Mellor, Anne K. 1978. "Physiognomy, Phrenology, and Blake's Visionary Heads." In *Blake in His Time*, ed. Robert N. Essick and Donald Pearce, 53–74. Bloomington and London: Indiana University Press.

Melville, Stephen W. 1990. "The Temptation of New Perspectives." *October* 52 (Spring): 3–15.

1986. *Philosophy Beside Itself: On Deconstruction and Modernism.* Theory and History of Literature, vol. 27. Minneapolis: University of Minnesota Press.

Melville, Stephen W., and Bill Readings, eds. 1995. *Vision and Textuality.* Durham, NC: Duke University Press.

Messer-Davidow, David R., David Shumway, and J. Sylvan, eds. 1993. *Knowledges: Historical and Critical Studies in Disciplinarity.* Charlottesville and London: University Press of Virginia.

Mildenberger, Hermann. 1992. "Bertel Thorvaldsen und der Kult um Künstler und Genie." *Künstlerleben Rom. Bertel Thorvaldsen (1770–1844): Der dänische Bildhauer und seine deutschen Freunde*, 189–201. Exh. cat. Nuremberg: Germanisches Nationalmuseum.

Minden, David. 1868. "Vortrag über Portraits und Abbildungen Kant's." *Schriften der Königlichen Physikalisch-Ökonomischen Gesselschaft zu Königsberg* 9:24–35.

Mitchell, Timothy F. 1993. *Art and Science in German Landscape Painting 1770–1840.* Oxford: Clarendon.

Mitchell, W. J. T. 1995. "Interdisciplinarity and Visual Culture." *Art Bulletin* 77, 4 (December): 540–44.

Monk, Philip. 1987. *Paterson Ewen : phenomena : paintings 1971–1987.* Exh. cat. Toronto: Art Gallery of Ontario.

Morris, Meaghan. 1988. *The Pirate's Fiancée: Feminism, Reading, Postmodernism.* London: Verso.

Most, Glenn W. 1996. "Reading Raphael: *The School of Athens* and Its Pre-Text." *Critical Inquiry* 23 (Autumn): 145–82.

Moxey, Keith. 1998. "Art History's Hegelian Unconscious: Naturalism as Nationalism in the Study of Early Netherlandish Painting." In Mark A. Cheetham, Michael Ann Holly, and Keith Moxey, eds., *The Subjects of Art*

History: Historical Objects in Contemporary Perspective. New York: Cambridge University Press.

1995. "Perspective, Panofsky, and the Philosophy of History." *New Literary History* 26, 4 (Autumn): 775–86.

1994. *The Practice of Theory: Poststructuralism, Cultural Politics, and Art History.* Ithaca, NY: Cornell University Press.

Nancy, Jean-Luc. 1993a. "The Sublime Offering." In Jeffrey S. Librett, ed. and trans., *Of the Sublime: Presence in Question,* 25–53. Albany: State University of New York Press.

1993b. "Preface to the French Edition." In Jeffrey S. Librett, ed. and trans., *Of the Sublime: Presence in Question,* 1–3. Albany: State University of New York Press.

Nash, J. M. 1980. "The Nature of Cubism: A Study of Conflicting Interpretations." *Art History* 3, 4 (December): 435–47.

Neiman, Susan. 1994. *The Unity of Reason: Rereading Kant.* Oxford: Oxford University Press.

Nelson, John S. 1993. "Approaches, Opportunities and Priorities in the Rhetoric of Political Inquiry: A Critical Synthesis." In R. H. Roberts and J. M. M. Good, eds., *The Recovery of Rhetoric: Persuasive Discourse and Disciplinarity in the Human Sciences,* 164–89. Charlottesville and London: University Press of Virginia.

Neumann, Thomas. 1968. *Der Künstler in der bürgerlichen Gesellschaft.* Stuttgart: Ferdinand Enke.

Newman, Barnett. 1992. "The Plasmic Image" (1945). In *Barnett Newman: Selected Writings and Interviews,* ed. John P. O'Neill, 138–54. Berkeley: University of California Press.

1967. "The Sublime Is Now." *Tiger's Eye 1,* nos. 6–9 (1948–49): 51–53. New York: Kraus Reprint Corporation.

Nicholson, Peter P. 1992. "Kant, Revolutions and History." In Howard Lloyd Williams, ed., *Essays on Kant's Political Philosophy,* 249–68. Chicago: University of Chicago Press.

Nietzsche, Friedrich. 1989. *On the Genealogy of Morals.* Trans. Walter Kaufmann and R. J. Hollingdale. New York: Vintage Books.

1974. *The Gay Science, with a prelude in rhymes and an appendix of songs.* Trans. Walter Kaufmann. New York: Vintage Books.

Norris, Christopher. 1996. *Reclaiming Truth: Contribution to a Critique of Cultural Relativism.* Durham, NC: Duke University Press.

1993. *The Truth about Postmodernism.* Oxford: Basil Blackwell.

1990. *What's Wrong with Postmodernism: Critical Theory and the Ends of Philosophy.* Baltimore: Johns Hopkins University Press.

Nussbaum, Martha. 1997. "Kant and Cosmopolitanism." In James Bohman and Matthias Lutz-Bachmann, eds., *Perpetual Peace: Essays on Kant's Cosmopolitan Ideal,* 25–57. Cambridge, MA: MIT Press.

Oeser, Hans Ludwig. 1932. *Menschen und Werke im Zeitalter Goethes: Ein Bildwerk.* Berlin: P. Franke.

O'Neill, Onora. 1992. "Reason and Politics in the Kantian Enterprise." In Howard Lloyd Williams, ed., *Essays on Kant's Political Philosophy*, 50–80. Chicago: University of Chicago Press.

 1989. *Constructions of Reason: Explorations of Kant's Practical Philosophy.* Cambridge: Cambridge University Press.

O'Quinn, Daniel. 1997. "The Gog and the Magog of Hunnish Desolation: De Quincey, Kant, and the Practice of Death." *Nineteenth-Century Contexts* 20, 3:261–86.

Orton, Fred, and Griselda Pollock. 1985. "*Avant-Gardes* and Partisans Reviewed." In Francis Frascina, ed., *Pollack and After: The Critical Debate*, 167–83. New York: Harper & Row.

Ostrow, Saul. 1989. "Avant-Garde and Kitsch, Fifty Years Later: A Conversation with Clement Greenberg." *Arts Magazine* 64, 4:56–57.

Panofsky, Erwin. 1991. "Perspective as Symbolic Form" (1924–25). Trans. Christopher S. Wood. New York: Zone Books.

 1981. "The Concept of Artistic Volition" (1920). Trans. Kenneth J. Northcott and Joel Snyder. *Critical Inquiry* 8, 1:17–33.

 1974. "Über das Verhältnis der Kunstgeschichte zur Kunsttheorie" (1924–25). In Hariolf Berer and Egon Verheyen, eds., *Erwin Panofsky: Aufsätze zu Grundfragen der Kunstwissenschaft*, 49–75. 2d ed. Berlin: Bruno Hessling.

 1968. *Idea: A Concept in Art Theory.* Trans. Joseph J. S. Peake. New York: Harper & Row.

 1962. *Studies in Iconology: Humanistic Themes in the Art of the Renaissance* (1939). New York: Harper & Row.

 1955. "The History of Art as a Humanistic Discipline" (1940). In *Meaning in the Visual Arts: Papers in and on Art History*, 1–25. New York: Anchor Books.

Parret, Herman, ed. 1998. *Kants Ästhetik. Kant's Aesthetics. L'esthétique de Kant.* Berlin and New York: Walter de Gruyter.

Passarge, Walter. 1930. *Die Philosophie der Kunstgeschichte in der Gegenwart.* Berlin: Junker und Dunhaupt.

Pearson, Fiona. 1981. "Phrenology and Sculpture 1820–1855." *Leeds Art Calendar* 88:14–23.

Peters, Ursula. 1992. "Das Ideal der Gemeinschaft." In *Künstlerleben in Rom. Bertel Thorvaldsen (1770–1844): Der dänische Bildhauer und seine deutschen Freunde.* Exh. cat., 157–85. Nuremberg: Germanisches Nationalmuseum.

Pippin, Robert B. 1996. "Kant on the Significance of Taste." *Journal of the History of Philosophy* 34, 4 (October): 549–69.

Podro, Michael. 1982. *The Critical Historians of Art.* New Haven, CT: Yale University Press.

 1972. *The Manifold in Perception: Theories of Art from Kant to Hildebrand.* Oxford: Clarendon.

Pointon, Marcia. 1993. *Hanging the Head: Portraiture and Social Formation in Eighteenth-Century England.* New Haven, CT: Yale University Press.

Porter, Roy, and Mikuláš Teich, eds. 1981. *The Enlightenment in National Context.* Cambridge: Cambridge University Press.

Preziosi, Donald. 1993. "Seeing through Art History." In Ellen Messer-Davidow, David R. Shumway, and David J. Sylvan, eds., *Knowledges: Historical and Critical Studies in Disciplinarity*, 215–31. Charlottesville and London: University Press of Virginia.

———. 1992. "The Question of Art History." *Critical Inquiry* 18:363–86.

———. 1989. *Rethinking Art History: Meditations on a Coy Science*. New Haven, CT: Yale University Press.

Pries, Christine, ed. 1989. *Das Erhabene: Zwischen Grenzerfahrung und Grössenwahn*. Weinheim: Acta Humaniora.

Randolph, Jeanne. 1991. *Psychoanalysis & Synchronized Swimming and Other Writings on Art*. Toronto: YYZ Books.

Raymaekers, Bart. 1998. "The Importance of Freedom in the Architectonic of the *Critique of Judgment*." In *Kants Ästhetik. Kant's Aesthetics. L'esthétique de Kant*, ed. Herman Parret, 84–92. Berlin and New York: Walter de Gruyter.

Readings, Bill. 1996. *The University in Ruins*. Cambridge, MA: Harvard University Press.

Reiss, Hans. 1999. "Kant's Politics and the Enlightenment: Reflections on Some Recent Studies." *Political Theory* 27, 2 (April): 236–73.

———. 1991. "Introduction." In Hans Reiss, ed., *Kant: Political Writings*, trans. H. B. Nisbet, 1–40. 2d ed. Cambridge: Cambridge University Press.

Reudenbach, Bruno, ed. 1994. *Erwin Panofsky: Beiträge des Symposions Hamburg 1992*. Berlin: Akademie Verlag.

Reynolds, Frances. 1785. *An Enquiry Concerning the Principles of Taste, and the Origins of our Ideas of Beauty &C*. London: Baker and Galabin.

Ribeiro, Aileen. 1984. *Dress in Eighteenth-Century Europe, 1715–1789*. London: B. T. Batsford.

Ridder-Symoens, Hilde De, ed. 1996. *A History of the University in Europe*, vol. 2: *Universities in Early Modern Europe (1500–1800)*. Cambridge: Cambridge University Press.

Ringer, Fritz K. 1969. *The Decline of the German Mandarins: The German Academic Community, 1890–1933*. Cambrdige, MA: Harvard University Press.

Rodowick, D. N. 1994. "Impure Mimesis, or the Ends of the Aesthetic." In Peter Brunette and David Wills, eds., *Deconstruction and the Visual Arts: Art, Media, Architecture*, 96–117. Cambridge University Press.

Roehr, Sabine. 1995. *A Primer on German Enlightenment, with a Translation of Karl Leonhard Reinhold's* The Fundamental Concepts of Ethics. Columbia: University of Missouri Press.

Rorty, Richard. 1989. "From Ironist Theory to Private Allusions: Derrida." In *Contingency, Irony, and Solidarity*, 122–37. Cambridge: Cambridge University Press.

Ross, Stephen David. 1996. *The Gift of Beauty: The Good as Art*. Albany: State University of New York Press.

Rubenfeld, Florence. 1997. *Clement Greenberg: A Life*. New York: Scribner.

Ruskin, John. 1987. *Modern Painters*. Ed. David Barrie. London: André Deutsch.

Sallis, John. 1987. *Spacings of Reason and Imagination in Texts of Kant, Fichte, Hegel*. Chicago: University of Chicago Press.

Sauerländer, Willibald. 1995. "Struggling with a Deconstructed Panofsky." In Irving Lavin, ed., *Meaning in the Visual Arts: Views from the Outside. A Centennial Commemoration of Erwin Panofsky (1892–1968)*, 386–96. Princeton, NJ: Institute for Advanced Study.

Schama, Simon. 1995. *Landscape and Memory*. Toronto: Random House.

Scheffler, Walter. 1987. "Von Königsberg nach Marburg: Ein Portrait Immanuel Kants." *Jahrbuch der deutschen Schillergesellschaft* 31:513–18.

Schiebinger, Londa. 1993. *Nature's Body: Gender in the Making of Modern Science*. Boston: Beacon Press.

Schiller, Friedrich. 1967. *On the Aesthetic Education of Man in a Series of Letters*. Trans. Elizabeth M. Wilkinson and L. A. Willoughby. Oxford: Clarendon.

Schlegel, Friedrich. 1860. "Letters on Christian Art." In *The Aesthetic and Miscellaneous Works of Frederick von Schlegel*. Trans. E. J. Millington. London: Henry G. Bohn.

Schlosser, Julius. 1924. *Die Kunstliteratur: Ein Handbuch zur Quellenkunde der Neueren Kunstgeschicte*. Vienna: Anton Schroll.

Schmidt, James. 1996. "Introduction." In James Schmidt, ed., *What Is Enlightenment? Eighteenth-Century Answers and Twentieth-Century Questions*, 1–44. Berkeley: University of California Press.

Schoch, Rainier. 1992. "Rom 1797 – Fluchpunkt der Freiheit." In *Künstlerleben in Rom, Bertel Thorwaldsen (1770–1844): Der dänische Bildhauer und Seine deutsche Freunde*, 17–23. Exh. cat. Nuremberg: Germanischen Nationalmuseums.

Schopenhauer, Johanna. 1810. *Carl Ludwig Fernow's Leben*. Tübingen: J. G. Cottaschen.

Schor, Naomi. 1987. *Reading in Detail: Aesthetics and the Feminine*. London and New York: Methuen.

Schott, Robin May, ed. 1997. *Feminist Interpretations of Immanuel Kant*. University Park: Pennsylvania State University Press.

Schulze, Sabine. 1994. *Goethe und die Kunst*. Stuttgart: Hatje.

Sekula, Allan. 1986. "The Body and the Archive." *October* 39:3–64.

——— 1985. "Dismantling Modernism" (1979). In Richard Hertz, ed., *Theories of Contemporary Art*, 163–66. Englewood Cliffs, NJ: Prentice-Hall.

Seliger, Jonathan. 1990. "Christian Eckart." Interview. *Journal of Contemporary Art* 3, 1 (Spring/Summer): 48–58.

Serequeberhan, Tsenay. 1996. "Eurocentrism in Philosophy: The Case of Immanuel Kant." *The Philosophical Forum* 27, 4 (Summer): 333–56.

Shapiro, David, and Cecile Shapiro. 1985. "Abstract Expressionism: The Politics of Apolitical Painting." In Frascina 1985: 135–51.

Shell, Susan Meld. 1996. *The Embodiment of Reason: Kant on Spirit, Generation, and Community*. Chicago: University of Chicago Press.

——— 1993. "Commerce and Community in Kant's Early Thought." In *Kant and Political Philosophy: The Contemporary Legacy*, ed. Ronald Beiner and William James Booth, 117–54. New Haven, CT: Yale University Press.

1992. "Kant's Political Cosmology: Freedom and Desire in the 'Remarks' concerning *Observations on the Feeling of the Beautiful and Sublime.*" In Howard Lloyd Williams, ed., 81–119. *Essays on Kant's Political Philosophy.* Chicago: University of Chicago Press.

Sherman, Daniel J., and Irit Rogoff, eds. 1994. *Museum Culture: Histories, Discourses, Spectacles.* Minneapolis: University of Minnesota Press.

Siebers, Tobin. 1998. "Kant and the Politics of Beauty." *Philosophy and Literature* 22, 1:31–50.

Silverman, Hugh J., and Gary E. Aylesworth, eds. 1990. *The Textual Sublime: Deconstruction and Its Differences.* Albany: State University of New York Press.

Simpson, David, ed. 1984. *German Aesthetic and Literary Criticism: Kant, Fichte, Schelling, Hegel.* Cambridge: Cambridge University Press.

Siskin, Clifford. 1994. "Gender, Sublimity, Culture: Retheorizing Disciplinary Desire." *Eighteenth-Century Studies* 28, 1:37–50.

Slettene, Randall. 1997. "New Ways of Seeing the Old: Cubism and Husserlian Phenomenology." *The European Legacy* 2, 1:104–9.

Soussloff, Catherine M. 1997. *The Absolute Artist: The Historiography of a Concept.* Minneapolis: University of Minnesota Press.

Spurzheim, Johann Caspar. 1815. *The Physiognomical System of Drs. Gall and Spurzheim; Founded on an Anatomical and Physiological Examination of the Nervous System in General, and the Brain in particular; and indicating the Dispositions and Manifestations of the Mind.* 2d ed. London: Baldwin, Cradock, and Joy.

Stadler, Ingrid. 1982. "The Idea of Art and of Its Criticism: A Rational Reconstruction of a Kantian Doctrine." In Ted Cohen and Paul Guyer, eds., *Essays in Kant's Aesthetics,* 195–218. Chicago: University of Chicago Press.

Staël, Germaine de. 1987. *An Extraordinary Woman: Selected Writings of Germaine De Staël.* Trans. Vivian Folkenflik. New York: Columbia University Press.

Stafford, Barbara Maria. 1991. *Body Criticism: Imaging the Unseen in Enlightenment Art and Medicine.* Cambridge, MA: MIT Press.

1987. "'Peculiar Marks': Lavater and the Countenance of Blemished Thought." *Art Journal* 46, 3 (Fall): 185–92.

Steffens, Henrich. 1810. *Geognostische-Geologische Aufsätze, als Vorbereitung zu einer innern Naturgeschichte der Erde.* Hamburg: Hoffmann.

Stemmler, Joan K. 1993. "The Physiognomical Portraits of Johann Caspar Lavater." *Art Bulletin* 75, 1 (March): 151–68.

Strack, Thomas. 1996. "Philosophical Anthropology on the Eve of Biological Determinism: Immanuel Kant and Georg Forster on the Moral Qualities and Biological Characteristics of the Human Race." *Central European History* 29, 3:285–308.

Summers, David. 1995. "Meaning in the Visual Arts as a Humanistic Discipline." In Irving Lavin, ed., *Meaning in the Visual Arts: Views from the Outside. A Centennial Commemoration of Erwin Panofsky (1892–1969),* 7–24. Princeton, NJ: Institute for Advanced Study.

1994. "Form and Gender." In Norman Bryson, Michael Ann Holly, and Keith Moxey, eds., *Visual Culture: Images and Interpretations*, 384–411. Hanover and London: University Press of New England.

1993. "Why Did Kant Call Taste a 'Common Sense'?" In Paul Mattick, Jr., ed., *Eighteenth-Century Aesthetics and the Reconstruction of Art*, 120–51. Cambridge: Cambridge University Press.

1989. "'Form,' Nineteenth-Century Metaphysics, and the Problem of Art Historical Description." *Critical Inquiry* 15 (Winter): 372–406.

1987. *The Judgment of Sense: Renaissance Naturalism and the Rise of Aesthetics*. Cambridge: Cambridge University Press.

Tate, John W. 1997. "Kant, Habermas, and the 'Philosophical Legitimation' of Modernity." *Journal of European Studies*, 27, 3, no. 107: 281–322.

Taylor, Charles. 1985. "Kant's Theory of Freedom." In *Philosophy and the Human Sciences: Philosophical Papers* 2, 318–37. Cambridge: Cambridge University Press.

Tytler, Graeme. 1982. *Physiognomy and the European Novel: Faces and Fortunes*. Princeton, NJ: Princeton University Press.

Usher, James. 1778. *Clio: or, A discourse on Taste Addressed to a Young Lady (1770)*. 4th ed. Dublin: J. Milliken.

Vaihinger, Hans. 1901a. "Das 'Dresdener Kantbild' – ein Werk von Elisabeth v. Stägemann?" *Kant-Studien* 6:112–13.

1901b. "Die neue Kantbüste in der Berliner Siegesalle." *Kant-Studien* 5:138–41.

Vergo, Peter, ed. 1989. *The New Museology*. London: Reaktion Books.

Vidler, Anthony. 1994. "Art History's *Posthistoire*." *Art Bulletin* 76, 3:407–10.

Vollrath, Ernst. 1974. "Kants Kritik der Urteilskraft als Grundlegung einer Theorie des Politischen," 692–705. Berlin and New York: de Gruyter.

Watson, Ross. 1969. *Joseph Wright of Derby: A Selection of Paintings from the Collection of Mr. and Mrs. Paul Mellon*. Exh. cat. Washington DC: National Gallery of Art.

Weiskel, Thomas. 1976. *The Romantic Sublime: Studies in the Structure and Psychology of Transcendence*. Baltimore: Johns Hopkins University Press.

Welchman, John C., ed. 1996. *Rethinking Borders*. Minneapolis: University of Minnesota Press.

Werkmeister, William H. 1949. "Cassirer's Advance beyond Neo-Kantianism." In Paul Arthur Schilp, ed., *The Philosophy of Ernst Cassirer*, 759–98. New York: Tudor Publishing Co.

White, Iain Boyd. 1994. "The Sublime." In *The Romantic Spirit in German Art*, ed. Keith Hartley et al., 138–46. Edinburgh: Scottish National Gallery of Modern Art.

Wigley, Mark. 1993. *The Architecture of Deconstruction: Derrida's Haunt*. Cambridge, MA: MIT Press.

Wilkinson, Elizabeth M., and L. A. Willoughby. 1967. "Introduction" to Friedrich Schiller, *On the Aesthetic Education of Man in a Series of Letters*, trans. Elizabeth M. Wilkinson and L. A. Willoughby, xi–cxcvi. Oxford: Clarendon.

Willey, Thomas E. 1978. *Back to Kant: The Revival of Kantianism in German Social and Historical Thought, 1860–1914*. Detroit: Wayne State University Press.

Wilton, Andrew. 1980. *Turner and the Sublime*. Exh. cat. New Haven and Toronto: Yale Center for British Art and the Art Gallery of Ontario.

Wind, Edgar. 1986. *Hume and the Heroic Portrait: Studies in Eighteenth-Century Imagery*. Oxford: Clarendon.

Wölfflin, Heinrich. 1950. *The Principles of Art History: The Problem of the Development of Style in Later Art*. Trans. M. D. Hottinger. 7th ed. New York: Dover.

Wood, Christopher S. 1991. "Introduction" to Erwin Panofsky, "Perspective as Symbolic Form," 7–24. Cambridge, MA: MIT Press.

Woodmansee, Martha. 1994. *The Author, Art, and the Market: Readings in the History of Aesthetics*. New York: Columbia University Press.

Wyss, Beat. 1999. *Hegel's Art History and the Critique of Modernity*. Trans. Caroline Dobson Saltzwedel. Cambridge: Cambridge University Press.

Yaeger, Patricia. 1989. "Toward a Female Sublime." In Linda Kauffman, ed., *Gender and Theory: Dialogues on Feminist Criticism*, 191–212. Oxford: Basil Blackwell.

Yovel, Yirmiahu. 1980. *Kant and the Philosophy of History*. Princeton, NJ: Princeton University Press.

Zakian, Michael. 1988. "Barnett Newman and the Sublime." *Arts Magazine* 62 (February): 33–39.

Zammito, John H. 1992. *The Genesis of Kant's* Critique of Judgment. Chicago: University of Chicago Press.

Index